A way of life

Kettle's Yard

Published by the Press Syndicate of the University of Cambridge
The Pitt Building, Trumpington Street, Cambridge CB2 1RP
32 East 57th Street, New York, NY 10022, USA
296 Beaconsfield Parade, Middle Park, Melbourne 3206, Australia

First published 1984

Printed in Great Britain by Balding and Mansell, Wisbech, Cambs

Library of Congress catalogue card number: 82–14686

British Library Cataloguing in Publication Data
Ede, Jim
A way of life : Kettle's Yard.
1. Kettle's Yard gallery – History
I. Title
708.2'659 N1219.C/
ISBN 0 521 25062 5

The title-page drawing is by Italo Valenti

Publisher's Note

This book provides an account of Kettle's Yard which gives more than a guided tour, catalogue, or history. Such categories may be appropriate to ordinary museums or galleries, but Kettle's Yard is not ordinary, and what is required is an introduction which conveys the unique nature of the place, the spirit in which it was put together, and the silent influence which it can exert on the visitor who is willing to feel it.
A way of life achieves this richly, bringing a hidden depth of understanding through a sequence of remarkable photographs, an adventure in themselves, accompanied by a personal and penetrating text.

The house and its contents are the gift to Cambridge of Jim Ede, an inspired contemplative who found that if he put things together in the right place in a room, the visiting light daily revolving in that space would create a play of presences. His friendships with the artists whom he was often the first to admire, and with other generous people, brought the steady growth of the collection; so that pictures, sculpture, pottery, glass, the furniture, the plates – even stones picked up on the beach – now stand as if entranced by each other.

The intention of the following pages is to give the visual equivalent of going inside the door and moving through the house, pausing to look at what there is to see, to feel the relationships of light and space, and to sense the further thing which is always hovering there, waiting to be called into a room, at the turn of a stair, through the mystery of a painting. Here and there the journey is suspended to allow the introduction of experiences which lie at the heart of Kettle's Yard; and the voices of the poets and mystics who have been Jim Ede's instructors are called on to supply texts which illuminate the journey.

The photographs are of especial importance: their quality, and their placing in relation to each other. The planning of the book follows Jim Ede's careful design, and the illustrations are placed as he placed them, as he lived again the constant joy he had felt while it was his home. He never felt it was his creation, he just put things where they seemed to belong; and here in this book he has found further inspiration through the new medium of black-and-white photographs: and they together with his text manifest his new findings.

Acknowledgements

The author and publishers gratefully acknowledge the financial support of the following institutions and private well-wishers, which has helped to make the publication of this book possible: Charlotte Bonham Carter, John Deacon, Laurel Gray, Hubert Howard, Harold Swan, Italo and Anne Valenti, the Henry Moore Foundation, and Kettle's Yard.

From the Vice-Chancellor of the University of Cambridge

Kettle's Yard is a unique benefaction to the University, since not only does it provide a harmonious setting for work by some of the best twentieth-century artists but also by its character it is a place where people can do more than just look (or glance) at pictures and sculpture. It is not a gallery, but retains the character of a house, a home; and the spirit which pervades it can refresh, strengthen and console, according to the need of those who spend a little time in it and feel what it has to give.

It is a great pleasure to think that this book records the intentions of the donor in his own words, so that it can become a permanent reference. The University Committee which administers Kettle's Yard has generously supported publication with a grant which will bring an otherwise expensive book within the reach of more people. The Cambridge University Press has undertaken publication, and tried to make the physical book worthy of the subject.

F. H. HINSLEY

1983
St John's College Cambridge

Foreword

A way of life was put together by Jim Ede, in the hope of making, in book form, some kind of parallel, a shadow of reality, to that which is the reality of Kettle's Yard.

In assembling this work it has been his hope that through the medium of black and white photographs something of Kettle's Yard's subtlety of light, its delicacy and assurance of colour, its peacefulness, will be manifest.

He wishes to thank all friends who have so greatly helped him, particularly those who have taken photographs over a number of years, and begs their forbearance if some are wrongly attributed. Above all he would wish to thank George Kennethson, who, with such great patience, supplied innumerable trial shots or enlargements whenever asked for, and never complained at the importunity. Without this initial and continued help he could not have started – nor could he have happily ended without the generosity of Harry Sowden who came in with such very special photographs needed to carry him through.

He would have liked to call the book 'A way of love' as someone suggested, for what is life without devotion? And without this ever-present Love, there could have been no Kettle's Yard. Spenser's words from the sixteenth century were thus his guide:

> So let us love, dear Love, like as we ought
> Love is the lesson that the Lord us taught.

O Beauty, so ancient and so new

St Augustine

Not without hope did I ascend
Upon an amorous quest to fly
And up I soared so high, so high,
I seized my quarry in the end.

As on this falcon quest I flew
To chase a quarry so divine,
I had to soar so high and fine
That soon I lost myself from view.
With loss of strength my plight was sorry
From straining on so steep a course.
But love sustained me with such force
That in the end I seized my quarry.

The more I rose into the height
More dazzled, blind and lost I spun.
The greatest conquest ever won
I won in blindness, like the night.
Because love urged me on my way
I gave that mad, blind, reckless leap
That soared me up so high and steep
That in the end I seized my prey.

The steeper upward that I flew
On so vertiginous a quest
The humbler and more lowly grew
My spirit, fainting in my breast.
I said 'None yet can find the way'
But as my spirit bowed more low,
Higher and higher did I go
Till in the end I seized my prey.

By such strange means did I sustain
A thousand starry flights in one,
Since hope of Heaven yet by none
Was ever truly hoped in vain.
Only by hope I won my way
Nor did my hope my aim belie,
Since I soared up so high, so high,
That in the end I seized my prey.

St John of the Cross

for they bring each unto another

From a local schoolboy, aged 16, in 1972

Near the foot of Castle Hill, just above the river stands a house which, although not so widely famous as the Fitzwilliam Museum, is no less beautiful or moving than its older counterpart. Kettle's Yard, owned by H. S. Ede . . . contains the pictures and objects collected by this man throughout his life, and the result is peculiarly exciting.

Jim Ede (as he is known) has lived in Kettle's Yard for the last 15 years and during this time, while he has increased his large collection of paintings and sculpture of the last fifty years, he has kept 'open house' for undergraduates every afternoon . . . and by allowing visitors to discover in his house the same exciting sense of beauty he himself still feels intensely, when walking among the rooms he knows and loves so well, he seeks to enable them to infuse a richness into their daily lives.

Six years ago now he gave Kettle's Yard to the University of Cambridge, with the intention of maintaining its domestic setting, and thus keeping the unique atmosphere which distinguishes it from an ordinary gallery. Its role is that of introduction to the visual arts which will allow young people to relate a beauty of everyday life in intimate and unified surroundings before they proceed to the larger, more confused world of the museum and the art gallery. One of the most impressive features of its structures is the basis of trust inherent in the way large numbers of works by well known artists are lent freely to undergraduates each term so that they may experience live works rather than reproductions, and generations of undergraduates must remember this trust with gratitude. Kettle's Yard was set up with the undergraduate in mind, and in view of its aims, rightly so; but this by no means excludes anyone, young or old, from visiting and enjoying a place of such wonderful beauty. Not only does Jim Ede positively encourage people to come and look at his house, but he shows an interest in each individual who does so; and this, when the numbers grew to an annual total of 1,700 in 1971 . . . This total was for new undergraduates. The year's total of visitors to the house was over 10,000.

Kettle's Yard, private house and introductory art gallery, becomes thus almost an artistic mission in a place so noted for its culture as Cambridge. I think that anyone with any appreciation of things of beauty will find the fruits of this fifty years of love of the arts, both uplifting and immensely exciting.

Robin Lister wrote the above for his school magazine, *The Fortnightly Magazine* of the Leys School, Cambridge.

Letter from a visitor, 1980

While having dinner with a friend in Cambridge (England), I asked what he thought
I should do during my short visit.

'Kettle's Yard' he said.

On asking what Kettle's Yard was, he replied 'a beautiful house full of beautiful
things'; and this is exactly what it turned out to be.

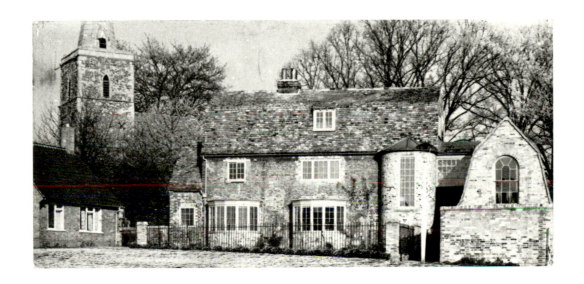

An article in *Country Life* by Christopher Neve, 1972

'Homes made public, particularly those in the United States like Dumbarton Oaks,
succeed in retaining the idea of a living collection inherent to a domestic setting but
yet accessible. At the same time – and here Kettle's Yard is supreme – a place that
has at least a sense of privacy, can be a sanctuary, in a way that can seldom happen
in a public gallery where works are on show in a more austere and altogether more
self-conscious way. As an escape from this dilemma Kettle's Yard is an inspired
lesson in how a highly individual selection, not only of pictures and sculptures, but
of books and furniture, and all sorts of stray objects, like pebbles, shells, wood and
glass, can retain its identity as part of one man's way of life, and yet be
institutionalised to the extent that it has belonged, since 1966, to Cambridge
University and is administered by a committee of the Council of the University
Senate.

'It is "open house", in that it may be visited by the public between two and four every afternoon of the year (with minor exceptions), and, nine times out of ten, when you go to look at it you will be met at the door by Jim Ede, and reach the larger part of the collection only after having first walked through his private rooms. This is an integral part of its effect, and an aspect that has been cunningly and sympathetically emphasised by the 1970 extension, that develops in a sequence of descending levels and increasing volumes from its connection with the original cottages at first-floor level.

'How you react, however, by no means only depends on your response to the main theme of the collection – Nicholson, Brancusi, Moore, Miro, Christopher Wood, Alfred Wallis and, most important of all Gaudier-Brzeska – but to the atmosphere that these things help to create. It is a particular ambience that one associates with the 1920s in the best sense, though by no means necessarily with the works themselves which do not always date from then . . .

'Its colour is a natural one; scrubbed wood, stone pottery, brick floors, biscuit, with a kind of powdery white that finds its way off the walls in concealed daylight, and quietly keeps everything fresh, ascetic, clear.

'Not everyone will respond, to an atmosphere expressed so passionately, and with such attention to detail, but if you enjoy it, as I do, it is a rare example of period placing and relating. There is almost nowhere else where you will see it on such a scale or done with such affection and refinement, and certainly nowhere with paintings and sculptures of such quality. The beauty of it is that it relates everything to everything else, not just distantly but closely enough for it to be next of kin and affect everything you do. To this extent Kettle's Yard is almost a work of art in its own right . . .'

In writing of Gaudier-Brzeska's work and the extraordinary quality of being very still at its centre, the article continues: 'It is precisely this, that the atmosphere of Kettle's Yard enables the visitor to appreciate fully, because of its sense of sanctuary, and because the senses have themselves been keyed up by its meticulous detail; details you have to work for; for example the mechanism of the light switches is deliberately left exposed so that you can see their precise motion.

'The air of seclusion and peace in what in fact is a busy and congested part of

Cambridge, is heightened by the shady trees and wild flowers in the old churchyard of St Peter's to the north and the open green that rises to meet the cottage from the west.

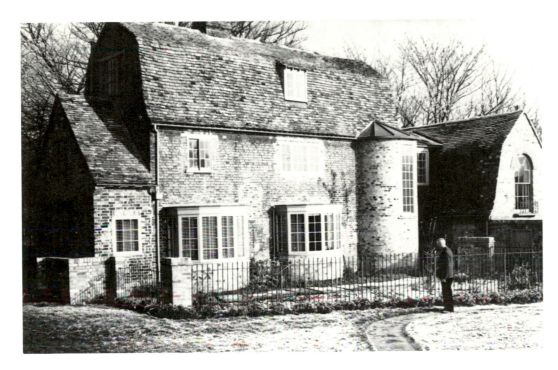

'The house is so folded in on itself that, once indoors, only when you listen are you aware of the surrounding heavy traffic . . . Where light sources are not concealed, windows are full of plants, china and glass, so that daylight arrives in the rooms through green leaves or reflected and refracted off a variety of hard surfaces. It is central to the philosophy of Kettle's Yard that a room is already furnished by the light that comes into it. The taut immobility of Gaudier's sculpture is complemented by a Khmer Buddha, from 14th century Cambodia, of which the pinkish stone is in turn affected by a pink head of a dried flower placed in its upturned hands.

'It affects the big self-portrait by Christopher Wood, the white Gaudier relief of "Wrestlers", the Gabo on the piano. Upstairs, when you find a double row of Wallises, frame to frame and some at knee-level, you remember that in his own cottage they would have lain at random on the floor and been seen at all angles; and again that this is not a museum.

'Even with the questions it poses, the vitality and success of Kettle's Yard as an alternative to the museum concept is self-evident, and perhaps it is an indication of how the problem can be solved elsewhere in the future, especially in other Universities where a constantly changing student population could benefit from its informal function, both as a sanctuary and as a museum to the visual arts.'

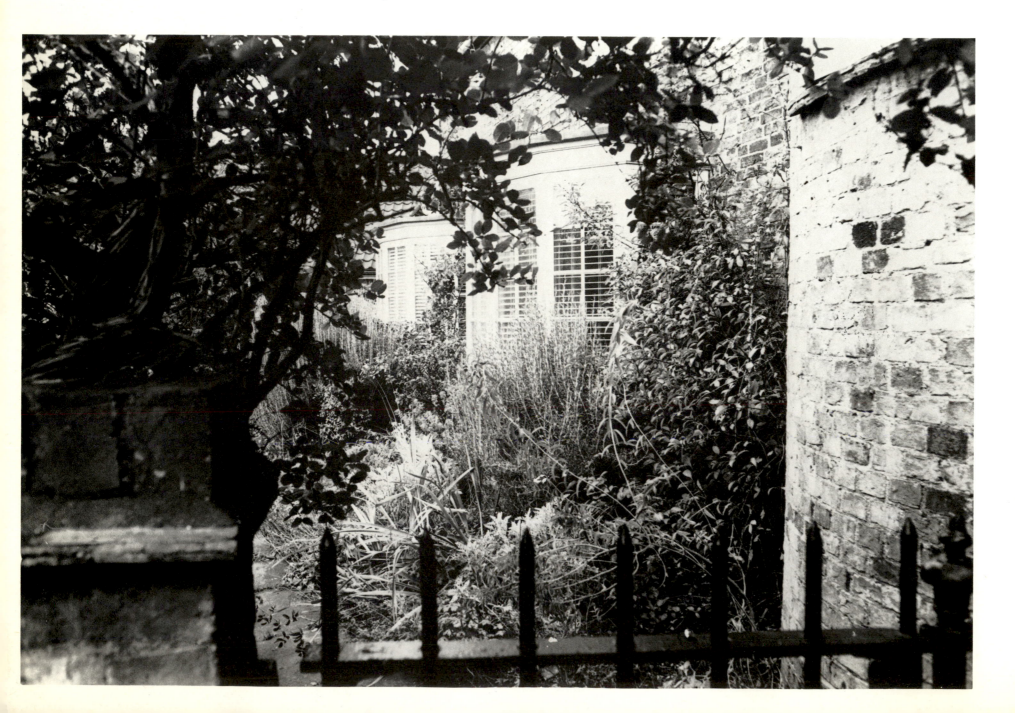

By Jim Ede

The forming of Kettle's Yard began, I suppose, by my meeting with Ben and Winifred Nicholson in 1924 or thereabouts, while I was an Assistant at the Tate Gallery. It started of course before that; I was 15 at the Leys School at Cambridge, and fell in love with Italian paintings and broke bounds to search the Free Library and Fitzwilliam Museum; and before that at 13 when I first visited the Louvre, saw nothing, but fell for Puvis de Chavannes near the little church of St Etienne du Mont.

So it wasn't until I was nearly 30 that the Nicholsons opened a door into the world of contemporary art and I rushed headlong into the arms of Picasso, Brancusi and Braque; not losing however my rapture over Giotto, Angelico, Monaco and Piero della Francesca.

Ben Nicholson shared this rapture, and I saw in his work a simple continuity from them into the everyday world of the twenties and thirties. There was no longer a break. Oddly enough, I turned out to be one of Ben Nicholson's very few admirers at that time, and after he had tried to sell a painting for a year or so he would tell me that I could have it for the price of the canvas and frame, usually one to three pounds. I could not always manage it, for my salary was under £250 a year; not much to maintain a family in London. Many he would give me, and now that Kettle's Yard has been catalogued I find it has 44 works of his, and many others have been given away.

Winifred Nicholson taught me much about the fusing of art and daily living, and Ben Nicholson that traffic in Piccadilly had the rhythm of a ballet and a game of tennis the perfection of an old master. Life with them at once seemed lively, satisfying and special.

Then came Kit Wood and David Jones. From Kit I learnt a clarity of perspective in regard to contemporary painters, a direct enjoyment, direct and easy, which became a touchstone in the world of what has often been called naive painting; and so came Douanier Rousseau and with him no doubt many works now held by Kettle's Yard. David Jones was different: he brought shape to the ephemeral in me, his profound

vision of essential truth supported me. He had tolerance not usual in artists and this enlarged my vision.

I think it was in 1926 I first began to get paintings by Alfred Wallis. They would come by post, perhaps 60 at a time, and the price fixed at 1/–, 2/–, 3/–, according to size. I once got twenty but usually could not afford so many. I suppose that Kettle's Yard now has a hundred. In looking back it is odd to remember how few people even wanted one as a gift, their children could do so much better. I never met him but he wrote me many interesting letters and I was grateful for the unsophisticated beauty of his work.

In that same year I first heard of Gaudier-Brzeska. A great quantity of his work was dumped in my office at the Tate: it happened to be the Board room and the only place with a large table. It was 10 years after Gaudier's death, and all this work had been sent to many art experts for their opinion, and London dealers had been asked to buy. It had become the property of the Treasury, and the enlightened Solicitor General thought that the nation should acquire it, but no, not even as a gift. In the end I got a friend to buy 'Chanteuse Triste' for the Tate, I subsequently gave three to the Contemporary Art Society, and three more to the Tate. It took some doing to persuade them to accept even this, and the rest, for a song, I bought. Since then it has seemed my task to get Gaudier established in the rightful position he would have achieved had he lived into the present time. The principal collections of his work today are the Tate Gallery, The Gallery of Modern Art in the Centre Georges Pompidou, Paris, and Kettle's Yard; and he will surely be recognised as one of France's greatest sculptors, and perhaps the most vital of his epoch.*

In Paris at this time I had become most happily familiar with all the well known artists save Matisse, whom I knew only in his work, though I once travelled with him for several hours in the same compartment of a train and dared not speak to him. Had it ever entered my head that I was collecting works of art I suppose this moment in Paris would have been my greatest opportunity. But all I thought of was trying to get my rich friends to buy the works of these new friends. But Miro gave me a small painting one sunny morning as we drank coffee in a Paris street. It was the day a President had been assassinated, and as we drank our coffee there was a terrific explosion nearby, and I, quite thoughtlessly, cried out 'Encore un président' and every one fell silent. Chagall offered me anything in his studio for £60, and some of

* See note 3, p.240.

16

his finest paintings were there. A small Rouault or one by Rousseau was probably £25. 'Les Noces' was £1,000 and 'Le Bohémien endormi' £4,000. I found friends to buy many, but still I never woke to the idea of buying anything myself; so Kettle's Yard has none of this.

Thus we come to 1936, and save for the period of the Second World War I left England for twenty years, living in Morocco and France and lecturing on art all over the United States. This brought me to Richard Poussette Dart, a passionate follower of Gaudier-Brzeska and light, and to William Congdon whose paintings of Venice at last exorcised Sargent and brought me back to Bellini. In England there was William Scott and Roger Hilton, and more recently that devoted primitive Bryan Pearce.

It was while we were still abroad in 1954 that I found myself dreaming of the idea of somehow creating a living place where works of art would be enjoyed, inherent to the domestic setting, where young people could be at home unhampered by the greater austerity of the museum or public art gallery, and where an informality might infuse an underlying formality. I wanted, in a modest way, to use the inspiration I had had from beautiful interiors, houses of leisured elegance; and to combine it with the joy I had felt in individual works seen in museums, and with the all-embracing delight I had experienced in nature; in stones, in flowers, in people. These thoughts were greatly encouraged by American action, by the Phillips Memorial Gallery and by Dumbarton Oaks; homes made public and vital, by continued enterprise. But how could this be managed without money? I tried for a 'Stately Home' which might become a source of interest to some neighbouring university and in the end was recommended by the President of the Cambridge Preservation Society the use of four tiny condemned slum dwellings. So Kettle's Yard began in its present form. This was in 1957.

By keeping 'open house' every afternoon something was gradually developed, which in 1966 was accepted by the University, whose intention it is to continue this activity in its present form.

On 5 May 1970 a large extension, designed by Sir Leslie Martin, was opened by His Royal Highness The Prince of Wales, who was then an undergraduate at Trinity College; and an inaugural concert was given by Jacqueline du Pré and Daniel Barenboim.

Kettle's Yard is in no way meant to be an art gallery or museum, nor is it simply a

collection of works of art reflecting my taste, or the taste of a given period. It is, rather, a continuing way of life from these last 50 years (1923–1973), in which stray objects, stones, glass, pictures, sculpture, in light and in space, have been used to make manifest the underlying stability which more and more we need to recognise if we are not to be swamped by all that is so rapidly opening up before us. There has always been this need, and I think there always will be; it is a condition of human life, and in Kettle's Yard, which should, I think, grow and change only very slowly, I hope that future generations will still find a home and a welcome, a refuge of peace and order, of the visual arts and of music.

I have felt strongly the need for me to give again these things which have so much been given to me, and to give in such a way, that by their placing, and by a pervading atmosphere, one thing will enhance another, making perhaps a coherent whole; and where a continuity of enjoyment, in the constantly changing public of a university, has some chance to thrive, and from which other ventures of this sort may spring. There should be a Kettle's Yard in every university.

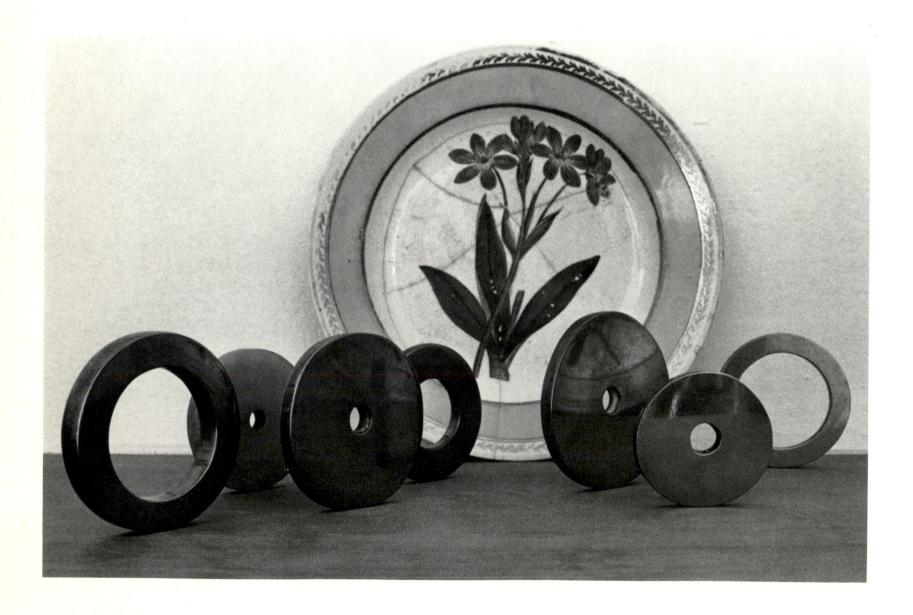

Six brass rings and one of jade, by Richard Poussette Dart.

Interlude I

Here it might be useful to give a short account of our moves between 1936 and 1956. Except for the years of war, we lived in Tangier where we enjoyed making a garden along a ridge of highland and using our home as a holiday place for soldiers cooped up in Gibraltar. Here from the immense stretches of land and sea I learnt much about light. In 1952, in order to be nearer our two daughters in Scotland, we decided to try to find somewhere in Northern France. We landed up with a place of real beauty, which became the prelude to Kettle's Yard.

Through a friend, we had heard of an old farm, very dilapidated but beautiful, between Blois and Amboise, and singularly cheap. Since my friend's geese were always golden I felt a little hesitant, but bought it, and later went to see it and move in. We were enchanted. A little avenue of pollarded limes, stretching their necks like camels; then a great gate opening onto a long courtyard, which later I found was just the size, if spread out, of the high arch at Chartres. On either side were tumble-down fifteenth-century outhouses, and at the end a separate large kitchen with a

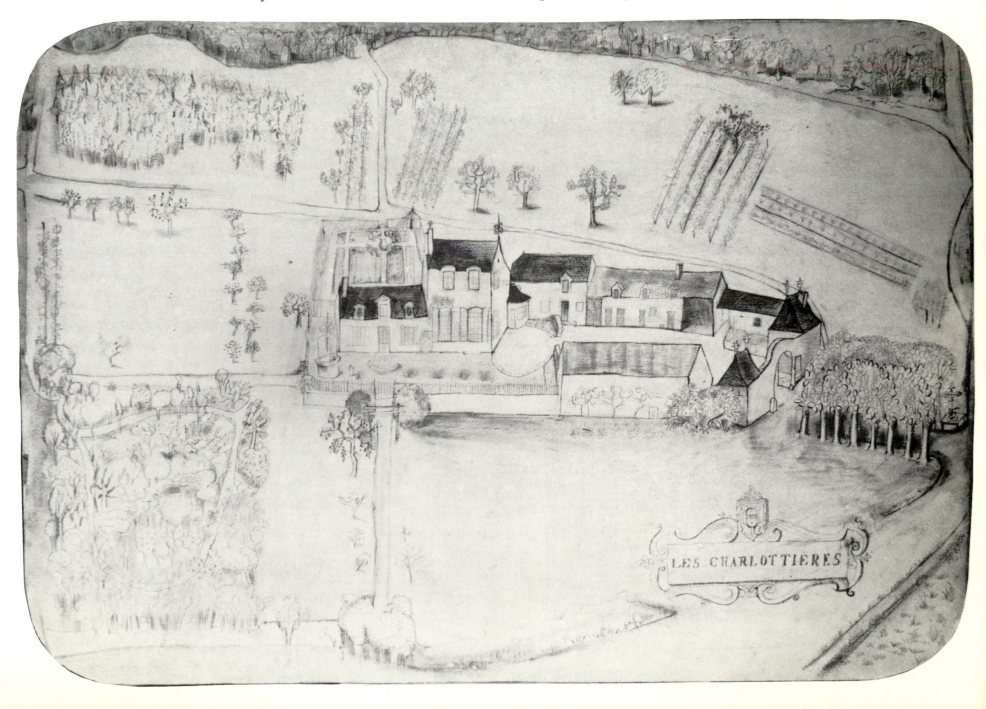

LES CHARLOTTIERES

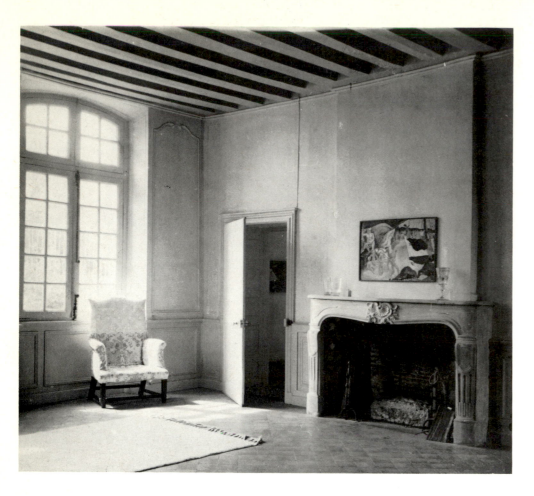

seventeenth-century house beyond. There was quite a bit of land, and two woods; many fruit trees and a tiny vineyard.

It was a dream world, and for the next three years we worked with pleasant artisans to bring it into standing order and to give it life. The Loire was less than a mile away, and all about us were Cézannes, Rousseaus and Daubignys. We were almost on a through road, and our friends kept coming from different directions of the world. There was time to think, to read, and to enjoy it all. Helen Ede hoped Heaven would be like it.

There was a richness of quality in that French life, a quick beauty in the home and a reality in the land so annealing after the strangeness of Africa. Floors were made of

ancient bricks, softly polished, and the windows were generous. Part of the house may have been built by a foreman of Mansard, who was responsible for two of the nearby Chateaux. There was an original little house of the twelfth century, done over in the nineteenth, in which Heloise and Abelard could have sheltered when they set out from Blois to go down the Loire. We crept into it during the extreme cold winters and were thankful for a great stove which we had installed despite its ugliness.

We loved working in the walled garden; Helen did the vegetables and I the flowers. There were peaches and walnuts, grapes, apples galore, apricots and cherries. I learnt to preserve these cherries in *eau-de-vie*, which was brewed on the premises.

French people from all around would call on 'les Anglais' out of curiosity; and opposite

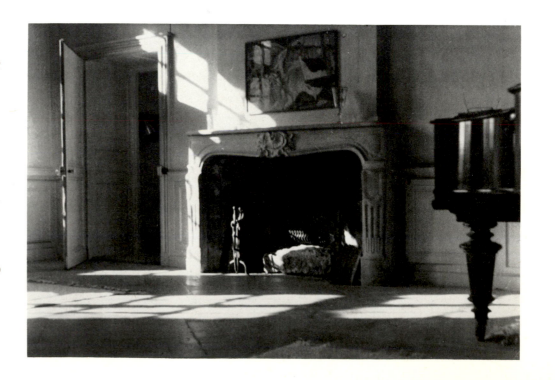

was a woman who sat in the ditch guarding her goats, who quoted Paul Valéry and was the sister-in-law of a Prime Minister of Canada.

It was a joy to walk about in our own land, while the workmen were restoring the house. We carried hot water in buckets to one of the woods to have our baths there; with white and blue periwinkles, strange striped tulips and the cooing of doves.

Blois, our shopping area, was five miles away, and had one of the most beautiful of perpendicular churches, so fine to walk in, with its wide floors.

Our house was called Les Charlottières; perhaps it once housed a group of Charlottes. From here we came to Cambridge.

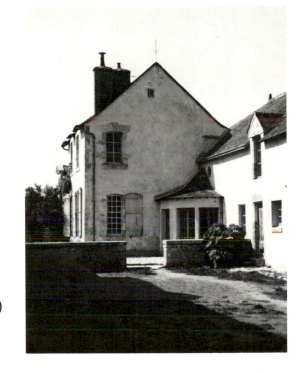

End of Interlude I (From a notebook.)

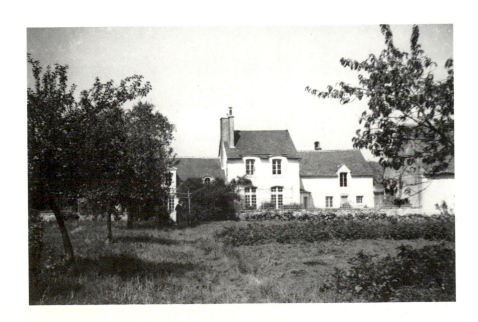
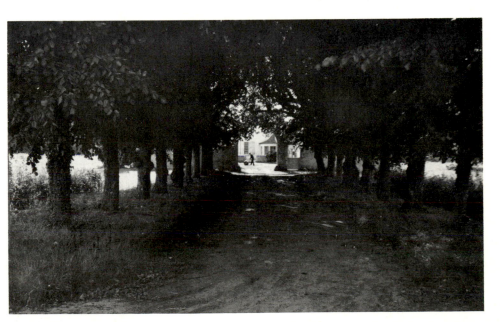

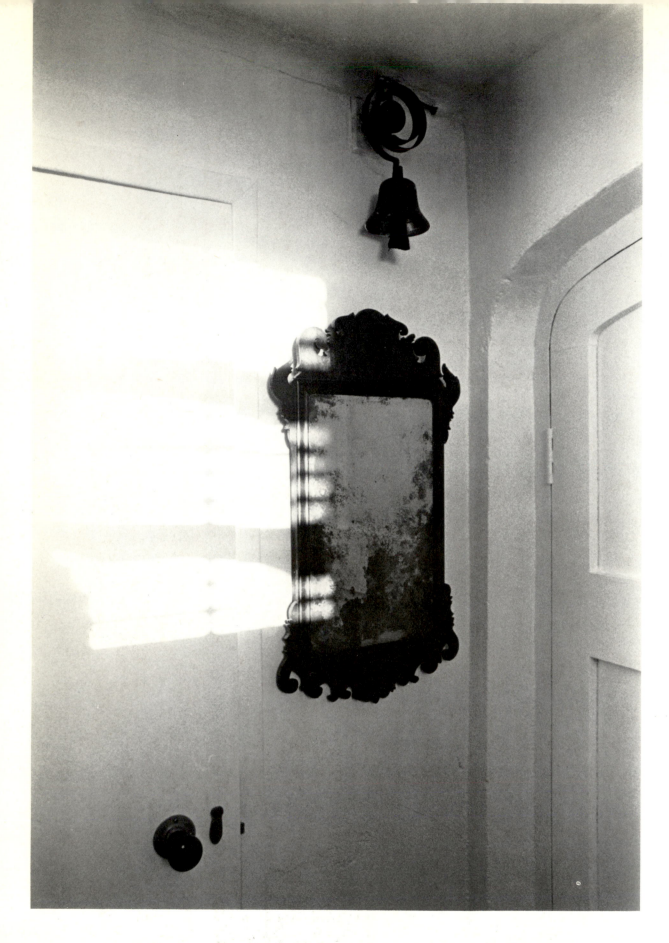

This bell is activated by pulling a fishing-net cork on the end of a rope outside the front door.

The bell comes from a Stately Home in Scotland, and was one of 35 or so lining a long passage.

The wood of the front door was made with the slats of the great family dining table in the Manse of Peterhead.

When you get inside you will find yourself in a tiny flagstoned hall with an open spiral stairway going to the floor above.

The flagstones were left over from many I bought from St John's College to pave the floor of St Peter's Church nearby.

The Chippendale mirror we bought for our Wedding Day in 1921.

This hook, on which to hang buckets, is standing on one of the original chimney pots of Kettle's Yard, and came from one of the ancient wells of Les Charlottières in France.

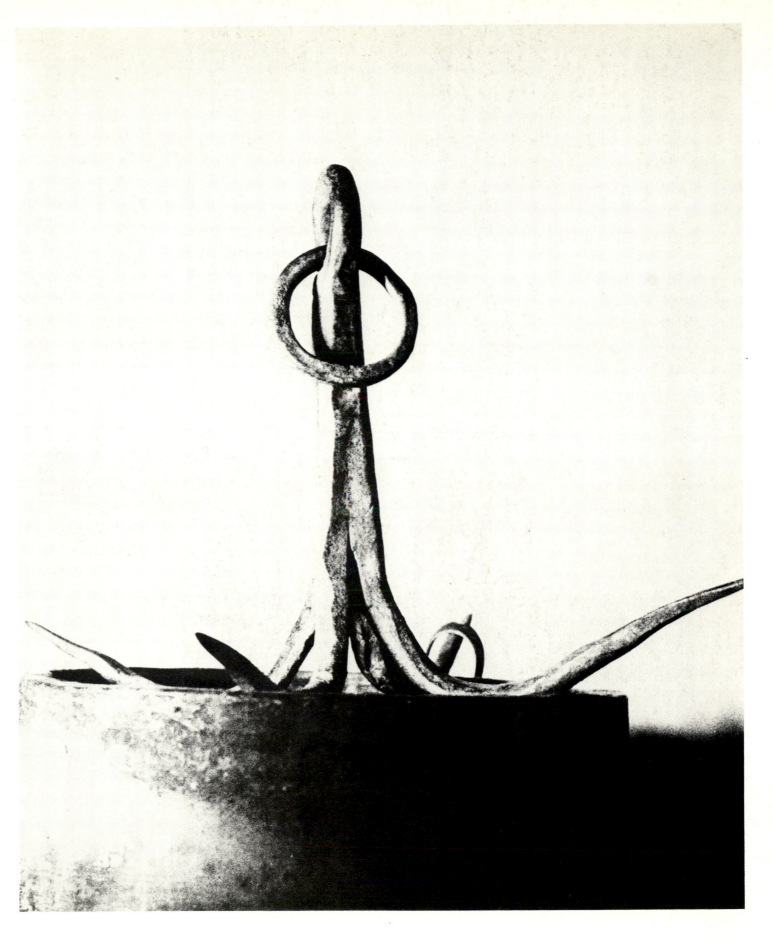

There are parts of three cottages in this vista through the sitting room to a bedroom and bathroom. The flooring I got from a seventeenth-century house which was being demolished; the boards are wider than those used later. On your left is one of the very early Shetland chairs, and between it and the bureau (opposite page) is a large semi-circular window embrasure. The bureau is 'Queen Anne' and was my first purchase of a piece of furniture. I was 12 and it cost £8, the price of a first-class bicycle. I think I owned £12 at that time; our pocket money was two pennies a week, so it was some purchase. My parents had great misgivings.

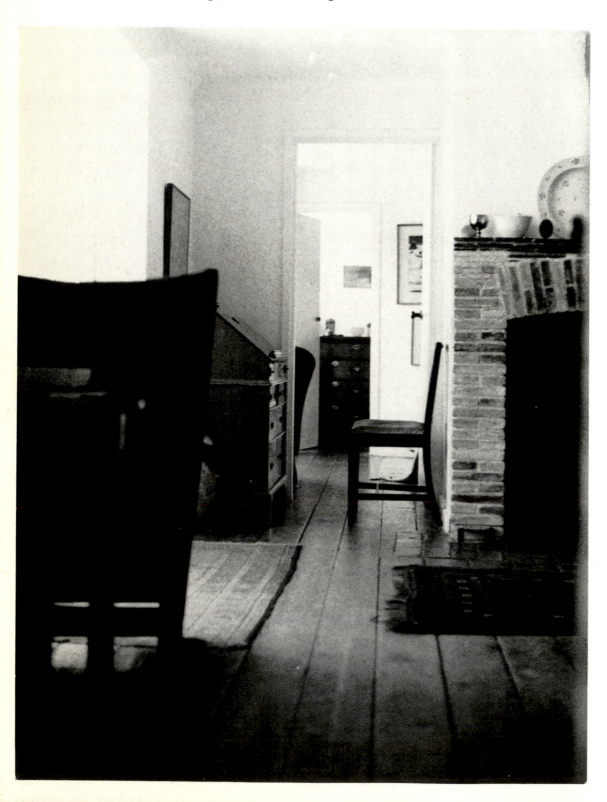

This desk became my office during the first 12 years of life in Kettle's Yard; when the bell rang, I had only to close the lid, and the office disappeared!

The name Kettle's Yard was really obsolete – it was up on the wall of the passageway through – and I, realising that our house would be the only one in it, called the house Kettle's Yard, Cambridge. The Post Office objected, saying that the postmen would not know where it was. I pointed out that it was an honour to a city to have a few places without street names: in Cambridge the colleges named no street and London had Buckingham Palace, and would they wait till after Christmas and by then the postmen would know where it was, and they did.

The painting above the bureau is a snow scene in Barcelona by Christopher Wood. I have always been amazed how on a snowy day this painting never loses the brightness of snow.

The glass dish containing feathers is part of a set of three, the other two pieces are in the Extension. There is a large basin, now containing pot-pourri, which this one, turned the other way up, fitted; and on it stood a large jug to contain rose-water. Servants in Turkey would pour this warmed rose-water over the hands of guests after they had been eating with the help of their fingers. I once assembled these three parts – and decided it was not suitable for Kettle's Yard.

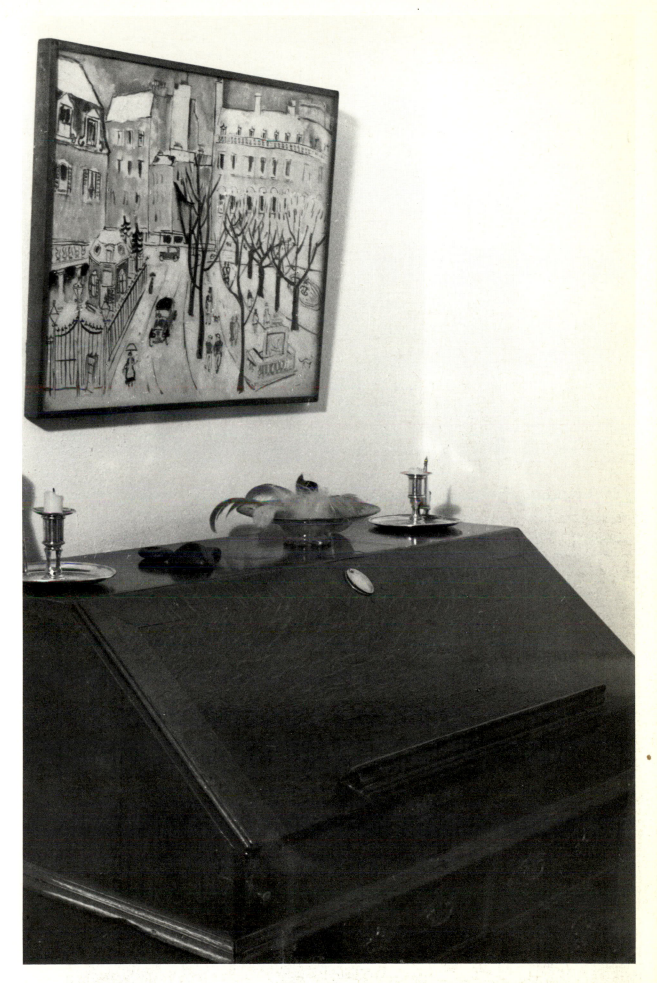

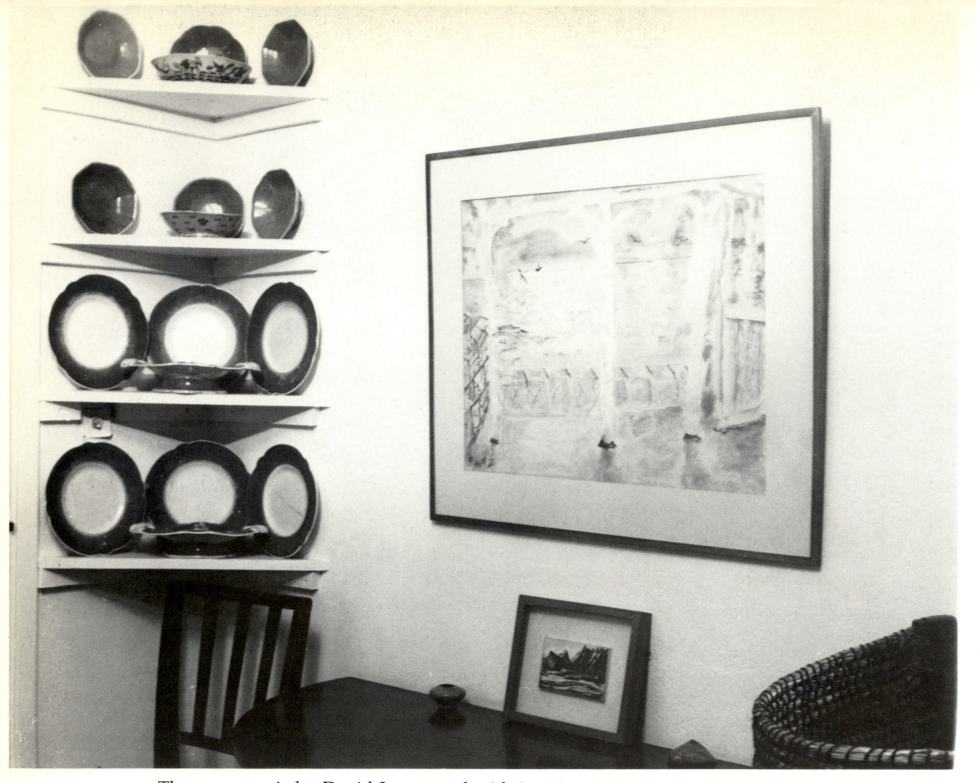

The seascape is by David Jones, and with imagination you can see (centre right) his face reflected in the glass behind which he was sitting. He wrote about this 'I always work from the window of a house if it is at all possible. I like looking out onto the world from a reasonably sheltered position. I can't paint in the wind, and I like the indoors–outdoors, contained yet limitless feeling of windows and doors. A man should be in a house; a beast in a field, and all that.'

The small dishes on the two top corner shelves are Chinese and are bright green; they used in 1920 to cost one shilling and threepence each. The plates below are blue-rimmed and were bought as a snap-up while I was driving through Marlborough. I think it was £1 10s 0d the lot. I remember thinking 'each plate?', but had the presence of mind not to let on!

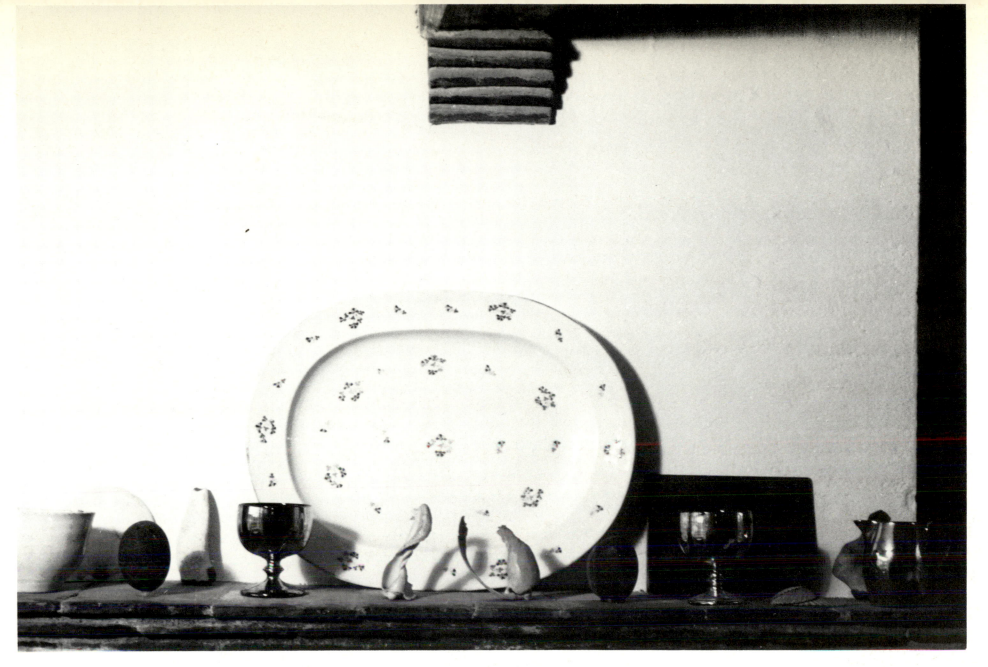

It was twenty-five years ago that I constructed this fireplace shelf with ancient tiles which I had found in the neighbourhood – each one a surface of beauty, rose-pink with its stains of worn plaster – I overlapped them to the top – and used the same pattern to hold up a beam across the ceiling lest the floor above should fall in. I am still so bewildered by the beauty of everything here, that I am pained to spoil the page with my writing. The Crown Derby dish I bought in Dorset and carried it rejoicing over the Downs. I thought it was French. The two lustre goblets came from Cardiff in the very early twenties. I had gone from London to visit my parents, and my father gave me £2 to cover my fare. On my way to the station I saw these goblets and blued the £2 on them. My father was grieved by my wanton wastefulness. The stone on the left was given by a daughter, a great lover of stones – and so a great gift. The two shells I found on the beach of Ceuta opposite Gibraltar. Had it not been for the paintings of Dali, I would have kicked them away as broken and Kettle's Yard would never have had this so beautiful combination of forms. The dark rectangle on the right is a 'scraper board' drawing of a ship by Christopher Wood. I forgot to put that the stone above has a superb and delicate web of lines, almost white. There are other objects which inform my heart and the whole is a deeply lasting experience.

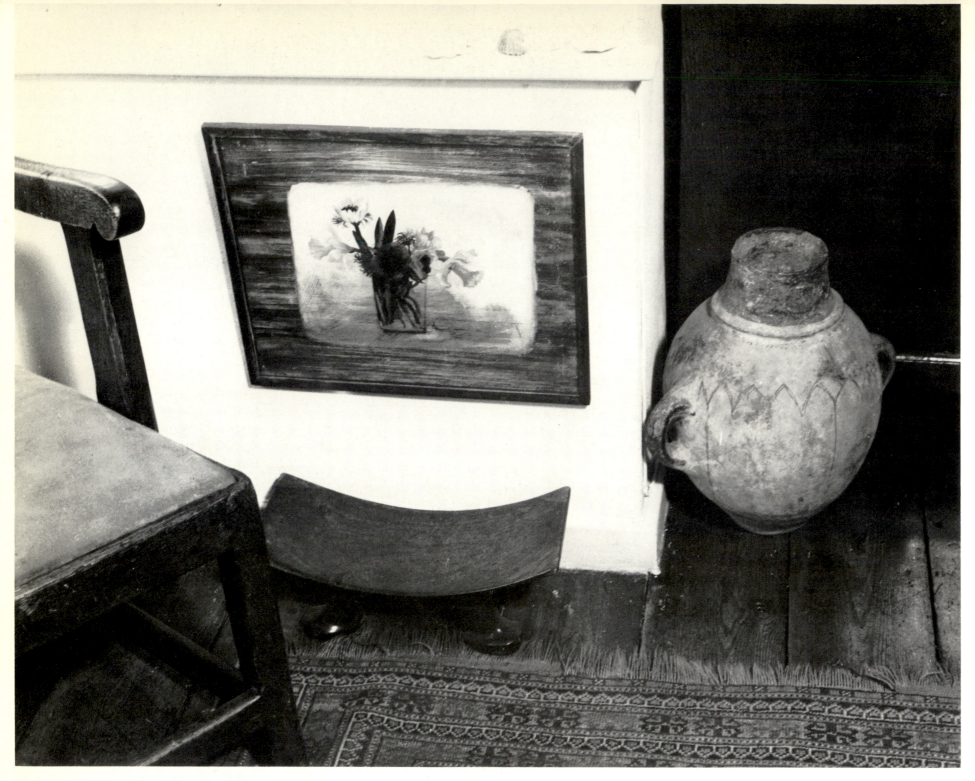

Flowers by Christopher Wood bring the right yellow and red into Kettle's Yard. The yellow is echoed across the room by a pale lemon on a seventeenth-century pewter plate. The jar is from Fez and the wooden pillow-stool from an island off the coast of Africa. I got it in Penzance when I was 16 for 4 shillings and sixpence. I thought it was a block of iron with an interesting dip; no legs were to be seen. After much washing this beautiful bit of wood emerged, cut in one piece from a tree. 'Le Phare', by Christopher Wood is perhaps the painting of his I like most. The mystery of his life lies in it, this love of light and darkness; and, I think, his joy of Alfred Wallis, whose painting of a lighthouse and ships belonged to him and now accompanies his own. For me the white news sheet, and whites on white, replace the white flicker of seagulls probably there, but fussy in a painting. The playing cards denote his constant 'fate'.

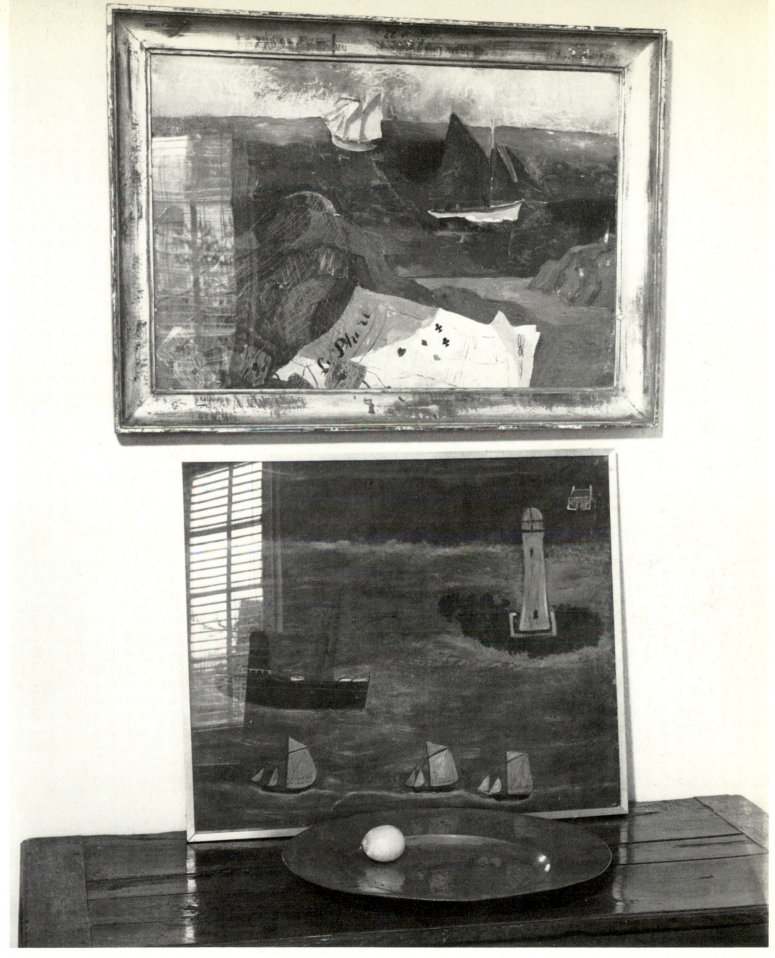

I like very much the movement of light and reflection in such pictures' glass. It adds a miraculous new quality to the work. The chest under the pewter dish is seventeenth-century, from our home in France.

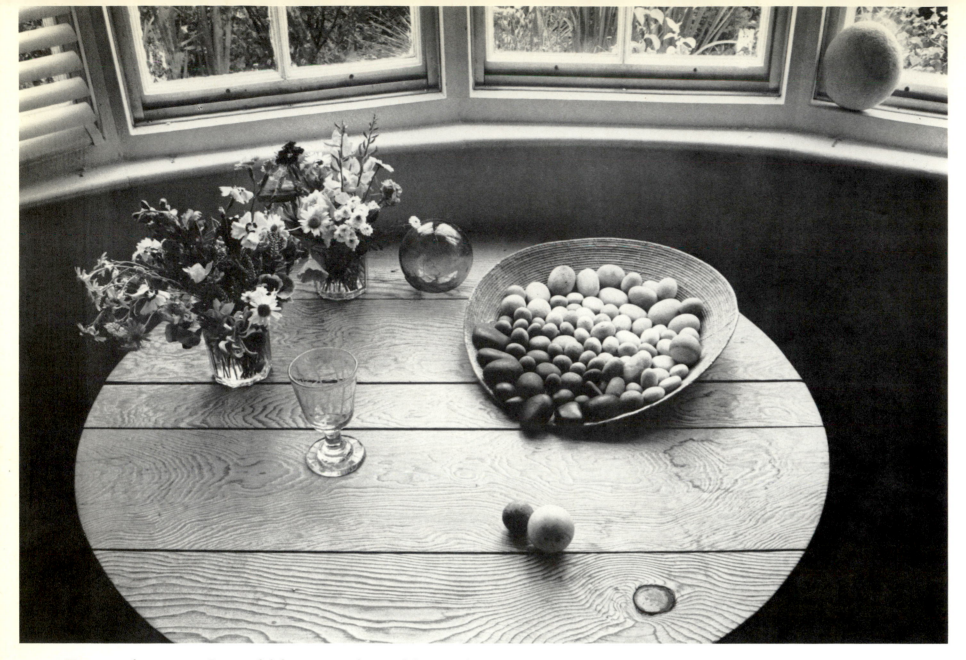

Every afternoon I would be near this table ready to receive guests, whose names I put down on a card and entered into the book each evening. The table is one of two, the other being in the bedroom next door. They are supported by iron frames, which, turned up the other way, held two immense oil jars, one of which can be seen in the courtyard of our French house (p. 21). I once packed 3 children into it as a hideaway surprise for their parents; all now hold important posts. I had the wooden circles made in Morocco of cedar wood. The ivory billiard ball would fascinate most young people of this generation who have only seen them made of plastic.

The decanters (opposite) belonged to the author George Moore who bequeathed them to his friend Lady Cunard; together with much china, riveted or cracked. He had left me his Rockingham teapot which would not hold liquid, and she in turn gave me the rest with a word, saying 'I know *you* don't mind broken china.' It was a happy haul.

The Miró was to me an opportunity to show undergraduates the importance of balance. If I put my finger over the spot at the top right all the rest of the picture slid into the left-hand bottom corner. If I covered the one at the bottom, horizontal lines appeared, and if somehow I could take out the tiny red spot in the middle everything flew to the edges.

This gave me a much needed chance to mention God, by saying that if I had to find another name for God, I think it would be Balance, for with perfect balance all would be well.

This often led to interesting talk.

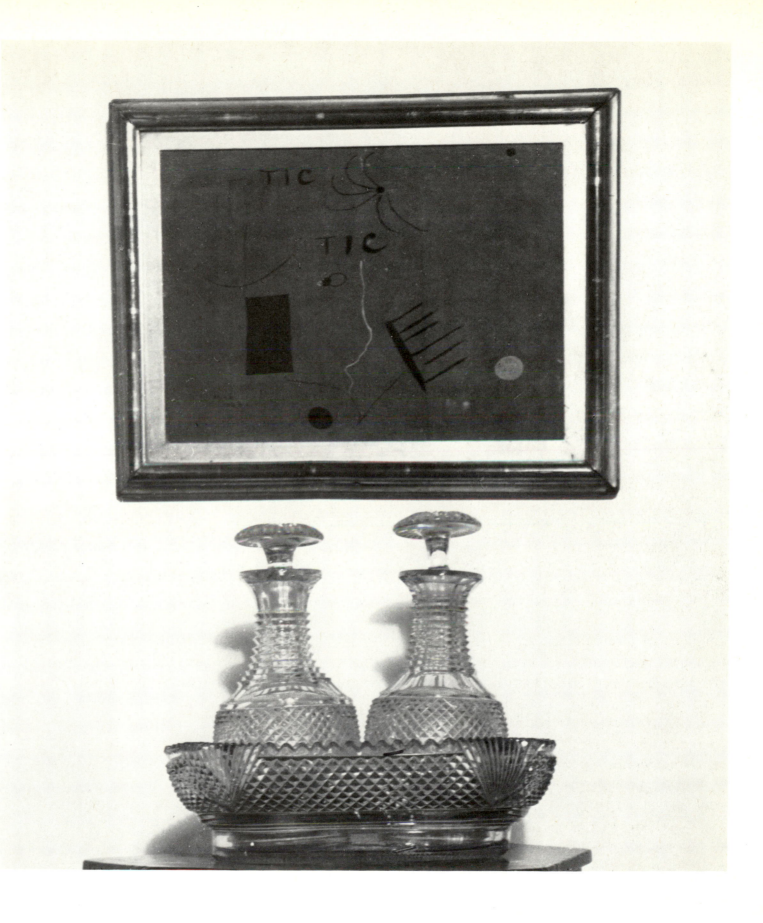

Two elderly English women who had spent most of their lives in Normandy, as artists, were having a sale in Tangier of their possessions before returning to England. Amongst their things, this lovely cider screw, marked £1. It is probably eighteenth century but could be much earlier. I have always had great joy of this, and find it and the beauty of its shadow amidst the cool variety of white around it more than arresting, and when I look across to the snow scene opposite, which I could not resist placing there, and find these same visual delights, I am fulfilled.

Its coldness, changeableness, and out-of-doorness are a delight. I remember a young soldier, over from Gibraltar to stay with us, along with four others, lying back in a deck chair with a cigar, on our terrace in Tangier. It was after dinner and the moonlight filled the 100-mile or so landscape to the Riff mountains. He exclaimed, 'Now let me die' not knowing its counterpart, 'If it were now to die . . .'

To go back to the other page, the door on the left of the screw opens into the kitchen, I don't know why it looks so dark in there, for it was light though tiny, with pleasant china and a couple of paintings by Wallis, and a view, as by Samuel Palmer, out over the churchyard.

Just beyond it is a little nineteenth-century door from one of the original cottages, which happily fitted across the corner of the room, edged with new boarding. It hid such needed things as an Electrolux, a broom, floor polish, dusters and much else.

This corner happened to be the highest part of the room, perhaps 7 ft 2 inches. The regulation height was a minimum of seven feet, the rest of the room was quite a bit less than this; so I took a calling Inspector to that corner and all was well, he even admired the 'natty cupboard'.

In these two views the things I was telling of a while back can be seen far better. I can almost smooth my hands across the tiles; and in the lustre jug, opposite, as in a Van Eyck, I see reflected the cider screw, decanters and kitchen door.

The pot-pourri above is in a jelly mould, and the big Crown Derby dish in the middle of the shelf can almost be reconstructed.

Both these photographs speak the stillness of Kettle's Yard. Although some way ahead, on reaching the next floor, I have written that I have not yet found spaces in which to put 'thoughts' which were in my mind – I now have, here and on the next three pages.

> Sleep dwell upon thine eyes, peace in thy breast!
> Would I were sleep and peace, so sweet to rest!
> *Romeo and Juliet*

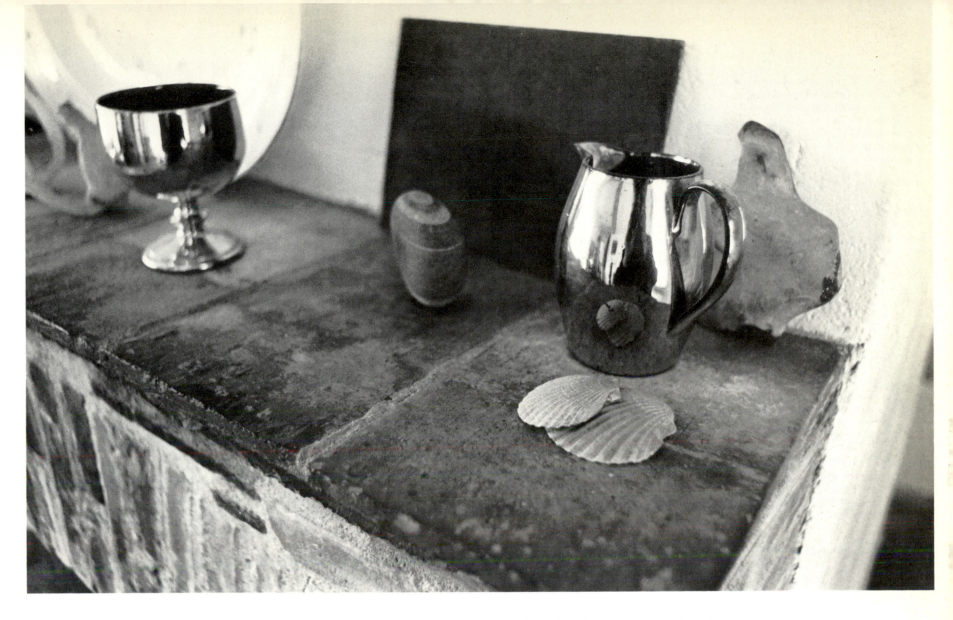

My fascination with details will I hope never cease. Each object is a miracle.

 We are such stuff
As dreams are made on, and our little life
Is rounded with a sleep.
 The Tempest

Thus have I had thee, as a dream doth flatter,
In sleep a king, but waking no such matter.
 Sonnet

I had forgot myself; am I not king?
Awake, thou coward majesty! Thou sleepest.
Is not the king's name twenty thousand names?
 Richard II

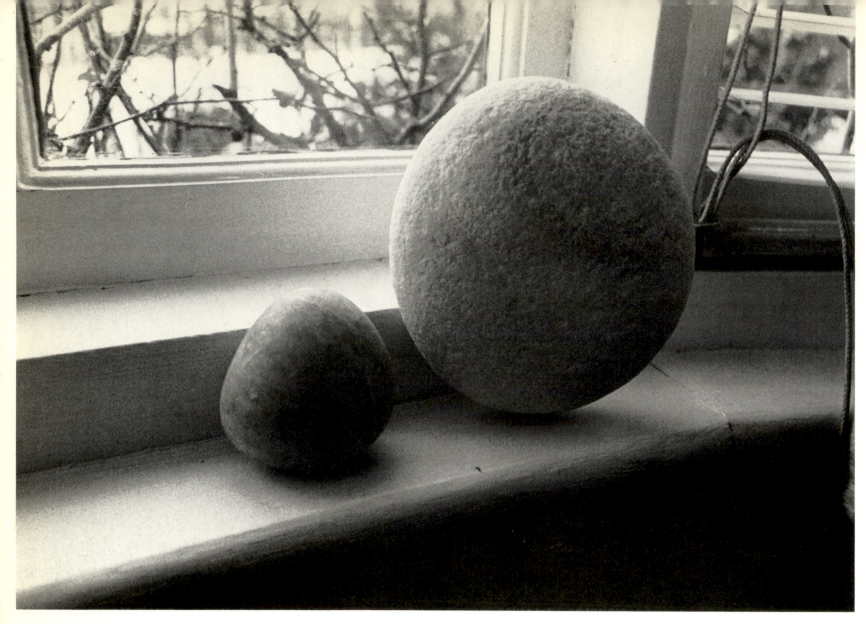

The larger stone is from Delos and I like to think it is a bit of Naxian Marble,
imported around 700 B.C., for making the famous avenue of lions, and other works.
There was much destruction, and this stone which has now become a big pebble
could once have formed some part of these same lions. I think one lion was taken to
Turkey – and another I have seen in Venice if my memory does not mistake me. This
stone was picked up by John Ady on the Delos beach and brought to me.

This royal throne of kings, this sceptr'd isle,
This earth of majesty, this seat of Mars
 Richard II

There in the blazon of sweet beauty's best,
Of head, of foot, of lip, of eye, of brow
 Sonnet

As on the finger of a thronéd Queen
The basest jewel will be well esteemed
 Sonnet

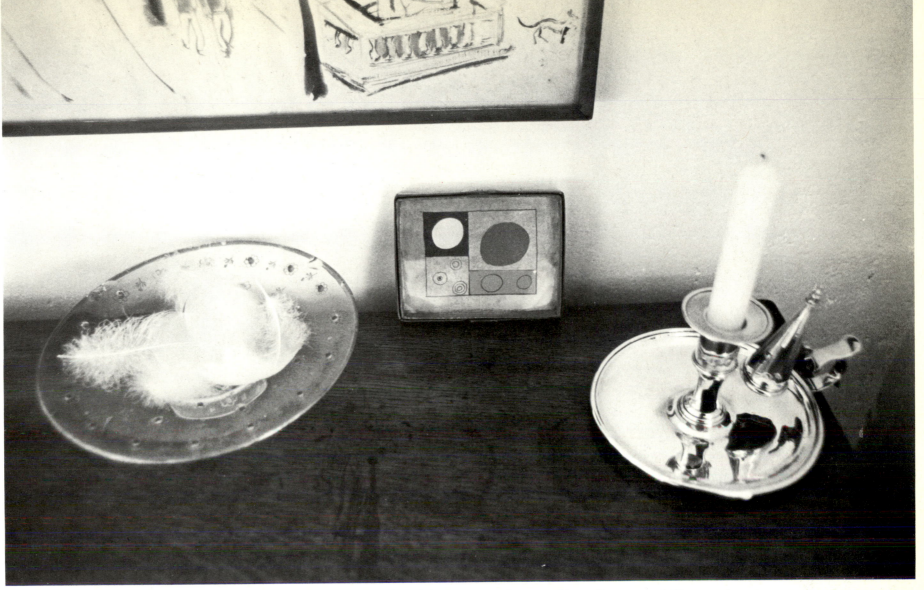

This curling feather – how can it be touched and how can it not live for ever! It flutters in my memory. There is a superb craftsmanship in the making of this silver candlestick, and each one is quite happy with Ben Nicholson's little box in which he sent me a tiny train, engine and three coaches.

A man that looks on glass,
On it may stay his eye;
Or, if he pleaseth, through it pass,
And then the heaven espy.
 George Herbert

He who bends to himself a joy
Doth the wingéd life destroy;
But he who kisses the joy as it flies
Lives in Eternity's sunrise.
 William Blake

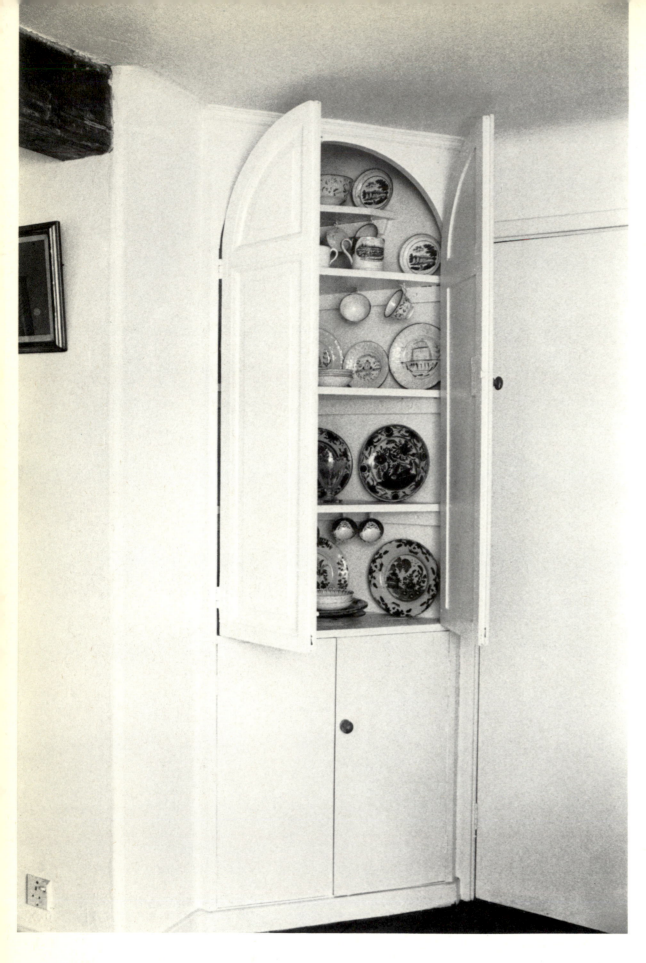

Glass and china play their part in Kettle's Yard; there is hardly a room without, even cracked things, teacups into which light falls like sunshine into pools. All this makes a home to live in, a place where people feel at rest; our family and our friends lived here for sixteen years.

This corner cupboard was made through the lucky find of two eighteenth-century doors; all the rest, the arch, the shelves, the closed cupboard below, was all constructed in 1957 to bring them into use.

That such a double page of beauty should exist is all due to the photographer, Harry Sowden. It was he who wrote at the beginning of this book that he had found it to be, as his host had said, 'a house full of beautiful things'.

On the top shelf is a pink lustre bowl which we found in Hampstead, and the pink lustre cups, hidden behind a silver lustre mug from Ireland and a white mug which was the christening mug for my grandfather Francis Ede – (my fingers itch to turn it round, for it is marked with a beautiful F), are probably rare, they are so delicate. How strange it is that a photograph such as this can make them and their saucers look bigger than life.

In our early married life, on special fête days we gave ourselves tea before breakfast. I would bring it up in these. On the third shelf the china is more ordinary, but the extraordinary quality of light revealed in the photograph holds me silent.

The delft plates below (on left) I found in Leeds as I passed through in a hurry. There was a big pile of them, all very dirty, and I knew nothing of 'delft'. I bought

a dozen at a shilling each hoping they would not prove a wild mistake.

Somewhere there is a Chinese celadon bowl; round 1920 they were 9 pence each in London, a most beautiful example of traditional descent, used for the cheapest and poorest way of life, as we would, I suppose, have used tin plates.

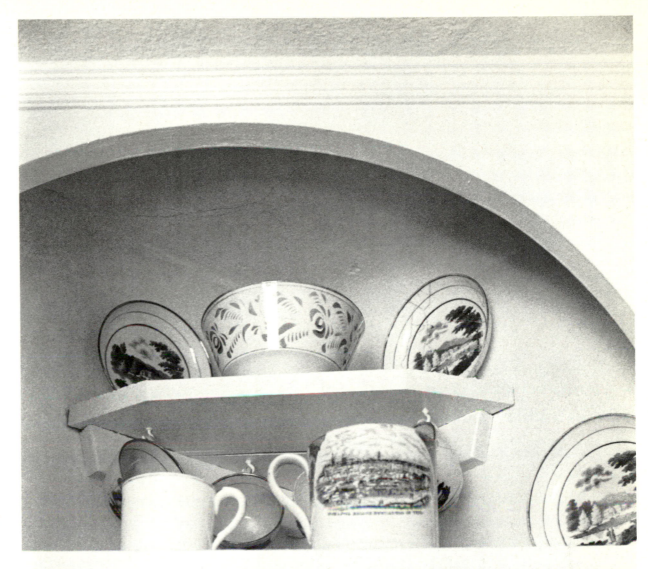

Of his bones are coral made:
Those are pearls that were his eyes:
 Nothing of him that doth fade,
But doth suffer a sea-change
Into something rich and strange.
The Tempest

There's a great text in Galatians
 Once you trip on it, entails
Twenty-nine distinct damnations,
 One sure, if another fails.
Robert Browning

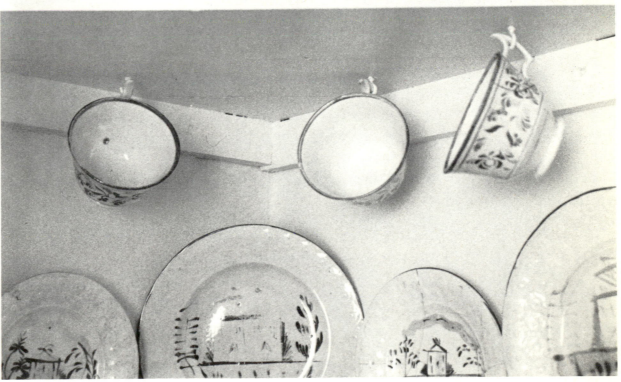

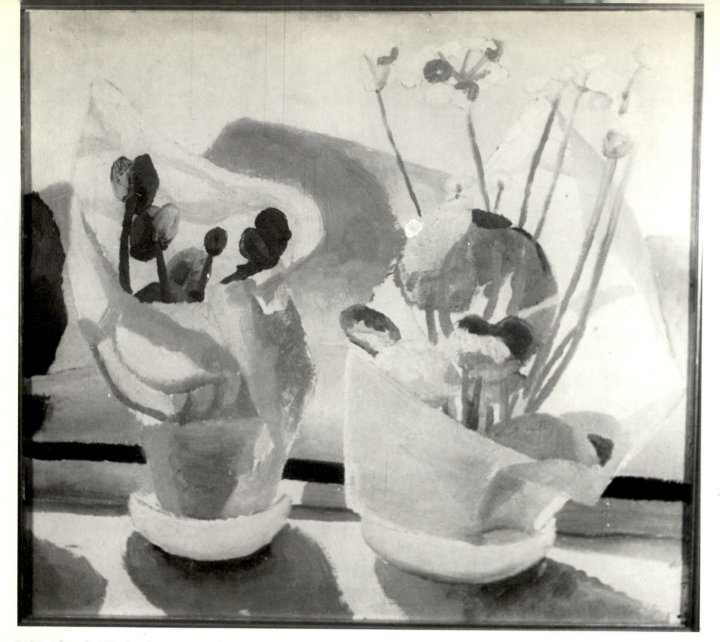

Winifred Nicholson's 'Flowers and Paper', c. 1923, hangs in the Extension with two other works by her. I had always wanted this particular painting which I think must have been in an early exhibition, or seen from a photograph; and then years later a Cambridge dealer had recognised it, so dirty as to be hardly visible, so he got it 'for nothing', cleaned it a little, and let me have it for what I could manage. Even then it needed a good scrubbing, and now is this delight of sunlit shadows and insubstantial substance.

Ben Nicholson's 'Apples and Pears', 1927, is in the first room on entering Kettle's Yard. The fact that I managed to get it in 1928 for the cost of frame and canvas showed how little even picture-lovers could interpret it into contemporary actuality;

the nearest approach being chicks hatching! When I first saw it I found myself comparing it with Van Eyck's oranges on the window-sill of 'Arnolfini and his wife'. It may seem quite a leap from the fifteenth-century Flemish to the twentieth-century British, yet the same spirit informs both. Always the still light caresses objects in the same loving way, and in each age there are artists who have used this, to revitalise the circumambient. Van Eyck is interested in his fruit's roundness, in the subtlety of light about it, in its weight and poise; it becomes an excuse for a further excursion into the beauty of such things. In the Ben Nicholson is found again, after many years, this light still folding itself around fruit, still separating one from the other. Such realisations can no longer just be a title, 'Apples and Pears'; it would more properly be 'Portrait of the Artist at the age of 33'.

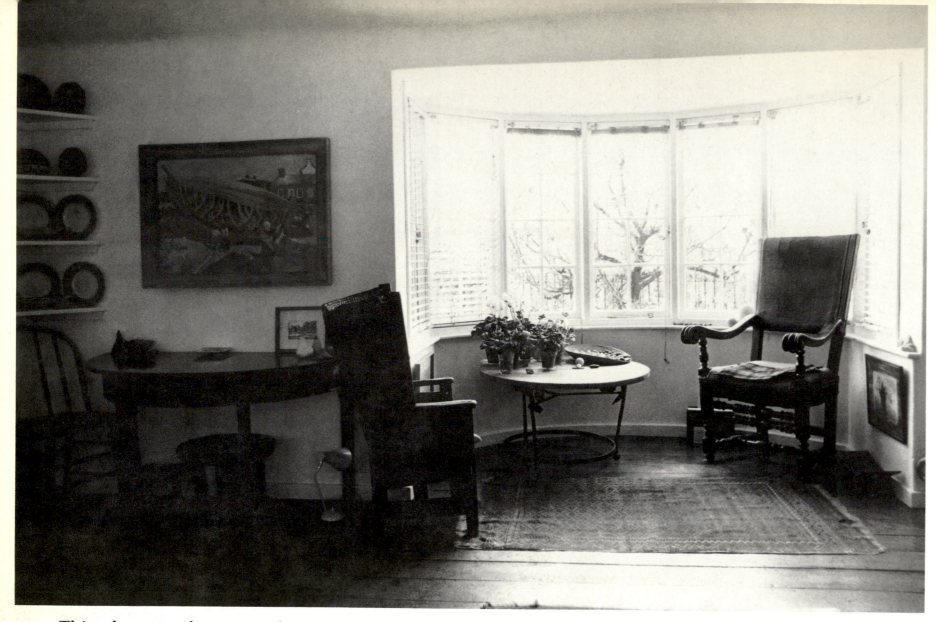

This photograph was made in 1968 before the Extension was built. It interests me that a bay window can give so great a sense of space to a room little more than ten feet square – the dimension of each cottage. Little could it ever have expected to hold a sixteenth-century great armchair from 'the mad grandeur of the Spanish soul'.

I had wanted to make the two bay windows true semi-circles, but it proved too expensive. The substituted angled circle irked me for many years.

> Not all the water in the rough rude sea
> Can wash the balm from an anointed king
> *Richard II*

> Now is the winter of our discontent
> Made glorious summer by this sun of York
> *Richard III*

> The bird of dawning singeth all night long
> *Hamlet*

This is an inspired photograph by Nicholas Mackenzie. These shells might be on the wet sand itself, the sea just having left them, instead of on the highly polished but ancient surface of a pewter plate.

The getting of this plate was quite an adventure in itself. I had sold an unneeded radiator for £8, and I at once thought – I will go to that pewter shop in the Brompton Road and see if I can get a big dish instead. It was a Monday morning and I arrived as the owner was opening his shop. He showed me this one (we have seen it before with a lemon on it). I was all for it, but the price was £16. I said that I had only £8 to spend, which seemed a huge sum to me. He turned away and I started to leave; perhaps a sadder and a wiser man. 'All right,' he said, 'it's a Monday and you are my first customer of the week, it may bring me luck: you can have it for eight.' By such strange ways, Kettle's Yard was formed; a plate some 300 years old, and many years before I had heard of Kettle's Yard or even seen the shells.

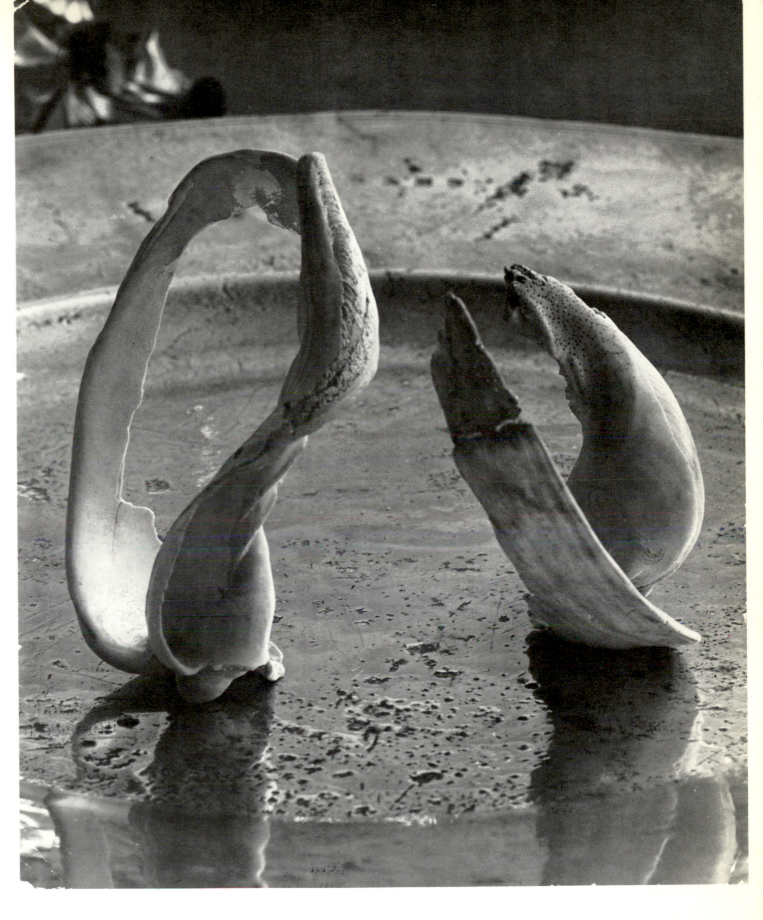

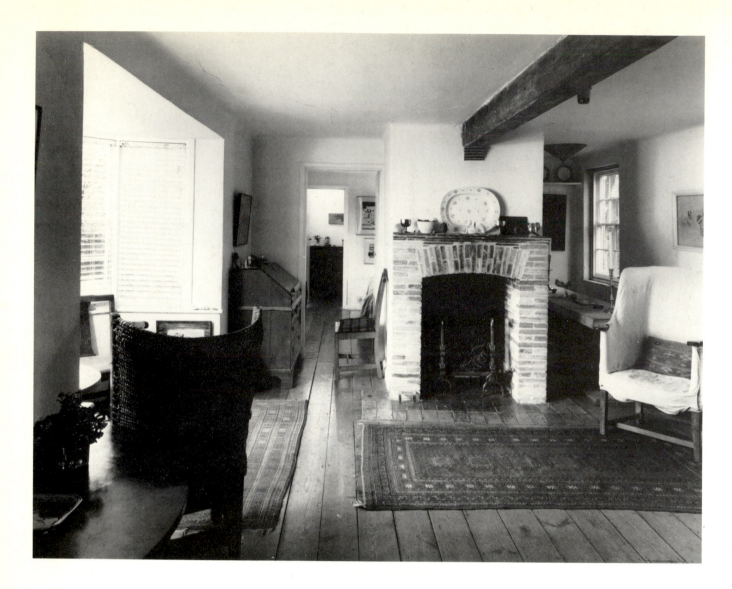

This view of the ground floor always gives me pleasure. I can walk in it as though I were there; with so many wide-reaching thoughts. The driftwood picked up on those immaculate shores of Shetland which in earlier centuries was used to make their by now commercialised chairs; the boards of the floor all aglitter, the 'dogs' from France, familiar in every fireplace; the rugs, one I carried all the way from India, the other a favourite of my mother's, and sacrosanct in my childhood.

The recess round to the right where undergraduates gathered for tea, Ben Nicholson's 'Apples and Pears' peeping in; the armchair, a little awry, but so great an excitement to have bought, it was only a frame and took some faith in its rebuilding. My dear bureau, a companion for nearly 70 years; and on through the bedroom to the bathroom, with its perfect and simple eighteenth-century chest of drawers. I put a jeweller's magnifying glass to my eye and bring everything to the point of sensing the act of touching, picking up and putting back.

In the next page we can go more easily into the recess where there is this beautiful area of light and darkness formed by Congdon's painting 'Istanbul'. I of course can see the details in it, knowing it so well. The two candlesticks are from Mazagan and Tarudant, a hundred miles or so apart, and each a shilling. In Mazagan I heard the muezzin calling the Faithful to prayer in the midst of night, from a mosque outside our bedroom; the sound will ever be with me while I live; its clarity and continuity and width. They told me that the muezzin had to swallow large portions of butter to lubricate his throat. The two delft tiles were in the house of a friend with whom I was staying when I visited Holland. I had looked for others in the shops but found nothing to my liking. On my way back to England, at the first frontier I had to search into my very small attaché case which was all my luggage, to get my passport – and there I found these tiles, slipped in with no disorder by my host. The Rockingham

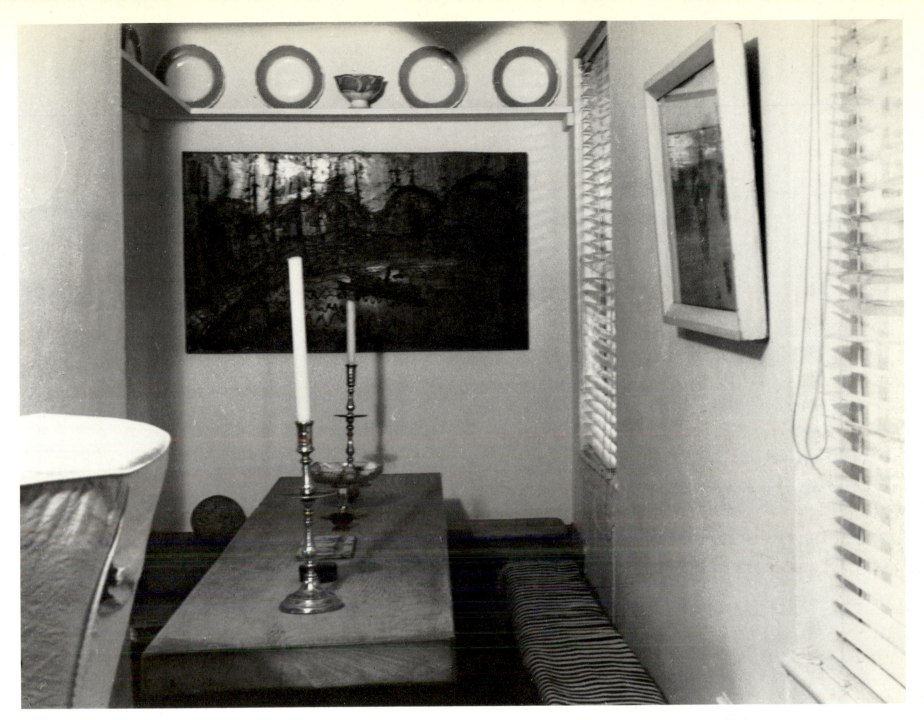

plates (six) and sugar bowl I got from a Mrs Ede, daughter-in-law of Dean Moore Ede of Worcester. She ran a fantastic restaurant 'The Red Lion' in London – gave her guests coffee in ample bowls until her bank manager told her she was in the red, then there were small coffee cups for a few days, a mere gesture. The plates have an apple-green border and they cost £3. All these prices are engraved on my mind. I suppose because they often seemed an unwarranted extravagance. The table itself was one block of American elm shipped back as ballast in the eighteenth century when our empty slave-ships were returning to England.

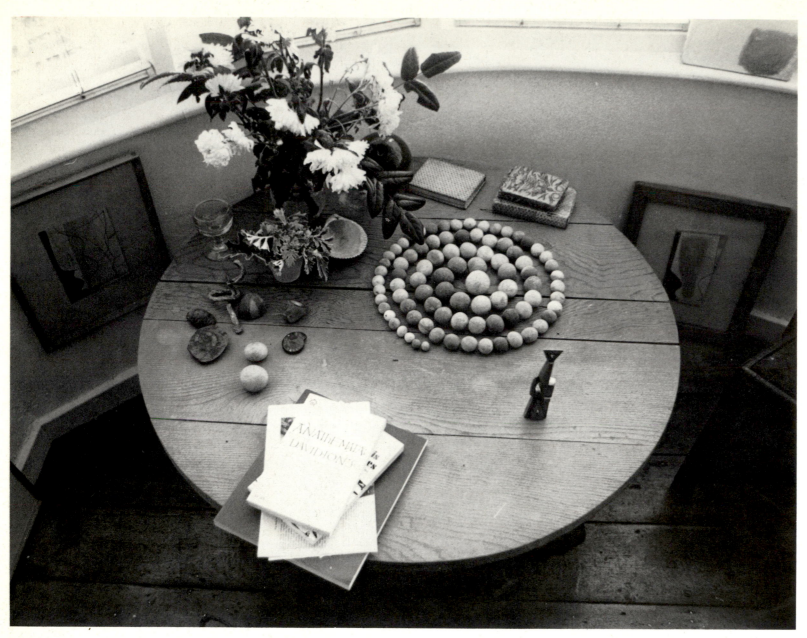

The spiral of pebbles was a case of 'necessity is the mother of invention'. I hadn't meant to make it. We were staying in a small lodging by the sea in Norfolk and I began to look for spherical pebbles. This was in 1958 and there was no sand on the beaches except far out to sea. To my astonishment in this multitude of pebbles a spherical one seemed impossible to find (Kettle's Yard has only one). So lowering my standard I used daily to pick up what I thought might pass, and laid them out in our tiny sitting room where the only space possible was a small, deep and almost square window recess, perhaps 20″ × 18″. Gradually as I placed them it occurred to me to grade them in size, and in so doing I started with the biggest in the middle of the window space, surrounding it with smaller and smaller ones, and thus the spiral came into being, having to be altered each day as I returned with other and better ones. At the end of a week I was getting quite good at spotting a winner, but always a little short of the mark.

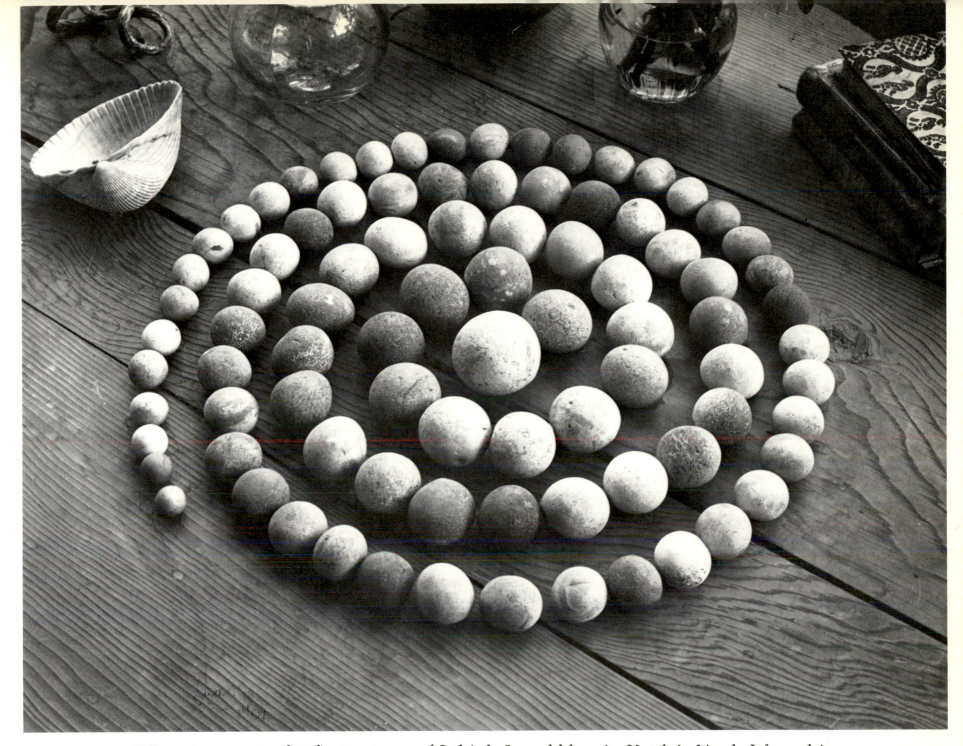

When it came to the first set-up, of I think 87 pebbles, in Kettle's Yard, I found it very conducive to blowing the dust away instead of a proper clean, but somehow they never looked dirty.

The lovely shell was once used for a christening in St Peter's Church nearby. This room occupies a part of the third cottage to the west. It is really very small but looks large with the big bay window. Visitors used to say 'Do you really sleep here?' and to my 'Yes' would ask how I kept it so tidy; perhaps that is part of the way of life. I did spend nearly a third of my life in this bedroom. It never seemed to me that there was much in it except a bed and a table. It may have been 9 ft by 7 ft plus the window space; and actually it contained 7 Ben Nicholsons, a Henry Moore, two by Alfred

Wallis, a John Blackburn, a Gaudier-Brzeska and David Jones's thrilling watercolour 'Vexilla Regis'. There was a cupboard full of lovely Georgian glass and china (an overflow from the kitchen not given to the University) and there were books of poetry and a little book of 'specials', things I had learnt by heart. It also has two chairs and a barrel in which we used to fetch excellent wine at a shilling a litre. I think the Ben Nicholsons made the space, for how could they be there without and who wouldn't keep all that tidy? It led straight into the bathroom, a slot of a room but equally fully empty!

> Batter my heart, three person'd God; for, you
> As yet but knocke, breathe, shine and seeke to mend;
> That I may rise, and stand, o'er throw mee, and bend
> Your force, to breake, blowe, burn and make me new.
> John Donne

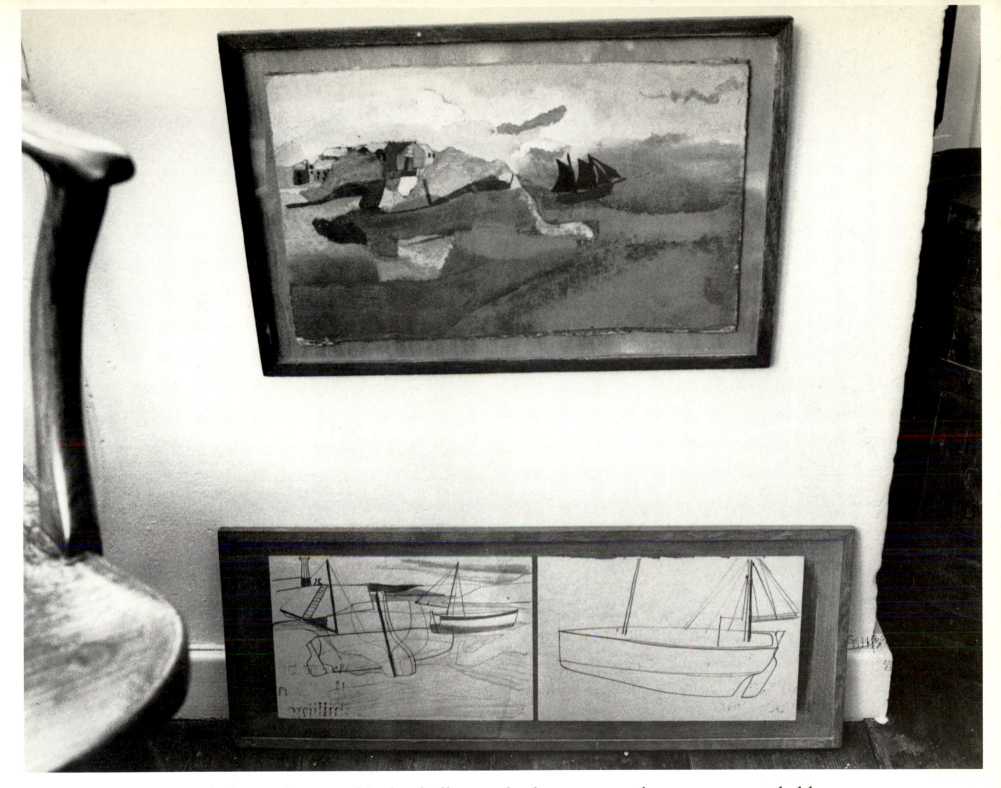

These Ben Nicholsons, here and indeed all over the house, are of course a remarkable asset to Kettle's Yard. So many gifts for which I am ever grateful.

The nature of God is a circle of which the centre is everywhere and the circumference is nowhere.

Origin unknown, possibly a lost treatise of Empedocles

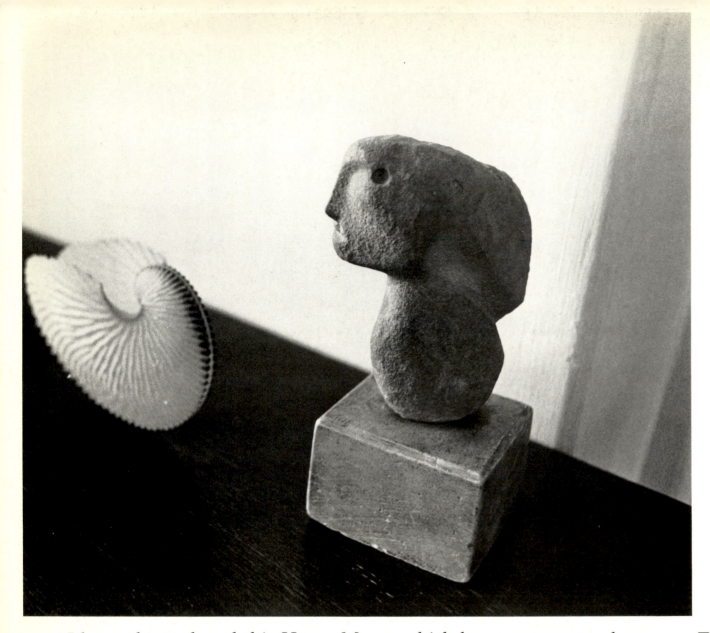

I have always loved this Henry Moore which he gave to me so long ago. The stone is stone and the swift measure of its forms, or complex lines, enter into that still energy which was so characteristic of Mayan sculpture, and particularly so, in our own day, of Gaudier-Brzeska. A stone, however carved, is first and foremost a stone; it belongs to things comparatively immobile, the rock from which it is separated, and must retain this parental force and immobility, yet it must also convey that strange admixture which is man; mutability of flesh and eternity of spirit.

In this small head the equilibrium of sculpture is reached, its life contained within its own nature; it is hard to think of it being made – it just is.

The world is charged with the grandeur of God.
 It will flame out, like shining from shook foil;
 It gathers to a greatness, like the ooze of oil
Crushed. Why do men then now not reck his rod?
Generations have trod, have trod, have trod;
 And all is seared with trade; bleared, smeared with toil;
 And wears man's smudge and shares man's smell: the soil
Is bare now, nor can foot feel, being shod.

 Gerard Manley Hopkins

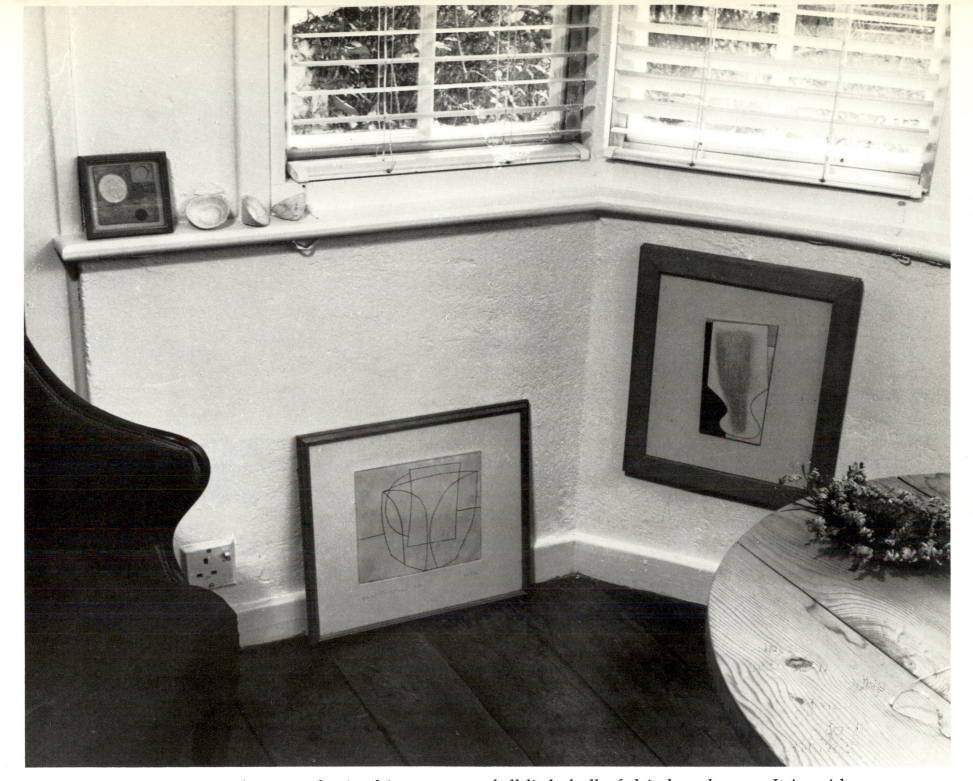

There is another wonder in this room – a dull little ball of dried-up leaves. It is said to live for ever and I think is called 'The Rose of Jericho'. Put it in water overnight and it opens up into a lovely curly fern. After a short rain the desert becomes all green with ferns. The one at Kettle's Yard on its arrival some twenty-five years ago was about six inches across when open, while now it is at least twelve. It is open on the table, along with my spectacles.

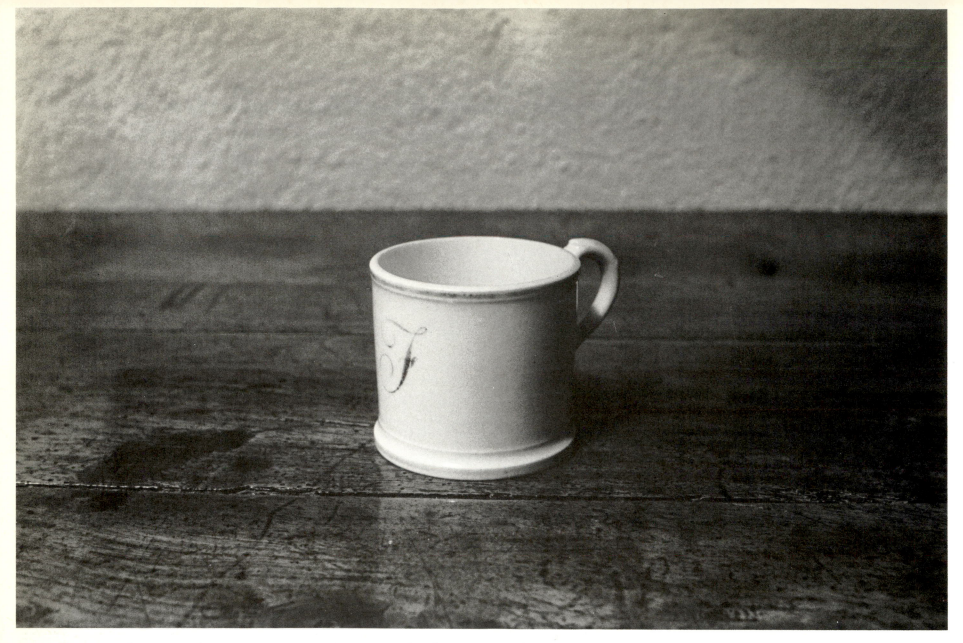

It was always a joy to me to go into my bathroom with a window at each end, one south with sunlight filtering through the slatted blind and the other looking across through cherry trees to St Peter's Church. I had it built onto the end of the last cottage and stole four inches of permitted building ground from the Corporation to allow me to install the smallest bath on the market. My grandfather's christening mug, 1828, has come back to join me in this photograph. In the first twelve years I had the large Gaudier-Brzeska painting of 'Lady Macbeth' hung in this tiny space; I had to cut slots in floor and ceiling to wedge it in. Undergraduates were 'astonied full sore'. With this big picture there were three by Wallis, a Congdon, a Christopher Wood, the two small children and a small bronze by Gaudier-Brzeska. There were inlaid boxes and miniatures which I have now replaced by a more beautiful collection of stones, and with all this no sense of clutter. I am reminded how a celebrated actor came walking across the Green: I saw him from the south window, carrying four dozen huge red tulips. After he had left I dealt with the tulips, using them all, evidently with some discretion, for a daughter staying with us said, 'After half an hour you would not have known there was a tulip in the place.'

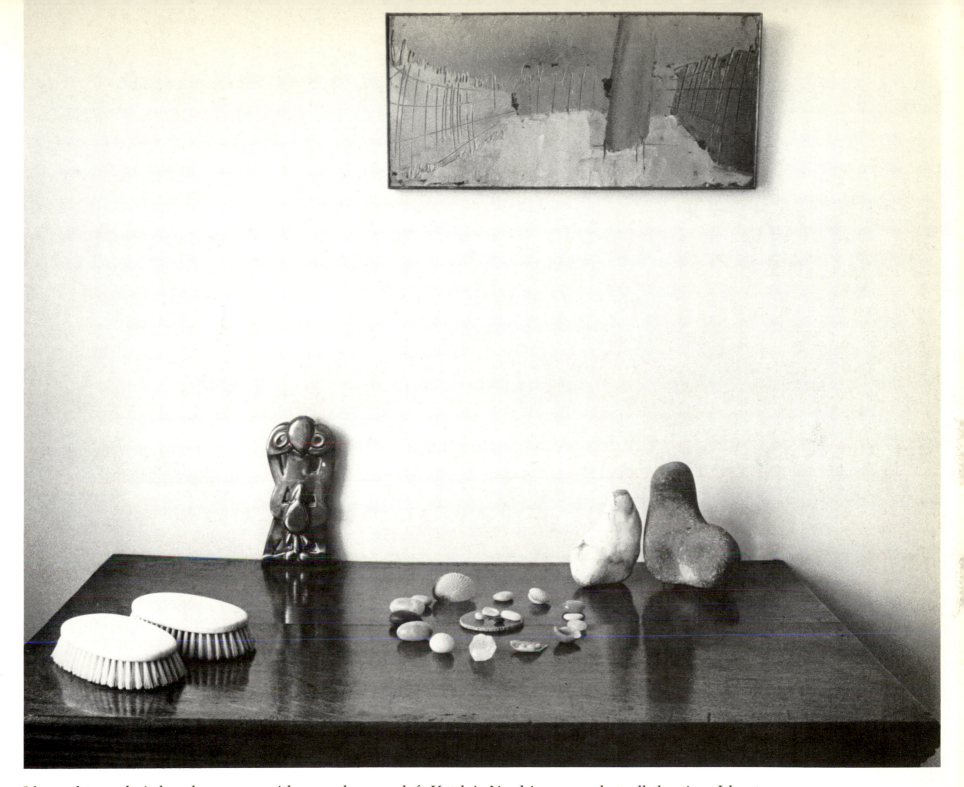

I brought my hair brushes away with me when we left Kettle's Yard in 1973 – but all the time I kept thinking how beautiful these flat ovals of ivory looked on this chest of drawers, so I sent them back to relieve my mind. They had belonged to B. R. Haydon, Royal Academician and friend of Keats. (For the 'Piazza' by Congdon see Biographical Notes.) The larger of the two stones has always been called the Henry Moore stone, it came from New Zealand. It used to be companioned by a large Argonaut like the small one upside-down amongst the circle of stones. A little while ago I found from the north coast of Scotland the white stone and at once thought of it as spouse to the other and so sent it to Cambridge.

 This is my first view of them together. The grey one looks very male and puffed up with his own importance. Perhaps the H.M.S. is just being proud and protective. The white stone is actually full of wisdom and this is not apparent. It may be that they are a shade too close to each other and that the distance between them should be doubled to allow the right vibrations their freedom – it is a fine shade.

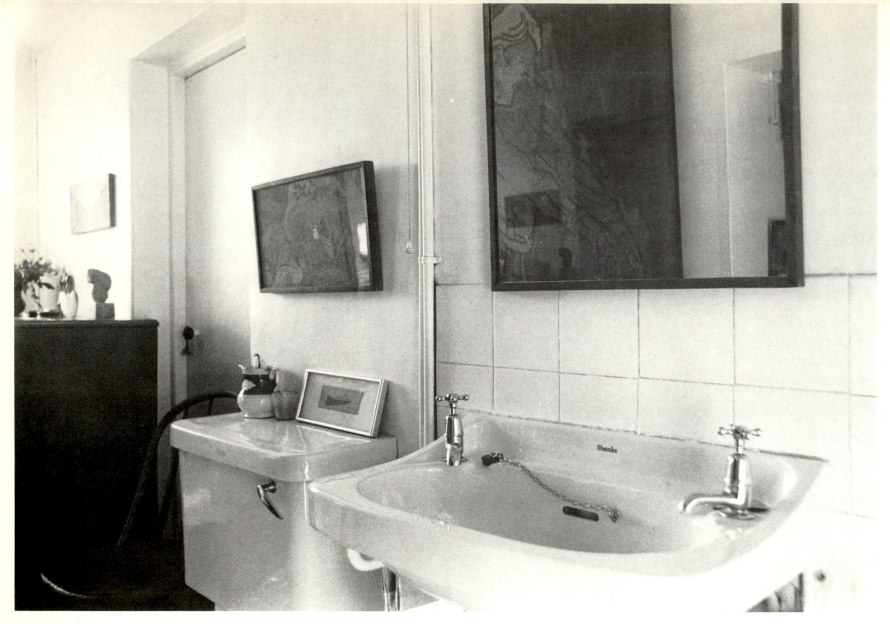

Lovers and madmen have such seething brains,
Such shaping fantasies that apprehend
More than cool reason ever comprehends . . .

A Midsummers Night's Dream

The poet's eye in a fine frenzy rolling
Doth glance from heaven to earth, from earth to heaven;
And as imagination bodies forth
The forms of things unknown, the poet's pen
Turns them to shapes, and gives to airy nothing
A local habitation and a name.

A Midsummer Night's Dream

 It becomes an interesting example of something on which the life of Kettle's Yard depends, a thousand unnoticed details. We too are such, both in our body and in our thoughts which are myriad. What computer could number these thoughts; and I think it is said that our unit as a person contains trillions of cells, each cell an entity. A friend from the moon came to see me; I asked him if when next he went he would bring me a few 'moon marbles' – I had seen a photograph and saw them as about an inch in diameter and of a semi-transparent blue. 'I have some in my pocket' he said, and pulled out two small bits of glass held together – 'Can you see a tiny dot in the middle of that, all your marbles are within it.'

This painting by Christopher Wood of a little house in Vence, even when almost totally black still has a magic quality. He gave it to me more than fifty years ago.

The little Wallis is a gem. The blue and white jug has been with me longer still, and it was here the christening mug used to be.

In regard to the so-called material world, all is threaded by this need to adjust the 'inanimate' to the animate, to fuse them into one, for essentially all matter is animate.

In 1917 I was making a seven-week voyage by ship to India, aged 22, and met a man who informed me that all is feeling, that the chair I sit in is no dead thing but alive with me. A child knows this quite naturally. Such things are I think essentials in life and not mere frivolity.

It is salutary that in a world rocked by greed, misunderstanding and fear, with the imminence of collapse into unbelievable horrors, it is still possible and justifiable to find important the exact placing of two pebbles.

I am reminded, a little off-beat, of something I heard about mankind; that it is divided into two ways of thought: those who wake up in the morning with a bright 'Good morning, God' and those who mumble 'God! . . . morning!'

I apologise all the same for allowing myself to be led so far by those two pebbles; that is what comes of enjoying my bathroom.

Even as I write this I received a call to say that all was correct – together, I think, with a third pebble (this can be seen on p. 53).

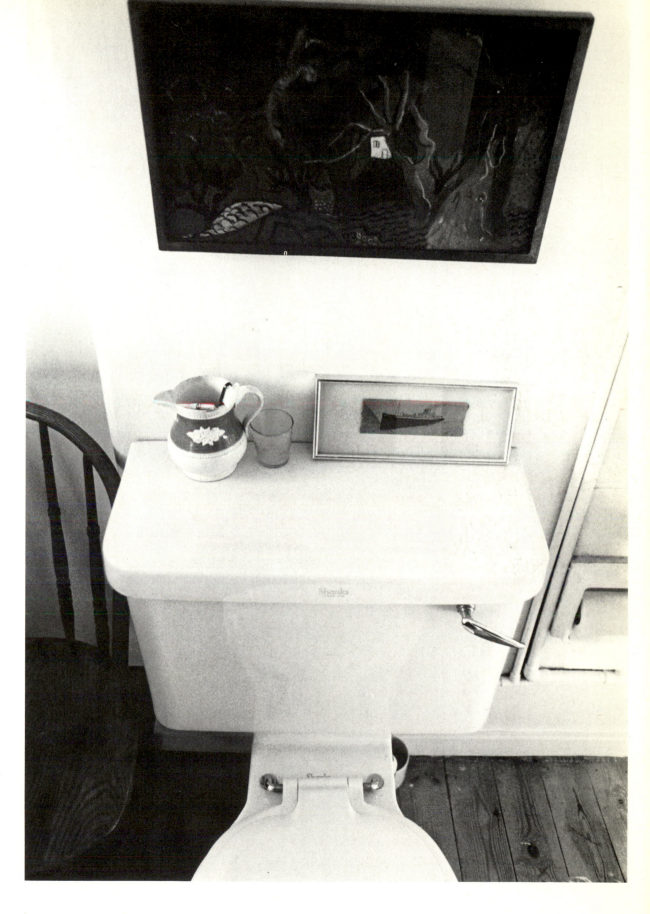

When I first saw this photograph I discarded it, but on trimming it a little it delighted me. This cavern between the bedroom door and the chest of drawers with its southern window; these two strange beings, my grandchildren, drawn by the larger one when she was five, of herself and her sister; and the bristles of the hair brushes repeating the serrated lines of the shells on the window sill. How beautiful too the deep texture of the two-hundred-year-old wood. All this filled me with interest. I see an Alfred Wallis on the floor – it is framed between glass since it is one of those with a painting on both sides.

Interlude II
One Elm Row, Hampstead, London

Before going on to the room above and the attic where so much of Gaudier-Brzeska's work can be seen, I think it will be of interest to stay a moment to get an idea of where it was and how it was that we met all these artists whose work has made so living a place as the ground floor of Kettle's Yard.

At One Elm Row all these artists were familiars, constantly coming in and out, and what is more bringing their work, hot from its making, to show or give. They brought their friends; it snowballed into quite a large section of London's artistic world. We even had all the top members of the Russian Ballet, and Arnold Bennett with them; he wrote an article in one of the evening papers 'How the poor live in Hampstead'. There were 25 to supper that day, and little did they know that it had cost only tenpence per head. It was a lovely evening with Vera Moore playing the piano and two of the best 'English Singers', accompanied by one of them.

Our purchase of this house was really an accident, unless it was a gift of the gods, for surely without it there never could have been a Kettle's Yard. Two of my colleagues said they each wanted a small house but could not find one. I too, so I suggested we should club together and get a big one, which was easier, and divide it up between us. They asked me to go ahead. I went to an agent in Hampstead, who after pointing out all the virtues of many fine houses, bethought himself of one recently put up for sale.

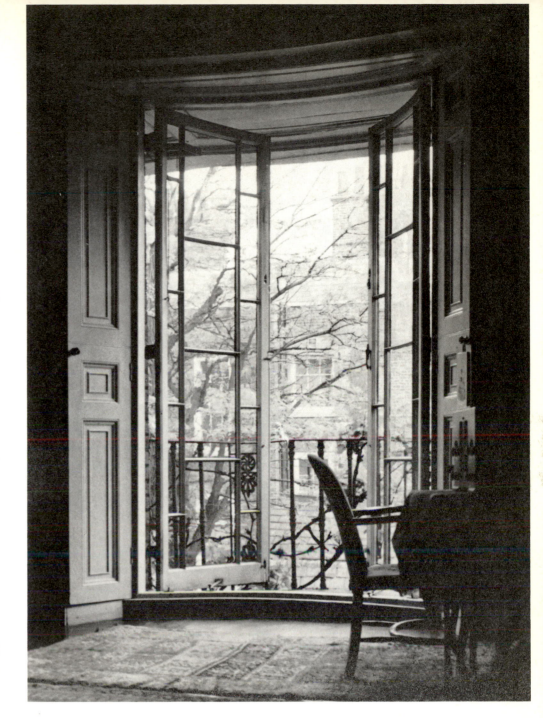

I knew it by heart and could imagine no house I wanted more; it had belonged to an elderly friend and we were often in it. My heart nearly missed a beat – but I told the agent I had quite enough on my list and so left; already I was living there. My friends still told me to go ahead; I did, but when all was at the point of settlement, they found they could not join me. It seemed a blow, but I at once determined to tackle it myself, and through my father's help and a small mortgage it was managed.

It was a rambling old house which had probably once been an inn, and had grown by degrees from the sixteenth century till the mid-eighteenth. It had powder closets and wig cupboards, and mysterious legends of secret passages and ghosts. It had lovely windows and shapely rooms, and an abiding sense of quiet, an inward quiet which could itself have been the ghost. I set to to make it perfect from top to bottom. When we moved in there were twenty-five workmen in the place, and every evening, after they had left we would run around hiding planks and ladders, pails and

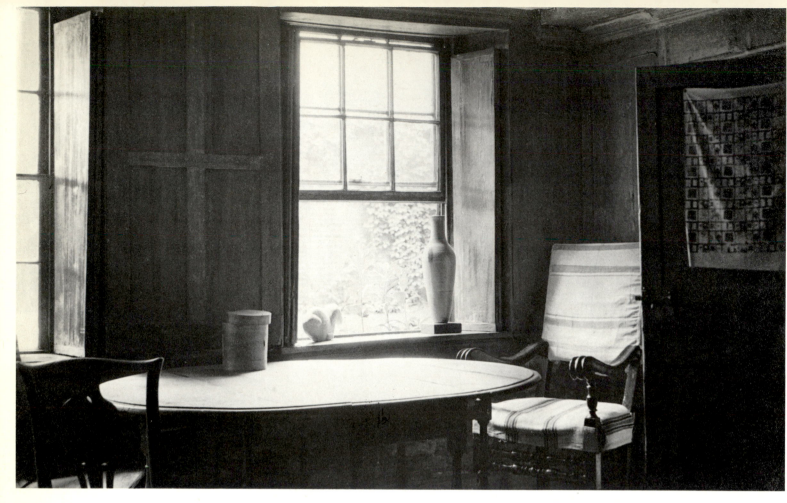

brushes, so that we could awake in the morning to see it clear and beautiful. Was this the beginning of that 'Way of Life'? All the workmen came trooping in at eight. In time all this settled down. By dismantling a large kitchen stove we found a most beautiful ancient fireplace and with candles lit on the table, a fire sparkling and an easy welcome we never lacked company, a dozen did not seem too many. This table is now in Kettle's Yard; the chair and Staite Murray's 'Heron' also. It would be good to get back Gaudier-Brzeska's marble of 'Dog'. Here and in the music room, on the opposite page, which was a double room on the first floor, there was always a sense of space. There were times I will never forget when this big room, dimly lit, its floor mysteriously shining like the back of an old fiddle, looked exceptionally lovely. The street lights flickered through the vine leaves, making shadows on the white panels; odd leaves would blow into the room and someone's voice turned the wooden walls to stone, as it rang out with a sixteenth-century melody.

All this was a lasting education and delight to us both, always having artists about. So many evenings we would sit with just a few painters discussing life, or a pianist would arrive and want to play his next day's concert, or David Jones would be staying and evening after evening would read what he had written of *In Parenthesis*, and enrich the daily thoughts of life. We had no telephone, which was thought a crankiness, but gave us some respite. Braque noticing this said that he too had 'tous les conforts, pas de téléphone'.

An Indian who arrived unexpectedly into all this bareness said that he hoped Mrs Ede would not mind his having seen it, he thought we had just moved in and that the furniture had not come.

There was a small garden with trees in front of the house and a gate leading into Elm Row. Every day when I came home I would open this gate as though I were a stranger, and see for the first time that flat façade of ancient brick, with its many windows shining sombrely like deep pools in shadow; grey stones leading to it across emerald turf, each stone made magic by time's usage. Sometimes I used to wash each stone and laugh to see the bright sky reflected in its surface. As I came nearer to the house I could see into those other pools which were windows and distinguish walls of shadowy panels, and the nearer sills of softly polished wood, on which stood a

few shells, like seagulls, piercing white wings against the sea; or there was the glint of 'Waterford' (casket in Kettle's Yard), catching in its diamond surface the darkness of the room.

The garden was always a miracle, for it was set in high walls, which shielded it from the clamour of the street beyond, and as I opened the gate into it, I had the impression of entering a church, so sudden was the silence which fell on me; or of diving into a reach of water, so green and cool and fresh it was; and as I shut the gate my world became timeless, and a combining sense of past and future, a bubble insubstantial and invulnerable. Within this bubble I was intensely practical.

At that time, 1928–1938, I thought I knew myself. I had a profound feeling for the essence of life of which I felt myself to be a part. 'I know that my Redeemer liveth', so how could I despair? I knew what sort of a fool I was and what sort of a fool I wasn't. I knew I had little brain and much heart, that I was not clever but that I was quick, that I had no sense of self-importance but was persistent, that I was a Martha more than a Mary, that I wasn't witty but was intuitive, that I was no athlete, no club man, no toper, but friendly and willing, that I was no scholar but had a highly developed power of perception.

Twenty years later when I reached Kettle's Yard, 1957, I would not have known to differentiate in this way for what was I of myself; my so-called gifts seemed all to have become hidden by failure, failure to attain that union with God which I believe to be the essence of man's nature; and yet I still praise God for this very sense of loss which at least had shown me the greatness of my need. I can see now that my nature has not changed in essence though it has developed. I have lived within certain laws – that we are not free in the accepted meaning of that word, that freedom is conformity to a plan 'whose service is perfect freedom'. That works in with one of my earliest beliefs, that only in good is man alive. In this way I may have been alive for a few minutes and am ever grateful for those moments.

There are four south windows to this room, and a wonderful feeling of an interior carved out of its surrounding air.

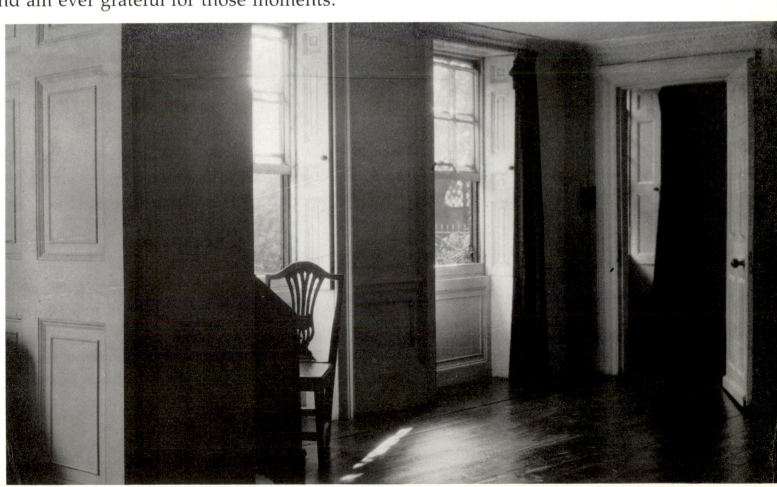

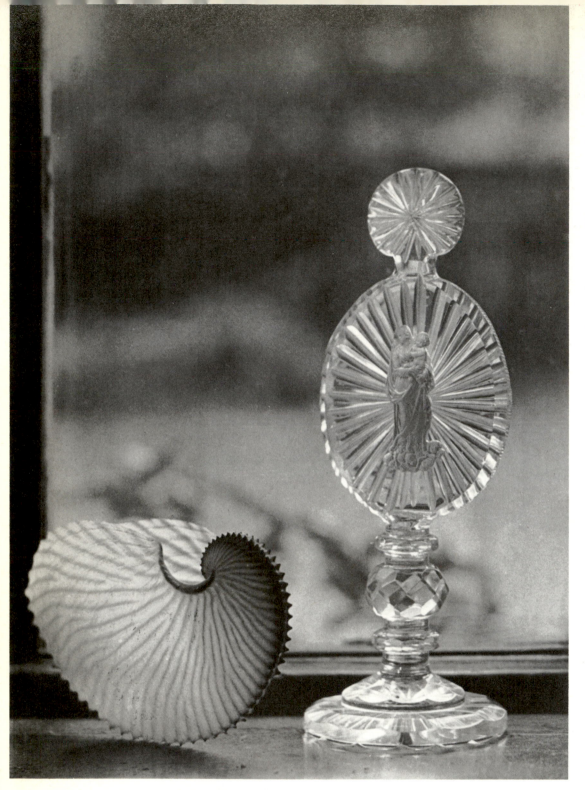

This was what I saw from the garden and not the casket, but both were Waterford and both an extravagance in the purchase of the house, as I have told elsewhere. It is now in a small oval window recess at Kettle's Yard. I had two shells: both have been broken and I have not found another.

The frontage of One Elm Row was beautiful, many windows, and the large curved William and Mary one, with railed balcony, to set them off. I have always been particularly inspired by the façade of houses, that curtain of stone which divides the outside from the inside, by windows whose transparency emphasises the privacy of the interior, by walls enclosing. Inside, a period of time is held suspended in silence, outside it is gradually dispersed to the incorporate air. In a garden these periods still linger in the corner of a wall, in a lawn, or in the shape of a path; and in the surrounding land too it sometimes holds, but out at sea it is all gone. This may be because the human past is crowded into rooms; that I sit amidst its long accumulated shades which softly and imperceptibly touch me at all points, like a mist, or like driving through a plague of butterflies, whose silent flutterings and velvet wings make no impression on the hard surface of a car.

I like to keep very quiet in a room, and to have it always still; for this reason I want a room to be orderly. It is to me as if it were a pool of silence, and just as a pool when stirred loses its transparency, so a room is stirred by movement. Sometimes I find that if I don't go into a room for a week, and then gently open the door and look in, I am invaded by its stillness; and if I tiptoe into it, that stillness stays about me for some moments. Most people's houses are hurricanes; a difference of thought which I find reflected in Carpaccio's 'St Ursula's Bedroom' and Van Gogh's 'Bedroom at Arles'. Each is limited to its own mood, is separate, and for perfection each must include the other.

The Mona Lisa is turbulent and still.

In old houses I always feel myself companioned, though I never had the gift of living visually in any period but my own, and have seen no ghosts, but often I have needed to escape into a garden where there is less pressure pervading me.

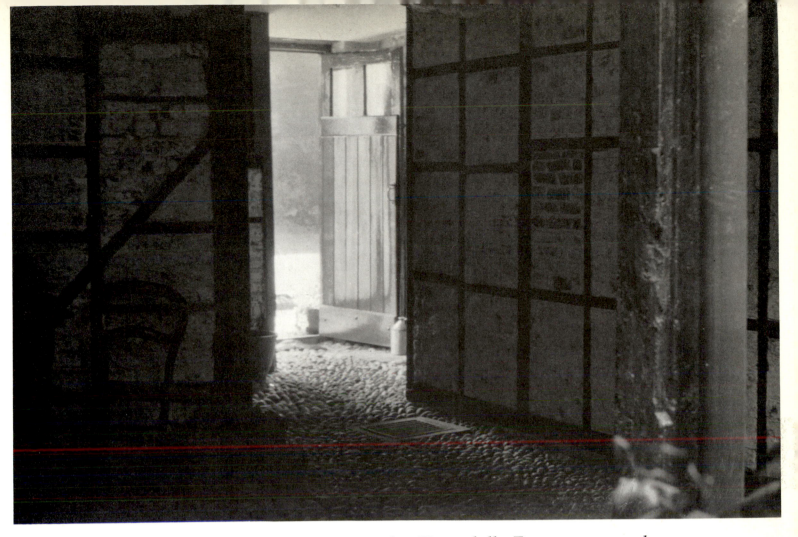

I remember how in Arezzo I went to see the Piero della Francescas, and saw nothing but an old faded curtain blowing gently by an open window and making shadows across the pictures. That this should have touched my thought more keenly than the frescoes was perhaps an invasion of Piero's vision. For me the vision of the mind, and material structure, grew increasingly mixed – a wall was but a web, the limited air a narrow chamber; ideas took shape in perpetual security, while cities blew away as dust. I had been immersed in Piero's own inspiration of light, a curtain making a mystery of light, through shadows filled with light, resolved in that frescoed wall of light, one day to crumble, while inspiration lives, fed by this light.

If you look long enough at the doorway seen from this sixteenth-century cobbled courtyard you will find light pervading. I could never go through this yard, which had become the side entrance to our house, without becoming involved in its deep stillness. It may once have been a pathway between cottages, held then as now in this same light and this same atmosphere.

Below all this, there is a cellar which became for me a kind of shrine, candle-lit and empty for the influx of all that is. If anywhere, it could be here that a tunnel started, leading to the solitude of Hampstead Heath.

End of Interlude II

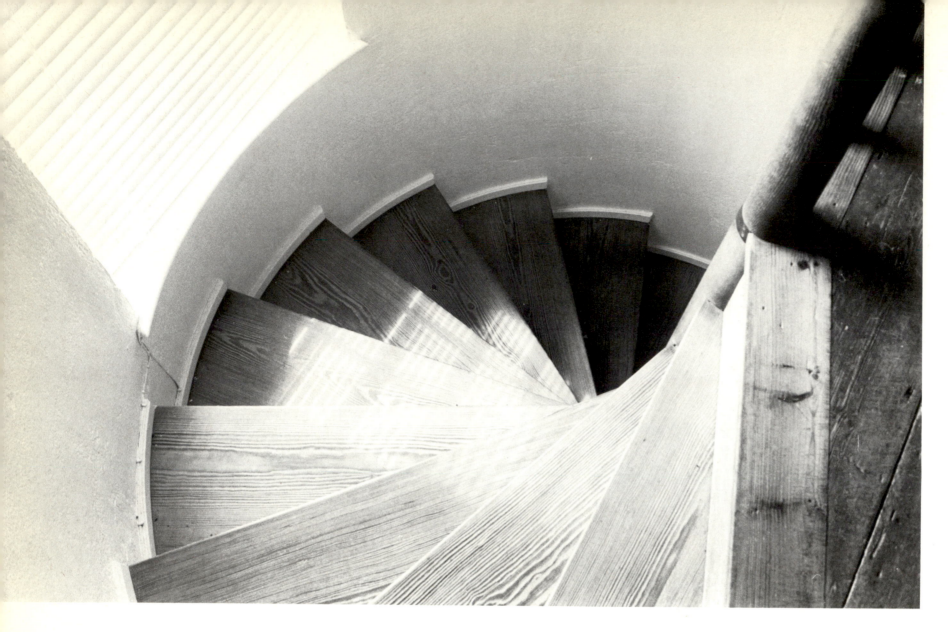

A spiral stair is always a great mystery. Does it go up or does it go down, where does it go to and from where does it come? The mystics through centuries have used it as a metaphor. The beauty of these two photographs really excludes words – the combining of the slatted window with the circle of the stair and the momentary inflowing of sunshine to make so fleeting, and yet so persuasive and so delicate a pattern with the differing grain of each tread leads into the world of poetry.

> What is your substance, whereof are you made,
> That millions of strange shadows on you tend?
> Since everyone hath, every one, one shade,
> And you, but one, can every shadow lend.
>
> *Sonnet*

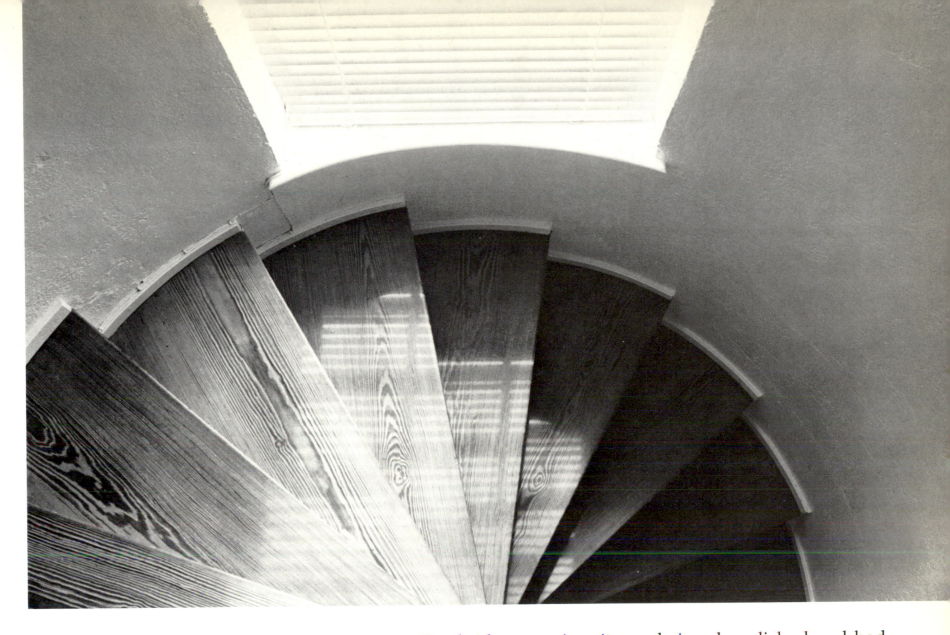

The treads came from a large Cambridge mansion; it was being demolished and had been called 'Rance's folly' for the last several lifetimes. I think perhaps it used up all his money and he never lived there. I did not search to find his history. From this same house I got the early eighteenth-century window with a curved top. I put it into the seventeenth-century cottage to the east of Kettle's Yard passage.

I used to love washing these stairs, finding all the differing patterns which responded so quickly to water, and soon I grew quite able in retaining the water on each tread while I wiped them dry, for as I grew into my seventies it became a bit of a backache washing the floor below. This floor was formed by seven 'left-overs' from the flagstones obtained from St John's College to pave the little church of St Peter's. It was sinking, so we made a raft of ferro-concrete for it to rest upon.

We had to build a semi-circular tower to contain these stairs. I little knew where they would lead.

Again here I am confronted by the adventurous pursuits of the outward and the inward which constitute our lives. The previous two pages draw me inward while these, though retaining both solitude and quiet, lead outward. The newel post is firm and allows no faltering. I had wanted to make it from a telegraph pole, but could not find one, so we had to cut a new one which is more sophisticated. Where it reached the floor above, an over-zealous carpenter cut it in two; it seemed a disaster, which I tried to remedy by covering the join with a brass circle.

These still are stairs within a dream and I am reminded, quite obliquely, of a poem by Michael Drayton which I happened to be learning when we first came to live here.

> You are not alone when you are still alone,
> Oh God from you, that I could private be.
> Since you one were, I never since was one,
> Since you in me, myself since out of me,
> Transported from myself into your being,

Though either distant, present yet to either,
Senseless with too much joy, each other seeing
And only absent, when we are together.
Give me myself and take yourself again,
Devise some means, but how I may forsake you,
So much is mine, that doth with you remain,
That taking what is mine, with me I take you;
 You do bewitch me, oh that I could fly,
 From myself you, or from your own self I.

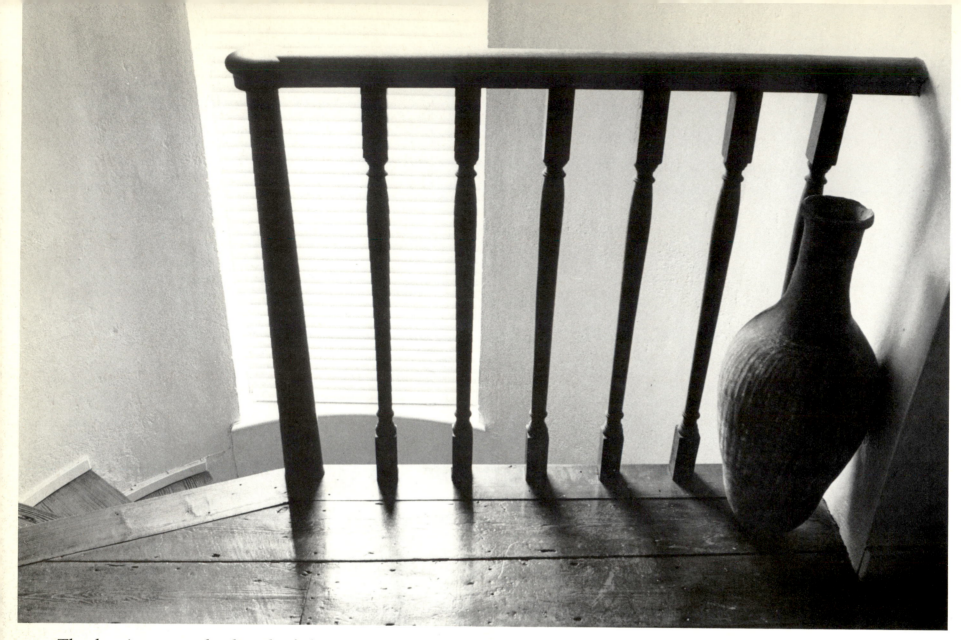

The banisters at the head of the stair I turned upside-down thinking that it made for a more fitting balance, and I was lucky to find a suitable length of handrail with its turned end.

The amphora leaning against the wall, and tied to a banister, we found in Safi, quite close to the Sahara Desert, and called it Safi. It cost twopence; there were five and this was by far the most beautiful. I only just managed to bring it away, for we were travelling by car with a friend who was sure that they must be full of disease, and the car was pretty full to say the least. Only when I had carefully wrapped it in a mackintosh sheet and agreed to sit in front with the driver was I allowed to have it. Later we took it with us to France and a friend who had come to spend the day with us picked it up the better to admire it, and dropped it on the tiled floor. She burst into tears and that was worse than all the bits of poor broken Safi. The story had a happy ending, for some friends from the Louvre came to tea, and said not to worry, they would get it mended in the Ceramics Department. It hardly shows a sign and only cost £5. Remembering this, I wired it to its support in Kettle's Yard.

Nearby is a Tibetan Yak bell which was given to me in Northern Kashmir in 1917. It made an effective and pleasant call to tea for people wandering around the house.

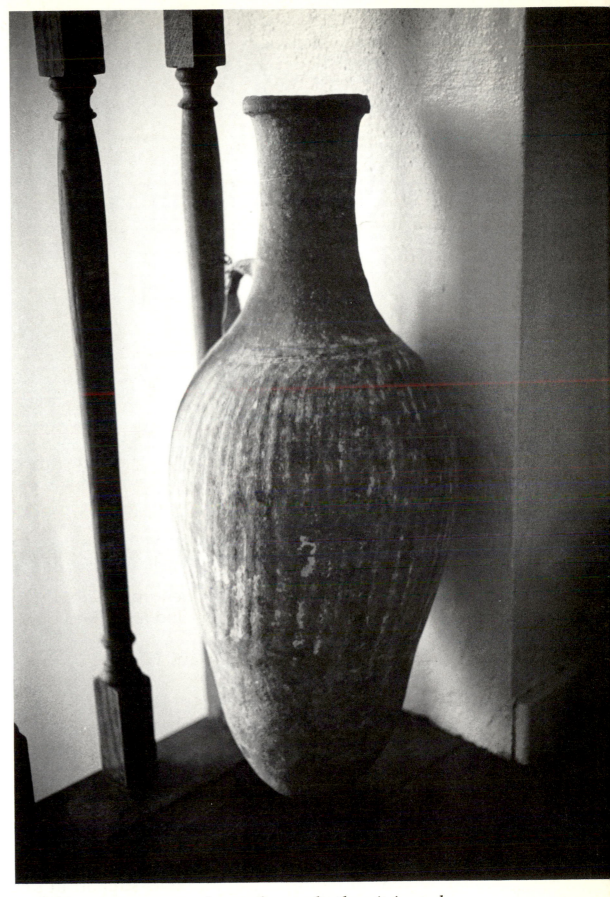

Safi's age seems to depend on whether it is early
Moorish or Phoenician. I never found out; I think
it makes a difference of a few thousand years.

The Argonaut, or Paper Nautilus, lives, to my knowledge, in the Mediterranean Sea. I have often picked them up after a storm, blown far up the coast.

A girl, who was visiting Kettle's Yard, told me that one sailed past her while she was swimming – paddling itself along with its fins. The shell becomes a boat, and the mollusc lifts itself up as a sail. It was a memorable experience.

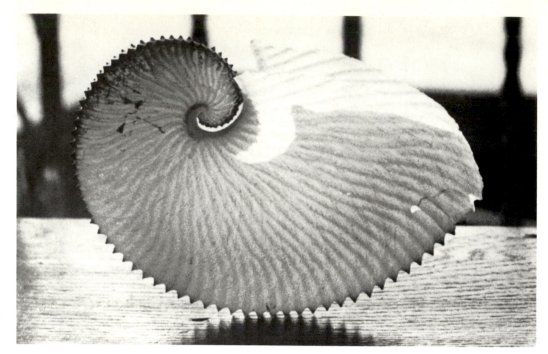

This may be the place to introduce a few of the thoughts of others which sustained me while Kettle's Yard was being put together. I had thought to slip them in here and there throughout the book.

To collect them together will be better – for if they are unwanted the reader can turn on.

Put on thy jumping shoes and leap straight into the heart of God. Meister Eckhart

We should become what we have eternally been. Meister Eckhart

He is our clothing that for love wrappeth us, claspeth us, and all becloseth us for tender love, that He may never leave us; being to us all things that is good.
 Mother Julian of Norwich

It is said the Nightingale to song and melody all night is given, that she may please him to whom she is joined. How muckle more with greatest sweetness to Christ my Jesus should I sing, that is spouse to my soul by this present life, that is night in regard to charms to come. Rolle, *Fire of Love*

For as verily as we shall be in the bliss of God without end; so verily we have been in the foresight of God, loved and known in the endless purpose without beginning. In which unbegun love He made us; and in the same love He keepeth us.
 Mother Julian of Norwich

Laissons le corps s'occuper de sa maladie, mais, O mon âme, demeure toujours dans la félicité divine. Ramakrishna in *La vie de Ramakrishna* by Solange Lemaître.

This Venetian mirror was bequeathed to me by Leverton Harris, generous donor to the V. and A. and to the Fitzwilliam Museum. When I first hung it in our bedroom we could not sleep all night, it was like having the moon for company, so bright it shone. On our first weekend away from home I took it with me. An awkward companion, it has always astonished me how simply it fits into Kettle's Yard.

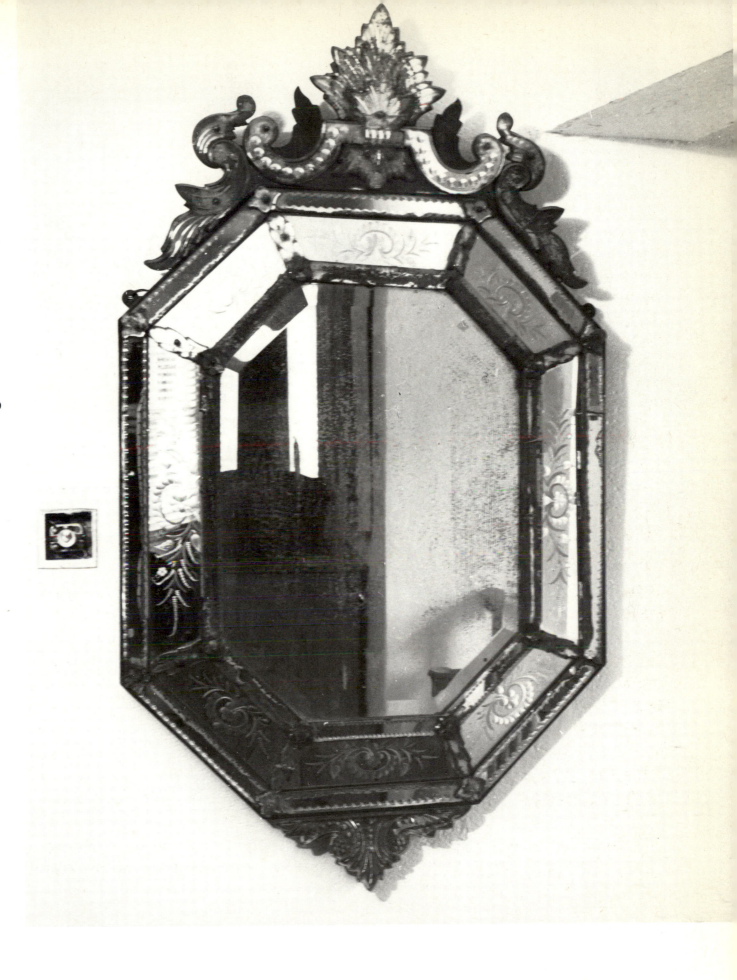

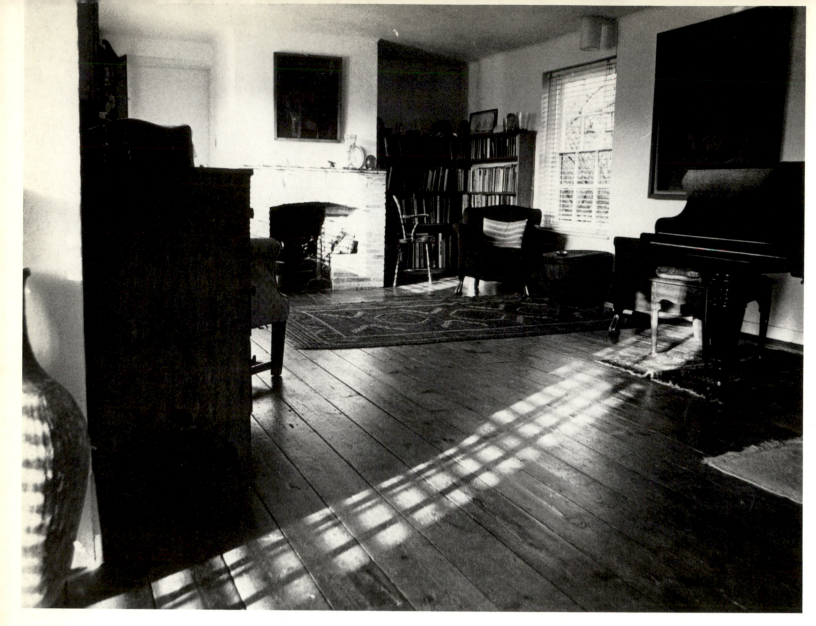

There are parts of three cottages in this room. Beyond the door on the left is a bedroom. I put its fireplace into this one, so doubling its space.

In this first-floor sitting room covering these two pages, there are so many small personal treasures. The low round table; coffee tables where you sit upon the floor, came from Fez, we hired a donkey who carried five to the station for us. The Dutch engraved glass on mantelshelf and bookshelf came from the Workman collection sale in Park Lane which I attended. I was sitting in a place very unfavourable for seeing glass and anyhow knew precious little about it. I felt that each 'lot' must be false and only at the last two bids did I pull myself together and got five objects, almost, I think, to have got something. When I got them home and washed them they seemed to be magnificent pieces, which they are. The price was negligible.

There is a French sword somewhere in the fireplace used as a poker. It had belonged to M. Béranger who sold us Les Charlottières in France, and it immediately takes me to a painting of French soldiers by the Douanier Rousseau which used to hang in Picasso's Paris appartment – he was rich by then, as he told me. On the first occasion that I met him he asked me to go to dinner with him at the house of his friend Madame Errazuriz who had many of his paintings which he would like to show me. I felt that this was the moment for me to be quite rash and call for a taxi, but when we got down to the street, there was a large limousine with a chauffeur waiting with knee rugs, and Picasso sensing my surprise, said 'Je suis grand maître maintenant, faut avoir une automobile', and off we went.

The stone (it can be seen a couple of pages on) with a hole through it (and there were Barbara Hepworth and Henry Moore arguing across a dinner table as to which of them had first put a hole into sculpture) came from the island of Aix, the last place

in France where Napoleon set foot. The two fossils near it are from Pescadero, a beach a little south of San Francisco. They now and again fell out of the cliff above.

The Bohemian sweet glass came out of Vauxhall Bridge Road. There were two at £1 each and for several months I would go and look at them wondering if I could buy them and at last took the plunge. One was perfect, with a lid; I gave it as a wedding present to a friend; the other had a patched-up lid (on small table above). It exactly fitted a glass which I found thrown into the boundary hedge of our place in Morocco.

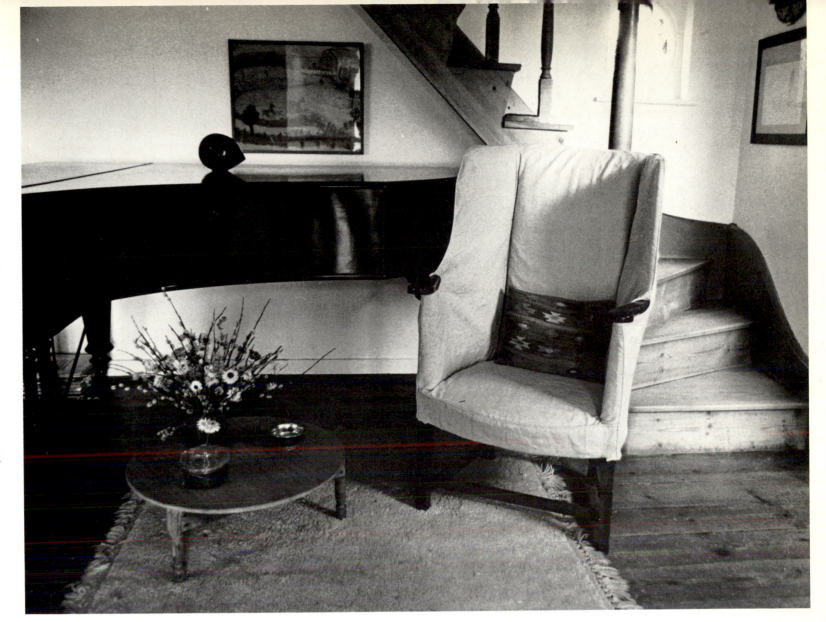

I had never heard of Quaker Pegg when I bought five plates by him in Page Street on my way to the Tate. I felt the price of 1/6 each a bit steep (8p). The shopman said that the rivets alone were worth more than that! It would seem that plates by this remarkable workman are very rare.

The seed pod on the mantelshelf is a most astonishing bird (I have cheated a little to stand it on an egg-pebble), it comes I think from South America and those fine curves in its tail reach such a tension that it splits the 'body' and thus scatters the seeds.

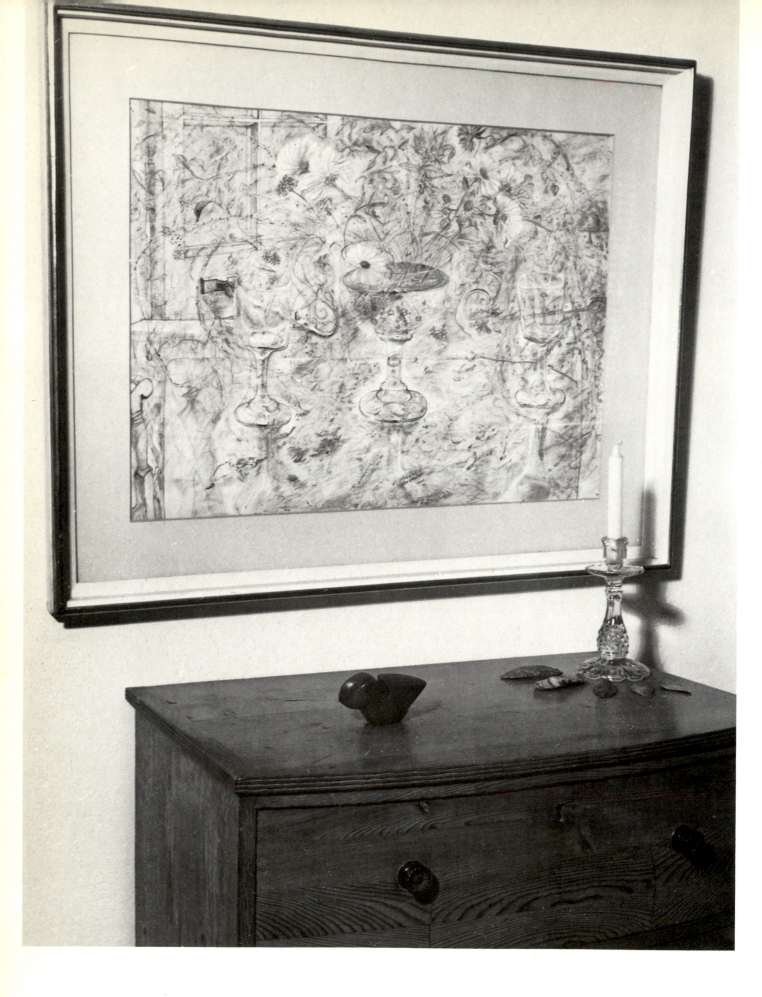

David Jones's 'Flora in Calix-Light', 1950, is shown in greater detail in a biographical note on him at the end of this book, but this is far closer to its subtle mystery.

It is of course a Trinity, a Crucifixion – even if wanted, the Holy Grail, the Eucharistic Chalice. Always in one of David Jones's paintings, meaning underlying meaning can be found; a spray of bramble carries its thorns in memory of that particular Crown.

The glass candlestick is almost part of the painting, an echo of the artist's vision.

This candlestick was given by Sylvia Townsend Warner after her first visit to Kettle's Yard. The flints around it are rose-coloured, and come I think from Australia. A friend came back with a bag full and gave me my choice. They are already almost prehistoric tools.

When Museum officials came to borrow pictures for an exhibition I tried to head them off my many favourites, but I never had any trouble with Ben Nicholson's 'Guitar'. They would have liked to have it, but did not dare since it was already falling to pieces. 'Look how the paint is flaking' they would say. I never undeceived them that the effect was the artist's intention. Nor did I point out that no flakes had fallen inside the frame; but how, I wondered, could they not know?

I have always liked the position of this painting, dark above the darkness of a fireplace below.

At the turn of the page the things collected on the shelf will be found in closer detail.

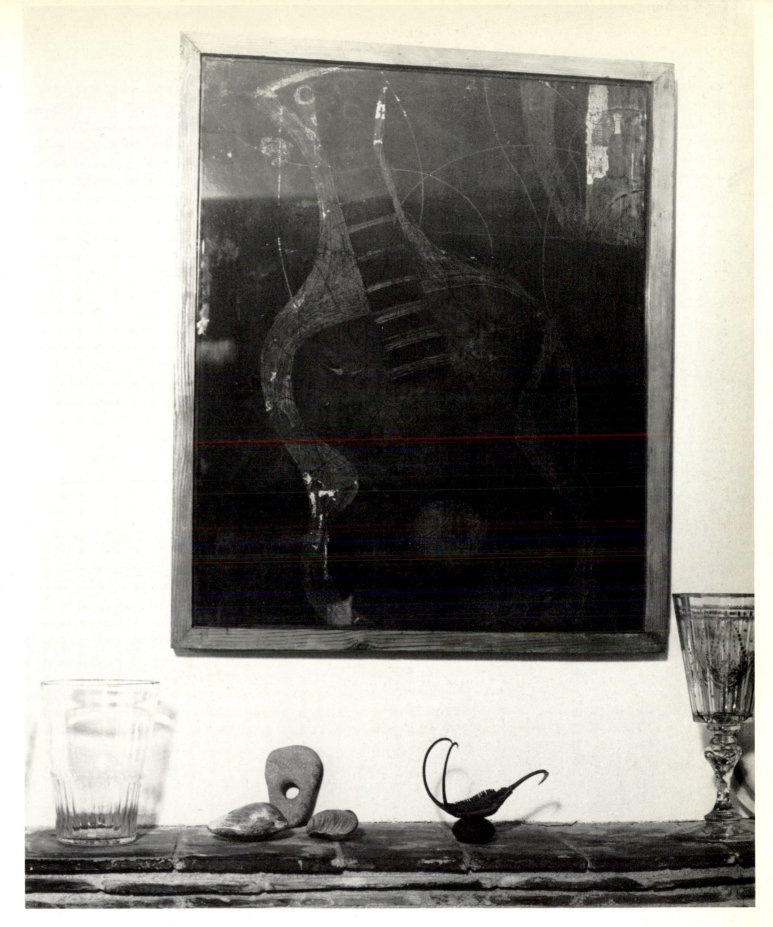

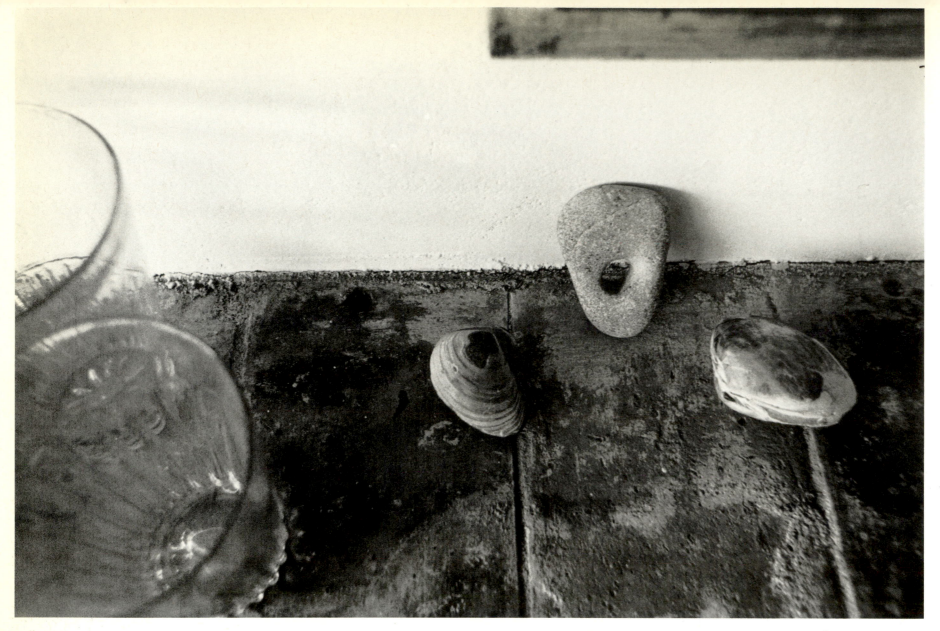

I have written of all this on the previous pages, but again it is exciting to be brought so near, almost to touch each object, lift it up and feel its so close vibration.

> The which he will not every hour survey,
> For blunting the fine point of seldom pleasure.
> Therefore are feasts so solemn and so rare,
> Since, seldom coming, in the long year set,
> Like stones of worth they thinly placéd are,
> Or captain jewels in the carconet.
>
> *Sonnet*

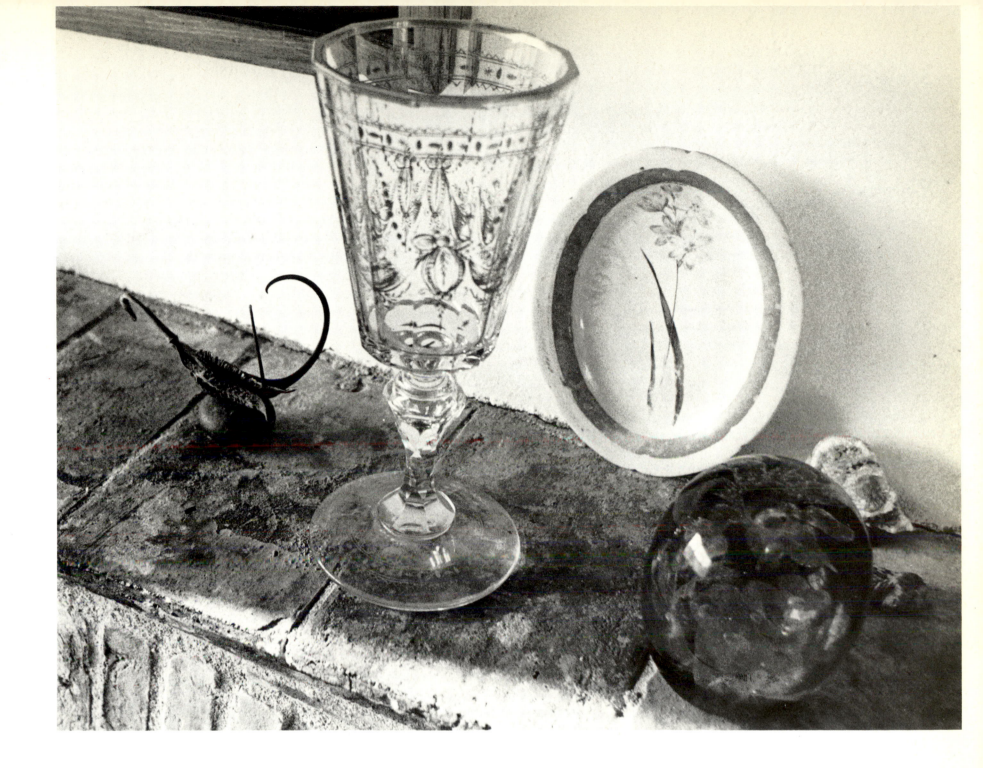

But thy eternal summer shall not fade,
Nor lose possession of that fair thou ow'st;
Nor shall Death brag thou wander'st in his shade
When in eternal lines to time thou grow'st:
 So long as men can breathe, or eyes can see,
 So long lives this, and this gives life to thee.
Sonnet

Ben Nicholson, 'Cumbrian Landscape', 1928. Contents of cupboard: two square dishes, French – a New Hall teapot – six Coalport plates – small square glass decanters – six liqueur glasses from Blois – cups and saucers, formerly the property of the novelist George Moore.

 Don't think that I'm wooing!
Angel, even if I were, you'd never come! For my call
is always full of outgoing; against such a powerful
current you cannot advance. Like an outstretched
arm is my call. And its hand, for some grasping,
skywardly opened, remains before you
as opened so wide but for warding
and warning, Inapprehensible.
 Rainer Maria Rilke, last lines of the Seventh of the *Duino Elegies*

Thoughts

The sacrament of the present moment. De Coussard

The Adversary's question becomes the opportunity of learning. St Augustine

Our tears are God's joy. Anon.

Put thou my tears into thy bottle. Psalm 56

They that have the Gale of the Holy Spirit go forward even in sleep.
Brother Lawrence, *The Practice of the Presence of God*

For I am persuaded that neither death, nor life, nor angels, nor principalities, nor powers, nor things present, nor things to come, nor height, nor depth, nor any other creature, shall be able to separate us from the love of God, which is in Christ Jesus our Lord. St Paul

O lead my blindness by the hand
Lead me to Thy familiar feast
Not here or now to understand
Yet even here and now to taste
How the eternal Word of Heaven
On Earth in broken bread is given. William Gladstone

It is not Jesus as historically known, but Jesus as spiritually arisen within men, who is significant for our time, and can help it. Not the historical Jesus but the spirit which goes forth from Him. Anon.

. . . though we have known Christ after the flesh, yet now henceforth know we him no more. St Paul

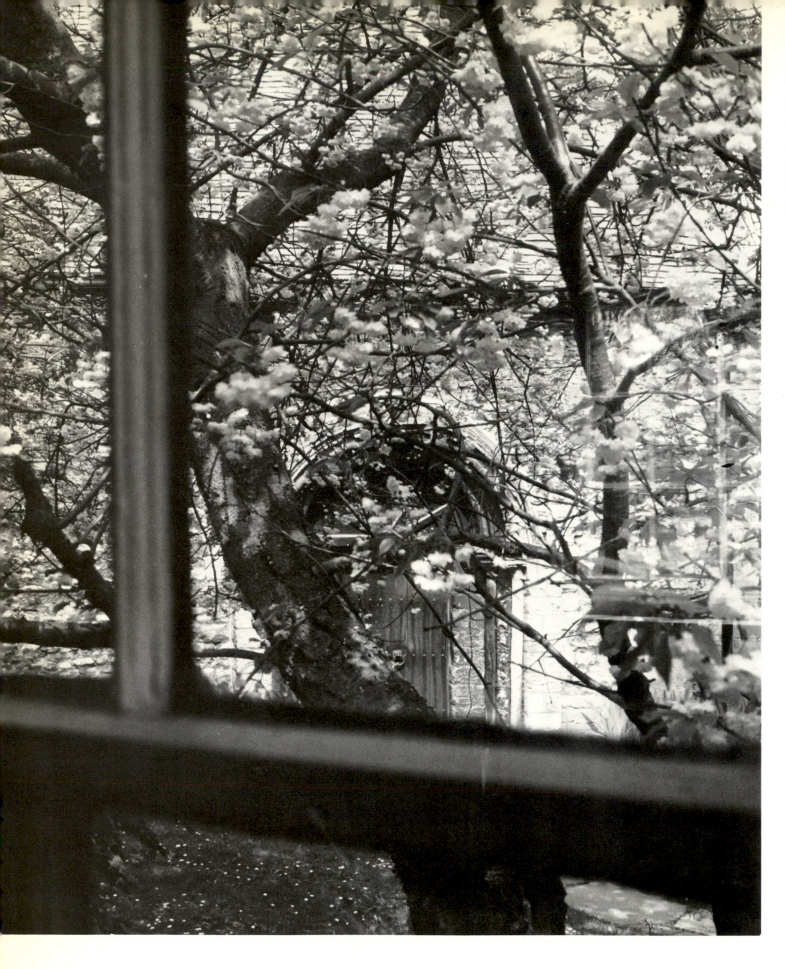

Beyond the corner cupboard and table (pp. 76 and 80) there is a second bedroom with its bathroom situated immediately above the one on the ground floor and it became for us a much anticipated joy to reach the moment when the cherry blossom in the churchyard almost thrust itself through the window.

At first we could see our way along the path leading to the thirteenth-century doorway of St Peter's Church, and then within a week all was blossom. A great marvel.

The room itself was pleasant, with windows on both sides, and another looking west through the bathroom to the setting sun.

In the skirting of the bedroom is a small door which connects with the top of a glass-cupboard in the room below; when I was on the ground floor, I had only to open this cupboard to speak to Helen Ede, who was in the upper bedroom. She could always retire into this room, and very few people visiting the house were aware of its existence.

The making of the bathroom and keeping it uncramped and even commodious beneath the steeply sloping roof was quite a feat.

I think it is important to Kettle's Yard to show that bathrooms and kitchens are incorporate with the beauty of everyday life, which as Simone Weil writes 'is rooted in the heart of man'.

In ancient times the love of the beauty of the world had a very important place in man's thought, and surrounded the whole of life with marvellous poetry . . .

Today one might think that the white races had almost lost all feeling for the beauty of the earth . . . and yet at the present time, in the countries of the white races, the beauty of the world is almost the only way by which we can allow God to penetrate us . . . Real love and respect for religious practices are rare even among those who are most assiduous in observing them, and are practically never to be found in others. Most people do not even conceive them to be possible . . .

On the other hand a sense of beauty, although mutilated, distorted and soiled, remains rooted in the heart of man as a powerful incentive. It is present in all the preoccupations of secular life. If it were made true and pure it would sweep all secular life in a body to the feet of God . . .

Moreover, speaking generally, the beauty of the world is the commonest, easiest and most natural way of approach.

Simone Weil, *Waiting on God*

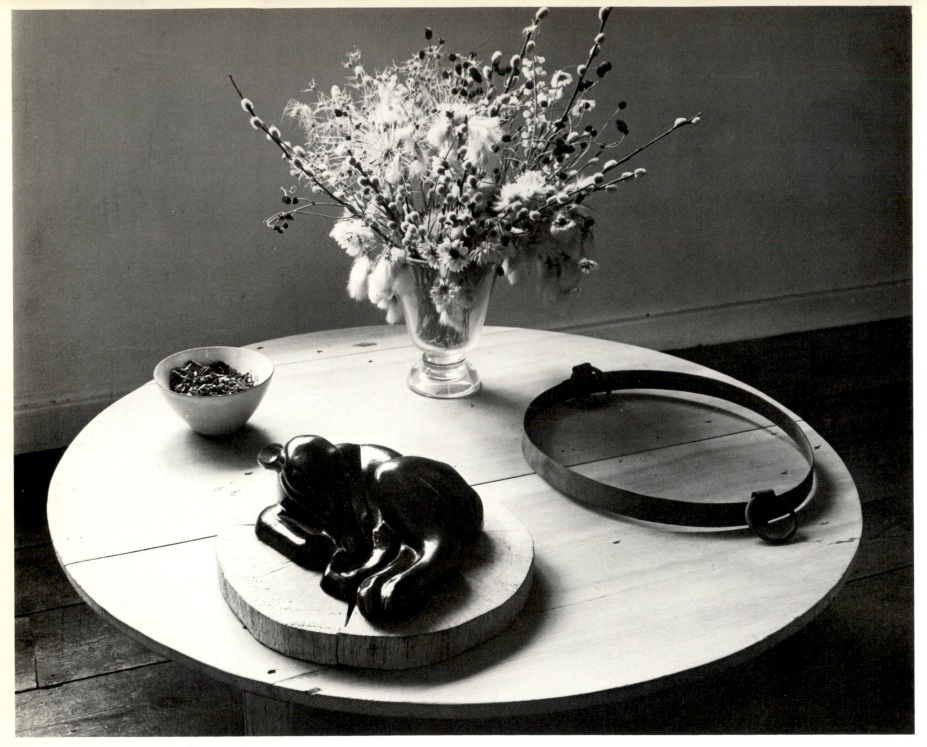

I stare and stare at this extraordinary photograph and cannot get my fill, everything in it is perfection, each object is poised in stillness, and their brilliance claps its hands for joy. Follow each shadowed form and light encircles it. Is it moonlight? The iron circle lifts to leave its shadow – which artist could place a line with such appeal? Even the 'Sleeping Fawn' will not waken from a trance so spellbound. I may have placed these things and made this bunch, tense with a celestial light, but it is the photographer who has reached and revealed this 'sacrament of the present moment' which I mention somewhere in a group of 'thoughts' and which now nudges me for recognition. How strange, I turn back three pages and find it there; 'Turn but a stone and start a wing.' In actual life I don't think that the iron ring could be left in that position – it would usurp too much table space, while in a photograph it is beyond questioning. This emphasises something which has become for me almost a rule; that each medium has its own unique way of life.

Verses written after an ecstasy of high exaltation

I entered in, I know not where,
And I remained, though knowing naught;
Transcending knowledge with my thought.

Of when I entered I know naught,
But when I saw that I was there
(Though where it was I did not care)
Strange things I learned, with greatness fraught.
Yet what I heard I'll not declare,
But there I stayed, though knowing naught,
Transcending knowledge with my thought.

Of peace and piety interwound
This perfect science had been wrought,
Within the solitude profound
A straight and narrow path it taught,
Such secret wisdom there I found
That there I stammered, saying naught.
But topped all knowledge with my thought.

So borne aloft, so drunken reeling,
So rapt was I, so swept away,
Within the scope of sense or feeling
My sense or feeling could not stay.
And in my soul I felt, revealing,
A sense that, though its sense was naught,
Transcended knowledge with my thought.

The man who truly there has come
Of his own self must shed the guise;
Of all he knew before the sum
Seems far beneath that wondrous prize;
And in this lore he grows so wise
That he remains, though knowing naught,
Transcending knowledge with his thought.

The farther that I climbed the height
The less I seemed to understand
The cloud so tenebrous and grand
That there illuminates the night.
For he who understands that sight
Remains for aye, though knowing naught,
Transcending knowledge with his thought.

This wisdom without understanding
Is of so absolute a force
No wise man of whatever standing
Can ever stand against its course,
Unless they tap its wondrous source,
To know so much, though knowing naught,
They pass all knowledge with their thought.

This summit all so steeply towers
And is of excellence so high
No human faculties or powers
Can ever to the top come nigh.
Whoever with its steep could vie,
Though knowing nothing, would transcend
All thought, forever, without end.

If you would ask, what is its essence –
This summit of all sense and knowing:
It comes from the Divinest Presence –
The sudden sense of Him outflowing,
In His great clemency bestowing
The gift that leaves men knowing naught,
Yet passing knowledge with their thought.

 St John of the Cross

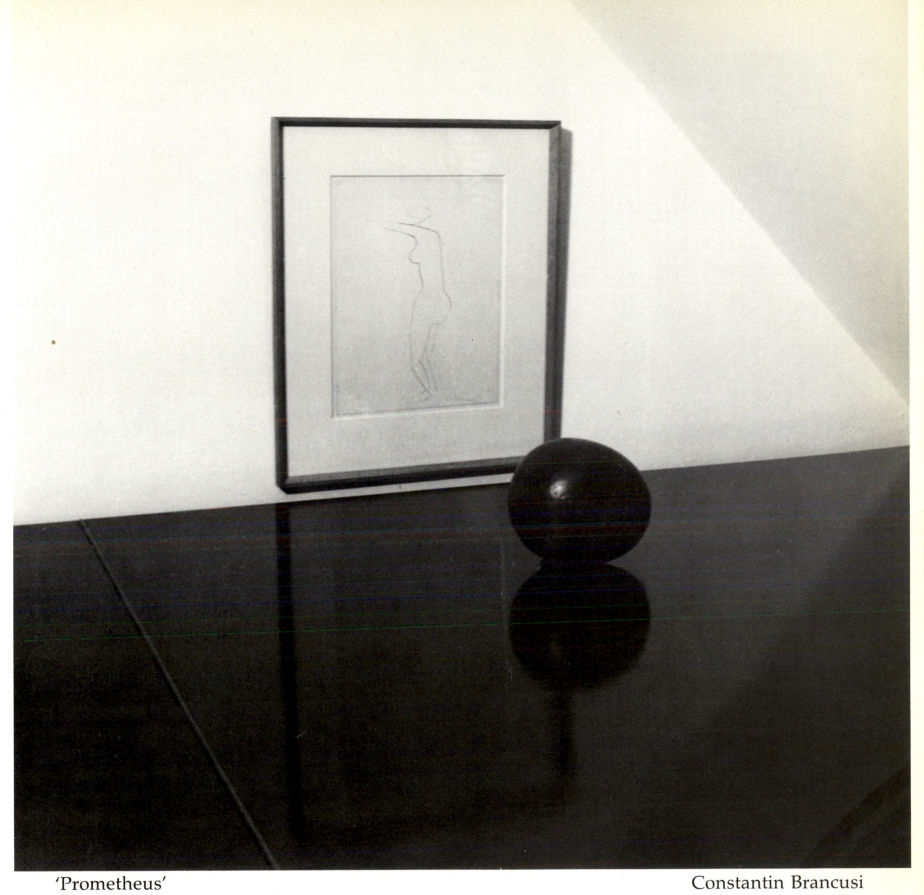

'Prometheus' Constantin Brancusi

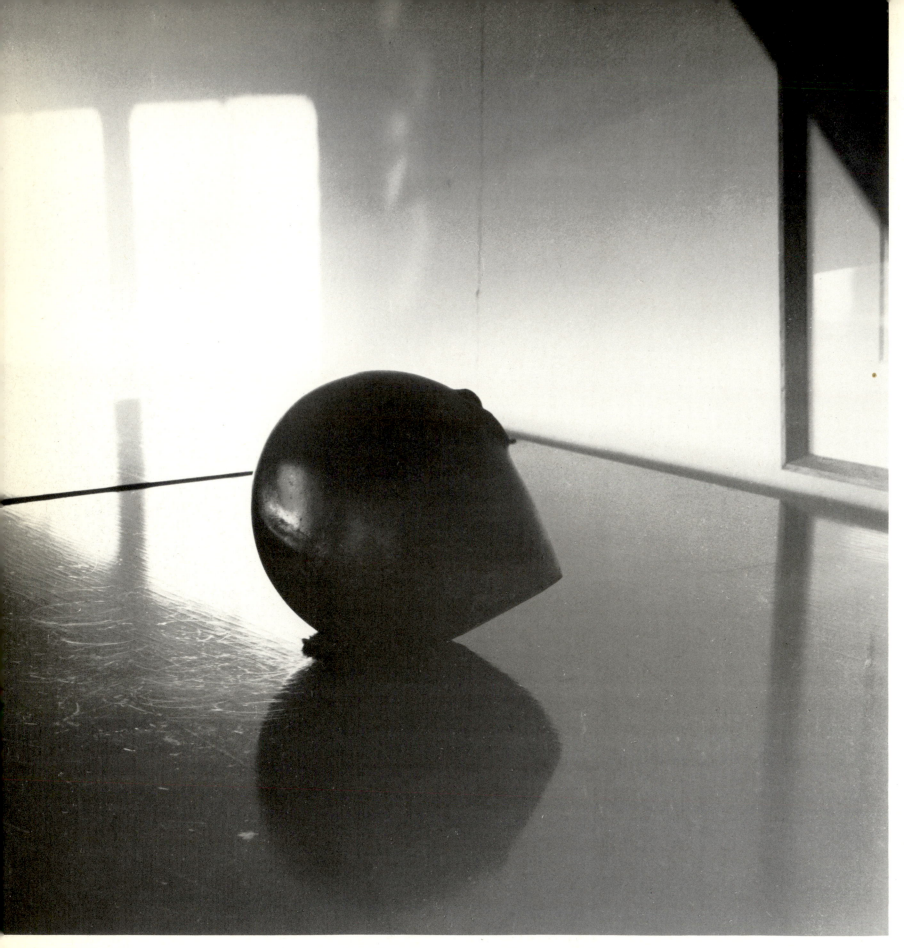

Morning

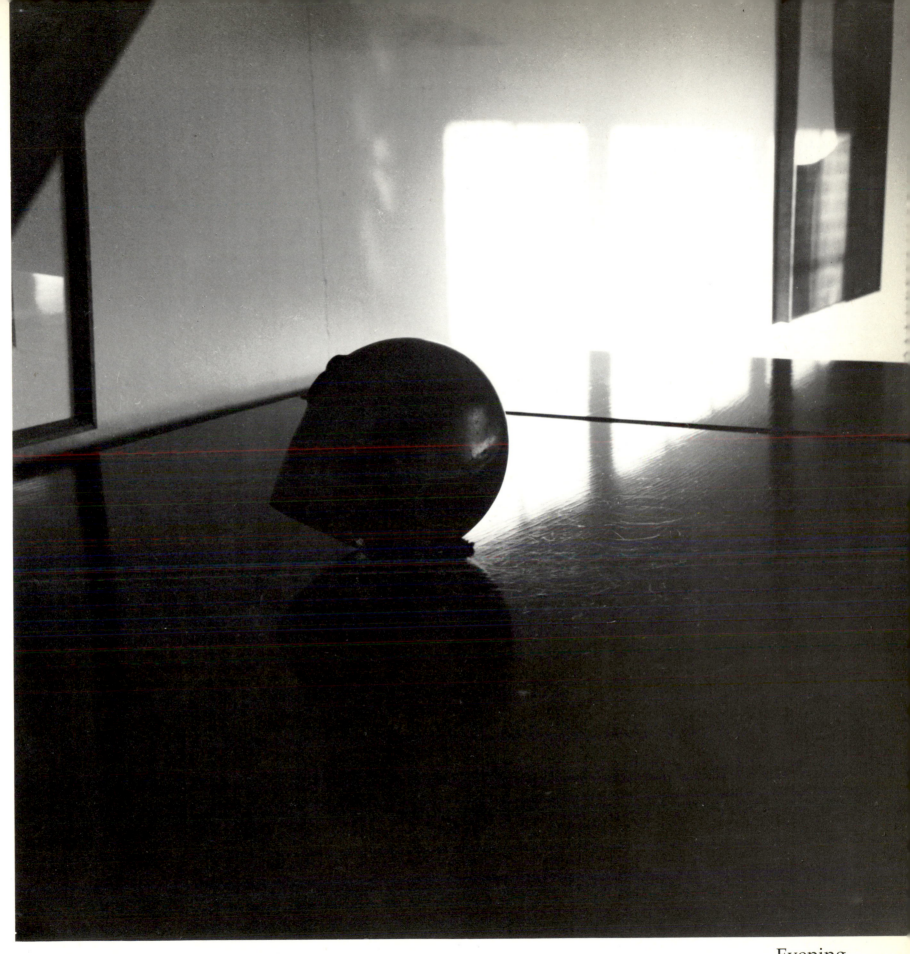

Evening

The reflection in the drawing is of the head of the stairway from the ground floor. The other stair leads to the attic devoted to Henri Gaudier-Brzeska.

A drawing by Brancusi given to me in 1926

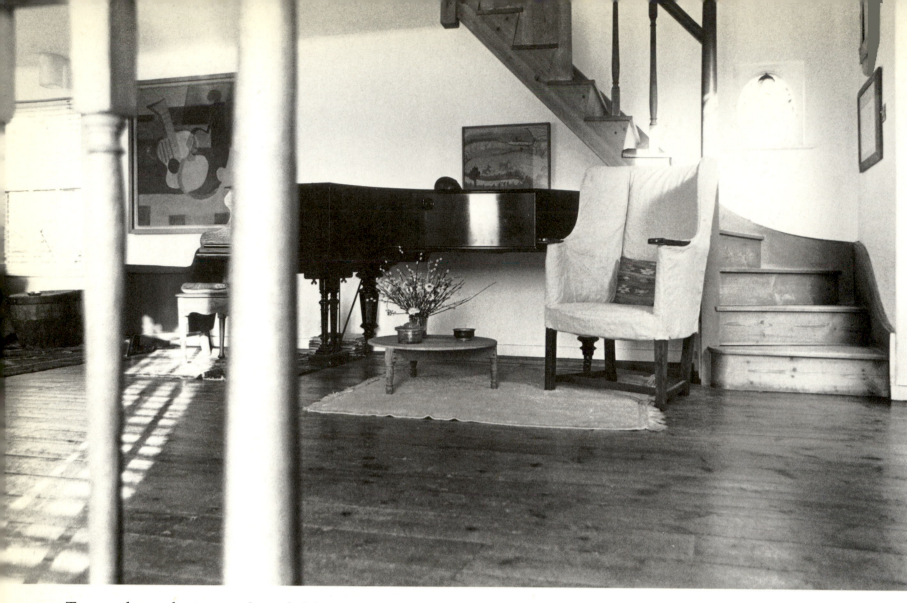

Two other photographs of this same room enthral me by their differences. Again
Eternity lies in the present moment. It is remarkable how these few thin banisters can
fill the room with space and mystery. It is hardly more than two steps from the
armchair to be across the foreground, as I can show; but what a beauty comes to life
in the continuity from one side to the other, from the dark yet light piano and the fall
of light upon the stairs to the small Queen Anne chair beyond the room. It is as
though the room revolved across the page or stretched into areas on either side.
Perhaps this is caused by the wide newel post coming in different positions.
Whatever it may be, I feel that I can walk here at my ease.

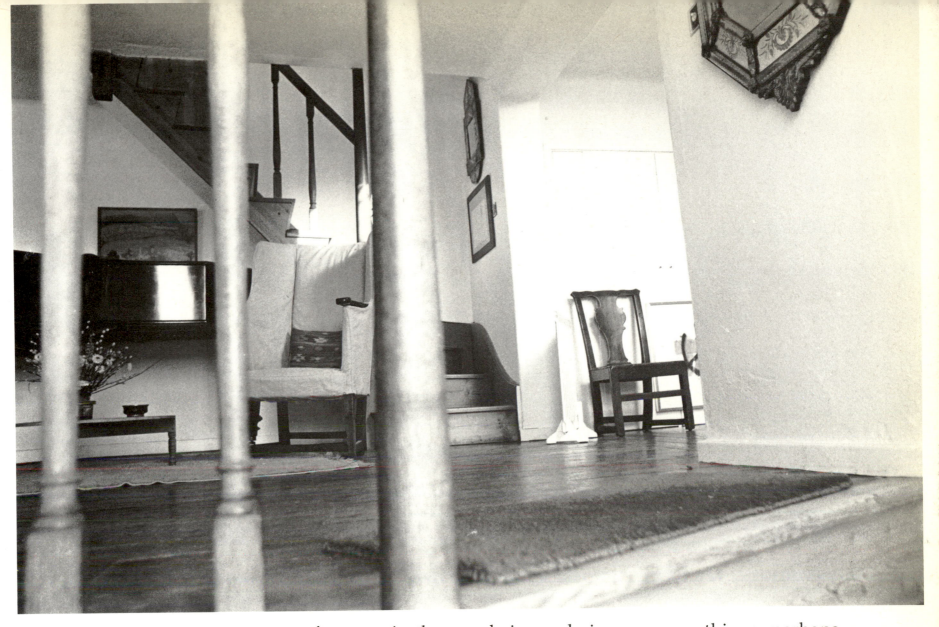

I was sitting one afternoon in the armchair pondering on many things, perhaps reciting some of the many 'thoughts' which I am entering in handy places as I go along with the making of this book; or perhaps I had fallen into sleep, but I think not, when the bell rang just below me. I sprang up and made for the stairs, all in one movement, slipped at the edge of the stairway, but managed to catch, as I passed, the floor on either side of the first banister to the left, and there hung an instant, my feet a bare six inches from the floor below, let go, turned and opened the door. 'You've been very quick', they said – the bell was still vibrating. 'You're telling me, come in', I replied. Not many answers to the bell were quite so dramatic, I am glad to say. Looking back over this constant ringing of the bell, it was always with a sense of interest and adventure that I heard its sound. The above anecdote does bring home the very small scale of this older part of the house and the skill of the photographer to make it all so large and free. These were taken some fifteen years before the next one.

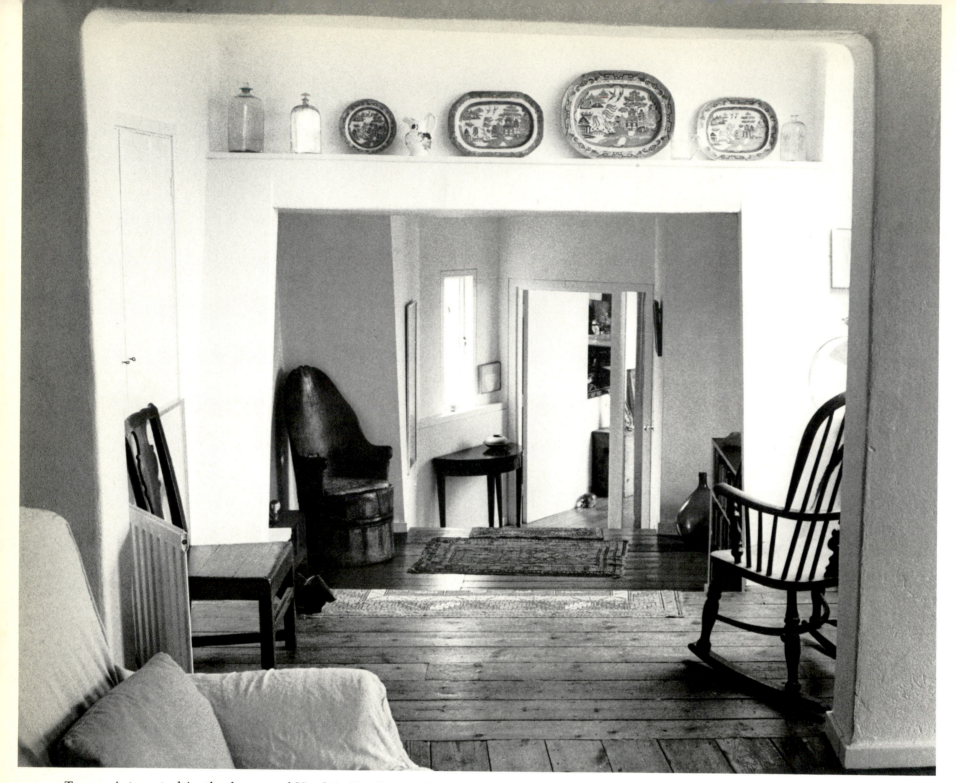

To one interested in the layout of Kettle's Yard this photograph gives a clear picture. It is taken from the first floor of the first of the three western cottages. The Bechstein is on our left just behind the armchair and there also is the small stairway going up to the attic. The immediate square opening was once the outer wall of this cottage and is above the present front door. The bridge across the outside passageway consists of the bit of horizontal flooring in front, and at the first carpet there are three steps going down through the roof of that one eastern cottage to its first floor (on the ground floor of this part we made a small guest house). When the first extension was built in 1970, we again went through the roof by going down another three steps to the small space with the semi-circular table beside the door of the extension. In the next section of this book I hope to convey something of what this small area has so wonderfully become.

The construction of this bridge was quite an adventure. As you have seen, it was needed to join the three cottages on the west of the public passageway, to the fourth cottage on the east. It seemed a straightforward business while I was planning the interior in London where we were living at the time. I had never been inside any of the cottages, nor seen through a window, for all was boarded up, so I was not hampered by the actual sordid fact of smallness and decay. All I had to do was to get a bit of squared-up paper, draw in the outside measurements and within these measurements get what I could.

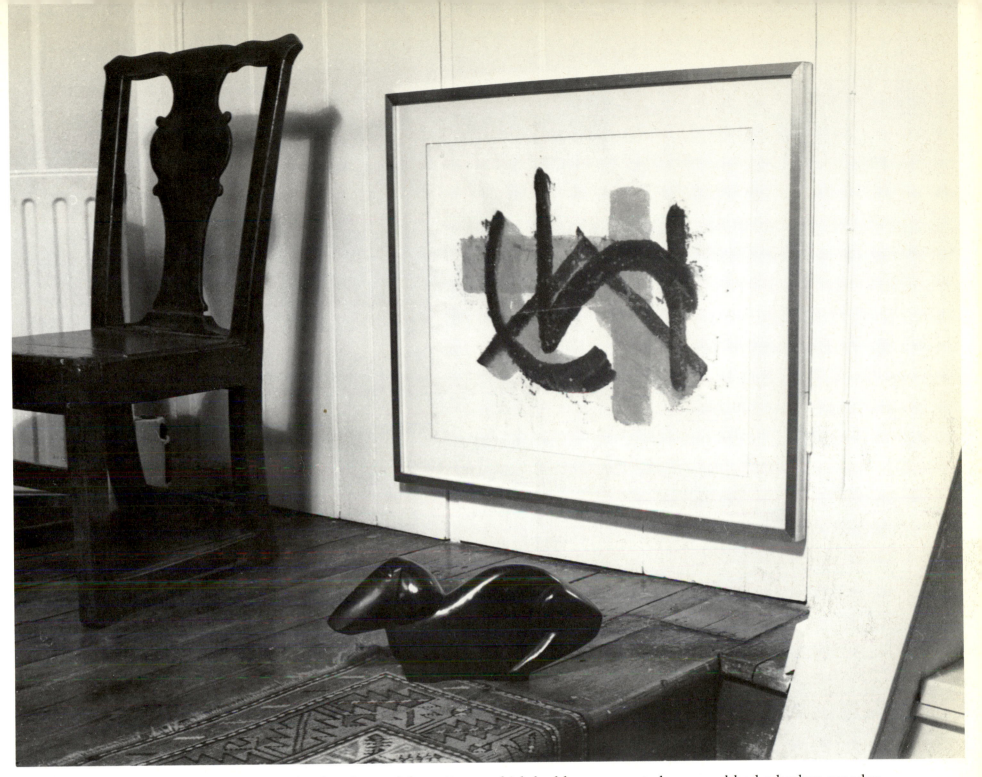

There was a little land in front of the cottages which had been cemented over and had a broken wooden fence around it. I got permission to make two bay windows, and add a bathroom. With more difficulty I achieved the circular 'tower' to hold a spiral stairway, but when it came to suggesting the bridging of the passage, I met with a stern refusal. They said there was no precedent! I soon found many, and the decision was revoked. Delays and uncertainties created a dangerous moment in the building. I wanted a rather large double-doored front door, normally only using half of it. It was to be arched and would open into the passageway. This necessitated a large hole in the side wall of the cottage – indeed it seemed to take up most of that side. Then, with permission to construct a bridge, work got a bit out of hand and a far larger hole was made in the floor above and just over the doorway, leaving a little span of rather loose rubble unsupported. A picture remains in my mind of the foreman stepping in to do the Samson act (mercifully he hadn't lost his hair) and he more or less held up the archway with his hands while workmen rushed in a few wedges and supports. I cravenly walked away: I just could not stick it. Now as you will see from the following photographs it all seems quite secure and easy, as it did when I first started to draw out the plans.

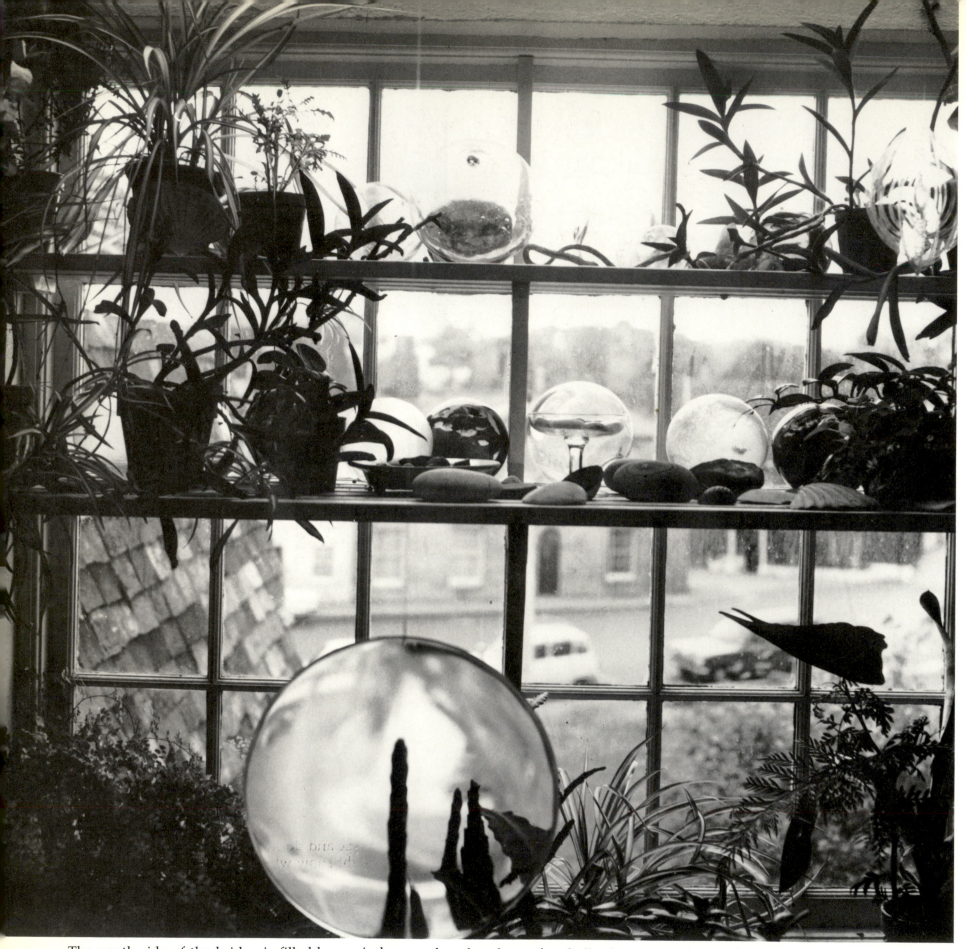

The south side of the bridge is filled by a window, a place for plants, for shells, for stones, for the hanging disc in plexiglass, and the 'spherical construction', both by Gregorio Vardanega, for fishermen's floats, those transparent glass balls for invisibly holding up the nets. They were so enchanting to find on the beaches of ▶

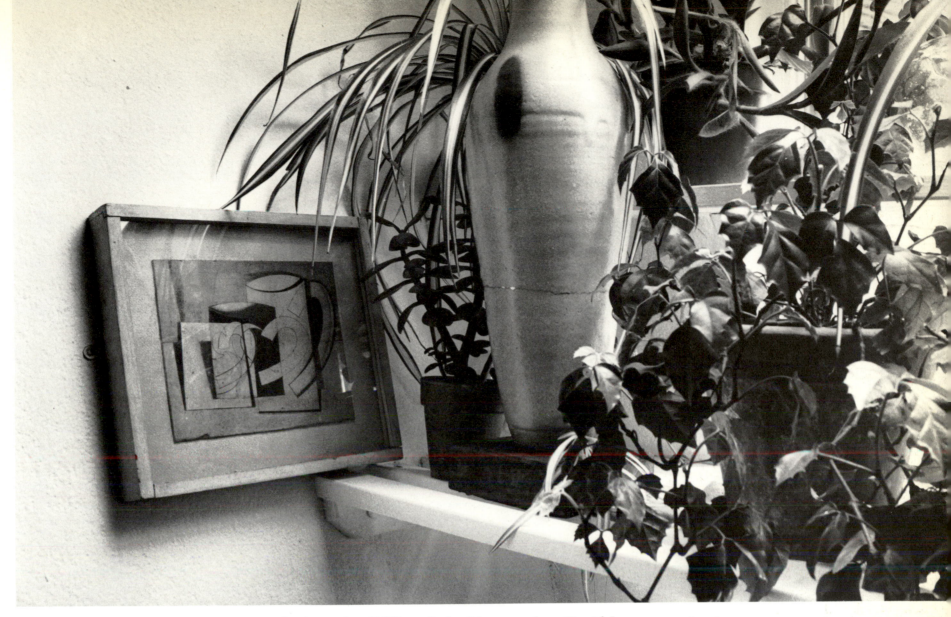

'The Heron' had just been given to me by its maker William Staite Murray when David Jones came to stay and knocked it off the window-sill of his bedroom. It was in several pieces. With much anxiety I told W.S.M., but he was delighted since it gave him the opportunity to mend it in the traditional way with gold. He had never liked to break one of his pots just in order to mend it.

The Ben Nicholson brings a most special colour and shape to Kettle's Yard, and is one of his so many gifts.

▶ the world, they were like jewels in the early morning sunlight; in Japan they were blue and got washed up sometimes on the shores of the Western Americas. Today these floats are made of plastic and do not shine at all. In Kettle's Yard the glass ones still shine and are harmonious objects against the light snow which falls outside. This is an interior which looks into the outer world and has for me a transparent stillness through which to find and hold a sense of peace amidst 'the manifold changes of this world'; peace which will, I hope, create a touchstone for life itself.

I was delighted to find in Paris, soon after it was made (1960), Vardanega's large disc. Even the short length of fishing gut which holds it allows it to rotate on its own for quite a while. I have often thought how excellent such a disc, perhaps twice as big, would be, hanging over the baptismal font in Coventry Cathedral, catching all the varied colours of the windows. With this great distance from ceiling to font, a fine line would probably allow perpetual movement of a still nature.

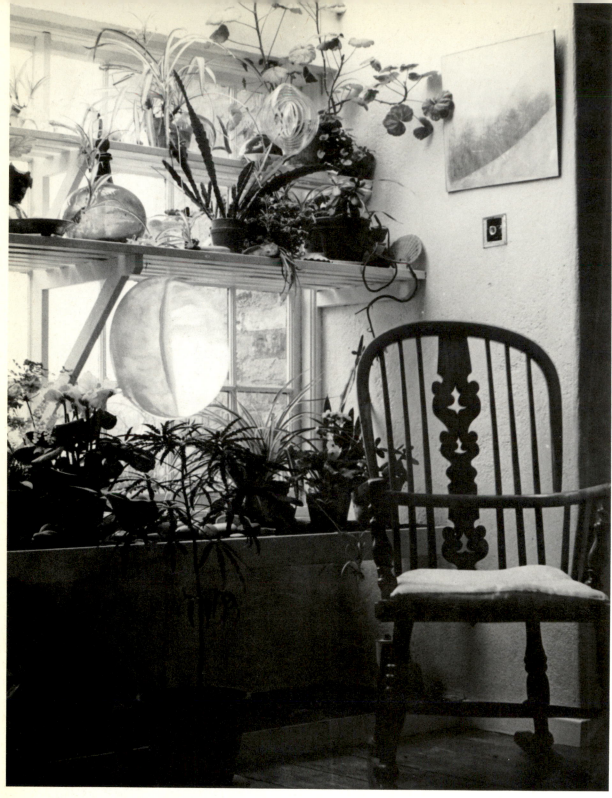

If the lost word is lost, if the spent word is spent
If the unheard, unspoken
Word is unspoken, unheard;
Still is the unspoken word, the Word unheard,
The Word without a word, the Word within
The world and for the world,
And the light shone in darkness and
Against the World the unstilled world still whirled
About the centre of the silent Word.

O my people, what have I done unto thee.

Where shall the word be found, where will the
 word
Resound? Not here, there is not enough silence
Not on the sea or on the islands, not
On the mainland, in the desert or the rain land,
For those who walk in darkness
Both in the day time and in the night time
The right time and the right place are not here
No place of grace for those who avoid the face
No time to rejoice for those who walk among
 noise and deny the voice.
 T. S. Eliot, *Ash Wednesday*, 1930 (excerpt)

This Elisabeth Vellacott was the first of her works which I
acquired, perhaps in 1960. It was a great joy to me to find an
artist who could leave untouched a large area of paper and yet
keep it full. Never in the drawing itself does her paper become
empty, so subtly does she approach it with her pencil. No
photograph could realise this.

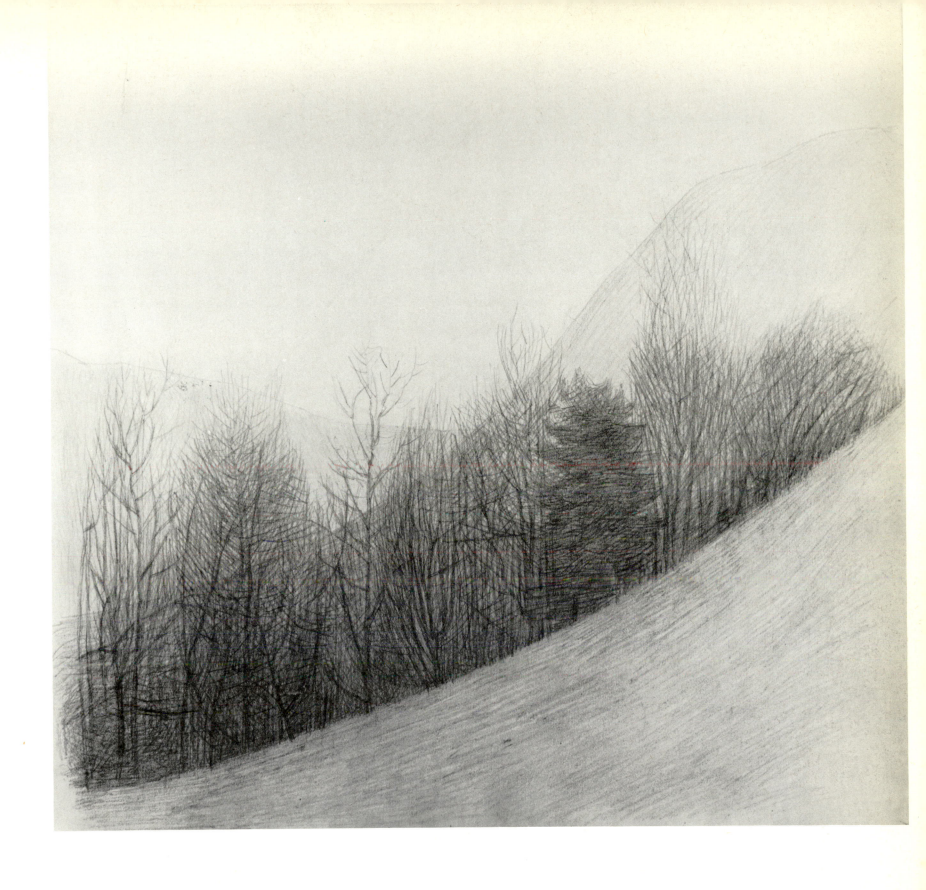

Elisabeth Vellacott

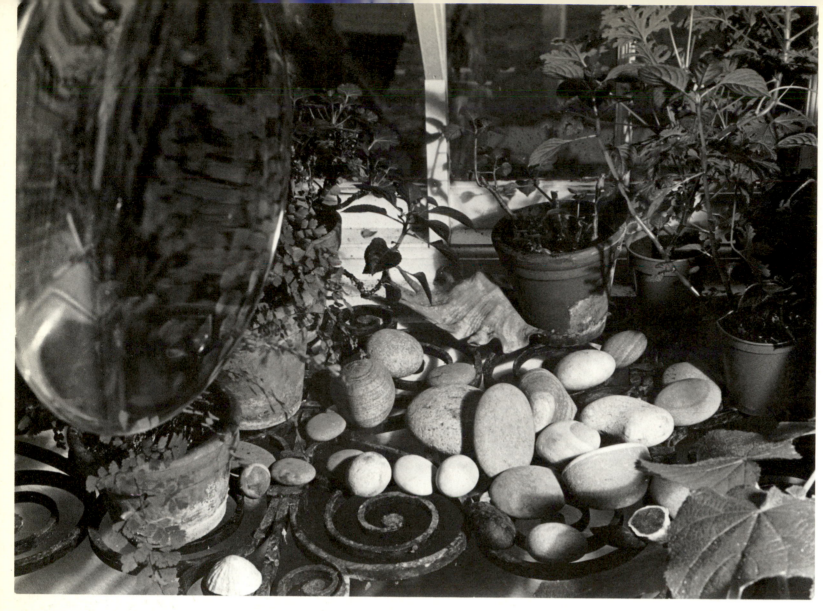

The wrought iron
under the pebbles
came from the main
staircase in 'Rance's
Folly' (Cambridge).
 The plexiglass disc
is by Gregorio
Vardanega, *c.* 1960,
already mentioned.

Is nothing less than nought?
Nothing is nought
And there is nothing less
But something is, though next to nought
That a trifle seems
But such am I.

Yet man no trifle is
Born an immortal soul
That cannot die to nothing,
Nor yet be nothing.

That soul is man
Born not of the dust
Nor yet to dust returns.
But born of God, eternal as his sire
Living forever
An immortal soul.

John Clare

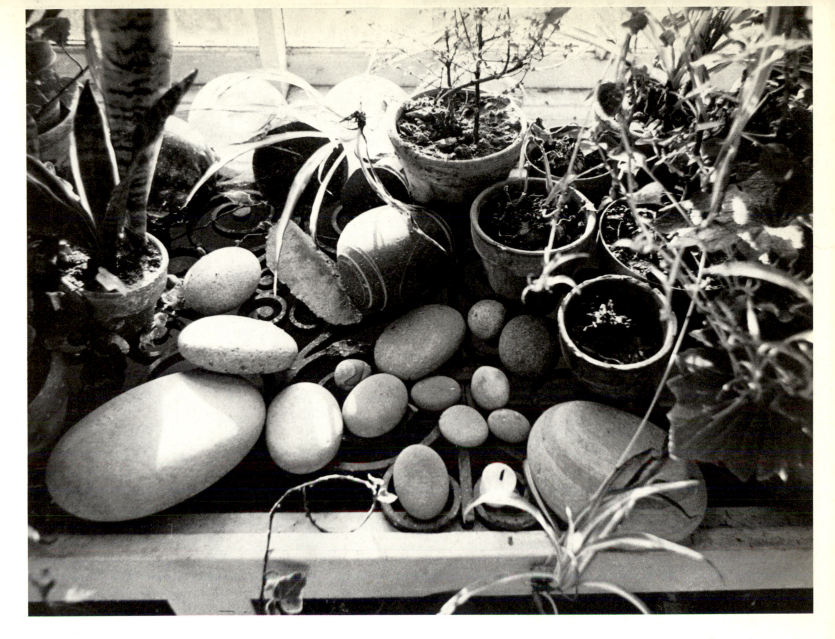

My spirit longs for Thee
Within my troubled breast
Though I unworthy be
Of so Divine a guest.

Of so divine a guest
Unworthy though I be
Yet has my heart no rest
Unless I live with thee.

Unless I live with thee
In vain I look around
In all that I can see
No rest is to be found.

No rest is to be found
But in Thy blessed love
Thou art indeed the Ground
Whence comes that Heavenly Dove.

John Byrom, 1692–1763
(*The last two lines are altered*)

Song of the soul in rapture at having arrived at the height of perfection, which is union with God by the road of spiritual negation

Upon a gloomy night
With all my cares to loving ardours flushed.
(O venture of delight!)
With nobody in sight
I went abroad when all my house was hushed.

In safety, in disguise,
In darkness up the secret stair I crept,
(O happy enterprise)
Concealed from other eyes
When all my house at length in silence slept.

Upon that lucky night
In secrecy, inscrutable to sight,
I went without discerning
And with no other light
Except for that which in my heart was burning.

It lit and led me through
More certain than the light of noonday clear
To where One waited near
Whose presence well I knew,
There where no other presence might appear.

Oh night that was my guide!
Oh darkness dearer than the morning's pride
Oh night that joined the lover
To the beloved bride
Transfiguring them each into the other.

Within my flowering breast
Which only for himself entire I save
He sank into his rest
And all my gifts I gave
Lulled by the airs with which the cedars wave.

Over the ramparts fanned
While the fresh wind was fluttering his tresses,
With his serenest hand
My neck he wounded and
Suspended every sense with its caresses.

Lost to myself I stayed
My face upon my lover having laid
From all endeavour ceasing:
And all my cares releasing
Threw them amongst the lilies there to fade.

St John of the Cross

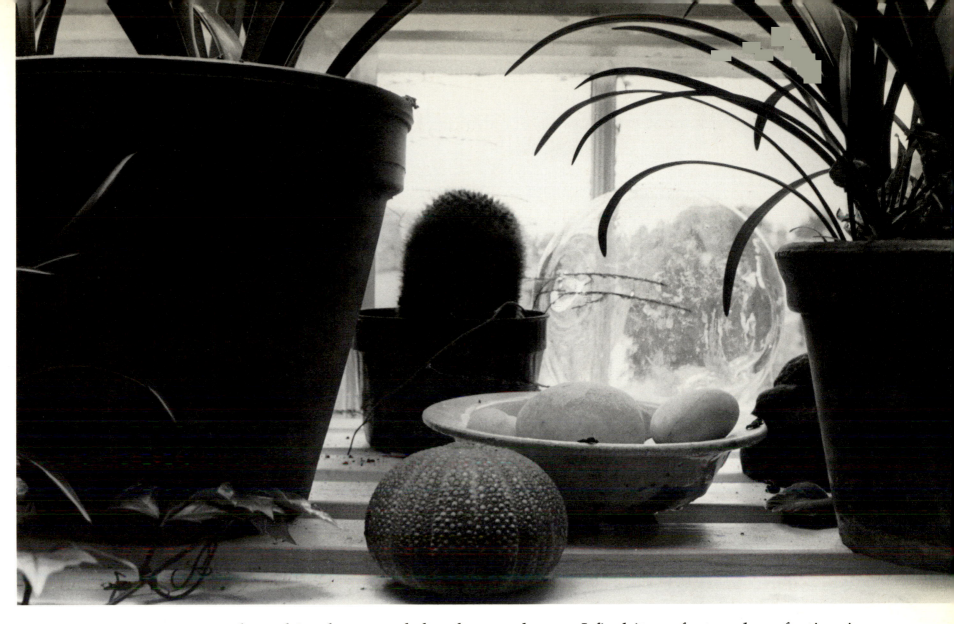

For many days this photograph has haunted me – I find it perfect and perfection is a challenge. I could surround it with Roy Campbell's translation of St John of the Cross's poem 'Upon a Gloomy Night' and say no more. Such poems were my companions while Kettle's Yard was being formed, and little did I guess that they would come back to me in concrete form. Here is life and light creating its own Way. The path between the pots, leading to space untold, is in itself monumental. I like to think that we who live in darkness may escape into a light which is still darkness but which will seem, through beauty, to be light itself.

There is here thought within thought – a moment of Eternity which is Eternity. We are such stuff as dreams are made on, and the world beyond the window pane eludes our solitude.

These stones folded within my hand so long ago, now lie in a dish given to me by a young potter striving to achieve – he gave me three and I have forgotten his name – I think he was in Bernard Leach's studio, residing in St Ives. That was probably fifty years ago and his gift my introduction to the art of pottery.

The fisherman's float which collects light and holds it, is large; it becomes almost invisible and these quite solid leaves do homage.

Interlude III.
à la recherche

From the time Kettle's Yard was first opened, towards the end of 1957, until shortly
before the first extension of the house was officially opened, together with an
extension for loan exhibitions, in May 1970, the attic was both surprising and
exciting. Not only did our grandchildren sleep up there, but it housed nearly all the
pictures and sculpture now in Extension I. It was quite an Aladdin's Cave.
Sometimes paintings had to be placed three deep around the walls. Somehow all in
all there were quite a few over 400 up in this attic, 50 being readily available to
visitors; the rest could be rummaged for. It surprises me from these photographs of
1967 how tidy I managed to keep it. As I look around I see that everything is now
elsewhere. It interests me to see how quickly I can tell where each thing is. In 1969 I
made a radical alteration by devoting this whole area to the work of Henri Gaudier-
Brzeska. It had already taken me over 40 years to arrive at this, I hope, coherent
selection. The attic became an Art Gallery within the house, visitors had no need to
go up to it unless they were interested, and if they were they were welcome and had
the unique chance of seeing some 50 to 60 of his best drawings, from all periods of
his short life, and with the drawings a dozen casts of different works by him.

It was in about 1963 that I was informed from Paris, that if I could supply enough of his work, the Musée National d'Art Moderne would devote a room to it in perpetuity.

This became the reason for making several casts of his work, the sale of which would enable me to buy some originals for France. In this way I bought from Yale University the superb marble carving 'Seated Woman', and elsewhere 'Maternity' also in marble, and with these gave them, as well as the Tate Gallery, casts of each work that I had had cast, 10 or 12 (I have no longer exact dates or numbers. These will be in the Kettle's Yard archives).

At about the same time that all this was happening, there came an historic day, and one most joyful for me. The Director of the Musée National d'Art Moderne came over to select 32 drawings, engravings, pastels etc., from my reserved collection of Gaudier-Brzeska's best work. We chose them turn and turn about. We tossed a coin for which of us should have first choice and I lost.

All this happened at the table above and in this attic, and in 1965 a room was opened in Paris called Salle Gaudier-Brzeska. I was thus able to achieve for him the

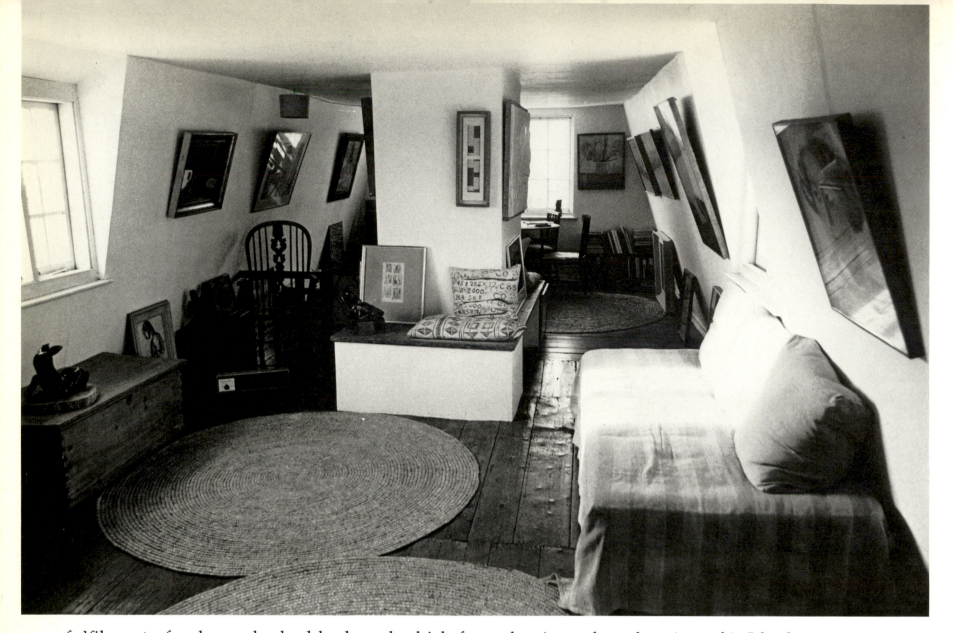

fulfilment of a dream he had had, and which from the time of my hearing of it I had longed to bring about. In a letter to Miss Brzeska he had written, 'I dreamed last night that I visited Paris and I came to a room where my name was written in letters of gold, over the door. I went in and there found all my works, so you see Sisik I will one day be a great sculptor.'

The lettering was not in gold, but in black – a trifle. Now the collection has been moved to the Place Beaubourg which I have not seen. Its space is not yet the stipulated size but I am confident that that will come.

The mats above come from the foot-hills of the Riff mountains – I think they were ten shillings each in 1937. I used to enjoy this room very much. The seats on each end of the chimney held our water tanks – I brought them down from just under the roof where the water would have frozen.

Whatsoever things are true, whatsoever things are honest, whatsoever things are just, whatsoever things are pure, whatsoever things are lovely, whatsoever things are of good report; if there be any virtue, and if there be any praise, think on these things.

St Paul

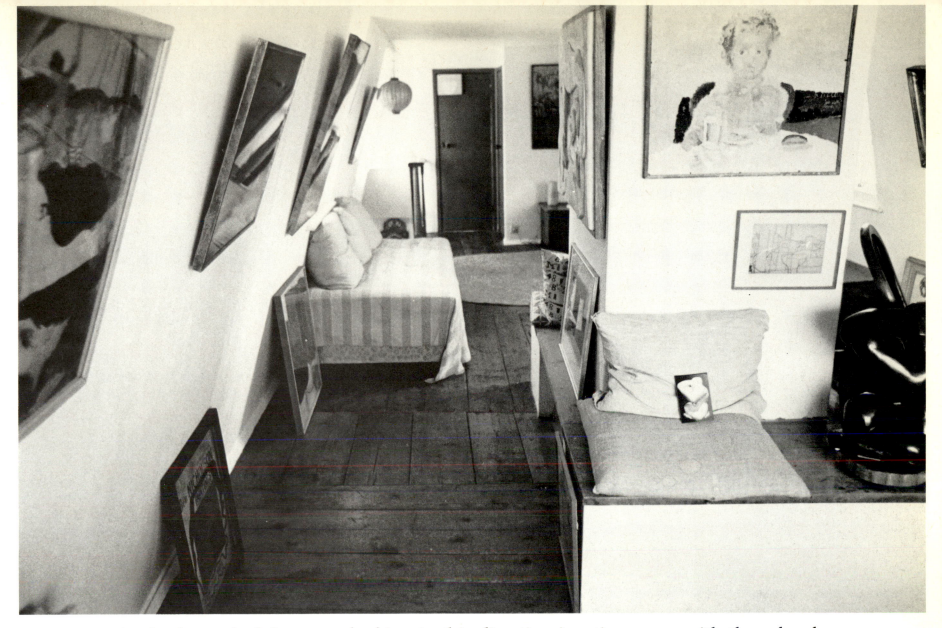

At the far end of the room looking in this direction is a tiny room with three bunks. It was here the grandchildren slept, with a basin and lavatory (*tous les conforts*) and it was here I had to keep all the pictures which got lent to undergraduates. It was a happy and a simple life. I apologise for the postcard of the marble 'Seated Woman'. I must have kept one, probably under the cushion, to compare it with the bronze, which can almost be seen on the right.

End of Interlude III

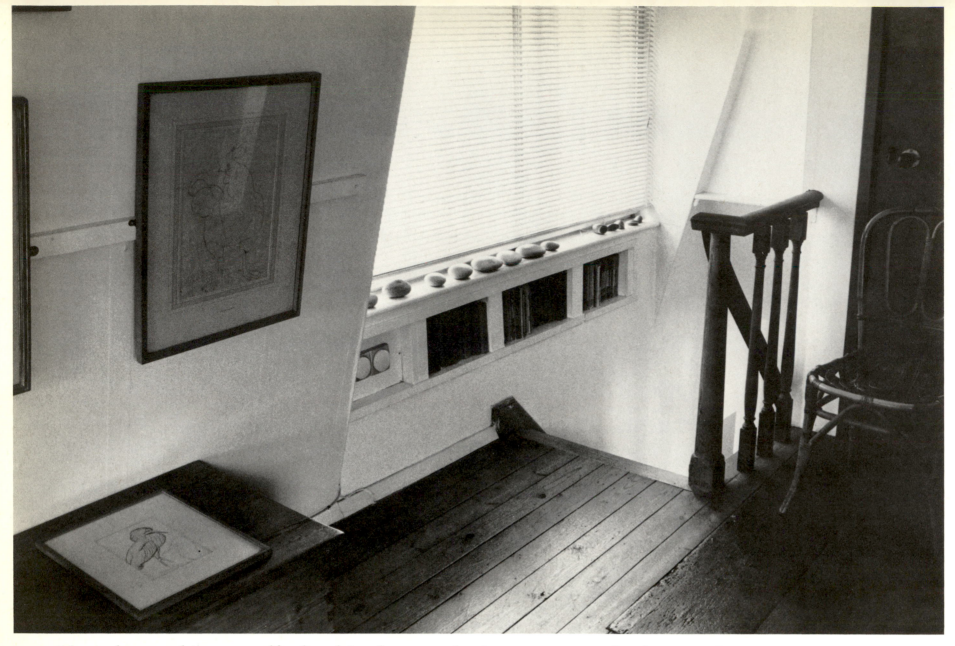

I have been asking myself why this photograph gives me so much pleasure. It is I think exactly the sort of room I would like to have – the sense of coming up into its light, out of light into light – with all those so gently floating shadows formed within the light. The drawing lying on the chest is probably right photographically, but physically it should not be there, someone might want to sit there in order to look across at all these other things – drawings, books, and 'Embracers' given by Ezra Pound. The chair, mercifully in shadow, I would eliminate. The pebble on the left needs to join the others on the left. This corner thus becomes a place of stillness, ready to contain that phrase, perhaps the most remarkable and powerful ever to come into the English language: 'Be still and know that I am God.' Eight words only but holding everything. I search always for this stillness, which penetrates our fullest activity and even our sleep. I at once think of two statements, one from *The Practice of the Presence of God*, 'They that have the Gale of the Holy Spirit, go forward even in sleep', and the other from St John of the Cross, 'Full well I guess from whence its sources flow', and in the Psalm itself, 'There is a river, the streams whereof shall make glad the city of God.' All are pointers to a full life, the pattern of which Kettle's Yard would fain follow.

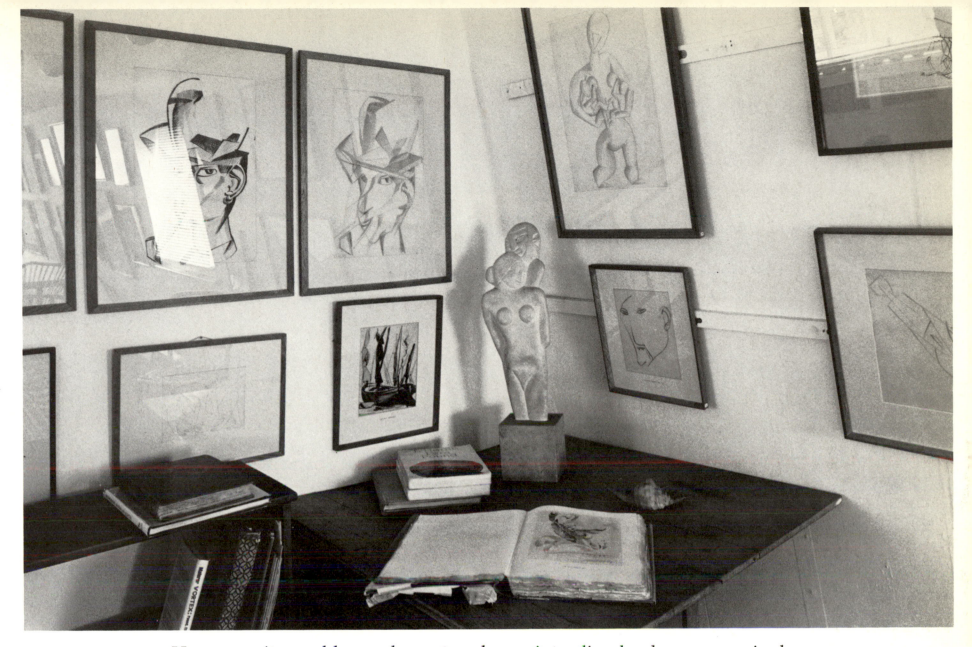

Here serenity could soon be restored – an intruding bookcase, seemingly more important than the drawings, can be altered and go elsewhere; the table flap can then be lifted, giving proper room for a book to be looked at with ease and safety from the comfort of a chair. Things on the table would not be crowded. The book across the corner of the table is *The Life of Henri Gaudier-Brzeska* and obviously Kettle's Yard needs another! I share these things with the reader who like myself may wish to get things right.

While thinking of this marvellous collection of drawings sprung from so hazardous a life, both for Henri Gaudier and for his friend Miss Brzeska, it would be good to leave it with a memory of happiness. I don't know where the account comes in the *Life*, but in the paperback *Savage Messiah* it is on pages 146–7.

'They had decided to spend the day in Arundel Park; outings of that sort were rare in their lives. It started badly and by midday they had had atrocious quarrels, Miss Brzeska was left alone – Gaudier trudging far ahead. He looked back and saw her in her trouble, and suddenly rushed to help her.

' "Zosik, darling, don't let us quarrel; we're only tired and hungry; let's be happy! We're a couple of queer fish – but it's quite natural – artists can't have the same nature as common bourgeois folk. We are capricious and proud and it makes things harder – don't you think so, Sisik?"

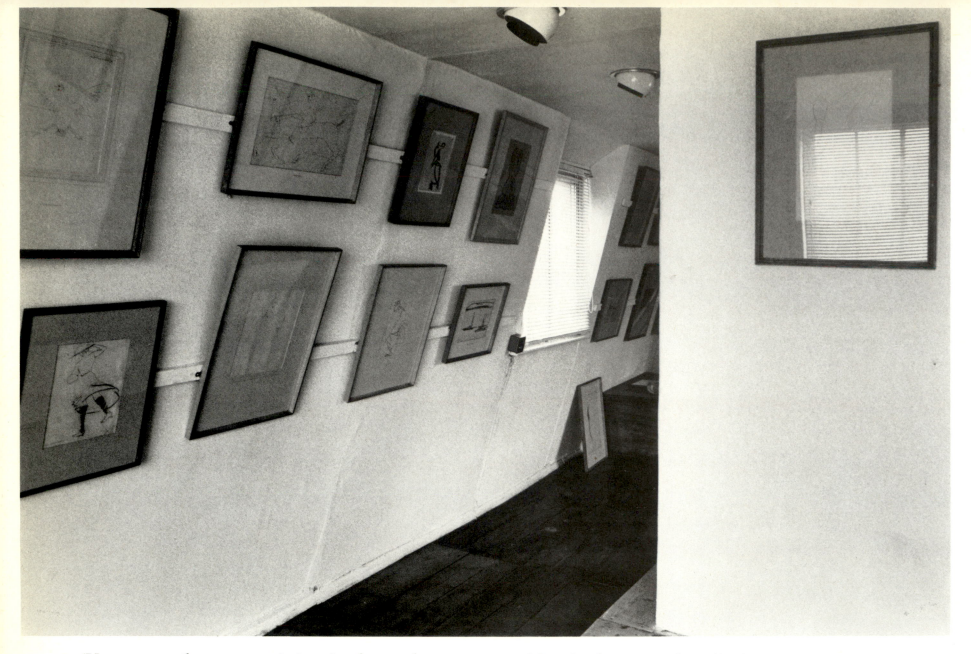

'Very soon they were sitting in the park, transported by the beauty of it all; the lake and the hills with woods spread over their slopes. They took off their shoes and stockings so that the sun might warm them better, and they ate their lunch among a flock of peacocks, which took food out of their hands. Later they found a crystal stream and refreshed themselves with its bright cold water. It was one of the happiest days they had ever had, and in the evening, as they left the park, they watched the deer on the hillside.

'One big stag was calling deeply and beating the branches of trees and the long grass with his antlers. Zosik was frightened, but Pic told her that it was the setting sun that gave him this longing. They followed him at a distance, and he looked magnificent with his great antlers sweeping the air and his rich colour outlined against the green of the hillside. He went over to a group of does who were feeding with some young stags nearby, and the young stags fled before so regal an approach, while the does allowed themselves to be driven, like sheep before a sheep-dog, into a small, wooded enclosure, where the royal stag would make love to them through the night. 'Many of Gaudier's best drawings (Kettle's Yard has one) and two pieces of sculpture by which he is usually known are the result of this vision of deer, and it was with joy in his heart at so pleasant an experience that he returned to London next day, leaving Zosik to stay on for a week or two more.'

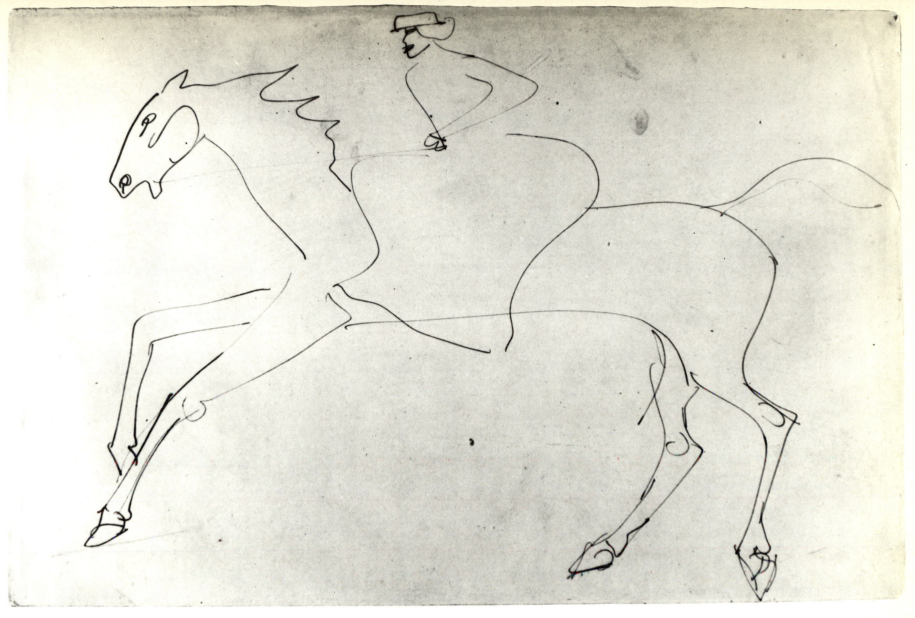

Gaudier-Brzeska as a draughtsman is superb. He has a swiftness and a certainty achieved by few. His subjects reach with ease and avoid with ease the full range of his page. Because a hoof or a tail touches the edge, and a hat sails past unhindered, it must mean that he has a complete control of his space – as a good motorist has of the width of his car. Such a drawing is instantaneous. Such a drawing as this was nine years before Picasso's, with similar use of line. Leonardo sits down to a drawing, it is within its period; Gaudier takes it on the wing and it is new.

He did a series called 'Rotten Row' of riders in the park, which at the time were food for ridicule, but now speak his genius across the world.

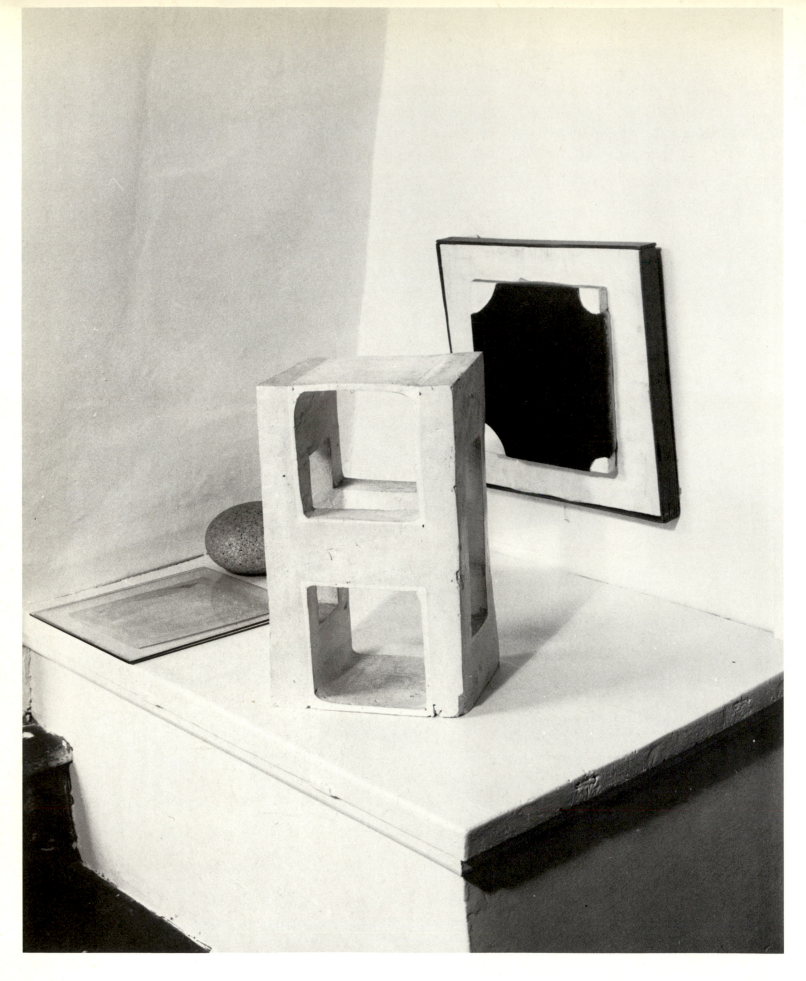

I have always thought that this 'construction' by Michael Pine would make a remarkable skyscraper. Its base might measure 80 ft by 70 ft, it would be made of glass or whatever appropriate material there now is, so that its face on any side not perpendicular, would catch large areas of reflected light. The four supporting columns would contain garages in one, plumbing in another, garden and other refuse in a third, and up or down rooms in the remaining one. There could be large double-storey living-space in the cross-sections and herbaceous gardens for each apartment. Trees could grow within its space and birds could fly through the building. It would accommodate itself to varied sizes of available land.

I enjoy it as an object in itself and it was perhaps inspired by proximity to Ben Nicholson in his St Ives period where they both lived.

The picture on the wall is a construction in lead, by John Blackburn.

It might be thought simple to make a sculpture like 'Dog' by H. Gaudier-Brzeska, but so far as I know no one had done so in the whole world of sculpture, nor is it like any other sculptor's work. It is essentially sculpture and at the same time is deeply realistic. I have known a child take it to bed instead of his 'Teddy Bear'. This might seem derogatory but it is not. It was carved direct in marble and demonstrates his famous 'planes' written about in Biographical Notes at the end of this book.

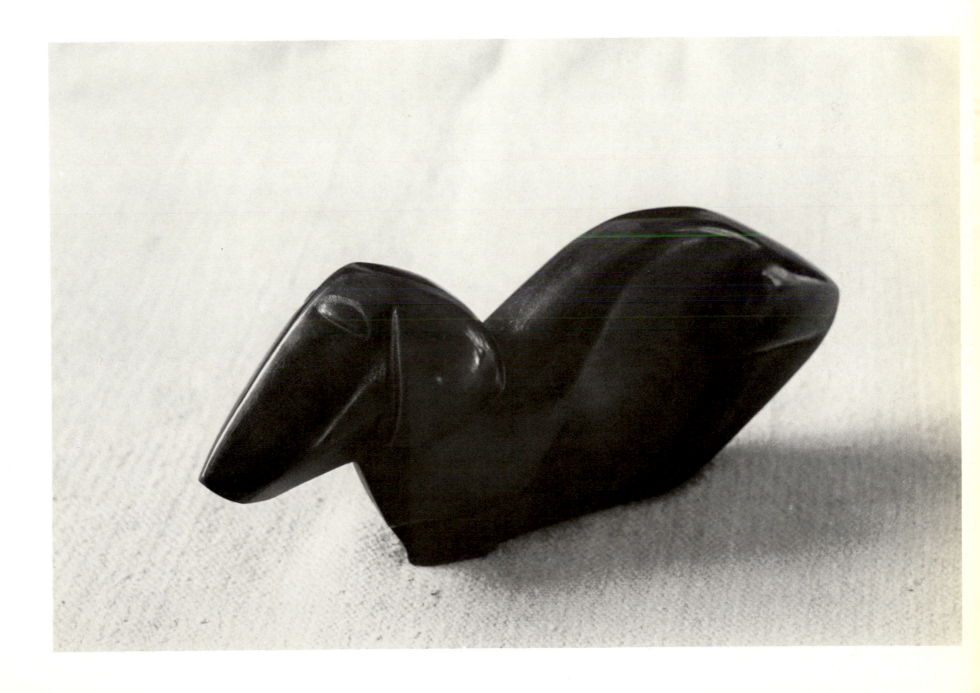

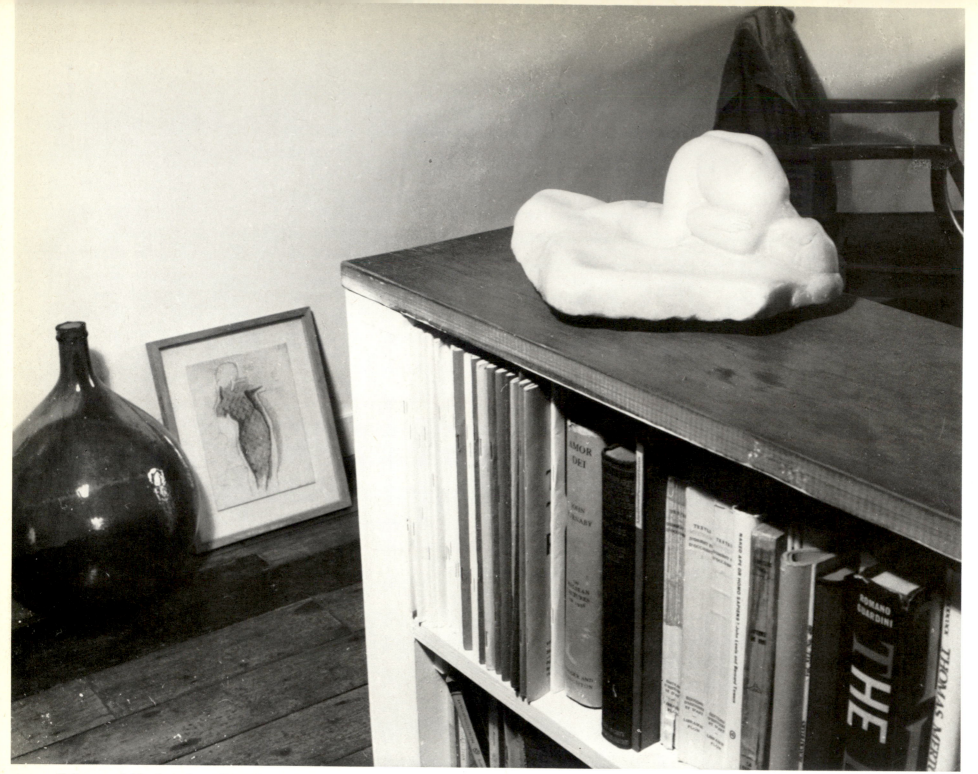

'Mermaid' also by Gaudier-Brzeska is an example of his total dedication to sculpture as something separate from subject; and though he was devoted to Rodin he did not make Rodin's mistakes. Rodin's 'Danaïd' must have been in Gaudier-Brzeska's mind, but a simple trick of the imagination will show the difference. Think of pushing a pin into Gaudier-Brzeska's 'Mermaid', there would be no reaction, all is marble, while with the Rodin, which is more woman than marble, she might scream!
Gaudier-Brzeska had long learnt the lesson that his medium must live as medium and that whatever form he used must comply with the nature of that medium. Rodin tried in his 'Danaïd' to make a naked woman lying on marble; most uncomfortable – while Gaudier-Brzeska's is all marble with no conflict.

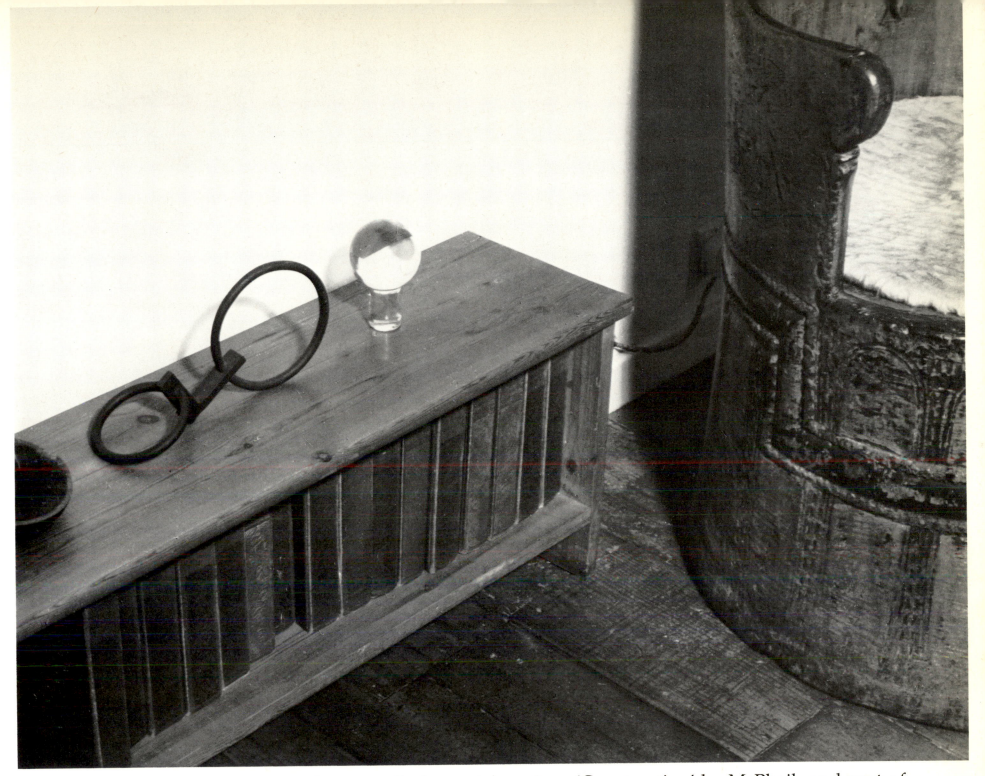

This shows a fortune-teller's crystal, an iron 'Construction' by McPhail, and part of an ancient Norwegian chair cut entirely in one piece from a tree, the bottom part of the chair being the upper part of the tree. I was told that such chairs are listed in some book in Norway. The collection of books are the works of Henry James, a great comfort to me when I was seventeen and in the war to follow and until I became too busy with Kettle's Yard.

The subtle light caught in these two photographs emphasises the variation of light and shade so often experienced when going from one area to another in Kettle's Yard.

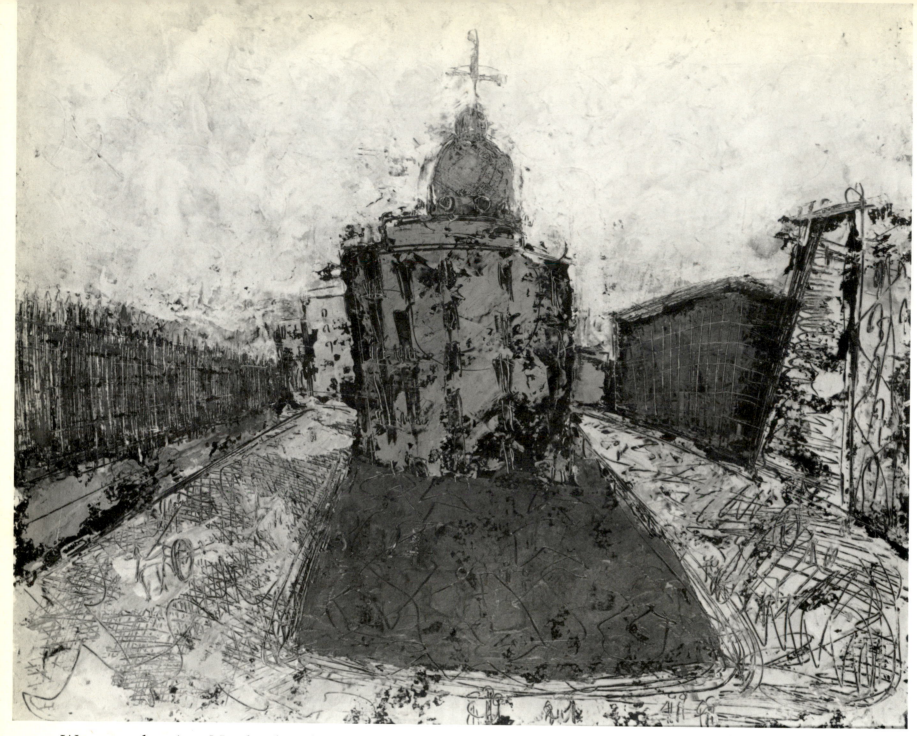

We were leaving Naples by ship and suddenly we turned a corner, on our way to the docks, and were in this picture – only this little church remained. I had thought these shapes on either side were Congdon palaces, but found the rubble of slums and a roughly made wire fence closing off the dock where our ship lay.

Congdon has this power to use his darkness to form light. Here you can walk unhindered through shadows, remaining always in that same air which permeates both land and sky. Congdon is expert in achieving calm through a frenzied activity; he paints with vigour and simplicity; sometimes his paintings are drawings in fluid paint, but always they create an unforgettable reality. It is the painting I remember rather than the place. It is a case of the artist's inner fire, blending nature and his experience, to his own unique form.

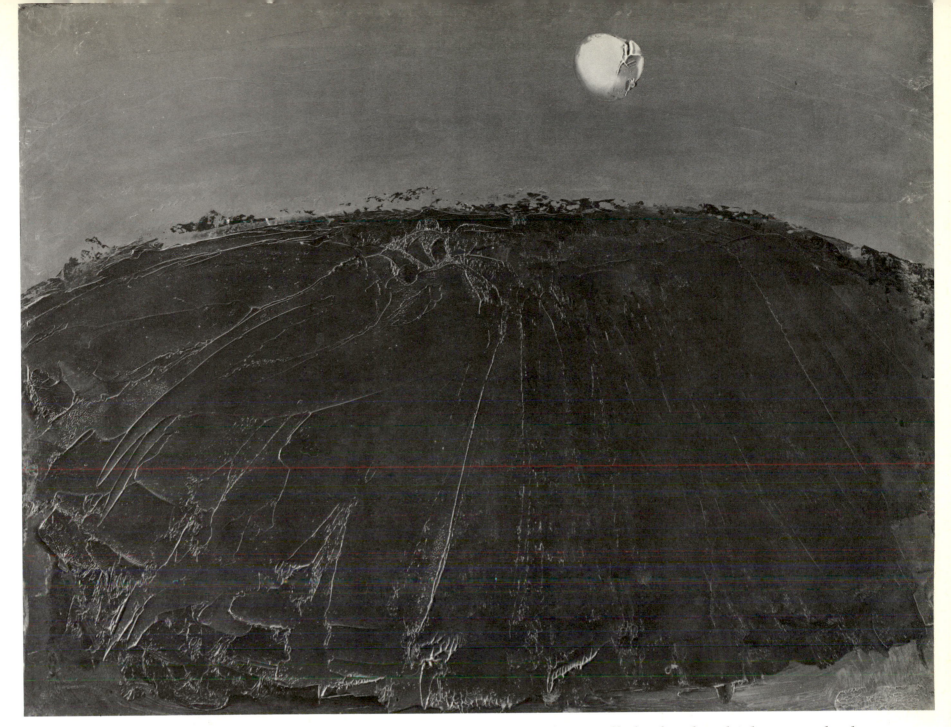

In 'Subiaco' a moon so pale and so green irradiates all the land, which none the less remains in darkness. It is the artist's gift to find this light that 'shineth in darkness'. It is an intensely realistic painting – I walk through the woods and feel the warmth and the steepness of the hills, and know of water. As I look at the moon in all this obscurity which it illumines, I feel, almost as I look, that it grows brighter, so much so as to be blinding. It might be the coming of the Lord.

I hear that someone writing in America, likened it to the Eucharist bringing order into our waywardness. In such a painting as this, one knows full well that there is light and clarity beyond our density. Congdon is often repeating this. In this painting the whole of his sky is awash with light made by that elusive and yet so dominant moon.

This is another of Nicholas Mackenzie's photographs and shows a carving in alabaster by his father George Kennethson. It can be seen already here how closely the life of Kettle's Yard touches, from a material point of view, the life outside. The renovated cottages opposite are just across the street, and yet Kettle's Yard holds its own quiet and lorries pass by unheard.

. . . O sleep, O gentle sleep
Nature's soft nurse, how have I frighted thee,
That thou no more wilt weigh my eyelids down
And steep my senses in forgetfulness?

2 Henry IV

The alabaster carving is a great asset
to the house. It is a happy
demonstration of form which does
not spoil the material used, but
brings out a beautiful and varied
light as it passes through the stone.

It makes of simple forms a block,
containing and diffusing this light,
the whole held together by the
magic of sculpture. It companions
enrichingly, and is itself enriched by,
the large Congdon, an oil painting of
San Marco, which is pearly white
and pink, seen in a mist but yet
revealed.

Methought I heard a voice cry 'Sleep no more!
Macbeth doth murder sleep', the innocent sleep,
Sleep that knits up the ravell'd sleeve of care,
The death of each day's life, sore labour's bath,
Balm of hurt minds, great nature's second course,
Chief nourisher in life's feast . . .

Macbeth

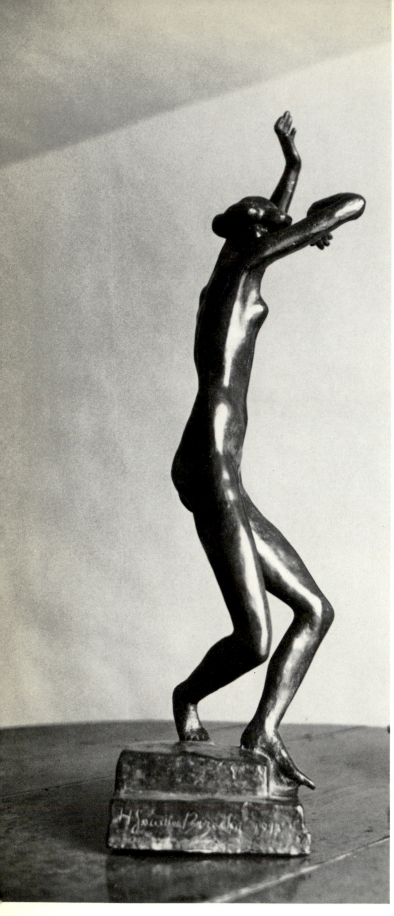
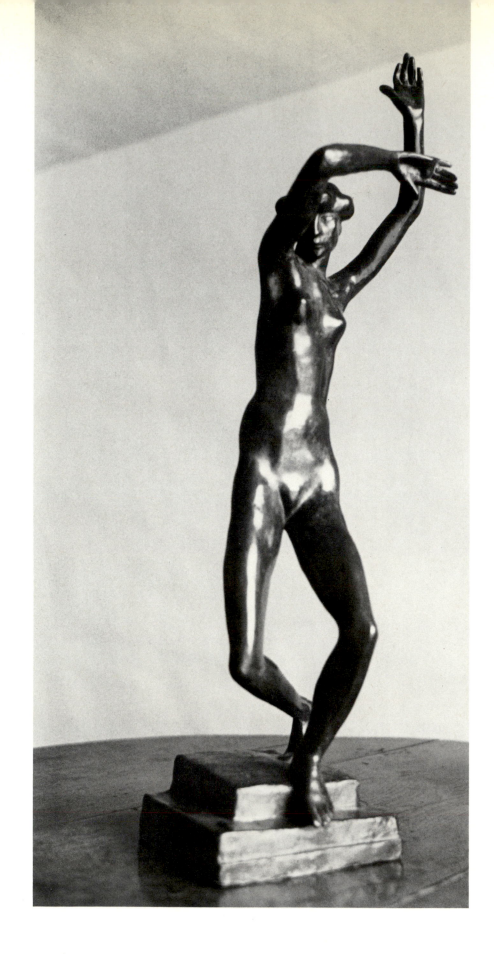

'The Dancer', 1913, Henri Gaudier-Brzeska
See Biographical Notes.

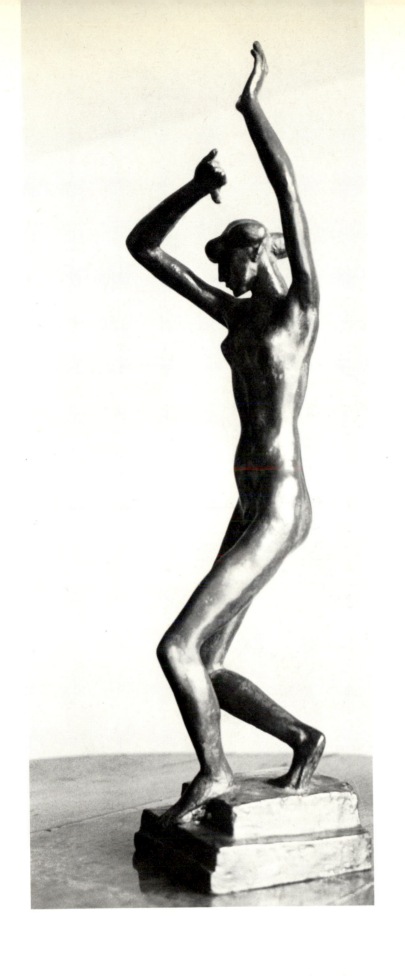
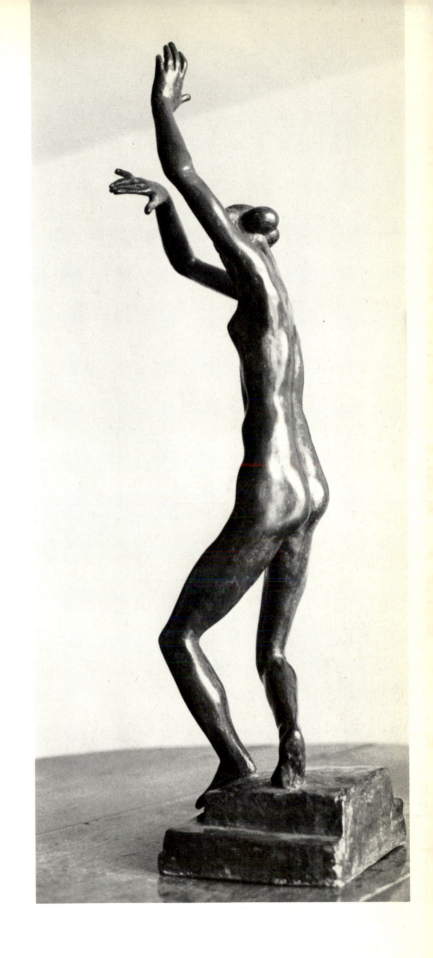

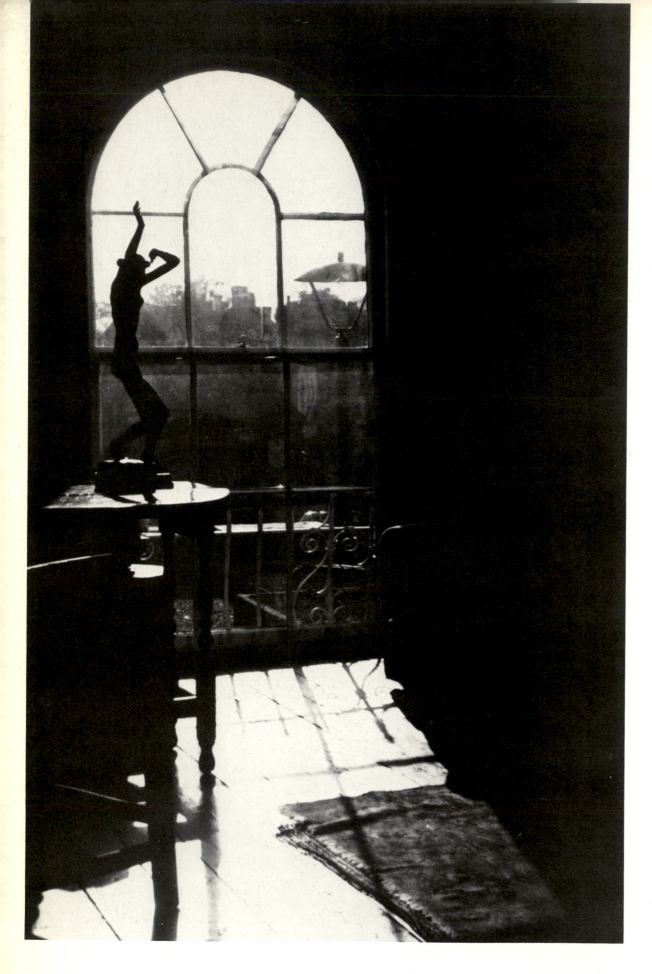

As I compose this book I have wanted to find some way to show pictorially the immense pleasure I got each evening as I walked around Kettle's Yard in the dark. It was never really dark because of large street-lamps which shed their light through the windows, and every month there was the great beauty of moonlight. All this created a new and special adventure, so much was blotted out and so much revealed.

Suddenly when I supposed that I could get no further, there arrived by post from Canada a newspaper cutting about Kettle's Yard with an article and photograph by Catherine Campbell, and all my wishes were fulfilled. Here through the magic of the camera I could find again the wonder of my moonlit home. The mystery of shadows revealing to me the presence of hidden objects, an armchair for instance on the right near the window, and again words by St John of the Cross ring out:

The cloud so tenebrous and grand
that there illuminates the night

(page 81)

I find so few people look at darkness
and find its light. '. . . the floor of Heaven
is thick inlaid with patines of bright gold.'
As I look I can begin to find the spaces
between the floorboards emerging, the
coldness of night and the knowledge that
Congdon's Subiaco moon is just beside
me, like God unseen yet seen.

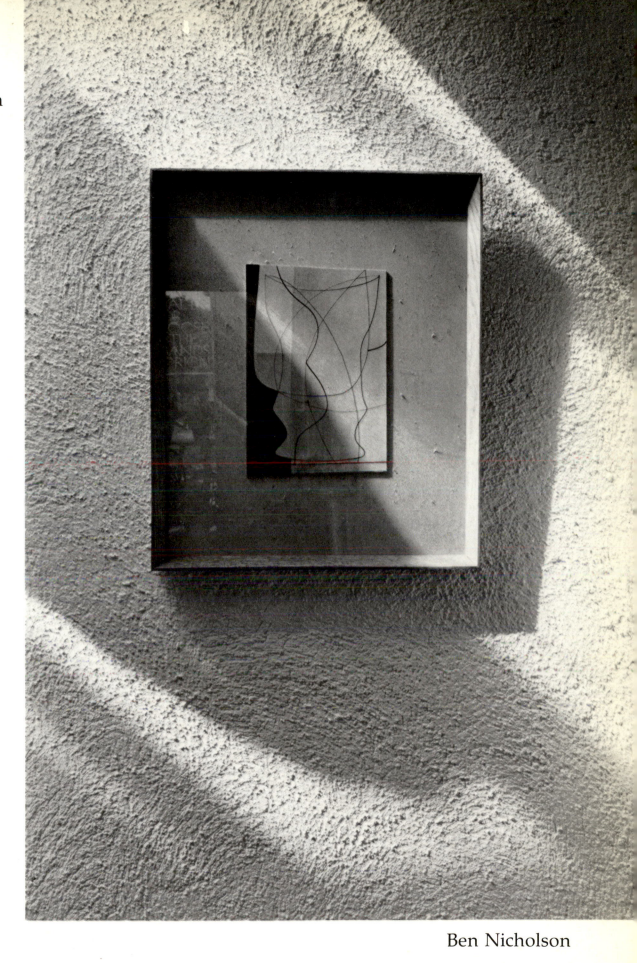

Ben Nicholson

This is the sort of thing which it is good to find in Kettle's Yard. I often think that such a fleeting moment as this is even more important than the paintings and sculpture, for it is this which brings inspiration to the artist. On the other side, were it not for the vision of the artist revealing such beauty, we might never see it. It is I suppose this natural interaction and interrelation which is at the root of life's joy.

As I look at these floorboards in the photograph they become intensely a part of myself; cracks, notches, joins, the passages of darkness and the transparency of shadow, here perceived, create something which I had not reached when I walked across them. It is this, I think, that Rilke means when he writes that we are here to tell things to the angels; that as created beings WE have this perceptive power and that it calls out to be used.

The link leading from the old part of Kettle's Yard to the new part is most skilfully carried out. It had to go through the roof of a seventeenth-century cottage into an entirely new twentieth-century building. It starts from the cottage with a couple of generously wide steps down, with no door disturbing the way, and continues through an open doorway into the very large and comfortably proportioned new building, which itself develops in easy and individual stages.

The 'numbers' are part of a large curtain by Ben Nicholson; it began to wear out, so I turned it into many 'pictures'. The bowl on the table is by Lucie Rie and the painting is by William Scott.

The marble carving is the work of Kenji Umeda, and is called 'Spirality'. Kenji Umeda was born in 1948 in Miyazaki, Japan. My first contact with him was when he called on me to show me some paintings he had done. They were strange but interesting. I found he was alone and in need, so I told him that I would show his work to undergraduates and sell them if I could – they were cheap, a few pounds each. They were soon sold. After a little I asked him if he would like to come in twice a week for an hour or so and help me with the cleaning of Kettle's Yard. He enjoyed his cup of coffee and a little talk but I had great difficulty in giving him anything else. He was very silent and may have been 22 at

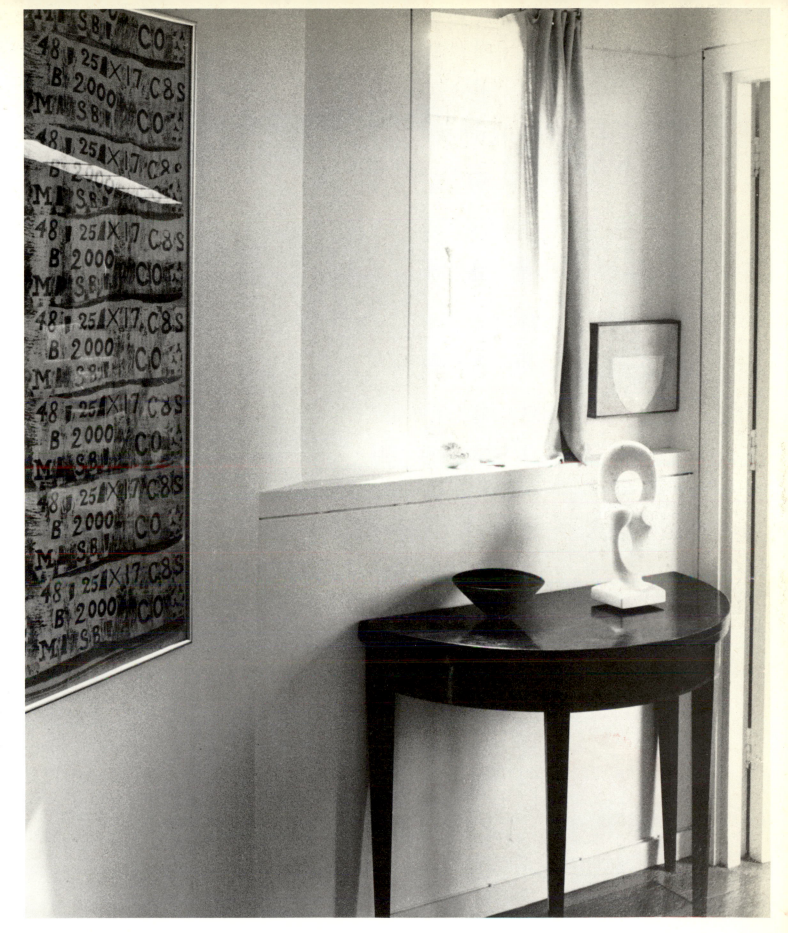

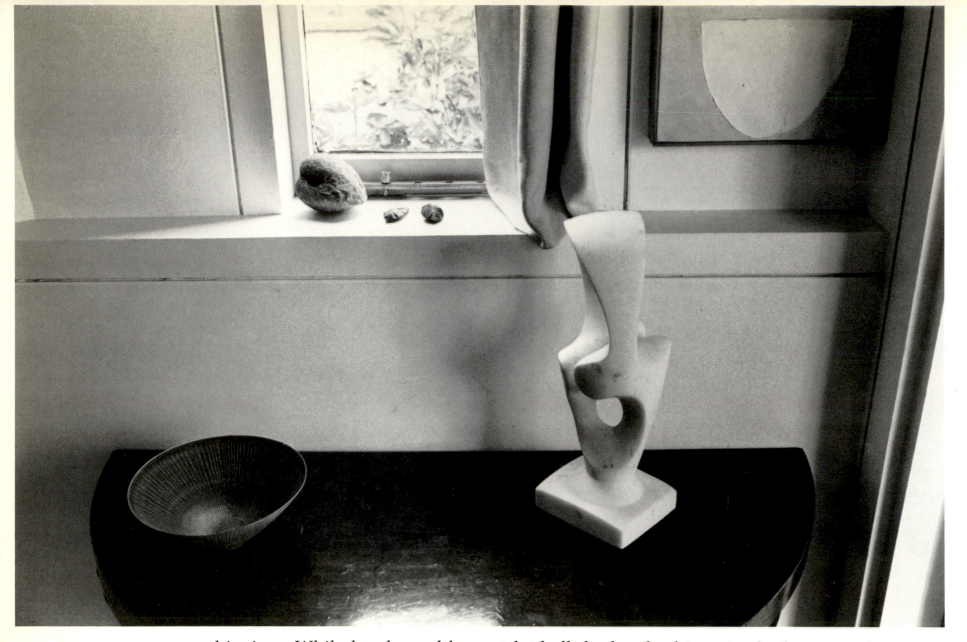

this time. While he cleaned he watched all the lovely things in the house and perhaps in particular those of Gaudier-Brzeska. In his secret heart he knew that he also was a sculptor, but he said nothing. This lasted for a year or more, when as silently as ever he got himself to Carrara, the home of marble. There he got scholarships and worked by day and by night for the next four years, sending me once a remarkable bronze head, quite small. It was no severed head, but something complete in itself, even the neck was no more cut off than the nose. It was unlike any head I had ever seen, most boldly sculptural and an intensely vivid portrayal of energy and thought. When I looked under its small pedestal I read, to my astonishment, that it was a portrait of myself, and as I came to know it better I found that this was so.

Each year he came a little nearer to himself and began to get municipal commissions; then suddenly he packed up his 18 chosen works, shipped them to the United States, and on a shoe-string got there himself, with a wife, also a sculptor.

His first exhibition there brought him establishment and a house of their own, and further exhibitions arranged. One day the postman here staggered in with a large wooden box and inside, exquisitely packed, was 'Spirality' which I have greatly enjoyed here in Edinburgh. I kept wondering where I could put it in Kettle's Yard, and at last thought of a perfect position, and so sent it there; thus it finds its place in this book. It is another conveyance of light and peace.

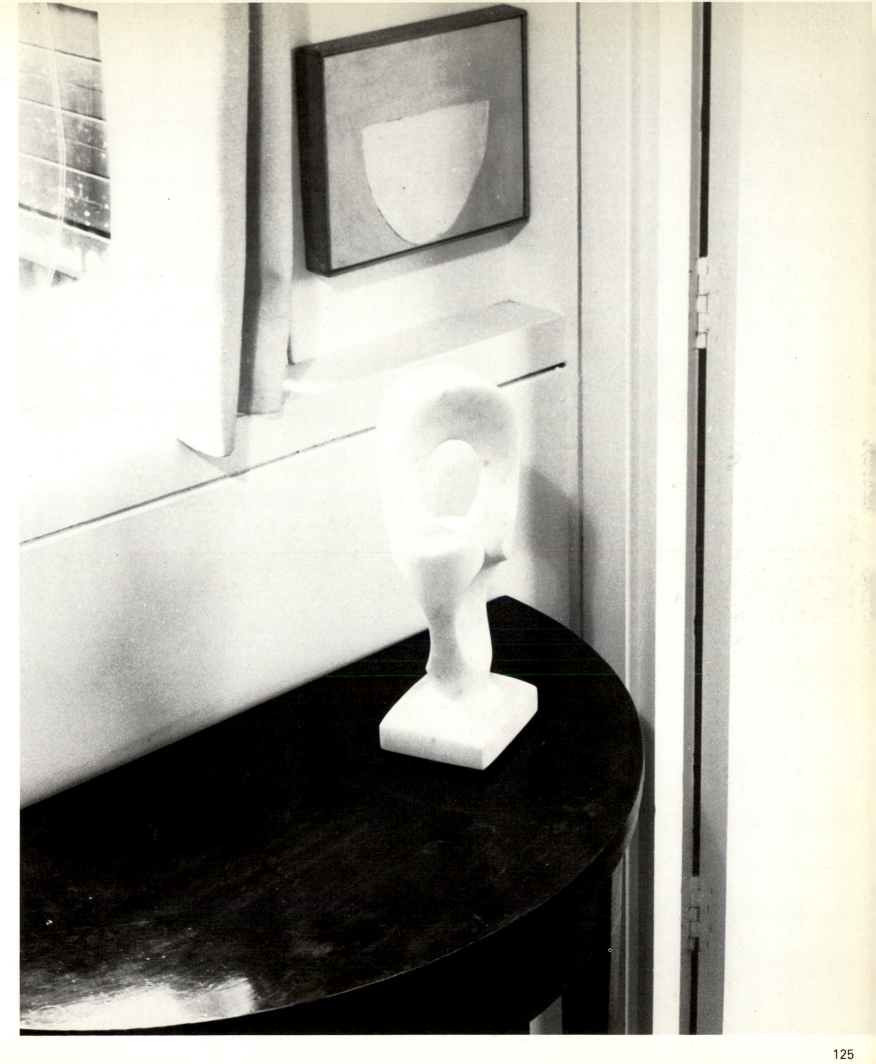

Kettle's Yard (for Jim Ede)

Yes, a sort of gallery
 and stage and habitat and wonder
 with music and tree-trunks
 and sloping walls,
With calligraphy, with Persian carpets,
 all agleam with quartz-like crystals
 and geologies in miniature, where
Translucencies beckon
 towards those vitrines,
 all porcelain and convex thoughts
Which magnify our awareness
 of symmetrical events, of strivings,
 of larch-cones, of chrysanthemums
 and offerings in ritual vessels.

Intertwined reflections in mirrors
 and Brancusi-smooth metallics
 are poised just so –
Amidst the lino-cuts and the geometrics
 and the puppets of the theatres of the East.

Writing desks, candles,
 pictures of sailing vessels
 pewter areas,
Alabaster, flint and shells and strata of aesthetics
 with pebble patterns
 inhabit the imagination
As it wanders between the grand pianos
 and the clusters of the Pleiades,
 and dances towards the shadows –
 even as the more succulent plants
Yearn towards the source of sunlight.

Carved familiars. Windsor chairs
 contemplate bishops and Buddhas.
There is bronze. There is blue shade.
 There is the sea, the Neptune vigour,
 and there are spices from distant shores
 and bas-reliefs of the embrace,
And canopies for projecting
 the whispers
 from the Spanish throne.

The senses
 experience the allegorical.
The engraved words are charged with meaning.
The fragments
 come together –
And there are cloves and scrolls of cinnamon
 for the remembering
 of all the vanished constellations.

 Robert Jondorf

An elderly friend jumped off her bicycle to ask me if I would like a puppet for Kettle's Yard. A puppet, I thought – no, that was going too far, surely it would not do. 'I think you ought to see it' she said, and I did, and found this fantastically alive creature with completeness and intention in every slightest movement and with so distinguished a head. She is reflected in a mirror which has replaced a painting by my most exciting aunt. The frame is I think sixteenth-century Renaissance. She said it was worth its weight in gold, a statement which perplexed her young nephew nearly eighty years ago when she gave it to me.

The puppet stands on an old clock box. This was a presentation to a grandfather towards the end of the last century. It was one of those 'see all the works' clocks and ticked away under a glass dome.

I had turned one of the sides of the box into a door and put in partitions so that it would hold gramophone records. The gramophone itself is a few feet away, built into an old French chest for making bread. An undergraduate put it together for us, and I, a little distressfully, cut a hole in the floor of the chest to release the sound.

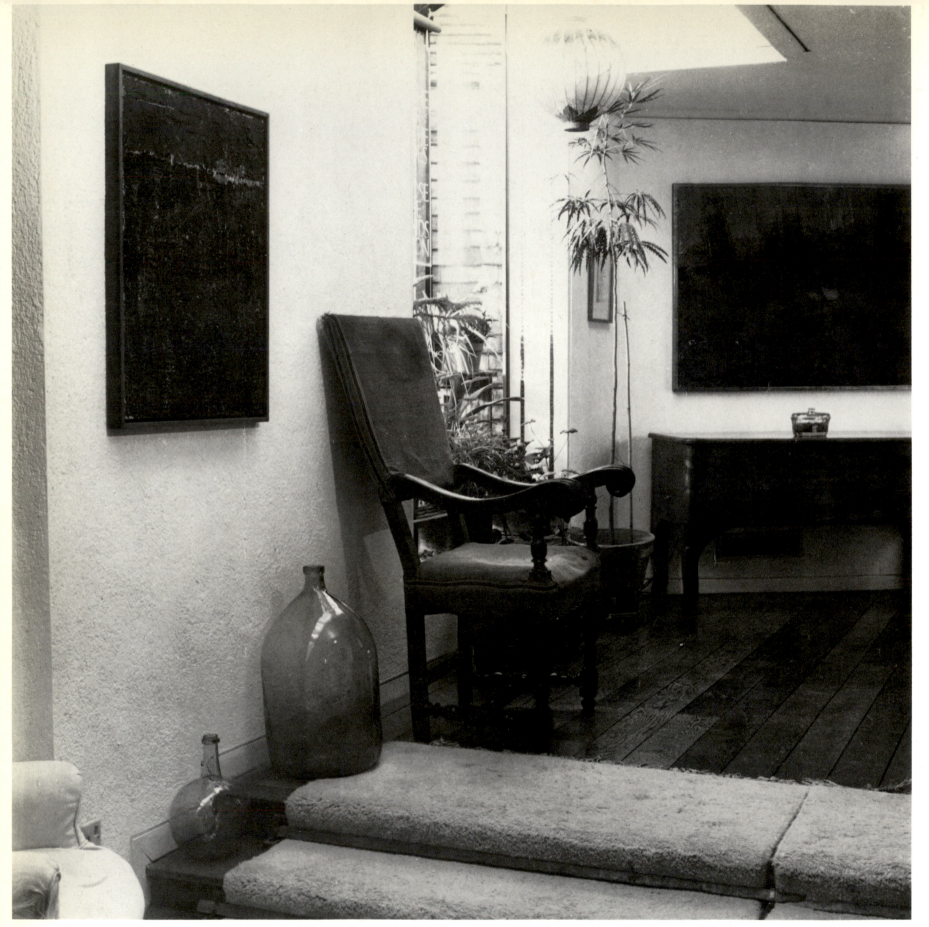

Beyond the small lobby, through a narrow door, the puppet shown on the previous page is immediately in front, and also the first view of Sir Leslie Martin's excellent Extension. This first space is not large, it contains the French chest, a large window for plants, the first of two sixteenth-century Spanish chairs which were previously in the old part of the house, and opposite is a Cromwellian settee. Two steps lead to a large area; the glass bottles were carried across continents.

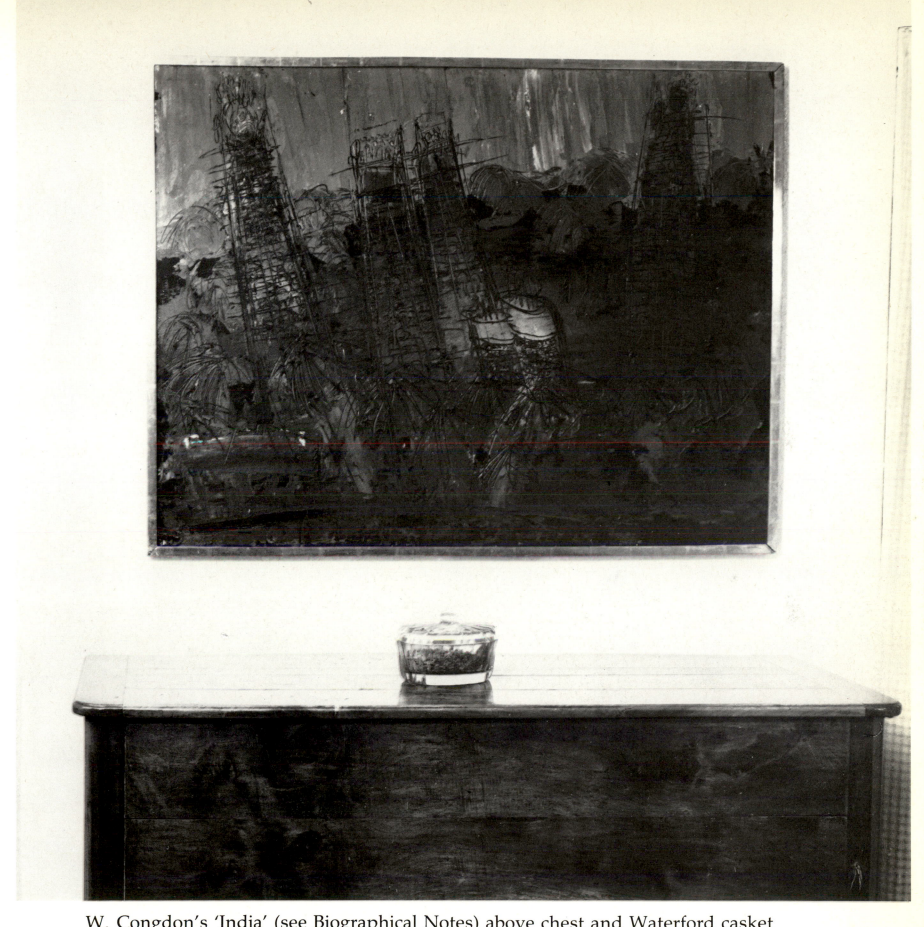

W. Congdon's 'India' (see Biographical Notes) above chest and Waterford casket

I bought four of these Japanese lanterns in about 1938 from an elderly man living in Tangier where we ourselves were building a house. The man had been a very young diplomat some fifty years before, when he had himself acquired these lanterns as antiques. They are made of silk, gossamer-thin.

'Pleiades', David Peace

A translation from French into English must become English, both in words and thought; so an engraved glass must become, all the more, glass, lines and shapes, proportion and spaces pressing towards this end.

David Peace is a master of all this. Glass is sharp, his line cuts; glass is brittle, his design fragments it; glass is hard, the clearness of his incision reveals it; glass is transparent, his engraving fills it with transparent light. We learn that to cut glass is quite other than to cut stone; that an engraving on glass is in no way an engraving on paper.

David Peace is also a great respecter of the shape of a goblet, a bowl or whatever form he uses, and the marks he makes upon its surface reveal that shape, giving it a new dignity and a new life. The beauty of the glass itself is not obstructed by the markings, but instead, vibrates and glitters; and for myself, who love the never-ending changes of light, its warmth, its coldness, its mysterious pervasion and enfoldment, this 'kissing with golden face', so much to be found in David Peace's work, as it was in the Dutch painters, it becomes miraculous.

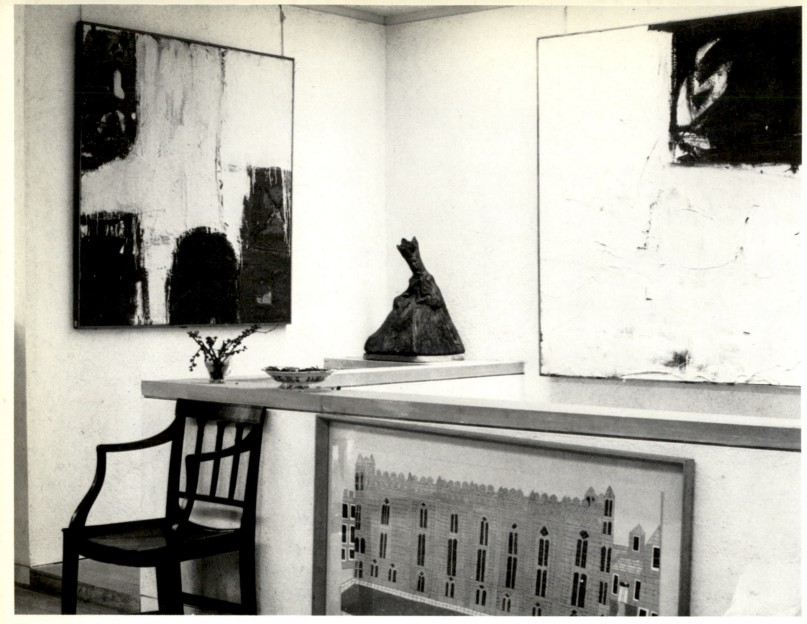

This was my first arrangement of this particular corner. The two top paintings are by John Blackburn whom I had met a few years before and so greatly enjoyed his variations of white and spaces of rich colour. The one on the right is more than double the part shown above. It had towards the middle a long end of rough canvas or whatever, hanging down – greatly needed for the balance of the picture as a whole. I lent it to one of the colleges and a tidy cleaner cut it off and dropped it into her bucket.

The painting of King's College Chapel is by Bryan Pearce of whose works Kettle's Yard has several. It is to be hoped that no child in Great Britain will now get the disease he suffered from, phenylketonuria, a brain damage preventing normal growth, for all are tested and special treatment given if needed. The result in Bryan Pearce's case is that he is perhaps a natural saint – he knows nothing of the deceits and meanness, greed and exploitation which so afflict us – and this mental disablement has probably been the enabling factor bringing a special freshness and a special purity into his so remarkable paintings. I know of no other painter with this

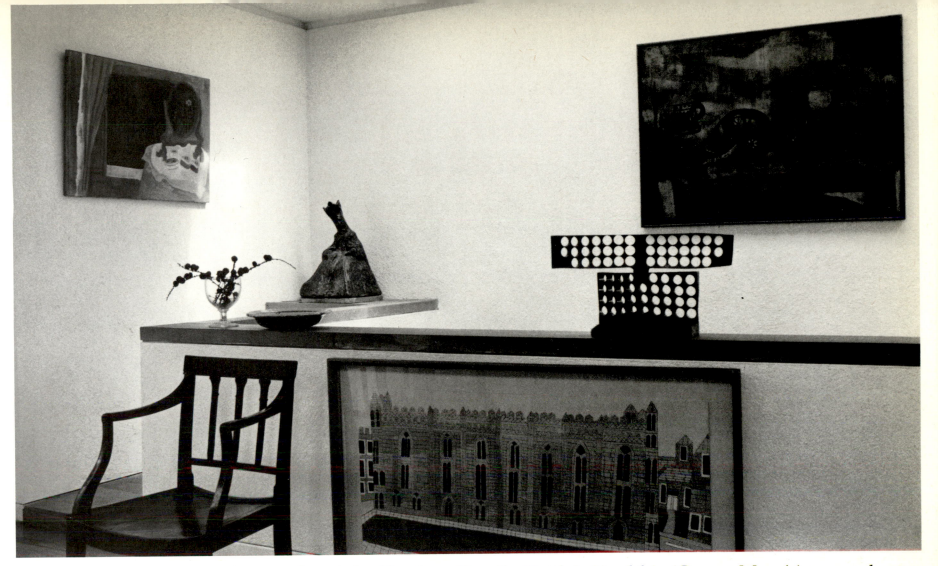

clear simplicity unless it be Fra Angelico. In Kettle's Yard his 'Queen Mary' is a good example of his pellucid juxtaposing of tones, particularly with the use of blue. He is devoid of all conscious sophistication.

Two Ben Nicholsons, 'Christmas Night' and 'Still Life with Knife and Lemon' now hang in place of the Blackburns (see Biographical Notes). 'Madonna', an early Gaudier-Brzeska is also written about in these same notes.

The construction in wood is by Ovidiu Maitec. There is an enlargement of it, and of a second carving on the next open page.

> Oh sleep! it is a gentle thing
> Beloved from pole to pole,
> To Mary Queen the praise be given!
> She sent the gentle sleep from Heaven,
> That slid into my soul.
> S. T. Coleridge, *The Ancient Mariner*

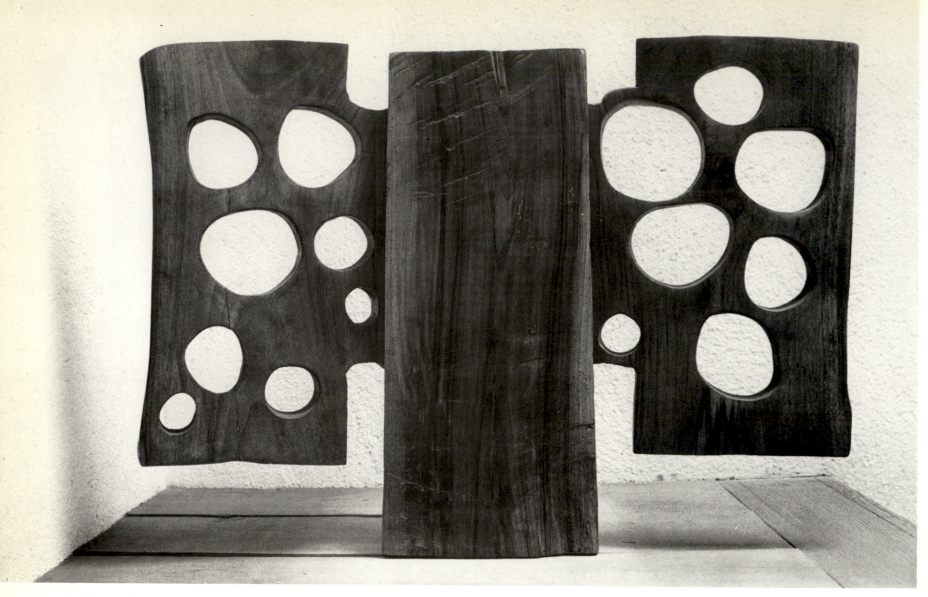

Ovidiu Maitec, born in Arad, Romania, in 1925

'Radar II' on the opposite page was the first Maitec which I bought especially for Kettle's Yard. To see his work was a great experience for which I am grateful to Richard Demarco who organised an Exhibition in Edinburgh which I was at that time visiting. The sculpture above, Maitec gave me from his London Exhibition, and still later he gave me 'Angels' which with 'Gate' comes into Interlude IV. He wrote to me that I was his sculptural home. These three works have a certain mobility. 'Angels' hangs in balance and can swing from side to side. The wings of the one above are movable, back and fore. With 'Radar II' the whole of the top structure can be rotated, and in addition to this the sculptor has so cunningly carved his wood on the reverse side that holes though similar take on an entirely different shape as they are looked through and as light meets their difference of direction. The work above challenges me, is perhaps the more outstanding, more personal and more creative. This pattern of light in both, so varied and forever mobile in its prison of wood, yet holding its own, gives to each a deep and sensitive individuality.

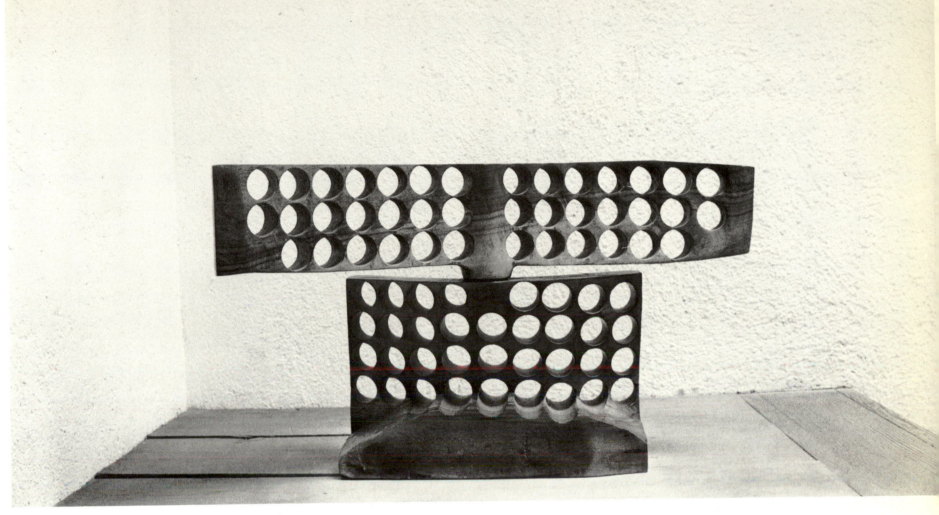

'Radar II'

Your face	your tongue	your wit
So fair	so sweet	so sharp
First bent	then drew	so hit
Mine eye	mine ear	my heart

Mine eye	mine ear	my heart
To like	to learn	to love
Your face	your tongue	your wit
Doth tend	doth teach	doth move

Form of verse popular in the seventeenth century.
It can be read in almost any direction.

Kettle's Yard is everywhere helped, indeed made, by the many generous gifts from Ben Nicholson. Reflected in the glass covering the right-hand drawing is a portrait of the photographer, Harry Sowden, which I am glad to have and in which I am sure Ben Nicholson would delight. Further comments about Ben Nicholson, and Winifred Nicholson are in Biographical Notes.

Such works as these push us on to recognise that there is a beauty and significance in life, just below its surface and its strife, something of infinite beauty, of transparent peace, waiting to break out, to be embodied in a tea party, a great civic dinner or a lino-cut or drawing. It is this fusing of human experience with the visual world, the combining of the inner life with the outward, which is surely the domain of the visual arts.

It is a kind of *Alice through the Looking Glass,* a passing each time of the Holy Grail. There is a passage in the *Morte d'Arthur* which expresses this fusion, expresses the way that with the coming of beauty we are each thrown into a state to appreciate everything more than before.

'And so after upon that to supper, and every knight sat in his own place as they were to forehand. And anon they heard cracking and crying of thunder, and them thought the place should all to drive. In the midst of this blast entered a sunbeam more clearer by seven times than ever they saw day, and all they were alighted by the Grace of the Holy Ghost. Then began every knight to behold other, and each saw other, by their seeming, fairer than ever they saw afore. Not fore then there was no knight might speak one word a great while, and so they looked every man on other as they had been dumb. Then there entered into the hall the Holy Grael covered with white samite, but there was none might see it, nor who bare it. And there was all the hall fulfilled with good odours, and every knight had such meats and drinks as he best loved in this world.'

Such full experience comes but seldom in our lives, and seldom in the arts, but partial realisation comes often, and through this we are made alive.

Still with unhurrying chase,
 And unperturbéd pace,
Deliberate speed, majestic instancy,
 Came on the following feet,
 And a Voice above their beat –
'Naught shelters thee who wilt not shelter Me.'
 Halts by me that footfall:
 Is my gloom, after all,
Shade of His hand, outstretched caressingly?
 'Ah, fondest, blindest, weakest,
 I am He Whom thou seekest!
Thou dravest love from thee, who dravest Me'.
 Francis Thompson, *The Hound of Heaven* (excerpts)

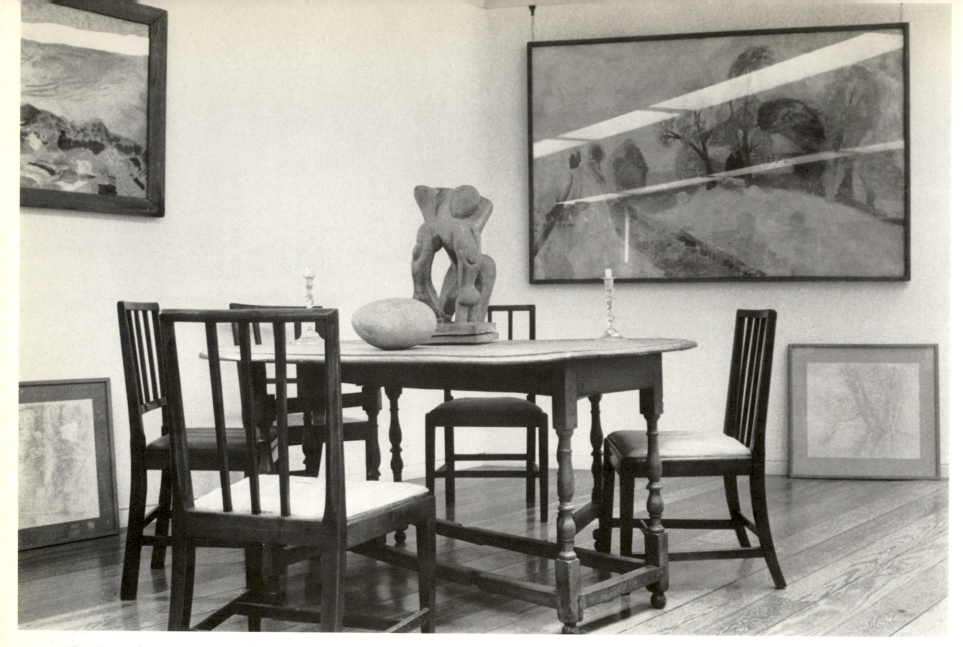

'Caritas' has come back to the same table on which it stood in Interlude III. It is perhaps a little daunting for a casual tea party sitting around it. It would be interesting to have a list of all the people who have sat at this table in these last fifty-eight years. Even Brancusi's 'Fish' was once its centre-piece. It must have been then that one of the evening papers wrote 'The Edes entertain extensively but not expensively; you may sit down to a three-course or even a two-course dinner but in the middle of the table may be a statue worth thousands of pounds.' This table appears also in Interlude II.

For a long time the big Winifred Nicholson 'Landscape' hung just outside my office at the Tate Gallery – I could not manage the £100 asked for it, but Miss Sutherland could – and when finally it came to Mrs Nicolete Gray she generously gave it to Kettle's Yard.

The upper picture to the left of the cupboard is made with matches and with the insight of Simon Hepworth Nicholson who was one of the first visitors to Kettle's Yard at the end of 1957. The work below is by Alfred Wallis, given by Ben Nicholson.

The glass is I think Greek, given with a collection described later. The china, ready for tea, is late Rockingham and was bought cheaply after an air raid on Hull. Push the armchair back a little and turn it square with the wall, it will then be communicative.

Let me not to the marriage of true
 minds
Admit impediments; love is not
 love
Which alters when it alteration
 finds,
Or bends with the remover to
 remove;
O, no! it is an ever-fixed mark,
That looks on tempests and is
 never shaken;
It is the star to every wandering
 bark,
Whose worth's unknown,
 although his height be taken.
Love's not Time's fool, though
 rosy lips and cheeks
Within his bending sickle's
 compass come;
Love alters not with his brief hours
 and weeks,
But bears it out even to the edge of
 doom.
 If this be error and upon me
 prov'd,
 I never writ, nor no man ever
 lov'd.

Sonnet

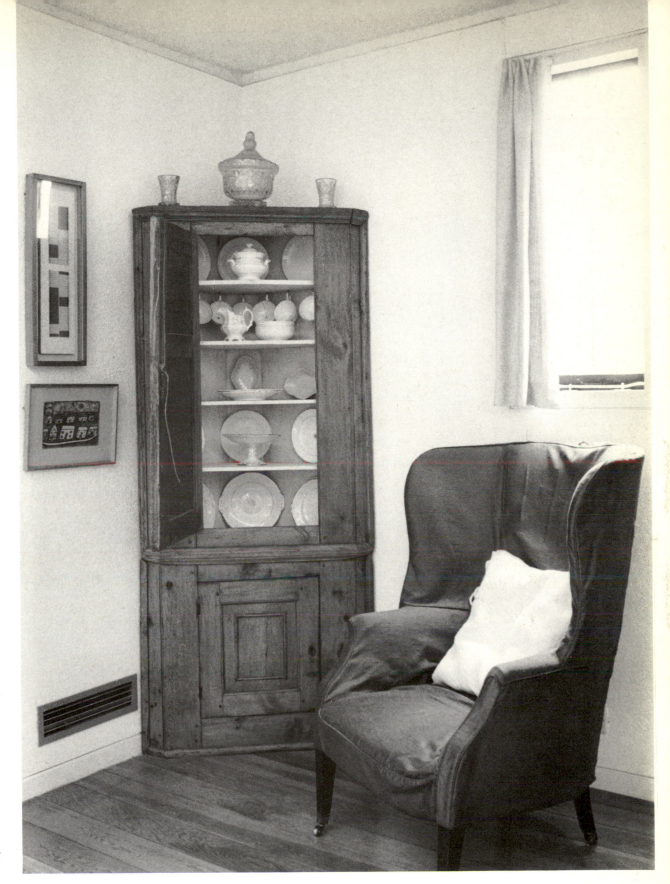

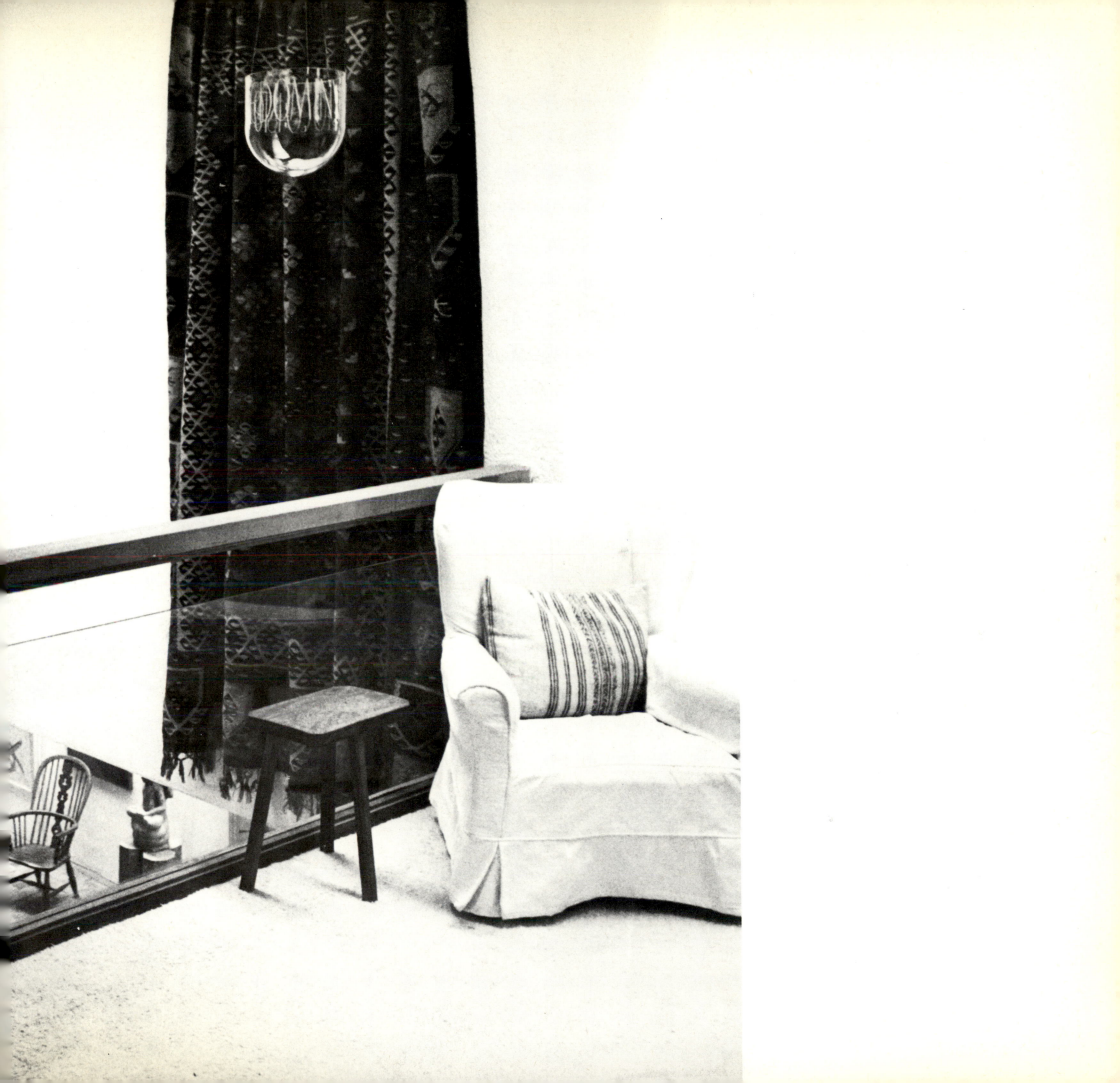

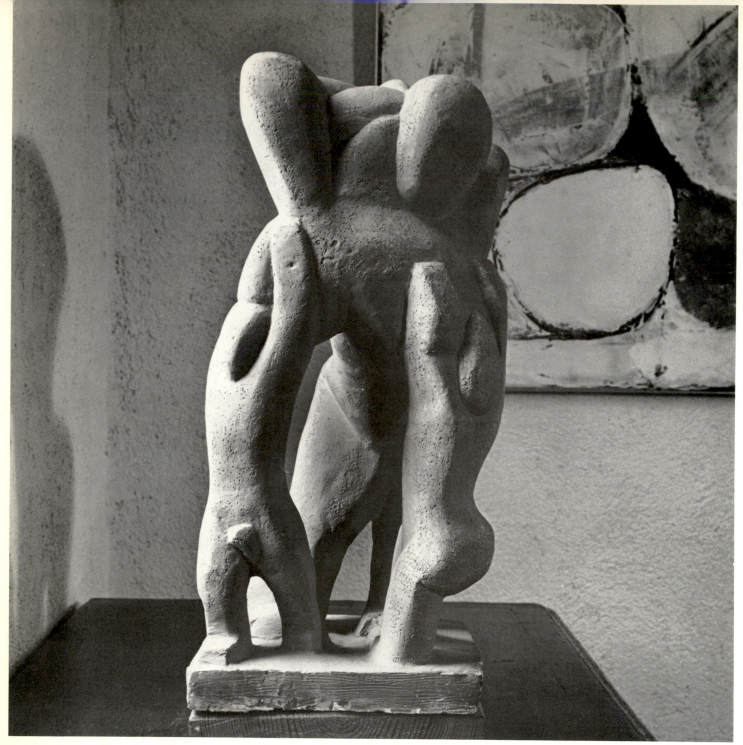

'Caritas' might be one of those statues which could be enlarged to cathedral size. Gaudier-Brzeska had to confine himself to small works, but this did not mean that he could not see big. His 'planes' were not a matter of inches but of yards. He probably saw people walking between the legs of the children, and that their upstretching to the breasts of their mother was as the great columns of a cathedral. The lines are so simple that they could be continued to encompass an immense work.
Gaudier-Brzeska's statue is but a simplification and a convenient measure of this work.

The painting on the wall is by Paul Feiler.

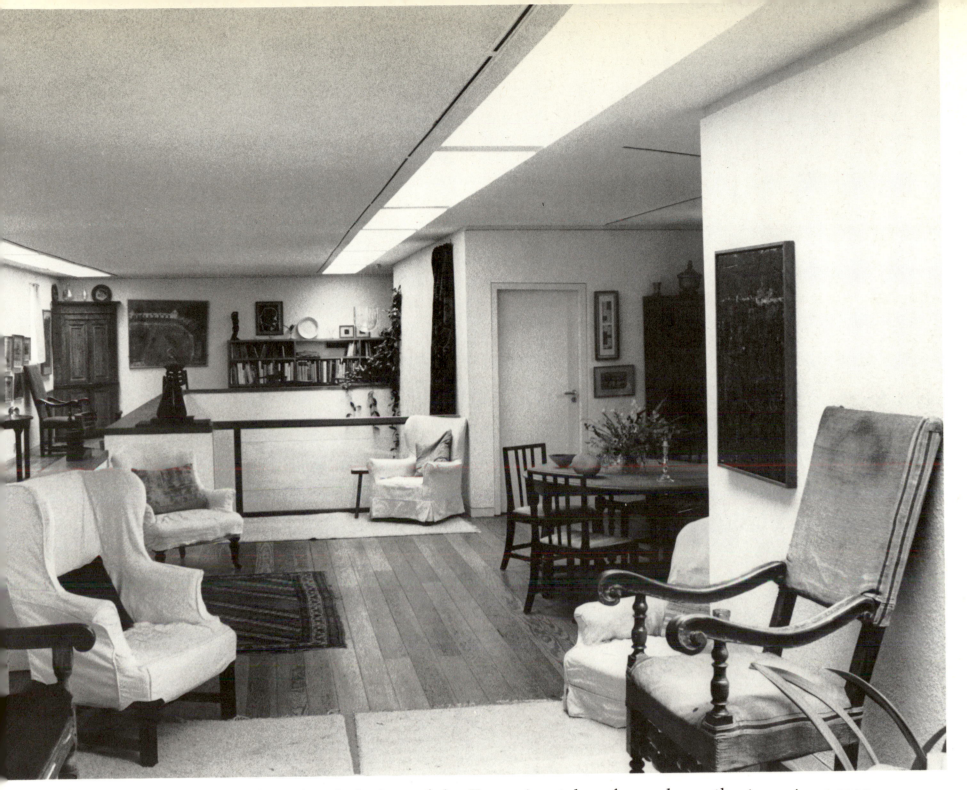

This is the first detailed view of the Extension taken from above the two steps seen earlier. It is easy to move within this area. Bryan Pearce's painting of 'King's College Chapel' is on the left between two armchairs and 'Madonna' is round the corner, left. 'Caritas' is now on the oval table instead of the bunch of dried flowers.

Interlude IV

We left Kettle's Yard in June 1973 and came to live in Edinburgh, Helen Ede's home town. We found a very suitable flat, on the ground floor towards the end of a cul-de-sac turning off from the main road. We had a small garden and overlooked many belonging to other people who did not disturb us, and from the windows we looked south to the hills going down towards the Border. Soon people were saying that it was another Kettle's Yard.

We brought away nothing which had been on show at Kettle's Yard except for an overflow from the kitchen which was in the cupboard of my bedroom. If Kettle's Yard is a way of life, that way continues and this Interlude will show a little of its light. Helen Ede spent four very happy years here and then died most peacefully while we were reading together one evening.

She was 84 and I was 83. It was good for her to feel the air of Scotland and not to be disturbed by the ever-increasing number of visitors coming to Kettle's Yard, to feel she had a home of her own after almost a lifetime of sharing it with others.

For my part I had embarked on an entirely new adventure, that of visiting the sick in nearby hospitals. I found I could just walk in and confront a total stranger who was always willing to tell me what was the matter with him; so every afternoon became occupied. I had well over 100 to see each week, I called them my 'victims', and I began to learn what it meant to be ill and how easy it was to die. I thought of them all as my family. They thought I must be the Minister.

As I try to construct this book in what spare time I have – early morning or evening – I am surrounded by the wonder of light. This mystery opposite we called The Glory of the Lord. It happened at its best in winter when the sun was low in the sky. It took about half an hour for this whole area to revolve out of the sun's range. The fishing-net float of aluminium in the middle became a blaze of light, the subtleties of moving light and shadow as they explored 'Angels', a carving by Ovidiu Maitec in wood, were a great wonder. The shadows across the carving are the arms of a circular wooden chair and the lid of a bureau. The float itself might be the moon as seen when out in Space.

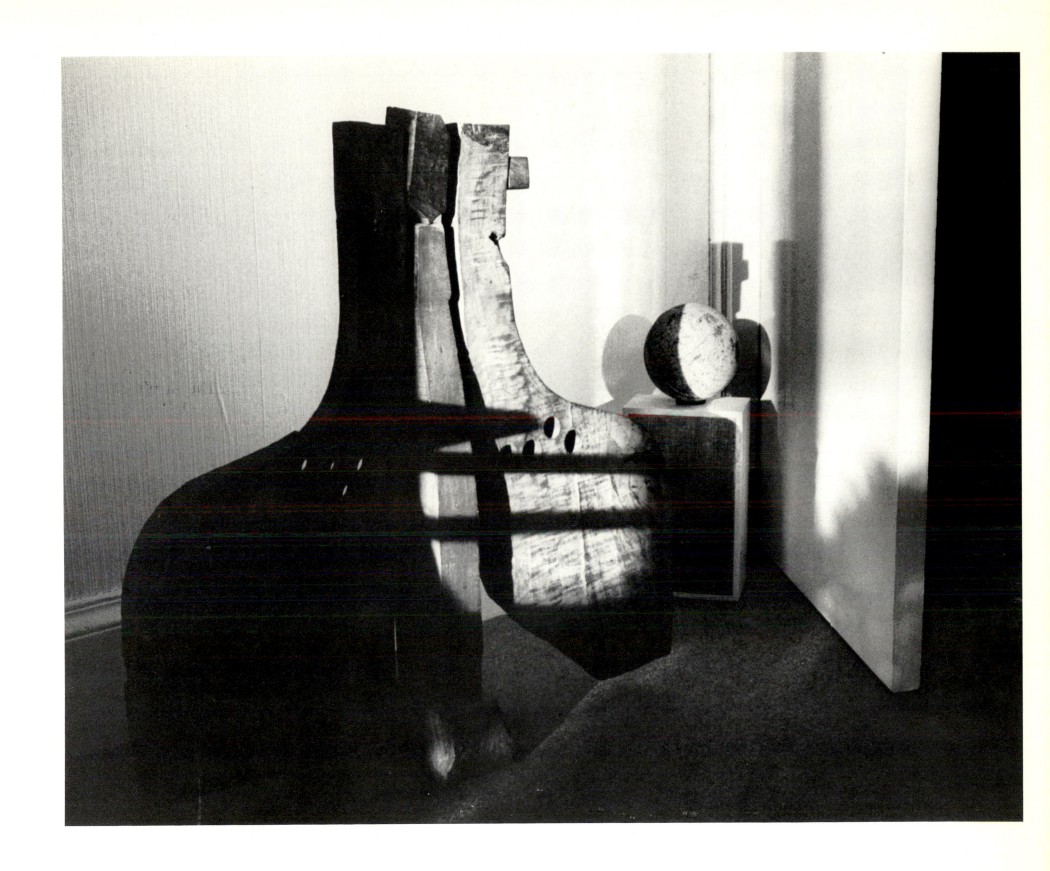

'Turtledove', a lino-cut by Caroline Hemming, is most satisfying to live with:
she is surely one of our best engravers since the time of Bewick, so anonymous and
yet so intensely perceptive. It is remarkable the way that the body of the bird echoes

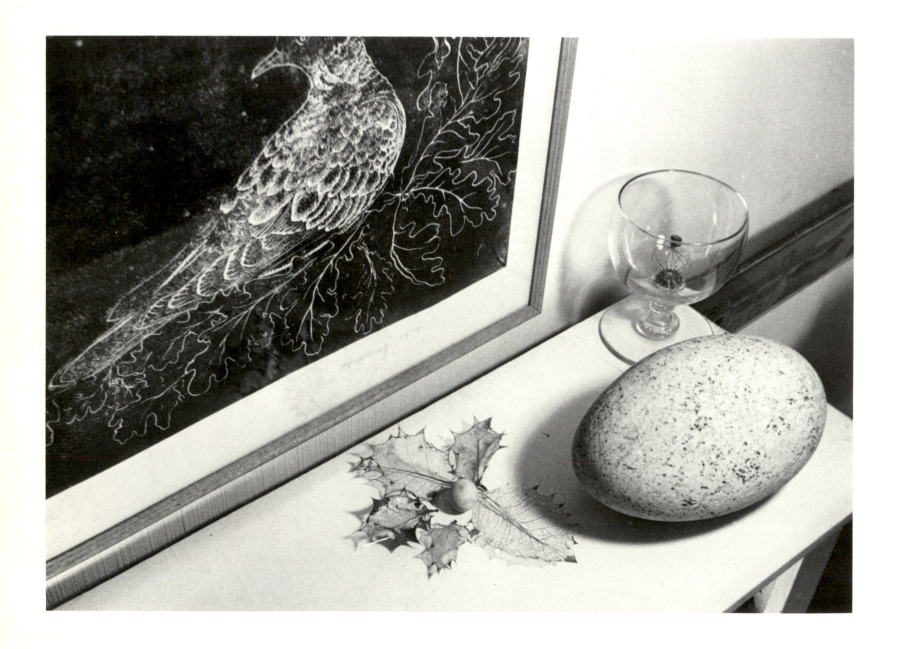

the shape and texture of the large pebble. The bird reminds me of a poem by Lucy Boston:

> In the night softly like a bird
> Love settled and stirred.

The skeletal holly leaves are one with the leaves in the engraving. I have many of her lino-cuts; everyone likes them, but few buy them. They are a poor man's fortune.

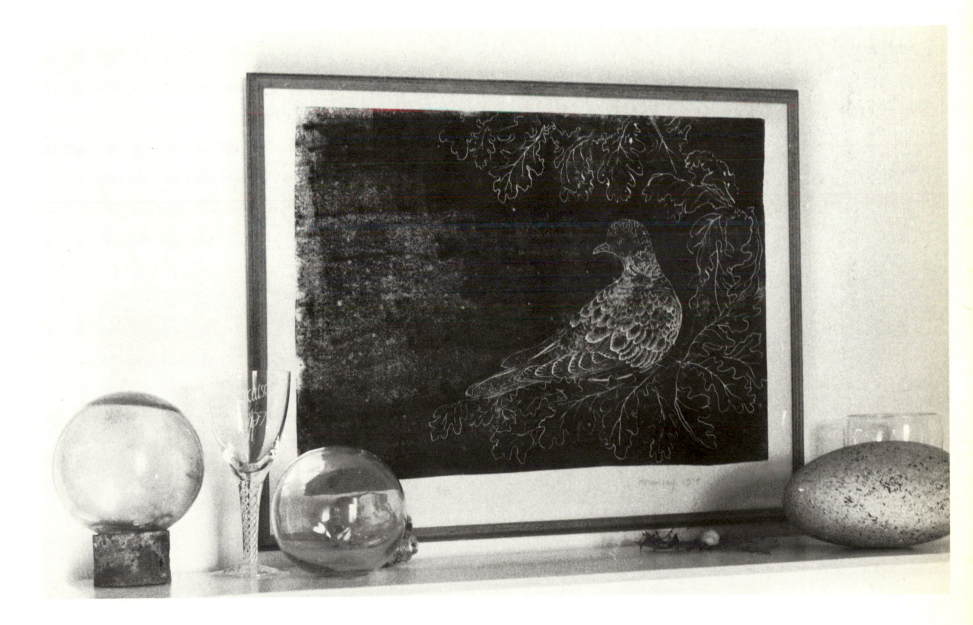

The Geode is a pool of light which has lain in total darkness for many millions of years until a camel may have kicked it open, so revealing all this wonder.

I have the feeling that when all our artificial lights are off and I am safely in bed and asleep, those eggs of light shine out illuminating all the house.

The poppy pod below is another great miracle and is I think a rarity. It was in a garden belonging to a daughter who thinks it had become desiccated, with all pulpy matter wasted away through the wet summer of 1980.

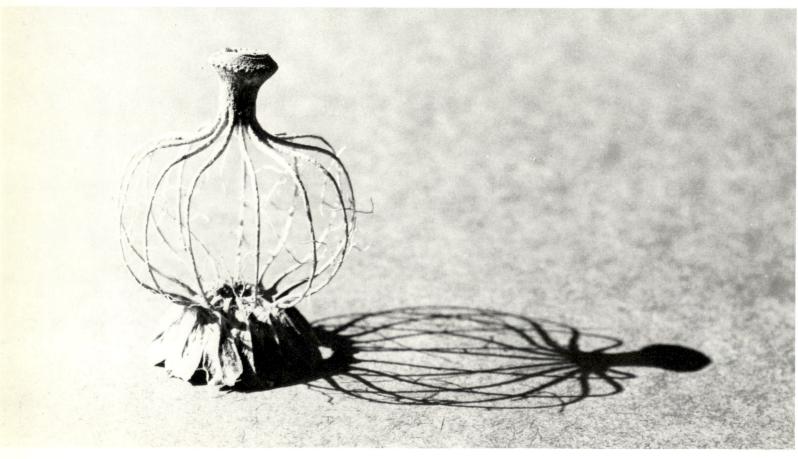

I put one into a rummer given to me by a friend of 95, whose father had bought a set in, I think, 1839.

She had never before seen a poppy pod in this condition, and said of one which I had given her that it had become a lantern lighting her to Heaven.

I found later that she too had put it in one of her father's rummers. These are now in Kettle's Yard. (I refer to the pod in a rummer.)

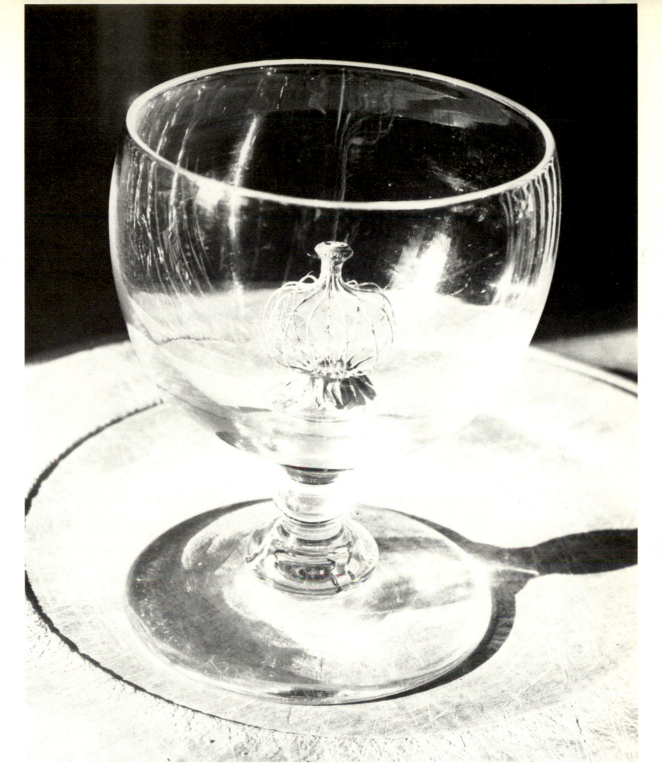

These photographs are of Ovidiu Maitec's 'Gate' and are approximately the same size.

It is carved in wood and can be thought of in colossal form, a Gate stretching, as it were from Earth to Heaven.

It is the Eternal Gate through which we all must pass; we enter in and are enfolded in the subtle intimacy of its interior; beyond is the whole unknown of Freedom.

These things I write of here should, with perhaps one exception, later form part of Kettle's Yard.

In 1973 I wrote of Maitec as 'a sculptor in the deepest tradition of Romanian art, sensitive, alert and purposeful.

'Like Brancusi he is immediately conscious of the needs of varied materials; stone being stone and wood being wood.

'His work in whatever substance springs from a grand and living love, and although we are in the midst of a technological age he will, for instance, show the beauty of wood and the love of creating an object by hand.

'He finds an interesting shape and by studying its nature, makes with imaginative vigour and immense skill, something new and yet in accord with its original nature.'

'The Cloud and the Column'

Such a picture as this by the Greek artist Constantineu Wilson, though new is classic, and for me it clarifies and brings together earlier vision. As the 'Mona Lisa' gyrates amidst its mountains, so this canvas gyrates on its column, yet both are STILL. They are complete. The Greek work juxtaposes tones with power. As I travel around the canvas, the white which is its 'background' keeps changing; sombre on the left and glowing on the right, and the edge of the canvas on that side becomes whiter than anywhere else, but in fact all is the one untouched sheet of paper. I remember when I was young, there hung in the main entrance hall of the National Gallery in London a large painting by Perugino. I used to turn back from the stairs in order to absorb – the cloak I think it was – of the central figure, outlined against the sky, blue on blue perhaps, but with so perfect an edge that space was everywhere and all sense of outline disappeared; so, in this picture the black edges of the canvas are entirely free. Since putting a frame with glass, a new dimension appears; for things about the room are reflected in the canvas and excite fresh experience. The line on the right is unsteady; it denotes the soul caught in our human frailty. So concrete an exploration is so suggestive and encompassing that each object in the room where it hangs, lives within the picture.

End of Interlude IV

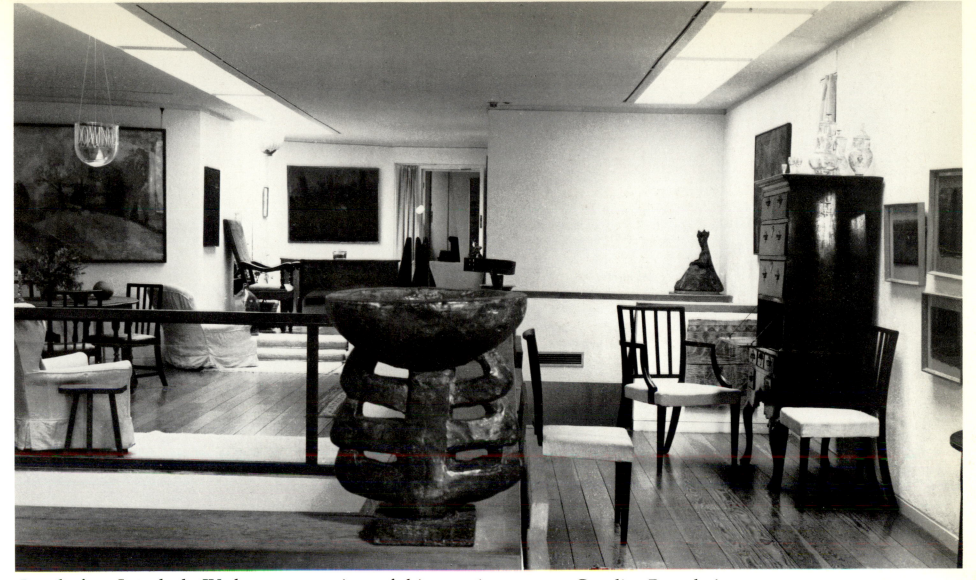

Just before Interlude IV there was a view of this area in reverse. Gaudier-Brzeska's 'Garden Ornament' was in the far distance while here it is in the foreground. The Ben Nicholson usually on the wall to the left of 'Madonna' had gone to an exhibition. The stairs leading to the ground floor are just beyond the three chairs.

Thou art indeed just, Lord, if I contend
With thee; but, sir, so what I plead is just.
Why do sinners' ways prosper? and why must
Disappointment all I endeavour end?
 Wert thou my enemy, O thou my friend,
How wouldst thou worse, I wonder, than thou dost
Defeat, thwart me? Oh, the sots and thralls of lust
Do in spare hours more thrive than I that spend,
Sir, life upon thy cause. See banks and brakes
Now, leavéd how thick! lacéd they are again
With fretty chervil, look, and fresh wind shakes
Them; birds build – but not I build; no, but strain,
Time's eunuch, and not breed one work that wakes.
Mine, O thou lord of life, send my roots rain.

 Gerard Manley Hopkins

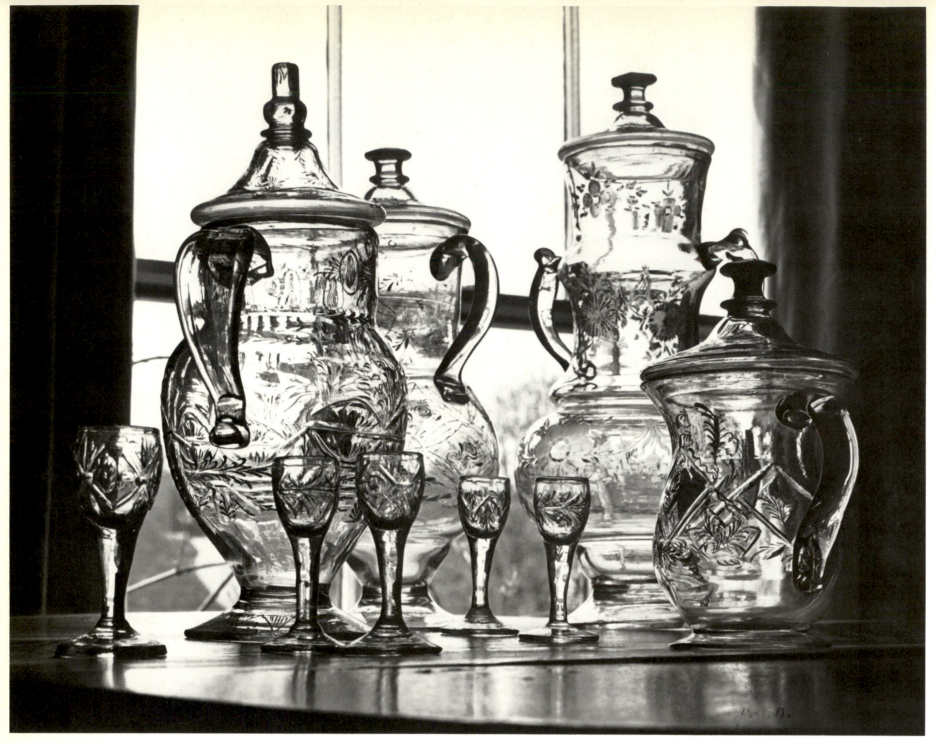

All this beautiful glass, fifteen pieces in all, was given by Naome Kirby Green. Three are on top of the corner cupboard near the oval table, one large dish on the library table, and two more on the large corner cupboard nearby. It all started with the small dish on what was my bureau in the first room of the original Kettle's Yard. We were leaving Tangier in 1950 and Ada Kirby Green who owned all this glass said I could have any piece I cared to choose. An overwhelming offer, so I chose the small dish in which I put feathers when Kettle's Yard came into being. Ada Green died and her son Philip reigned in her stead. Philip Kirby Green died and his wife Naome was left alone with all the glass.

I asked her if she might like to give one piece to Kettle's Yard in memory of her

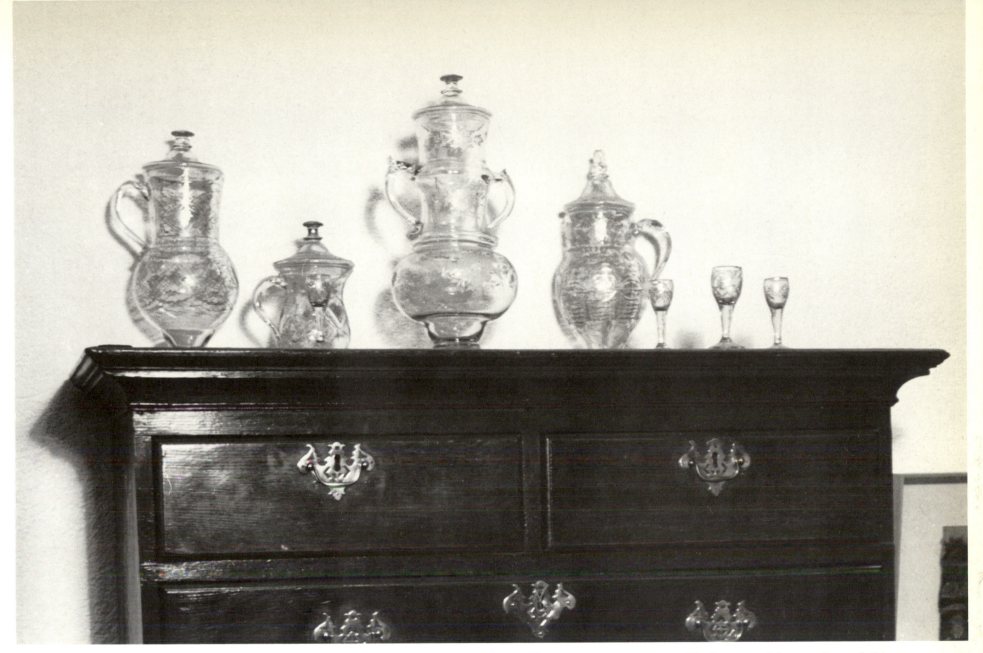

husband – she replied that the whole collection was mine if she could get it safely to me. A daughter called and fetched it, all carefully packed in boxes, together with some Minoan pottery, a jar from Crete and other smaller objects. When I first divided it up and placed those few on the tallboy, they seemed to me a golden city. I once took it all down to clean underneath them and around, a lid slid off and broke a jar (badly mended by me) and I was never able to 'place' it all again. I have often found this happen. I get something, I look for its home, and place it innocently and rightly. After that I have lost the touch.

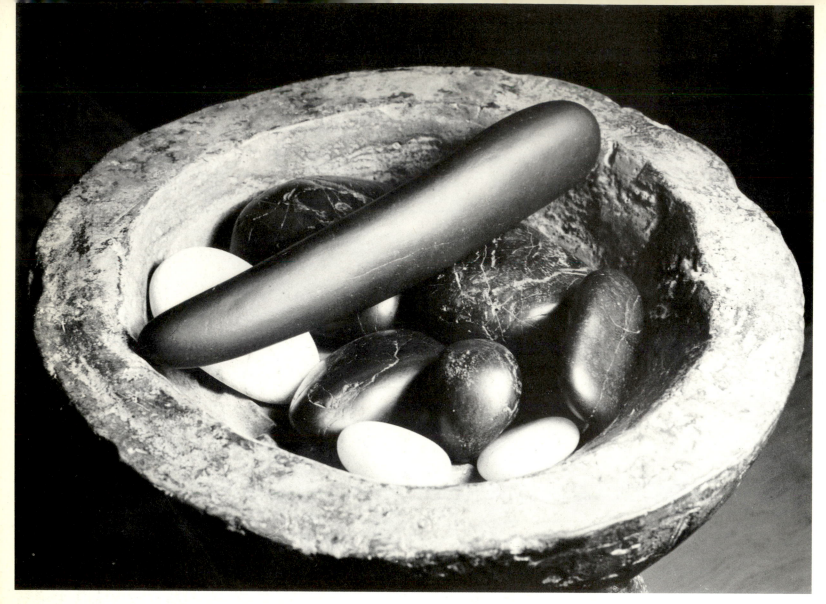

'Garden Ornament', 1914, H. Gaudier-Brzeska (detail)

In this top basin of the sculpture I have put stones; the shiny black ones have I think travelled from Iceland, and were picked up in Budleigh Salterton. The long black one has been 'lost, stolen or strayed'.

> Farewell, thou art too dear for my possessing,
> And like enough thou knowest thy estimate;
> The charter of thy worth gives thee releasing,
> My bonds in thee are all determinate.
> For how do I hold thee but by thy granting?
> And for that riches where is my deserving?
> The cause of this fair gift in me is wanting,
> And so my patent back again is swerving.
> Thyself thou gav'st, thy own worth then not knowing,
> Or me, to whom thou gav'st it, else mistaking;

Perhaps I could say that this photograph was the seed which after a dozen years has become this book. A young undergraduate was taking photographs of Kettle's Yard for his own enjoyment and when he showed me this one I at once thought that if he could spot this tiny detail and handle it with so much love and so much mystery, he should be able to create a book on Kettle's Yard. He kept the idea in his head, but it got no further. He became a professional photographer, and many of his photographs are included here.

So thy great gift, upon misprision growing,
Come home again, on better judgment making.
　Thus have I had thee as a dream doth flatter;
　In sleep, a king; but waking, no such matter.
<div align="right">Sonnet</div>

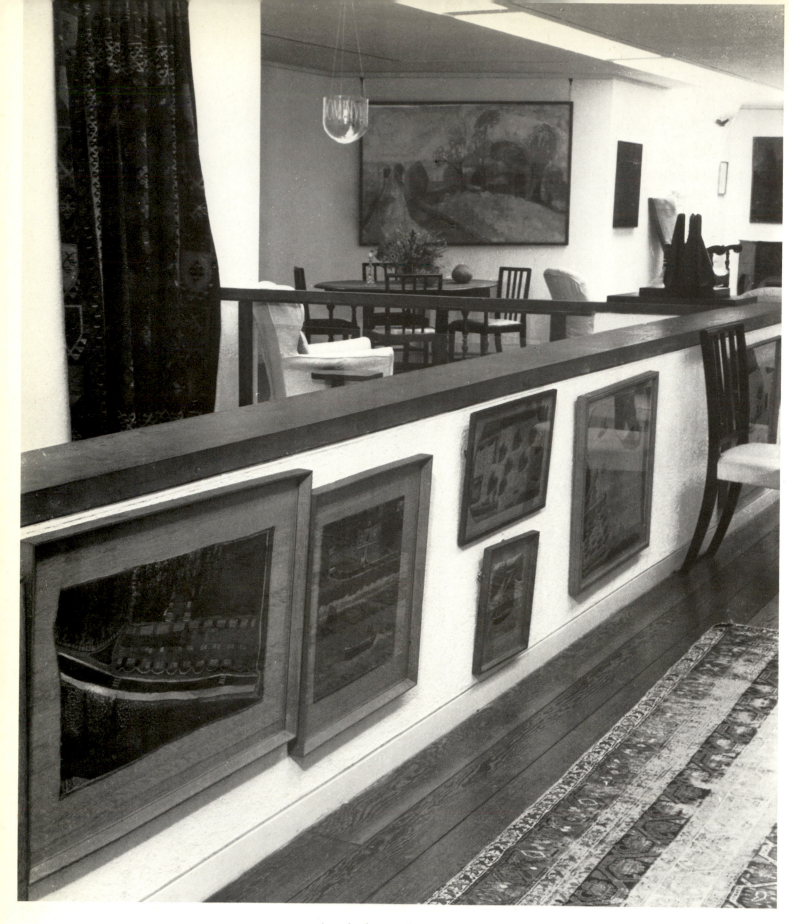

Around the corner with the tallboy and glass there comes a long balcony-passage with a collection of paintings by Alfred Wallis. (See Biographical Notes.) I decided to put most of them together, so that they could be studied as a whole by those who liked him, and easily passed by those who didn't. I have of course seen to it that there was at least one Wallis in every other place.

The only really dangerous act I indulged in while 'making' Kettle's Yard was the hanging of the Kelim rug (also a present from Naome Kirby Green) with Kirby Green's initials woven in, backwards, I seem to remember.

I had to stand on that very narrow ledge and fish for a hook which someone had put in for me some time before. I fished with a rod to which was attached the whole Kelim rug. Once hooked I let the Kelim fall and nearly fell with it. I then gathered the rug together and pinned in a string three-quarters of the way down to keep it hanging straight. In this photograph the string seems to have broken loose.

It was a comparatively easy task to hang the sanctuary lamp given and engraved by David Peace.

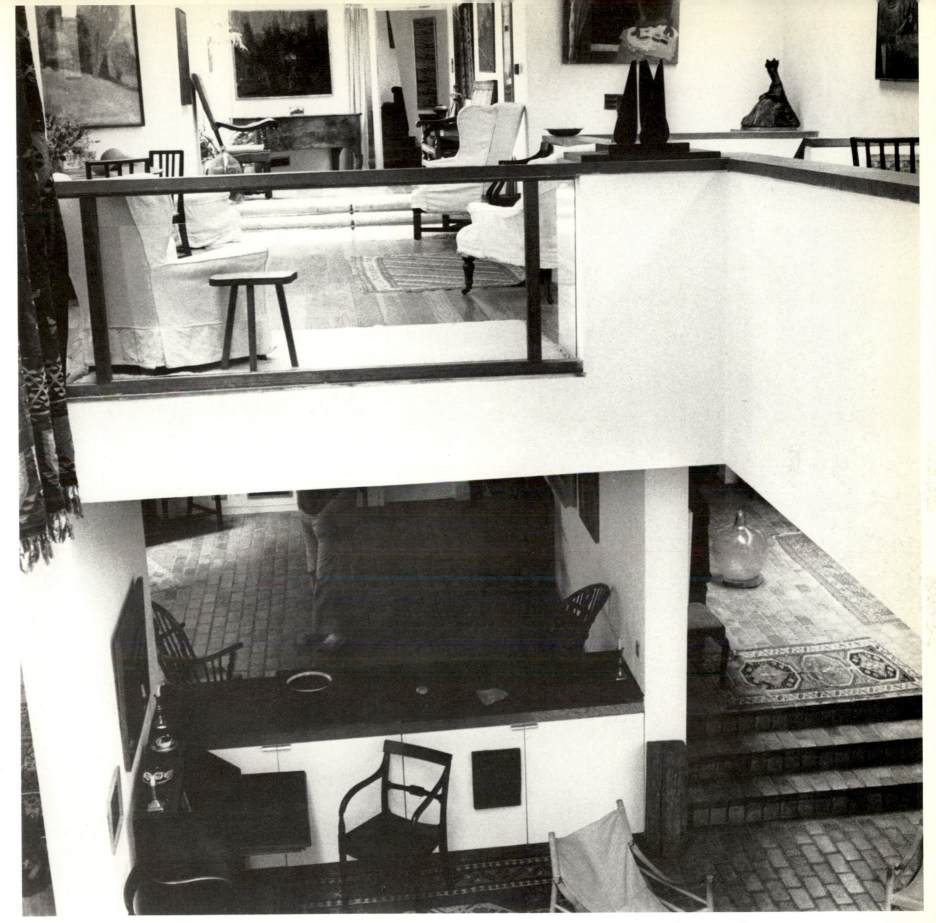

An unusual view showing the ingenuity of the architect in creating these varied areas. I think for concerts it is thought comfortable for 130 to sit below and 30 on the first floor. The sculpture, is Barbara Hepworth's 'Three Personages'. Downstairs is a carboy engraved by David Peace. He had hoped to make a play on the word Eden and the name Ede, in Latin; but found that Eden was a comparatively modern word, and at the time of his quotation would have been Paradise. I forget how he got around this.

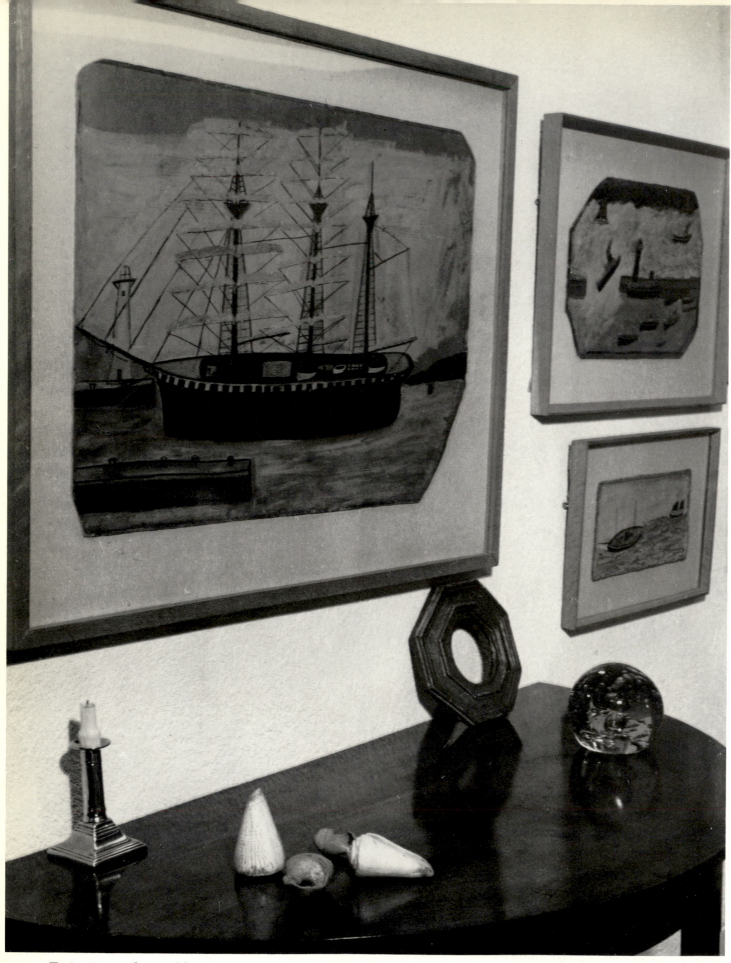

Paintings by Alfred Wallis. The little frame is Renaissance, and once belonged to Leverton Harris, and contained a drawing ascribed to Rembrandt of two angels. It was bequeathed to me. I gave the drawing to my brother, replacing it with an old convex glass mirror.

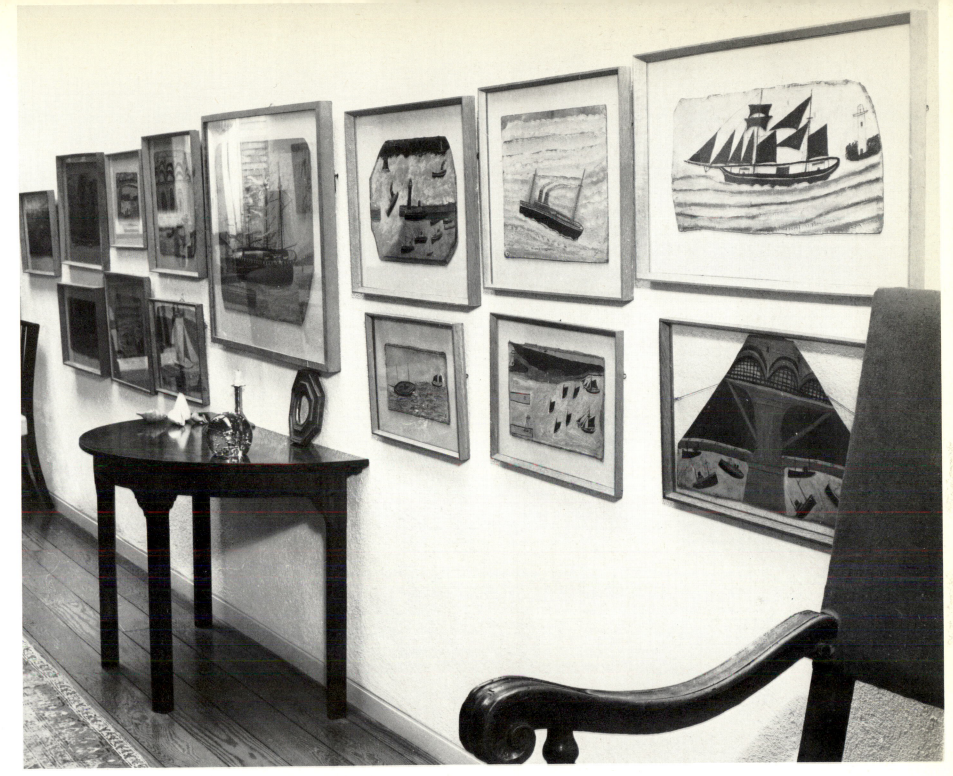

. . . for within the hollow crown
That rounds the mortal temples of a king
Keeps Death his court, and there the antic sits,
Scoffing his state and grinning at his pomp,
Allowing him a breathe, a little scene,
To monarchize, be feared, and kill with looks,
Infusing him with self and vain conceit,
As if this flesh which walls about our life
Were brass impregnable, and humour'd thus
Comes at the last and with a little pin
Bores through his castle wall, and farewell king!

Richard II

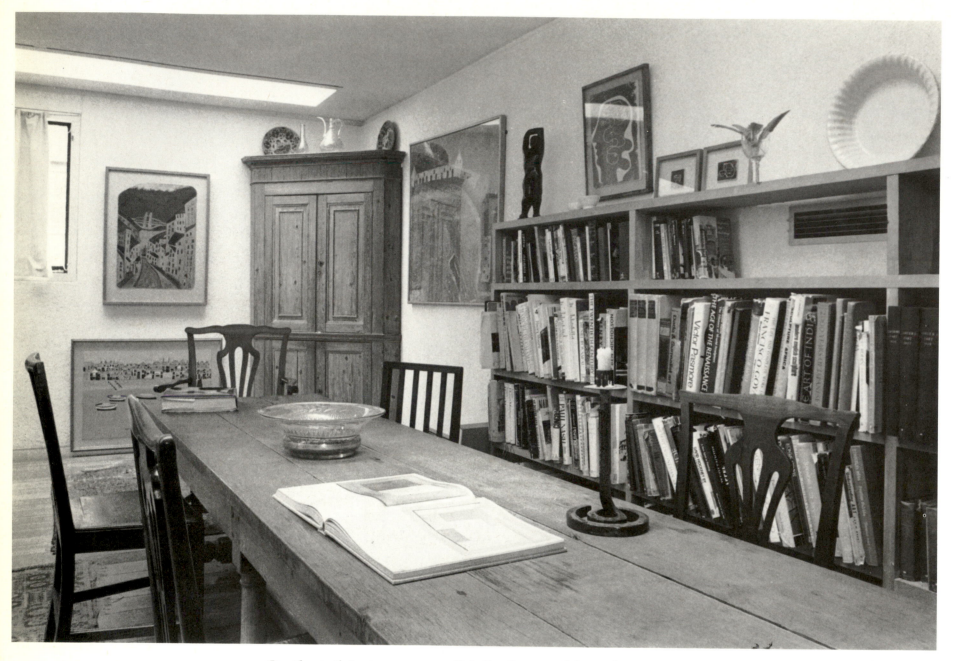

O, that this too too solid flesh would melt,
Thaw and resolve itself into a dew!
Or that the Everlasting had not fix'd
His canon 'gainst self-slaughter!

Hamlet

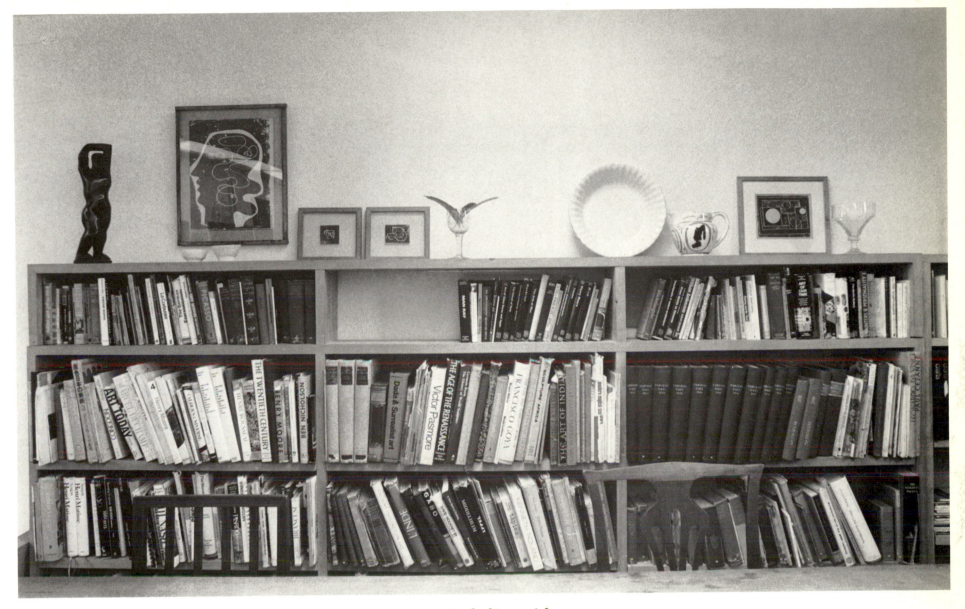

Canst thou not minister to a mind diseas'd,
Pluck from the memory a rooted sorrow,
Raze out the written troubles of the brain,
And with some sweet oblivious antidote
Cleanse the stuff'd bosom of that perilous stuff
Which weighs upon the heart?

Macbeth

If it is not necessary to change it *is* necessary not to change.
Viscount Falkland, seventeenth century

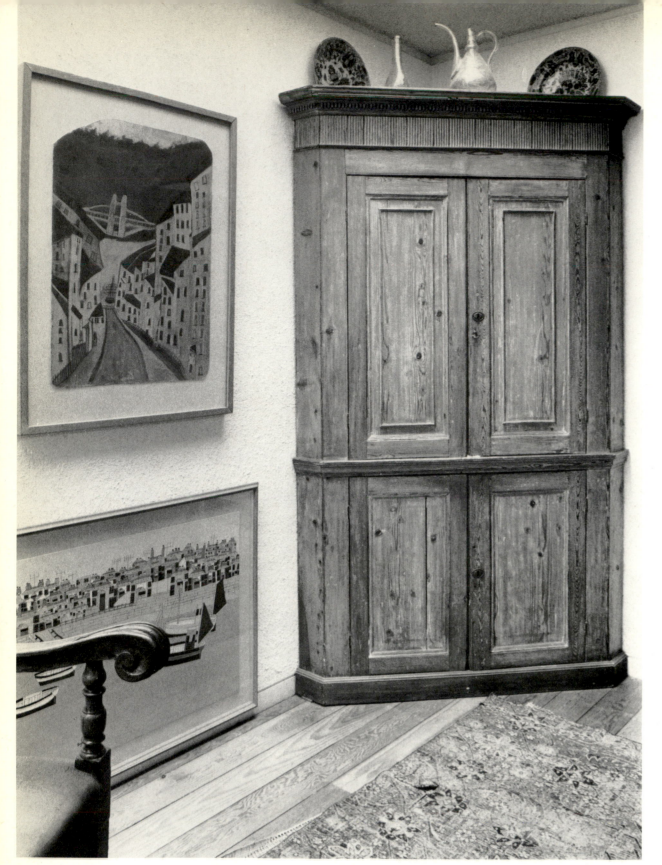

There is a rare beauty in the stripped woodwork of this eighteenth-century corner cupboard which combines so well both with the library table and the many varied things surrounding it. I have always been interested by the fact that it never looks closed when shut. On top are two glass vessels from the Kirby Green collection and two Peacock delft plates given to me by Charles Aitken, Director of the Tate Gallery, around 1930 when I was working there.

Psalm 23
A Psalm of David

The Lord is my shepherd; I shall not want.
He maketh me to lie down in green
 pastures: he leadeth me beside the still
 waters.
He restoreth my soul: he leadeth me in
 the paths of righteousness for his
 name's sake.
Yea, though I walk through the valley of
 the shadow of death, I will fear no evil:
 for thou art with me; thy rod and thy
 staff they comfort me.
Thou preparest a table before me in the
 presence of mine enemies: thou
 anointest my head with oil; my cup
 runneth over.
Surely goodness and mercy shall follow
 me all the days of my life: and I will
 dwell in the house of the Lord for ever.

The stairway leads from the first floor of the Extension to the ground floor. As I look up, Maitec's 'Radar' peeps over and a portion of Barbara Hepworth's 'Three Personages' can just be seen beyond the top step. On the right there hangs a beautiful Javanese painting on cloth of 'Heaven and Hell'. At its foot there is a comparatively small space giving access to the whole area of the Extension at this level.

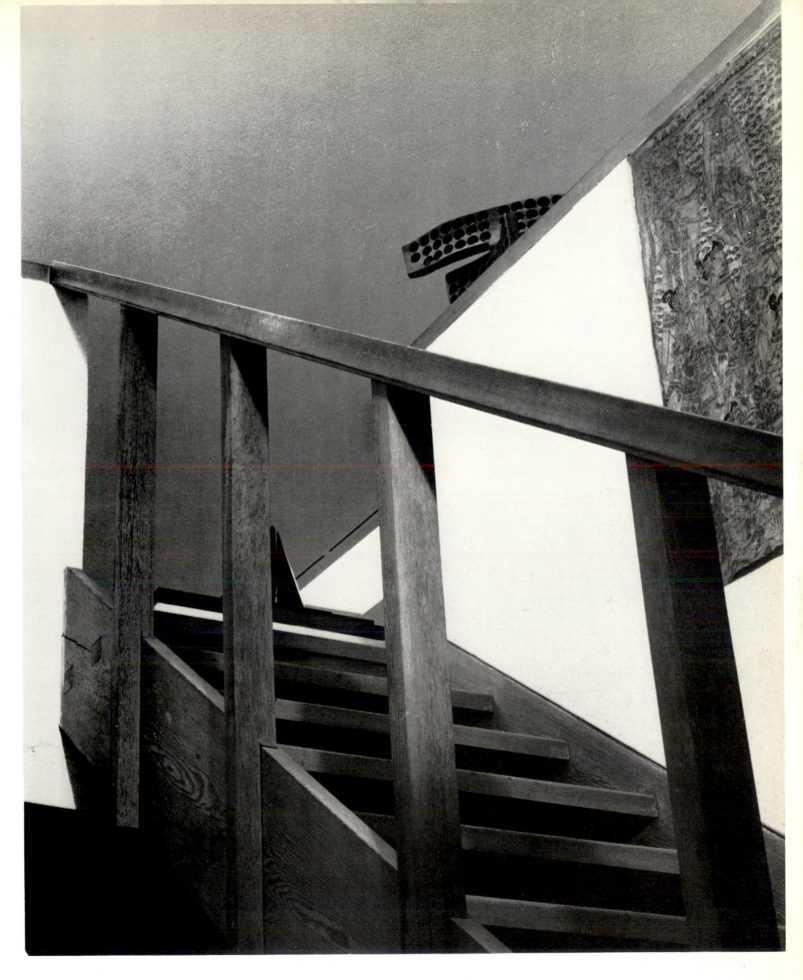

This Javanese painting came to me as wrapping for a number of paintings by the artist Ian Fairweather. His life is told quite vividly in *Portrait of an Artist* by Nouma Abbott-Smith. I had a good deal to do with him between 1928 and 1954, and so come into that book, so I need not tell of his wild exploits here (see note 5 on p. 240). The 'cloth' has always been very precious to me.

John Catto found this extraordinary bit of a burnt willow tree beside the Cam. He called it 'St Edmund'.

Thanks to his perception and generosity in giving it to Kettle's Yard I am able to introduce this formidable presence into this book. I should think it is very seldom that so remarkable a 'natural object' has been preserved.

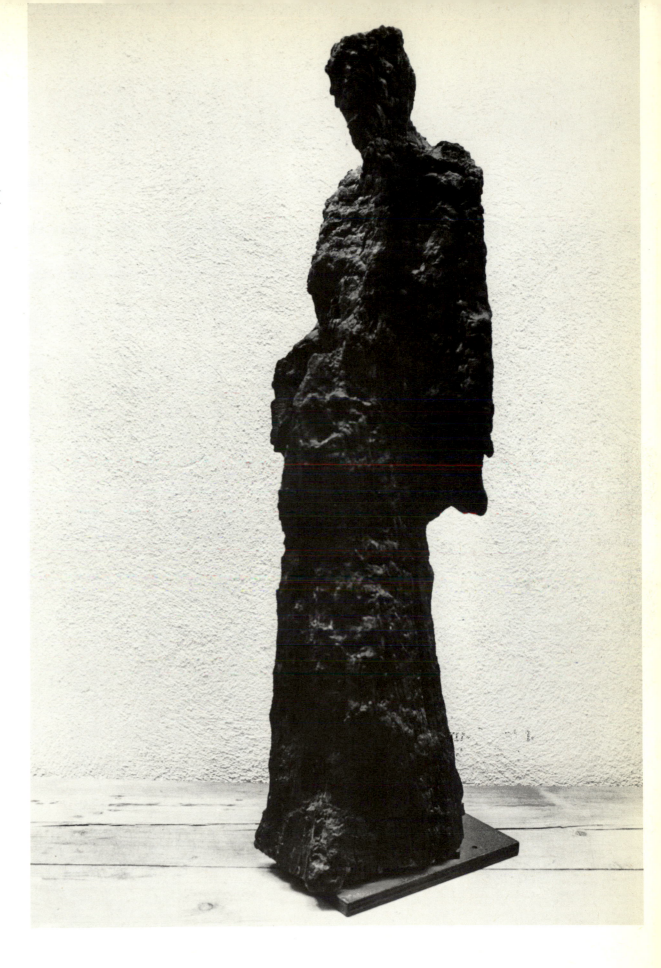

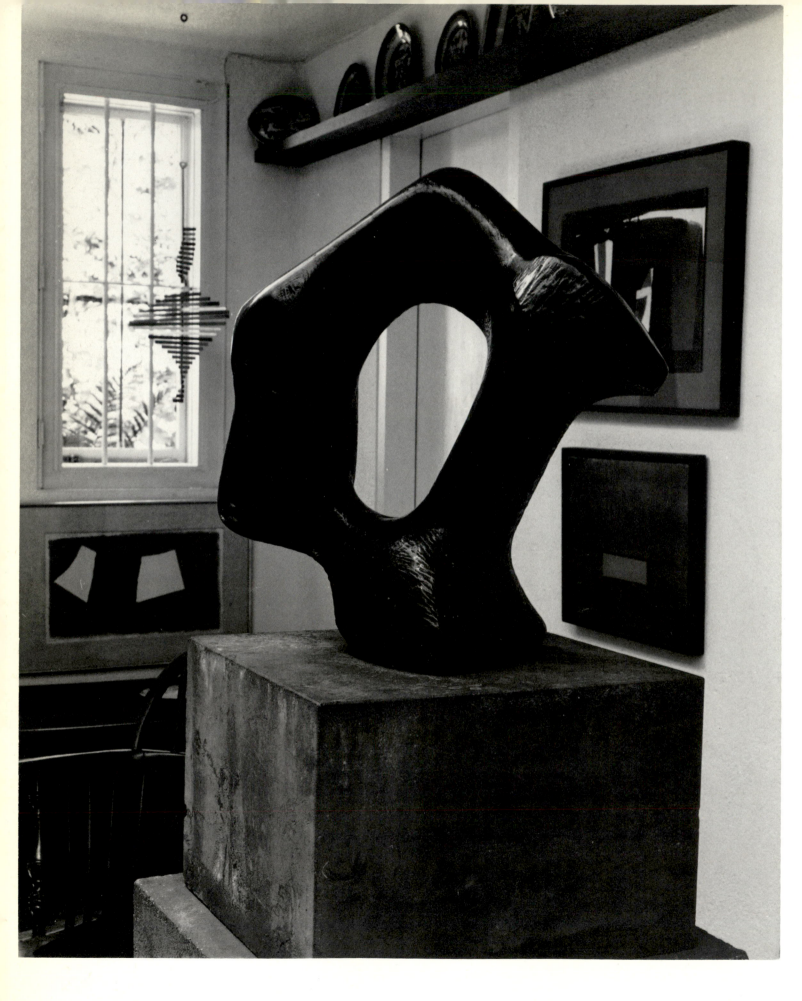

In the space at the foot of the stair there is ample room, not only for St Edmund, but for Henry Moore's 'Sculptural Object' which is quite massive, together with an ancient chest, three chairs, seven paintings by Italo Valenti, a mobile by Kenneth Martin, and a small collection of china. There is also a very beautiful painting by Bryan Pearce called 'The Queen Mary'.

The Henry Moore is wonderful to touch; sculpture should always be touched, at least in the mind, the hands exploring the miraculous continuity of planes, the coming together of masses. The work derives from some bone structure; perhaps the pelvis, but has so much more. The wonder of a circle, the nave of a cathedral, the constant interest of going through, the adventure of this side and that side and the dynamic magnetism of the whole.

Only by him with whose lays
shades were enraptured
May the celestial praise
faintly be captured.

Only who tasted their own
flower with the sleeping
holds the most fugitive tone
ever in keeping.

Make but that image the pond
fleetingly tendered
knownly endure!

Not till both here and beyond
voices are rendered
lasting and pure.

> Rainer Maria Rilke,
> *Sonnets to Orpheus*

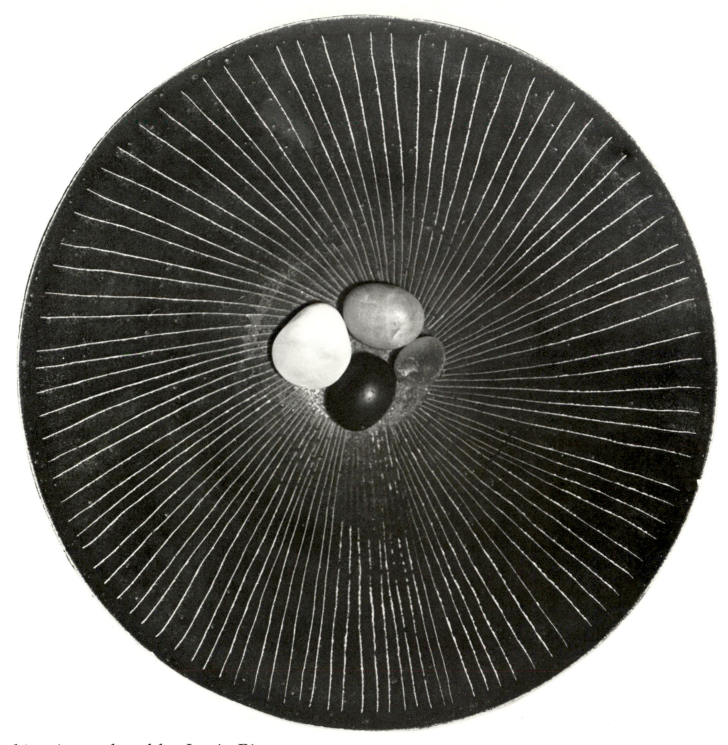

Looking into a bowl by Lucie Rie
The stones were my favourite pocket stones

VIII

Song of the soul that is glad to know God by faith

How well I know that fountain's rushing flow
Although by night

Its deathless spring is hidden. Even so
Full well I guess from whence its sources flow
Though it be night.

Its origin (since it has none) none knows:
But that all origin from it arose
Although by night.

I know there is no other thing so fair
And earth and heaven drink refreshment there
Although by night.

Full well I know its depth no man can sound
And that no ford to cross it can be found
Though it be night.

Its clarity unclouded still shall be:
Out of it comes the light by which we see
Though it be night.

Flush with its banks the stream so proudly swells;
I know it waters nations, heavens, and hells
Though it be night.

The current that is nourished by this source
I know to be omnipotent in force
Although by night.

From source and current a new current swells
Which neither of the other twain excels
Though it be night.

The eternal source hides in the Living Bread
That we with life eternal may be fed
Though it be night.

Here to all creatures it is crying, hark!
That they should drink their fill though in the dark,
For it is night.

This living fount which is to me so dear
Within the bread of life I see it clear
Though it be night.

 St John of the Cross

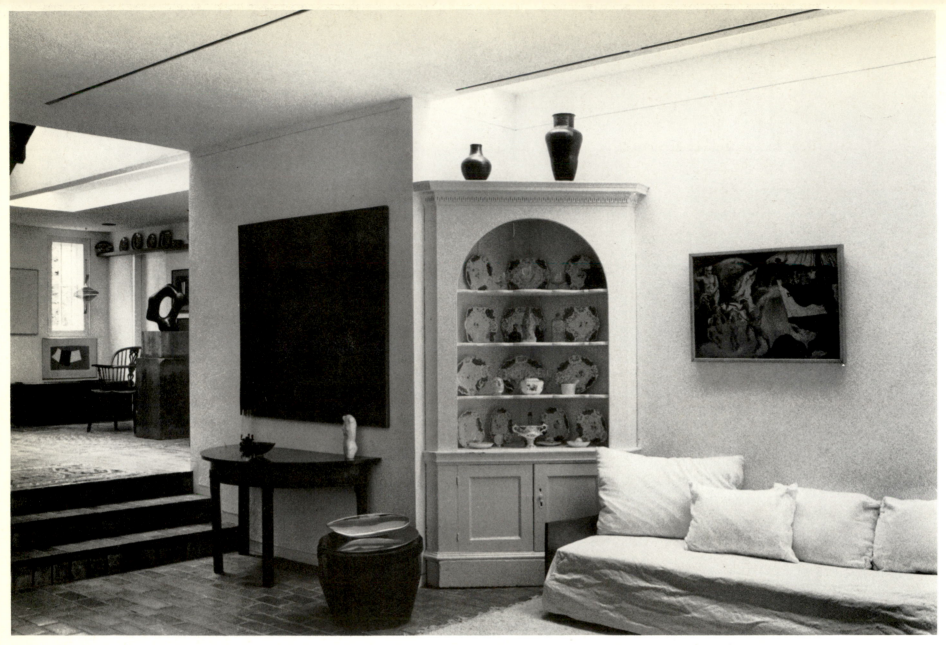

The stairs leading down to this ground floor are on the left just beyond this photograph. What is shown here gives a good sense of the spaciousness I wrote about a few pages back. Beyond the foot of the stairs is an opening leading to a much larger space which overlooks the main room and has on its far side three steps which balance the ones above. So visitors can circulate from one side to the other. The window in the distance looks onto a small courtyard outside a separate building for loan exhibitions organised by Kettle's Yard and the Arts Council.

The semi-circular table beneath a dark painting by Congdon, is the fellow to one upstairs in the Alfred Wallis passage. They could be the ends of a long table or a simple bridge table.

The corner cupboard is eighteenth century and was in so dilapidated a condition that the owner let me have it for £10 in 1969. I felt sure that, by cutting it here and there, I could fit it into this corner where it has become a living point in the room emphasising the fine lighting of the room. The smaller of the two pots on top, by Staite Murray, belonged once to Winifred Nicholson and the other we had with us in Morocco and France. It got broken by a severe frost in France.

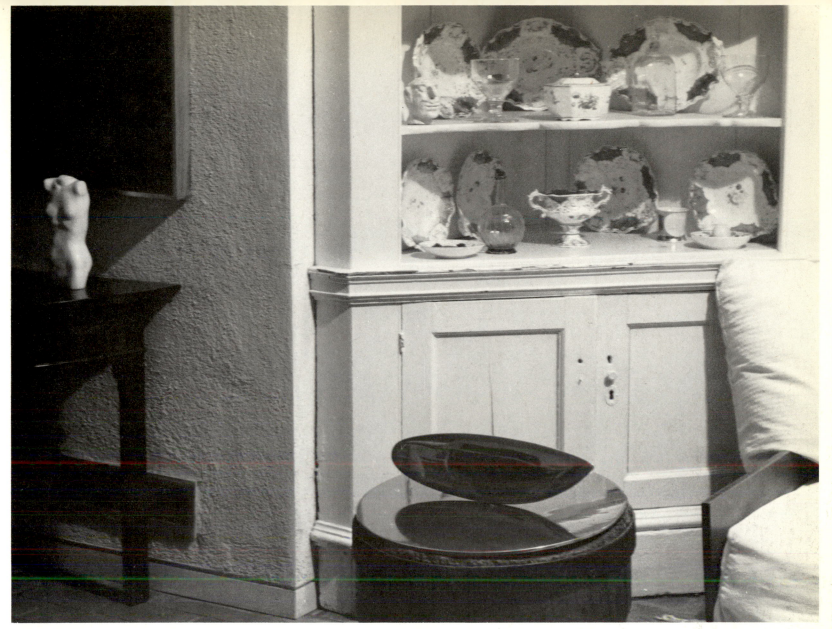

The thirteen blue and white plates were made for Trinity College, Cambridge, by Copeland and Garrett in *c.* 1820. They were in use at Trinity during the First World War while I was for a short time training cadets. The memory of them was of great comfort to me in the heat and distress of India where I went for the last year of that war. Their ineffable blue reminded me of skies painted by Tintoretto. Since I obtained them, together with many more, my family and I have put them to continued use. This will have been since 1923. There are many loved things on the shelves of this cupboard.

The 'Torso' to the left is a cast made from the marble statue carved by Gaudier-Brzeska, now at the Victoria and Albert Museum.

The placing of two beds, end to end, to make a long couch I first learned at Elm Row when we had moved into a small part of it. The room was narrow but long and at one end had a 'William and Mary' window with balcony – see Interlude II.

'Fish' is a cast made from Brancusi's original which I part gave, part sold to the Museum of Fine Arts in Boston. A little of the money restored St Peter's Church, and the rest formed a travel scholarship for the School of Architecture in the University of Cambridge.

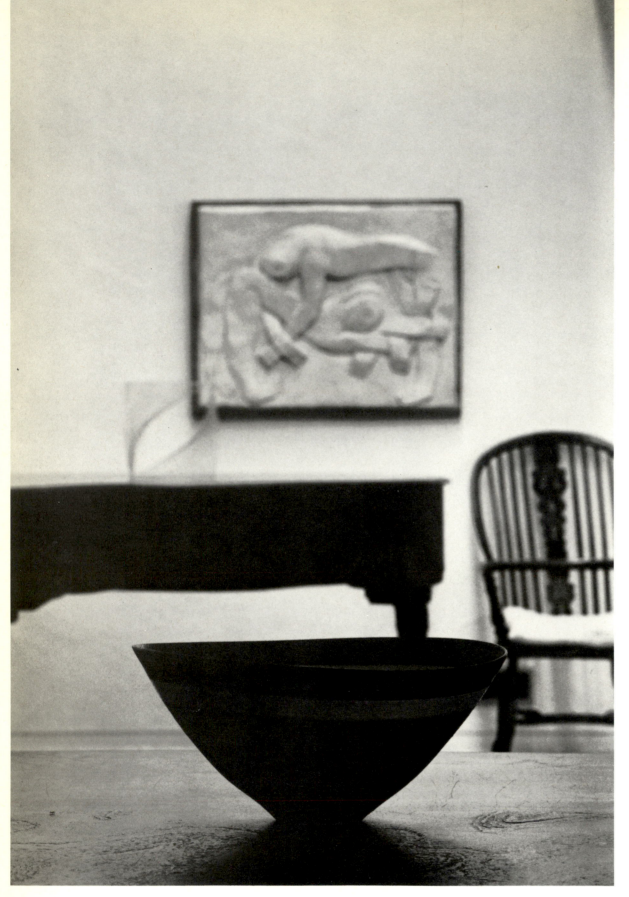

Bowl, Lucie Rie
'Construction', Naum Gabo
'Wrestlers', H. Gaudier-Brzeska

Now there are diversities of gifts, but the same spirit.

And there are differences of administrations, but the same Lord.

And there are diversities of operations, but it is the same God which worketh all in all.

But the manifestation of the Spirit is given to every man to profit withal.

For to one is given by the Spirit the word of wisdom; to another the word of knowledge by the same Spirit; . . .

To another the working of miracles; to another prophecy: to another discerning of spirits; to another divers kinds of tongues; to another the interpretation of tongues:

But all these worketh that one and the selfsame Spirit, dividing to every man severally as he will. St Paul

He that soweth little shall reap little; and he that soweth plenteously shall reap plenteously. Let every man do according as he is disposed in his heart; not grudging, or of necessity; for God loveth a cheerful giver. St Paul

. . . God, unto whom all hearts be open, all desires known, and from whom no secrets are hid; cleanse the thoughts of our hearts by the inspiration of thy Holy Spirit, that we may perfectly love thee . . .

Book of Common Prayer

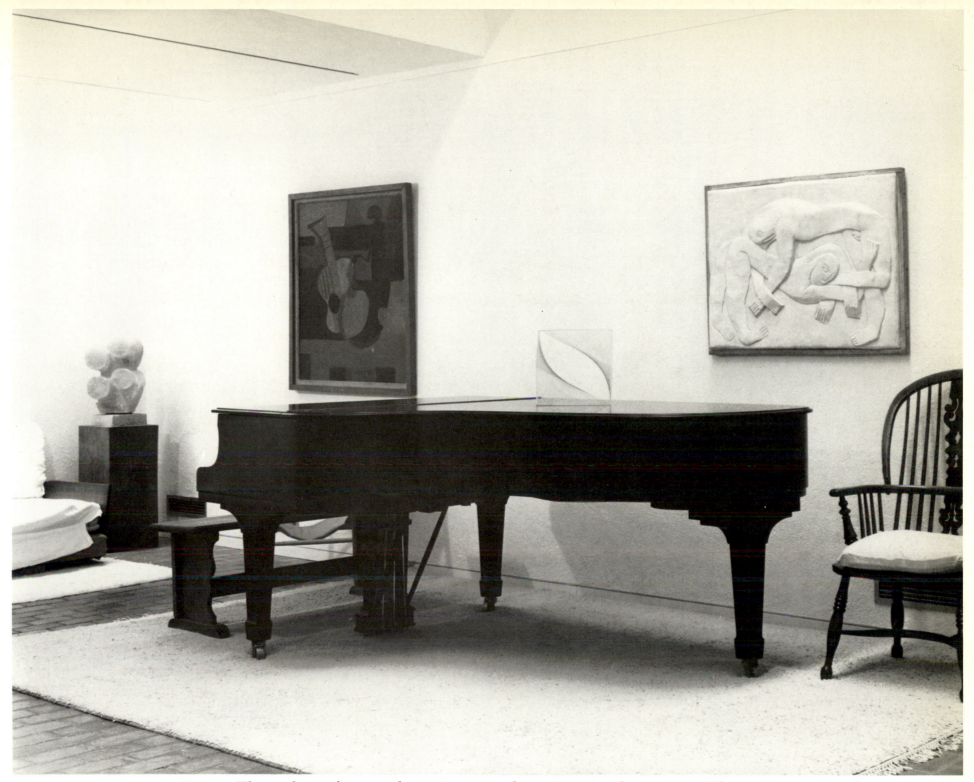

Every Thursday of term there is a good concert in this room. The space around spreads out in all directions as will be seen, and 160 people can be comfortably seated. Music plays a large part in the life of Kettle's Yard; even to look at the photograph of the 'Steinway' evokes the thought of music in that particular setting. Musicians say 'You haven't played until you have played at Kettle's Yard.' This got around London, greatly to our advantage. The Gulbenkian Foundation gave the piano, and the acoustics are superb, perhaps because no one knew that the place was being made for music.

The large eighteenth-century goblet in the foreground is standing on a wide platform of black slate dividing one area from another. Over on the left is Ben Nicholson's 'Two Guitars'.

We had this painting with us in Tangier where we lived for a time. In 1945 and 1946 we had a visit each week of five soldiers who came for five days, from Gibraltar. Saturdays and Sundays were free, Saturday a 'flop' day and Sunday a day of cooking and general preparations for the next five who arrived on Monday.

I had built on the roof of our house a large play-room with five bedrooms opening into it.

The painting by Ben Nicholson hung there and was a great puzzle to our guests until I told them that it represented two drunken sailors. They picked up the rhythm at once.

A very short story always remains with me. An Englishman in India had gone for a few days on safari, taking with him six bearers to carry all his belongings. After three days of hard going the bearers all sat down and no persuasion would induce them to move. 'Have I done anything you don't like?' asked the Englishman. 'O no Sahib, Sahib has been very kind, but we have gone so fast that our souls have been left behind, we are waiting for them to catch up with us.'

Again in India, but in the early sixteenth century, Babur the first of the Mogul Emperors was taking upon himself the approaching death of his son. This meant walking round and round his son's bed, with constant prayers until this happened. His courtiers begged him to desist, eventually suggesting that he should give God the Koh-i-noor instead. Babur replied, 'What! Shall I offer a stone to my God?' and continued his prayers. He died and his son recovered.

I had become friends with Naum Gabo and his brother Pevsner in Paris around 1923 or 1924. I had found them in a garret almost in the sky – they were making a model for a construction perhaps 40 cm high which they hoped to have placed in the Champs Elysées, but then it would be 100 metres high. It would be in perpetual movement. I don't think this was ever made.

One day, perhaps in 1960, a friend got caught in a traffic jam; she looked up and found she was just outside Kettle's Yard. 'Just the place for Frankie's Gabo', so she edged in towards the pavement, got out and came to our door. I was out shopping so Helen Ede answered the bell when it rang. 'Would you like a Gabo?' said Joy Finzi, for it was Gerald Finzi's widow who had rung. 'Yes indeed' said Helen Ede, 'but we could not afford it'. 'Oh that's all right, I want to give it.' At this point I returned and in course of time the Gabo became ours.

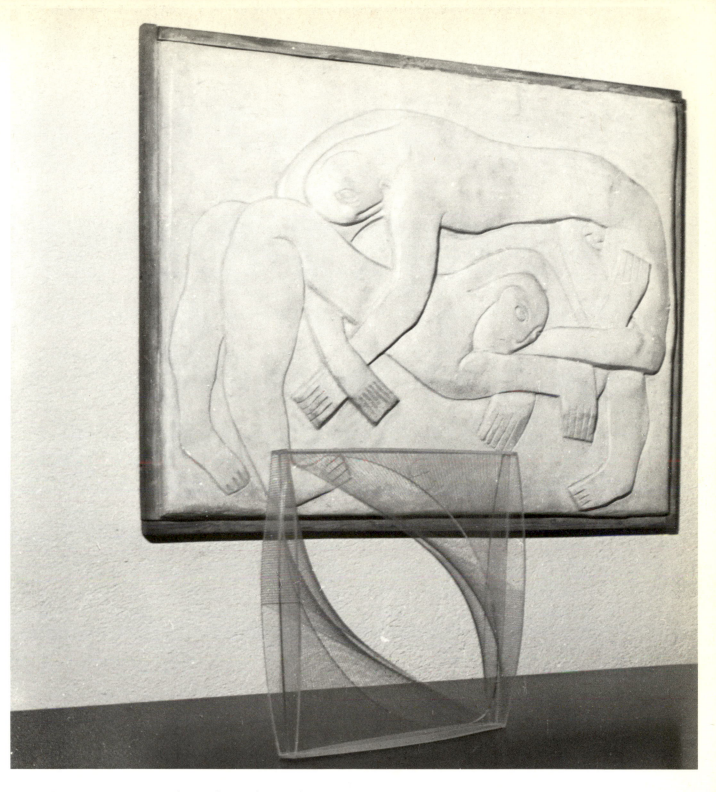

It was made in perspex in 1941. It is strung with nylon thread so that straight lines seem to curve into circles, an illusion since each thread runs direct from point to point. Behind it is a cast of Gaudier-Brzeska's 'wrestlers'.

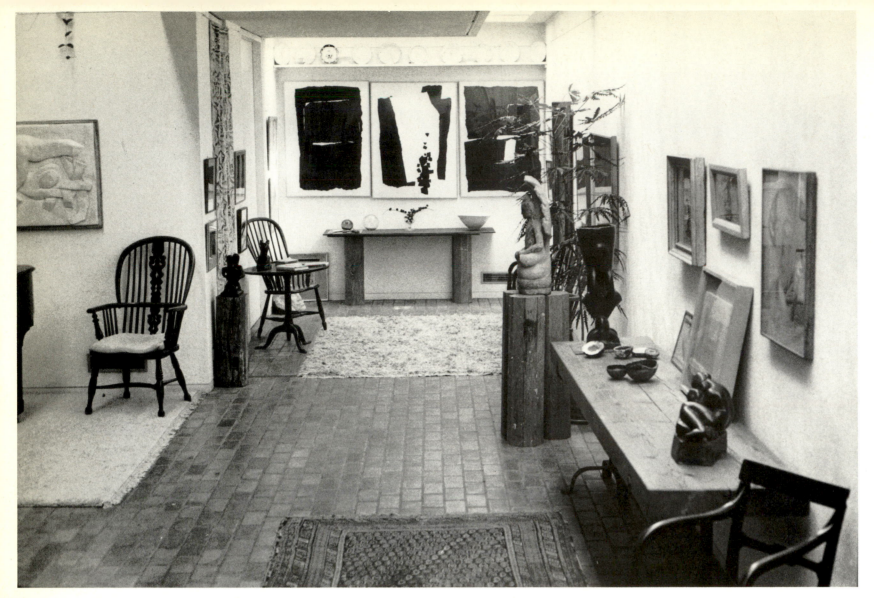

Two views left and right seen from a position near the Steinway piano. The two long planks, now forming a table, were in 1968 one plank which held up the tin roof of the large workshop which then occupied this site. I got someone to make the iron supports. The rug in front of this table is from India and was given by Lt Colonel Justin Hooper.

Who walked between the violet and the violet
Who walked between
The various ranks of varied green
Going in white and blue, in Mary's colour,
Talking of trivial things
In ignorance and in knowledge of eternal dolour
Who moved among the others as they walked,
Who then made strong the fountains and made fresh the springs

Made cool the dry rock and made firm the sand
In blue of larkspur, blue of Mary's colour.
Sovegna vos

T. S. Eliot, *Ash Wednesday*, 1930

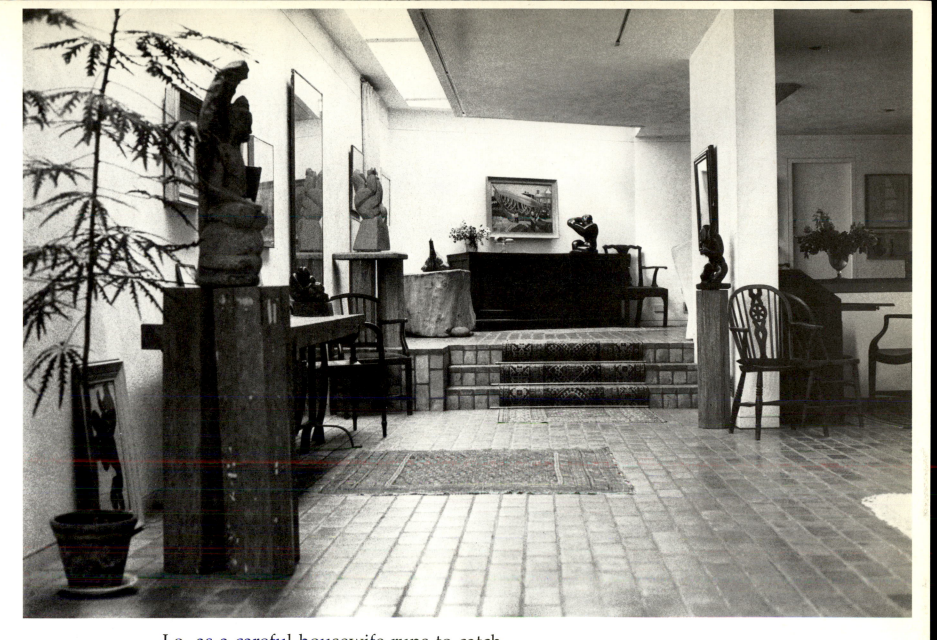

Lo, as a careful housewife runs to catch
 One of her feather'd creatures broke away,
Sets down her babe, and makes all swift dispatch
In pursuit of the thing she would have stay;
Whilst her neglected child holds her in chase,
Cries to catch her whose busy care is bent
To follow that which flies before her face.
Not prizing her poor infant's discontent;
So runn'st thou after that which flies from thee,
Whilst I thy babe chase thee afar behind;
But if thou catch thy hope, turn back to me,
And play the mother's part, kiss me, be kind;
 So will I pray that thou mayst have thy 'Will',
 If thou turn back and my loud crying still.
Sonnet

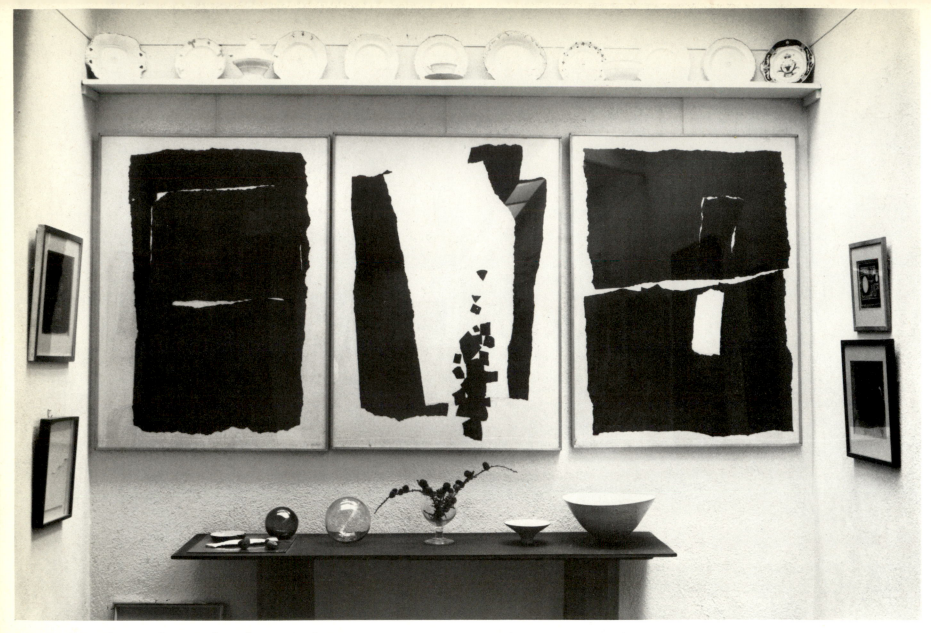

The china above the three Valentis was in constant domestic use for the previous
forty years until I impounded it to furnish this shelf.

My introduction to these collage works was a tremendous event. Ben Nicholson
had sent me a return ticket to see the Documenta III Exhibition in Kassel where he
had a room devoted to his work, and also a great Wall placed somewhere in the
grounds. I had gone over for two days and found these works by Valenti. There were
five, and they became a part of my life.

Black became really black, and white had infinite variety. The skill and sensibility
with which these pieces of paper were torn, left me amazed.

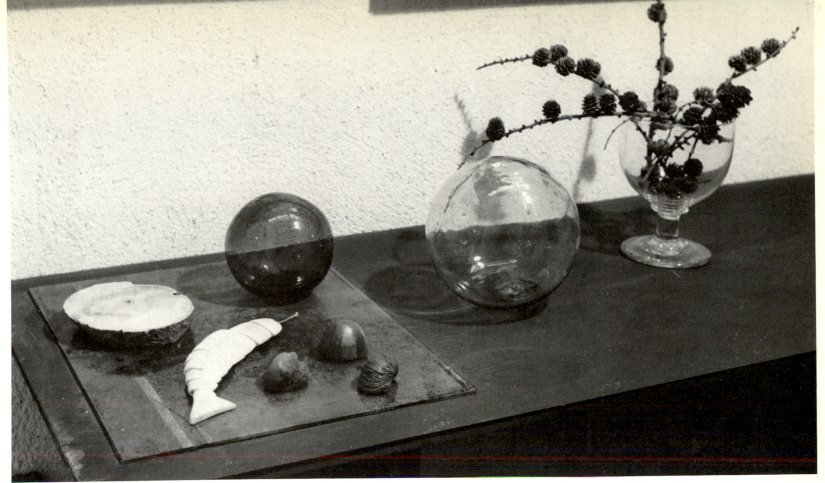

The white fish was cut by John Clegg from his mother's marble washstand. He had been travelling in Persia where he had found small versions cut in this way, and called 'Fiddle fish'. The glass floats were seen previously; for me they are things full of mystery, the light of the world, the substance of art. Old Alfred Wallis would call them 'they glass balls'.

'O Almighty God, who alone canst order the unruly wills and affections of sinful men; grant unto thy people that they may love the thing which Thou commandest, and desire that which Thou dost promise; that so among the sundry and manifold changes of the world, our hearts may surely there be fixed, where true joys are to be found.'

Collect

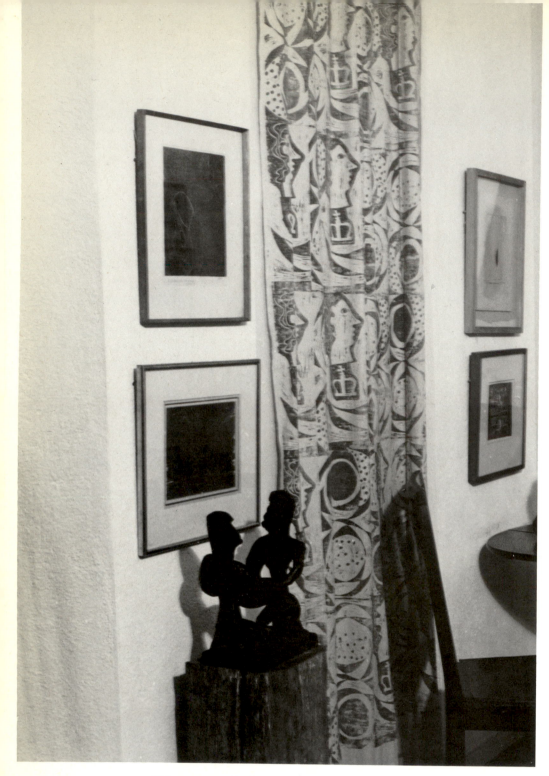

'Kings and Queens', one of Ben Nicholson's
many curtains created in the Mid-twenties.
Two pictures left: Naum Gabo, Marino
Marini; right: Ben Nicholson. 'Two men with
a bowl', H. Gaudier-Brzeska

Encounter
To Helen

Clear water pooled in light
seas stretched out, dark the white sand;
and in the wood a silence folds us.

This recurring adventure is always new
timid action floods the body
holds thought in conquest, fearful the
heart
but sure,
as a day breaks.

Ever there is this striving
gentle
fabric of air
iron substance of spirit

You were always there and I in you, but you
not knowing you that I invaded, nor you the I
that you persuaded.

One year a touch of hand
scarce touched,
the next a look
long landscapes of the soil of England
your eyes inhabited.

In you forgetting, the seasons growing,
year follows year, old friendships hid,
frustration nurturing a flame;
in me a space for your receiving
enveloped
lifted
and you came, you came.

 Anon.

Christopher Wood's 'Self Portrait'
(see Biographical Notes)

Three works by Ben Nicholson.

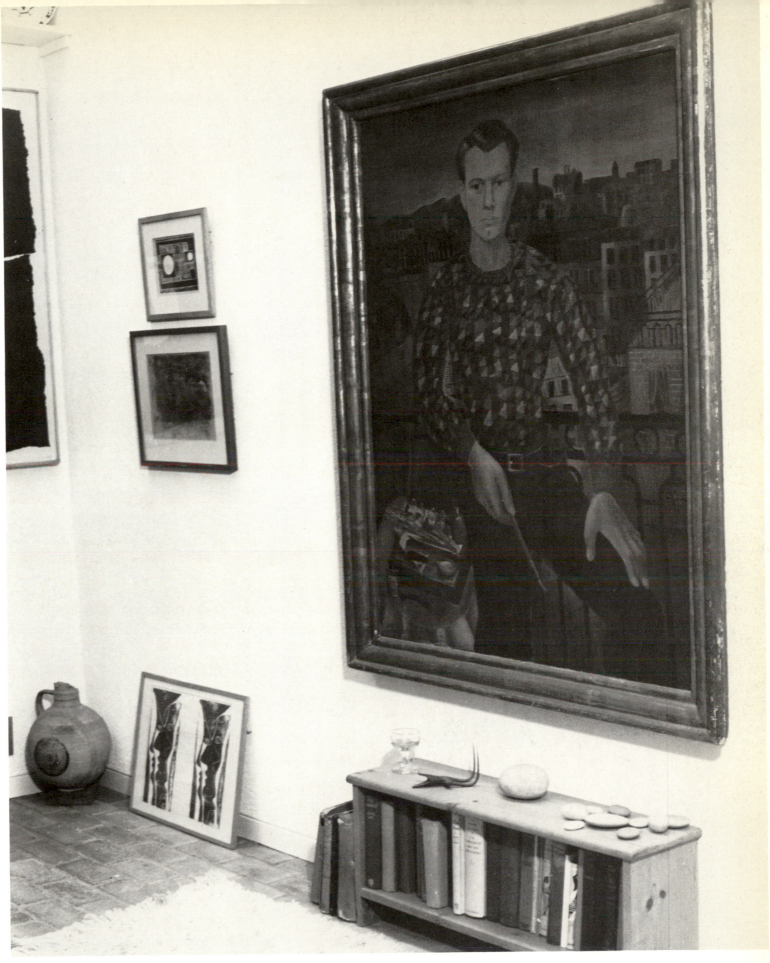

Jar from Crete, 800 B.C.

Books relating to T. E.
Lawrence to whom I
owe a great debt.
Without his example to
guide me I probably
could not have given
away Kettle's Yard.

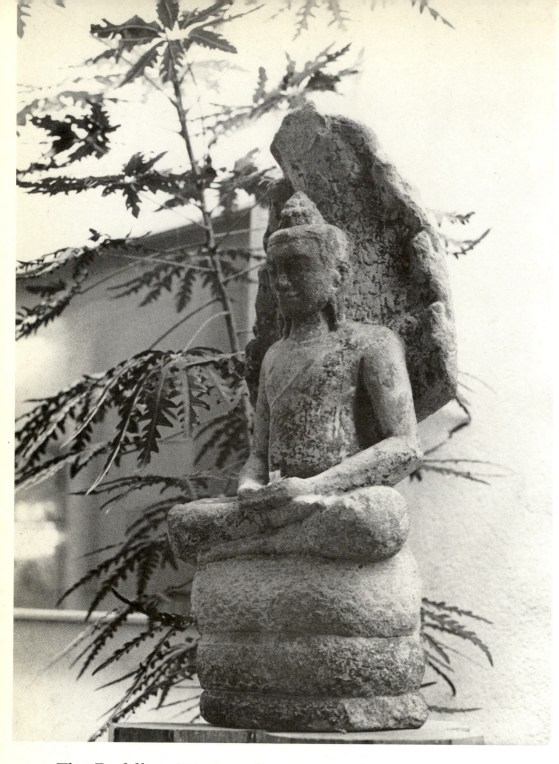

The Buddha preached absolute Truth 'which alone can conquer the evils of error'.

Truth is best as it is, no one can alter it, neither can anyone improve it.

Purify your hearts and cease to kill.

Give up hatred and ill will, this is true worship.

Be ye lamps unto yourselves,
Be your own reliance,
Hold to the truth within yourselves
As to the only lamp.

(In Christianity this lamp would probably be the indwelling God.)

For Buddha there was one absolute and factual Truth – namely that humanity suffered; and his life was occupied in searching for the cause of that suffering and for the way to eliminate it.

Truth is mind when it walks in the path of righteousness.

I see no other single hindrance such as this hindrance of ignorance, obstructed by which mankind for a long time runs on and circles on.

When the objective sphere of thought disappears, the objective which one could designate has also gone.

The Buddha sitting under a tree is from Siam (Thailand) and comes from the Khmer Temple P'ra Prāng Sām Yot at Lopburi, and dates from the thirteenth or fourteenth century, opinions differ. When the Khmers were overrun by the Thais, a great many of the Khmer statues of Buddha were destroyed as being unorthodox, but later generations found it more economical to alter the Buddha's features, sharp noses not blunt ones for instance, and then to cover it all with a black lacquer which they gilded; so the Khmer Buddha was transformed into a Thai Buddha. Later again the Khmers came back into power and all they needed to do was to remove the Thai lacquer and their own Buddhas were restored. This was, all the same, quite a difficult process and some of the Thai black lacquer remained with a rose-pink Khmer stone shining through.

But they who know fine-materiality, not remaining in immateriality,
They who are freed by cessation –
These are the folk that leave death behind.
Having in his person attained the
Deathless element which has no 'basis',
By making real the casting out of 'basis',
The Perfect Buddha, of no outflows,
Teaches the griefless, stainless state.

Gautama Buddha was a man, whose dates are generally given as 563 B.C. to 483 B.C.

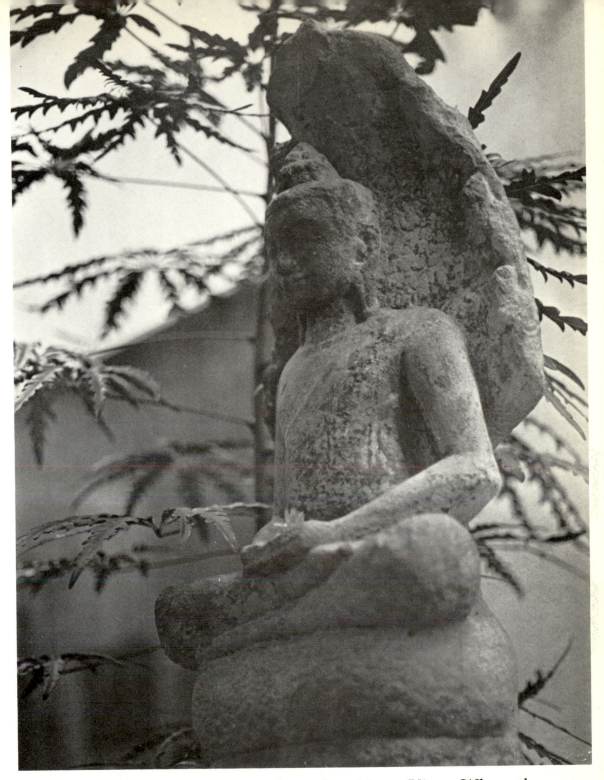

The Kettle's Yard Buddha is represented as seated on the cobra Naga King. When the sun got too hot Naga King raised its hooded head to shield Buddha from the sun's rays. The extremity of the cobra's head has been lost.

As I look at this statue I am very conscious of its blending immobility with activity. Easterners say that the greatest activity lies in inactivity and surely such a Buddha as this sits beyond time in its pose of calm, and emanates an ever-increasing power. As I put a flower in its hands someone standing near said 'Buddha is smiling.'

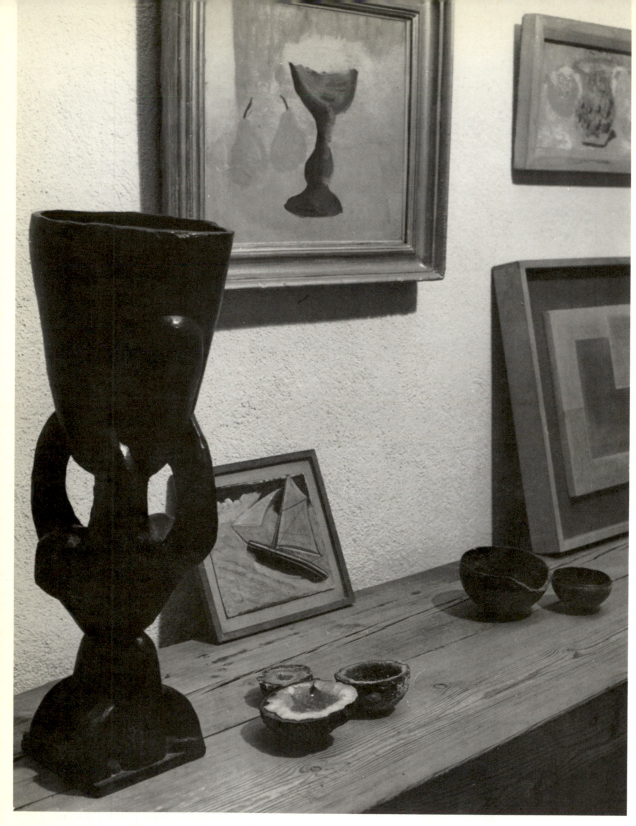

'Garden Ornament', H. Gaudier-Brzeska;
Ben Nicholson, Alfred Wallis, 3 Geodes, two Minoan bowls,
Cretan civilization (3000–1500 B.C.) named from King Minos.

We wax for waning
Count, though, Time's journeying
As but a little thing
in the Remaining.

End of unmeasured
hasting will soon begin;
only what's leisured
leads us within.

Boys, don't be drawn too far
into attempts at flight,
into mere swiftness – look

How rested all things are:
shadow and fall of light,
blossom and book.
Rainer Maria Rilke,
Sonnets to Orpheus

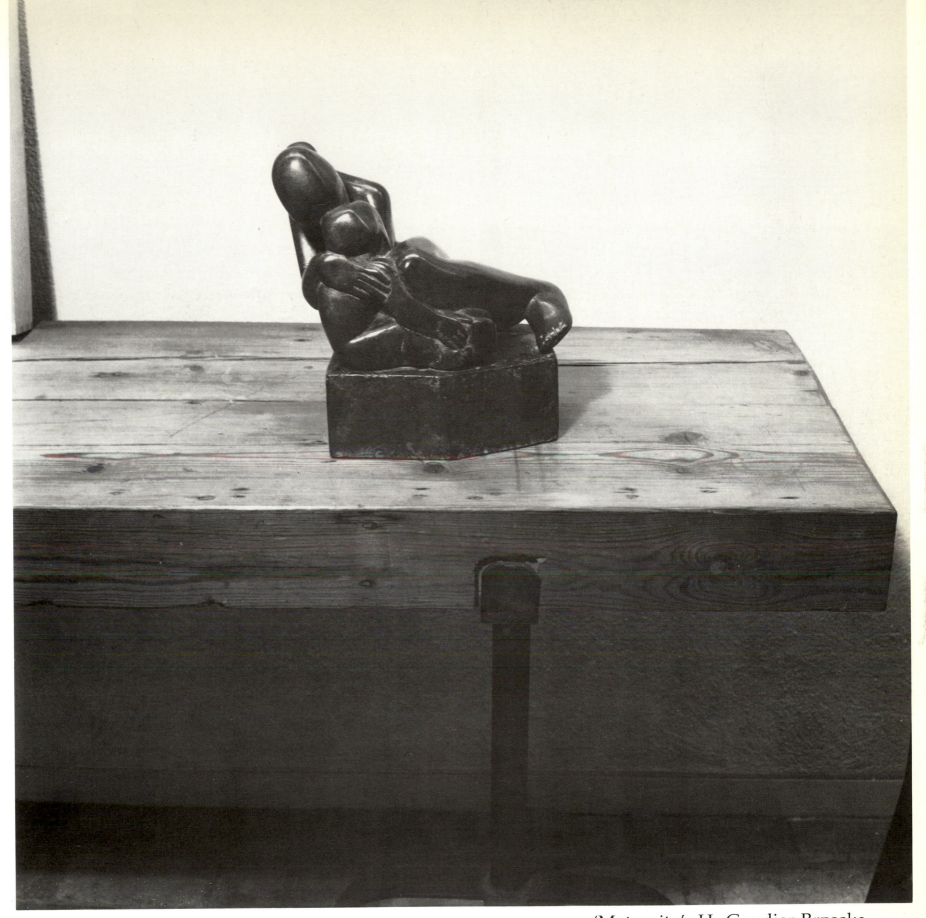

'Maternity', H. Gaudier-Brzeska

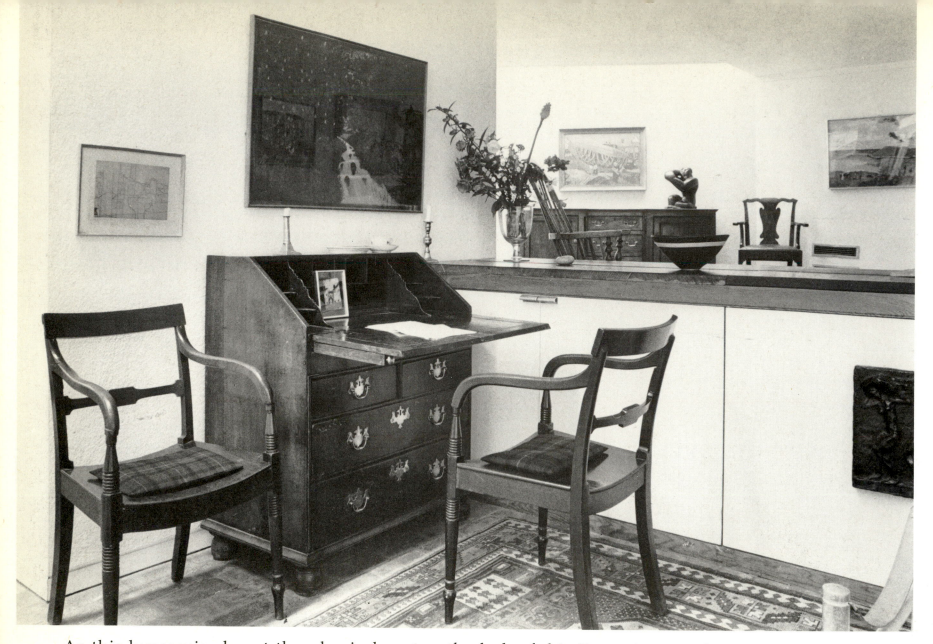

As this bureau is almost the physical centre, the hub of this Extension; so the picture above it could be said to be the hub of painting, the source. It is called 'The Glen' and was painted by a boy of twelve called Winston McQuoid.

I met him when he was fifteen and he had just painted another remarkable work 'The Round Pond, Kensington'; and 'The Glen' hung in his home. He hadn't much idea of what he was doing, it was all just part of his life. His mother thought him a second Jesus Christ and I thought he might be Great Britain's Douanier Rousseau.

When I think it the source of painting, I see it as that urge to convey the sight, the sound, the life of something that has held possession of the poet's heart. For the boy Winston this place had become his inward home and with a total innocence of all endeavour or contriving he conveys this thrusting up of trees in his dear land, his darkness and the mystery within these shadowed trees and the brightness of light beyond and this ever-rushing stream. Who could do such a thing better?

I found in my London days that all the artists who frequented One Elm Row (see Interlude II) had joy of this painting; it in no way competed with theirs, they each

had their way of doing what they did, while here there was no way.

His mother died and he was alone, always a little ill. More and more he looked to Constable as his guide and produced endless landscapes, seascapes, skies; but never again with this direct insight.

I tried to get him commercialised, but had little success; he was still far better than the daubs which sold by the million. He could not carry things through.

He often came to see me at Kettle's Yard, always with umbrella, bowler hat and striped trousers, and a small Gladstone bag. I got his paints for him since he thought that artists' material could only be got at one particular shop in the West End, and though he lived in London he found it simpler to come to me in Cambridge.

Finally at perhaps sixty he went to make a fortune in Ireland. I got one letter, no address, and have never heard of him again.

The bureau on the left is an exceptionally handsome one; it and the chairs were given to us by the Gulbenkian Trust. I would separate those chairs, they are too matey.

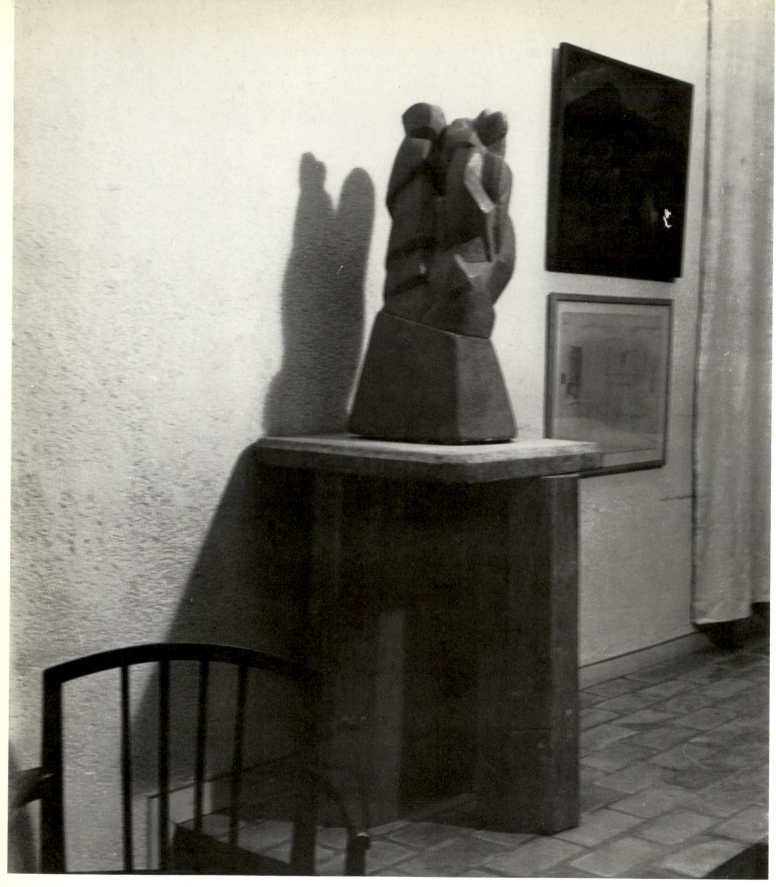

I sold this very early in my concern with Gaudier-Brzeska to a rich lady in New York for £70. Years later I found it lodged behind coats, hats and umbrellas in a cupboard kept for such things. I asked if she would sell it back to me since she did not like it, but no, it had suddenly become precious and she gave it to the Museum of Modern Art in that city. So it at last got to where I had originally hoped it would be. As I write I am wondering if she did not get it at a sale – perhaps the Quinn Collection. Anyhow New York very kindly sent me a cast which Kettle's Yard now has.

It is one of his last works, perhaps the last, and has this vertiginous feeling of birds nested on a cliff's edge.

'Birds Erect', H. Gaudier-Brzeska

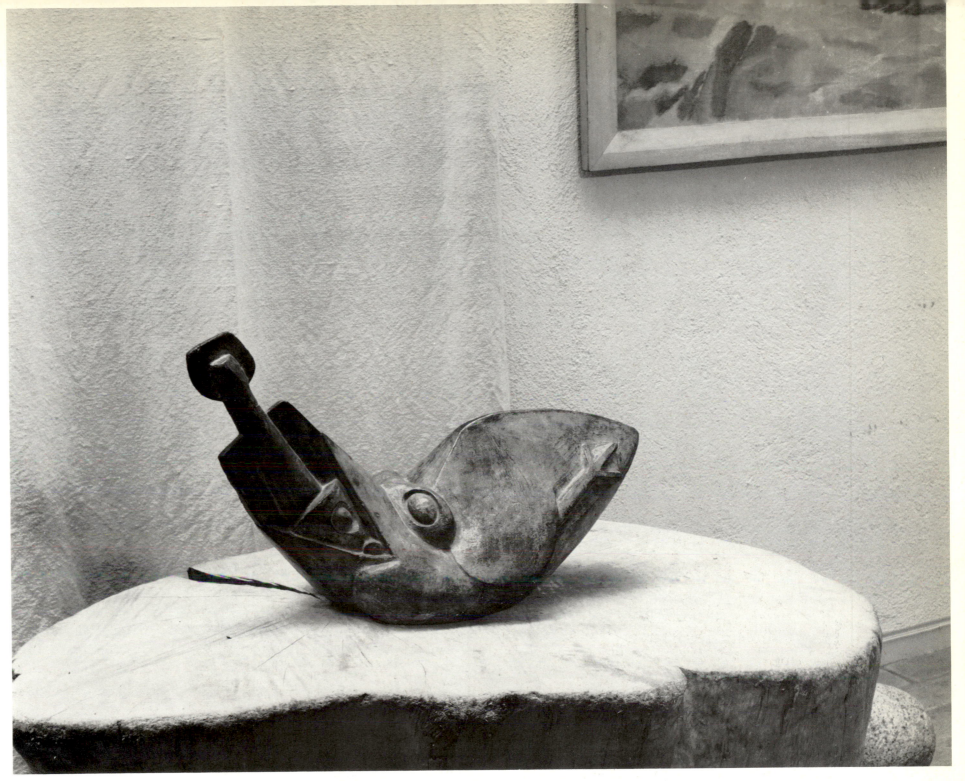

'Bird Swallowing a Fish', H. Gaudier-Brzeska, 1914

This is an example of how Gaudier-Brzeska used plaster to build up and carve a statue. He would of course have liked to be cutting it direct in stone but had no means with which to buy it. This particular work, so unlike anything done by others at that time, surely shows forth the cruelty of war and yet is so much more a statement of sculpture than of war.

It is placed on a great plinth of wood which I found one day newly washed up on one of the beaches of the Scilly Isles. It was part of a wreck around 1910 of wood brought from Canada and makes a lovely base for this sea-work. Gaudier at one time called it 'The Sea Bird'.

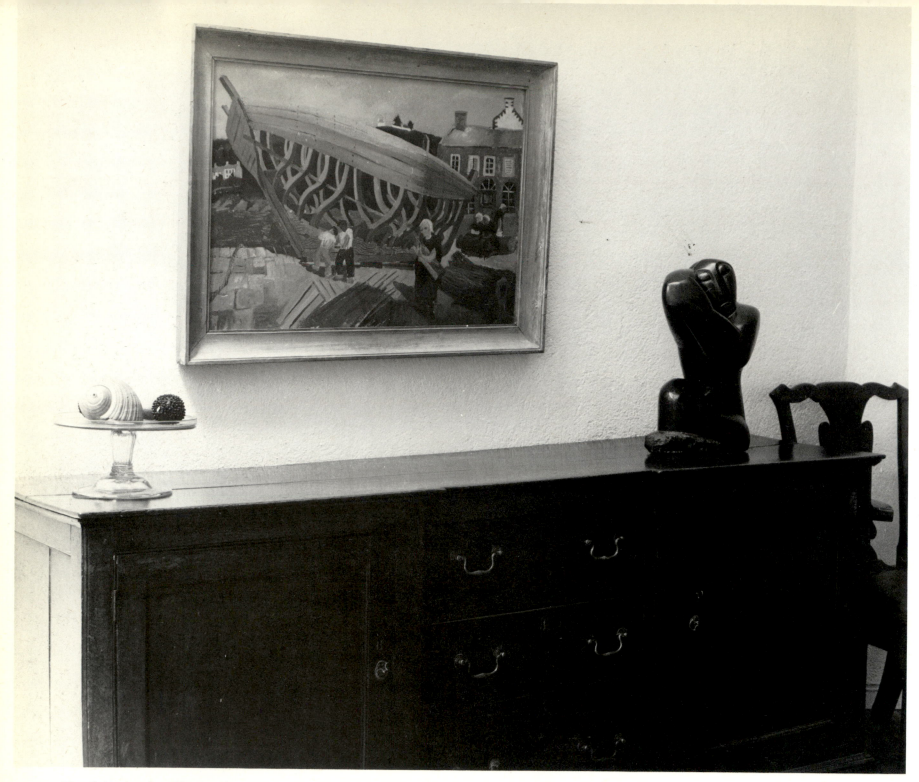

'Building the Boat' by Christopher Wood, and 'Seated Woman' by H. Gaudier-Brzeska, on a lovely chest given to Kettle's Yard by the Gulbenkian Foundation (for Wood and Gaudier-Brzeska see Biographical Notes)

This is a bronze cast from the original marble. (See Biographical Notes.) Though it has a realistic aspect, it is first and foremost a carving – there is no question of this shape standing up, which there generally is in the case of a statue by Maillol. His statues, which are contemporary with Gaudier-Brzeska, have become a lot of naked women sitting about in the Tuileries Gardens, while Gaudier-Brzeska attains the distinction of a Buddha, all its activity being held within itself and reaching to a surface calm, which so often in Rodin would become a surface frenzy, frozen to the shape of the statue.

For heaven ghostly is as near down as up, and up as down, behind as before, before as behind, on one side as on other. Insomuch, that whoso had a true desire for to be at heaven, then that same time he were in heaven ghostly. For the high and the nearest way thither is run by desires, and not by paces of feet. And therefore saith Saint Paul of himself and many others thus: 'Although our bodies be presently here on earth, nevertheless our living is in heaven.' He meant their love and their desire, the which ghostly is their life. And surely as verily is a soul there where it loveth, as in the body that liveth by it and to the which it giveth life. And therefore if we will go to heaven ghostly, we need not to strain our spirit neither up nor down, nor on one side nor on other.

The Cloud of Unknowing, fourteenth century

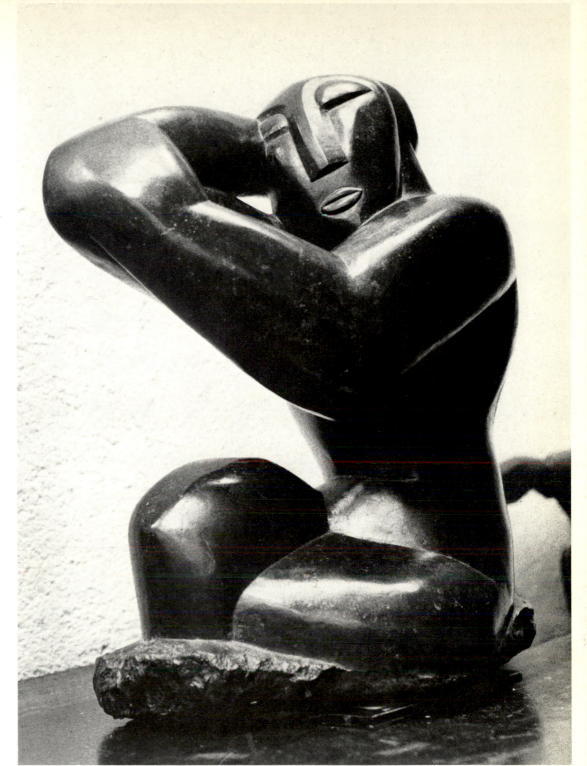

David Jones gave me this inscription while I was putting Kettle's Yard together and it was used for the cover of KYd's second catalogue. He never saw Kettle's Yard; I know he would have liked it. John Matthias in his book *Introducing David Jones* says in writing of the house that it 'is a visual, tactile equivalent for David Jones's accumulating written works'. He also wrote that 'These stones, pictures, sculptures and objects which he has assembled in his house are Ede's *Anathemata*.' In David Jones's sense of 'an Offering up' this has always been my wish and my hope.

Perhaps something I wrote long ago when thinking of his 'Self Portrait' will convey a little of his nature.

'In this painting there remains the feeling of a personality; of someone sensitive to an outside world, material and spiritual; of someone with a strange force which comes, not out of the strength of his body, but from the strength of his intention. Eyes which collect things inwardly; a body still yet alert; and fingers which are sensitive instruments at his commanding. An ear too, it also is receptive, and David Jones's more than most.'

Kate Nicholson's land- and seascape, so vibrant in its sweeping width of outlook, even at the age of seventeen, was totally disregarded as children's nonsense – the animals are a little queer and she burst into laughter when she saw them some twenty years later – but they are individuals, and all is so open and full of air.

Ben Nicholson's 'Decanter and Wine Glass' is written about in Biographical Notes.

The long box on the floor is a seventeenth-century Bible box which once belonged to Bishop Bromby of Tasmania. Beyond this, on the right, is the 'comparatively small space' at the foot of the stairs shown on p. 165, from which all the ground floor flows. Having taken visitors round this floor, I would often leave them here that they might make their return at their leisure; and here this section of the book will leave you with one of the Valentis about which I wrote for his retrospective exhibition in Zürich.

'Great lovers are rare and Italo Valenti is amongst them in the genius of his love for
that ineffable quality of Balance. His expression of this balance, this union of white,
of black, is something not to be explained in words; it is entirely a visual creation,
known by him as one would know the beauty of still sunlight in a wood, or a pebble
on the seashore. I obtained long ago one of his larger collage works, an area of white,
but what a white, with a shaft of black, and what a black, falling across it; and
somewhere as if by accident, and certainly by magic, a tiny edge of darkness, as of a
fallen leaf. It was called 'The Shadow' ('L'Ombre', 1966). It was for me the impulse of
day and night, and evoked in me the memory of a 3,000-year-old Indian teaching:

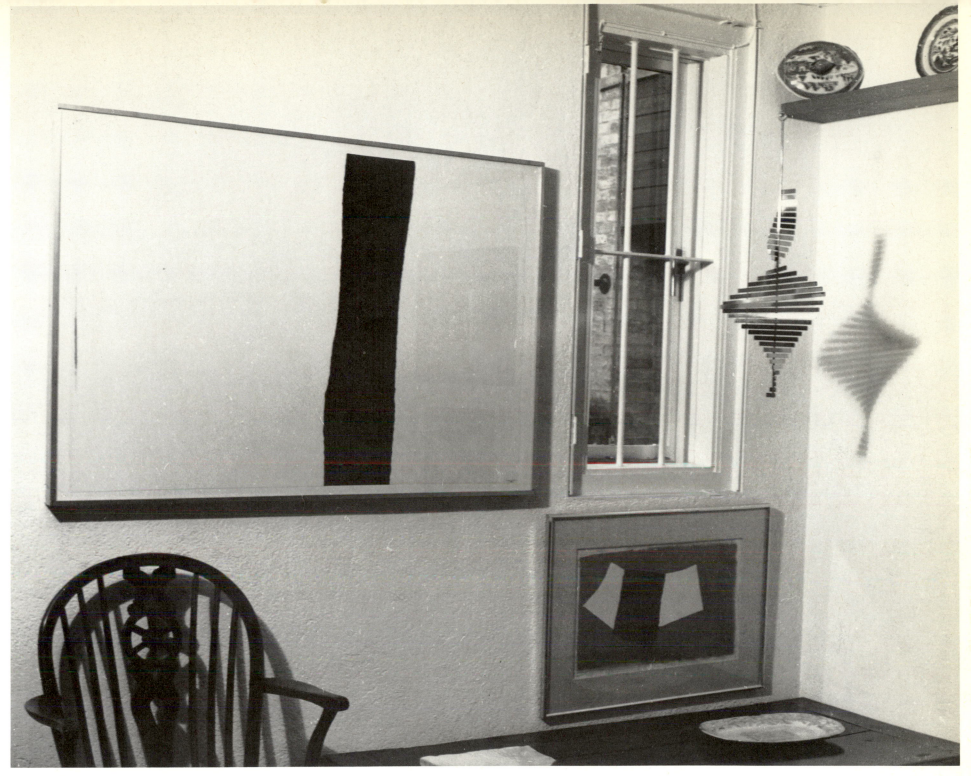

'L'Ombre', 1966, Italo Valenti

'They who see but one, in the changing manifoldness of the universe, unto them belongs Eternal Truth, unto none else, unto none else.'

A few years later we were having an evening bathe, and the shadow of Italo Valenti's leg prolonged itself across the sunlit grass. 'There is your picture', he said.

Biographical Notes

Brancusi

When I first went to see Brancusi I felt that all the elements were there collected in his studio, almost as though it were nature's workshop. There I found air and light, and the poise and rhythm of his carvings. It was really a collection of studios in a little courtyard; I pulled a string outside the door and a hammer hit upon a disc of brass within, making a lovely echoing sound. When Brancusi opened the door it was still vibrating. 'People bring me music while they wait' he said. The only dark thing in all that world was Brancusi's eyes, they were like wet pebbles on the sand, everything else was finely powdered over, his grey hair and beard, his face, his clothes, the tall columns of eternal movement, the 'Nouveaux nés', the 'Tête de Nègre', the white cloths covering the polished brilliance of the 'Fish', the 'Bird in Flight', and 'Mademoiselle Pogani'. Through the dim roof-glass the sky was blue and there was a gentle movement of trees.

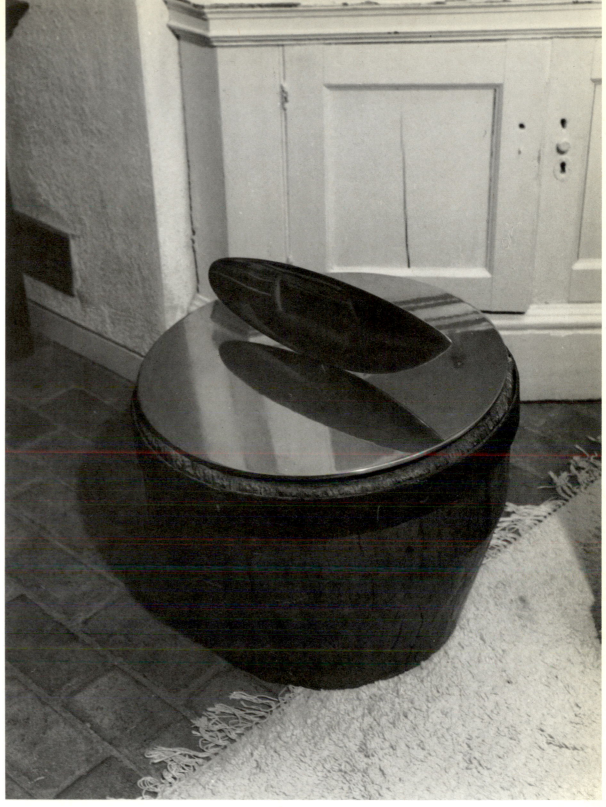

It was one of many visits, and I never lost the sense of living energy it was to be there. Brancusi seemed to talk more with his eyes than with his mouth, and he kept watching my enjoyment. He would lift the covers from those shining brasses, the 'Fish' would start revolving on its plate of clear reflection; the 'Bird' full-throated, hung poised like a star, the great grey 'Fish' of marble swam in limitless waters; and Brancusi was clearing a larger slab of stone, while he laid white paper on it, glasses, knives, butter and fresh radishes, a long French loaf; and all the time some new

object would come upon my wonder; forms of carved wood lying at hazard, or seemingly so; for nothing was at hazard in that studio, since all was part of one vision; or the remnants of some little bouquet. Brancusi's flowers seemed never to wilt, but to become immobilised, perhaps they thrived on powdered air; and in that air I now heard, so softly that it did not break my thought, the distant sound of xylophones, the quick beat of Balinese and Javanese music; and Brancusi was coming in with a bucket of ice, in which stood bottles of wine, looking themselves like statues by Brancusi. He laughed when I asked him where the music came from and said that a record should be placed at a little distance, as a background to company; and with it he brought the most marvellously cooked chops I had ever tasted, and *haricots verts*. The salt took on a special whiteness on that white paper, and the carvings all about became one, and I was in that unity. (*Written c. 1927*.)

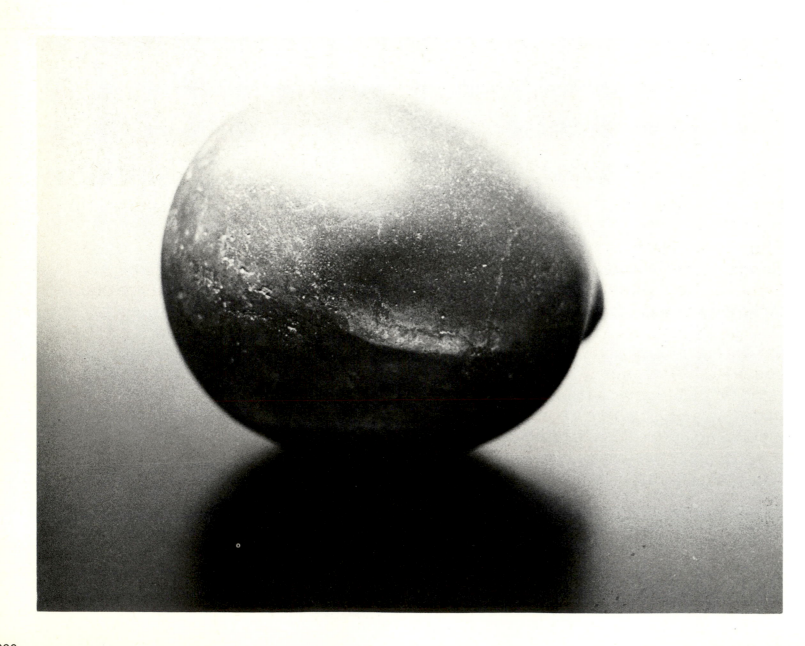

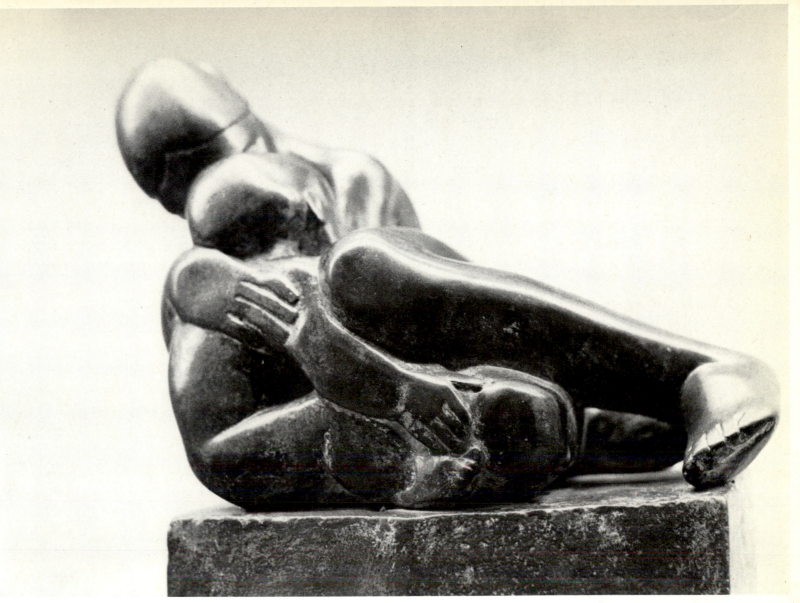

H. Gaudier-Brzeska 'Maternity', 1913

Christopher Neve writing in 'Country Life', says: 'To a considerable extent it is on Gaudier-Brzeska that both Ede's career and the existence of Kettle's Yard are founded. He published a life of the sculptor in 1930, followed by a very successful biography called *Savage Messiah*, based on Gaudier's correspondence with Sophie Brzeska. Works by Gaudier which Ede disposed of must have helped considerably in the acquisition and original financing of Kettle's Yard; and those remaining represent one of the most enthralling aspects of the collection.

'Some of the most important and characteristic last works are to be seen, in particular the original plaster carving of 'Bird swallowing a fish' and, although written about by Wyndham Lewis and Ezra Pound, it is really to Ede that Gaudier's reputation, for so long at a low ebb both in Great Britain and in France, was ultimately entrusted. That we can now see Gaudier's contribution in proper perspective, with Brancusi's and Archipenko's at the source of contemporary European sculpture, is largely thanks to him.

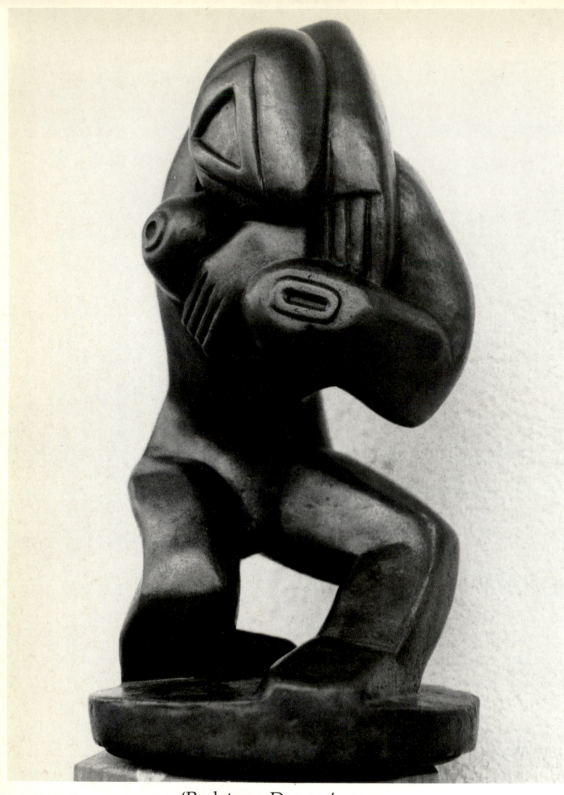

'Redstone Dancer', 1914

'Ironically Gaudier's short life has all the ingredients of a particular kind of artist hero, and it makes him a certain candidate for the thorough treatment from Ken Russell in the film being shot about him at the moment (1972). He came to London from Paris in 1910, and lived in the most atrocious poverty, working as a bilingual shipping clerk during the day, and reading philosophy and attending painting classes at night. From the drawings at Kettle's Yard it is possible to see how in only three years he somehow found his way, entirely alone from carefully observed studies of natural phenomena and a close scrutiny of the mechanics of a wide range of classical and renaissance sculpture, up through Rodin, via Lewis and Vorticism into a totally balanced and uncompromising style of his own. The final part of the process is traced in the sculpture at Kettle's Yard of the "Dancer", with its flickering silhouette and the turn of its body, much influenced by Rodin but somehow with more of an inner tension, more density; and in "Redstone Dancer", with its reference to Lewis; "Birds Erect" and "Bird swallowing a Fish" that entirely bears out his intention to "derive my emotions solely from the arrangement of surfaces, the planes and lines by which they are defined". In all this he was emotionally dependent on a hopelessly unsatisfactory affair with Sophie Brzeska, who was twenty years older than him and whose name he added to his own.

'He was killed in June 1915, after some extraordinary feats of bravery, in the attack on Neuville St Vaast when he was still only 24.

'For all the apparent glamour of a life so ruthless in its pursuit, against tremendous odds, of such early maturity, with all the change and violent activity that it implies, his sculpture needs quiet and thought, to reach its inward stillness.'

In *Some Modern Sculptors* Stanley Casson writes of Gaudier-Brzeska's 'Dancer':

'In this interpretation of movement he really achieves a new style in modern sculpture. The "Dancer" is a figure in which movement is detected rather than seen, and detected at a moment when it is neither static nor in motion: when it is potential, and yet not stopped. No sculptor, to my knowledge, has ever depicted a figure thus descending out of one movement into another. Rodin's definition of movement as "transition" is here carried out more clearly than he could ever have wished, and more effectively than he could ever have achieved. There is no representation of motion here, only its full and direct expression.'

Gaudier in writing to Miss Brzeska (near the beginning of 1914) said 'You will never make me believe that a man who is strong and healthy-minded cannot accomplish his ends. I have always done everything that I have wanted to do. So long as I have tools and stone to cut, nothing can worry me, nothing can make me miserable. I have never felt happier than at this moment; you must take happiness where you can find it, it's no good waiting until it comes and offers itself to you.'

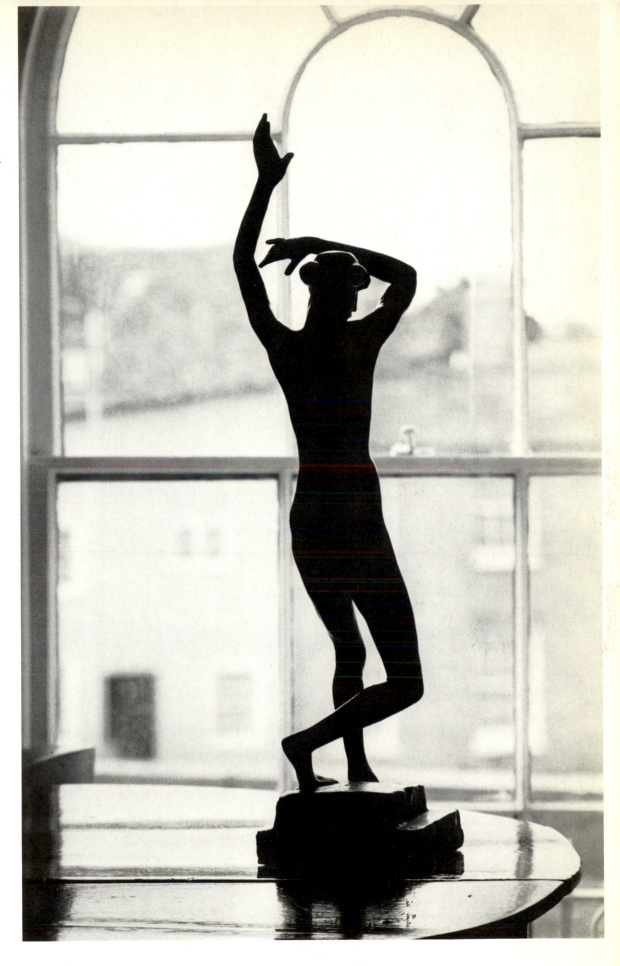

'Bird swallowing a Fish', carved direct in plaster, is a remarkable foreshadowing, early in 1914, of all that was to enter our daily lives so soon after; tanks, mortars, bombs. Nothing of this kind had yet been done. Gaudier was so swift in his reactions.

Very early in the 1914–18 war he left for France. He had come away to escape his military service and be free to live as a sculptor. His description of this to Miss Brzeska, shows the stature of his character.

'When I arrived in France I was told that I was a deserter, and that I should get twelve years' imprisonment. They didn't want my kind at the Front. So they whisked me off to a prison, and told me that I should be shot by the sentry outside if I attempted to escape. There was a tiny window in my cell, with a bar across the middle, and as I had one of my chisels with me, I managed, after many hours, to get the bar loose. I looked out, and saw no sentry; so being small I succeeded in squeezing out, scaling a wall and ran across many fields. I ran for several hours until I got back to Calais, where I lay concealed until it was dark. I then slipped into the harbour, having persuaded the man at the gate that I had come with baggage that morning; I even made him believe that he remembered my lighting his cigarette for him. I told him that I had been in the town for a bit and that I must get back to England by the night boat – and here I am.'

He swore never to return, but with the bombing of Reims he could stay no longer.

His 'Torso' cut in marble and belonging to the Victoria and Albert Museum, manifests his conclusion in regard to the Greeks when he was twenty. He found them to be good craftsmen whose work was utterly spoilt by the manner in which it

was done. 'Phidias' statues are beautiful because the planes are well disposed, but . . . the insipid draperies on 'The Three Fates' with their mawkish lines, are absolutely beneath consideration.' And again 'Line is nothing but a decoy – it does not exist, and although the Greeks are praised for having put it to so good a use, I am sure it has nothing essentially to do with beauty. There are few things more detestable than the 'Venus of Milo' – and exactly because she is no more than a line enjoyed by Vulgarians – an enormous stomach if you like, without lumps, without holes, without angles, without mystery, and without force – a flabby thing made of wool, which goes in if you lean against it, and what's more makes a fellow hot. Then in God's name . . . what hands could be more abominable than those of 'Venus of Cnidos': tapering hands, butter fingers which flow without joints, without phalanges, without tendons and with which she hides . . .' Strong words from a young man of twenty in 1911, when Greek sculpture was so praised.

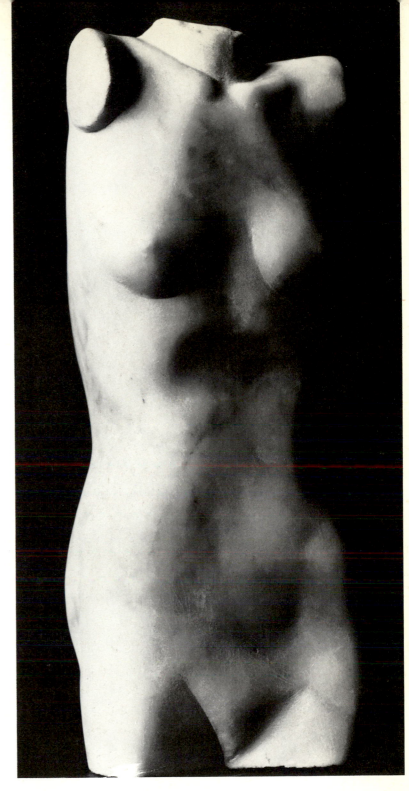

He sums up all this with a last statement: 'The Greeks were certainly right in balancing the masses, in studying planes and rhythm, yes, it was in this their grandeur lay; but that they were equally right for form in general, sweet lines, suave mouths, little feet, big breasts, no; there was their mistake, and I see no reason why I should adopt such ramblings.

'I understand beauty in a way which I feel to be better than theirs, and history and observation convinces me that I am right; that is why I am so enraged against their damnable lines which have falsified people's taste.

'Michelangelo has not manifested life in all its aspects, far from it. He has taken one aspect, and that without *desiring* it, but because it admirably served his technique – that is to say the latent life of a man, who thinks before acting; "David", "Night", "Dawn", "Evening", and "Day", the "Slaves", all without a definite and positive movement, all undecided. Rodin has put into the "St John" what he saw in his beggar, with less certainty it is true, because he is not perfect, and life is.

'The single statue is the only true way, standing or seated, whatever may be said about its monotony. The greatest masters have only made single statues, groups are always inferior; that is why Carpeaux, big though he was, is less so than Rodin, for he never knew how to make simple statues. He did not know how to find his rhythm in the arrangement of the shapes of one body, but obtained it by the disposition of several. The great sculptors are there to prove this. The masterpieces which we like most are all standing or seated, and one at a time and they are not in the least monotonous.' (From a letter to Miss Brzeska.)

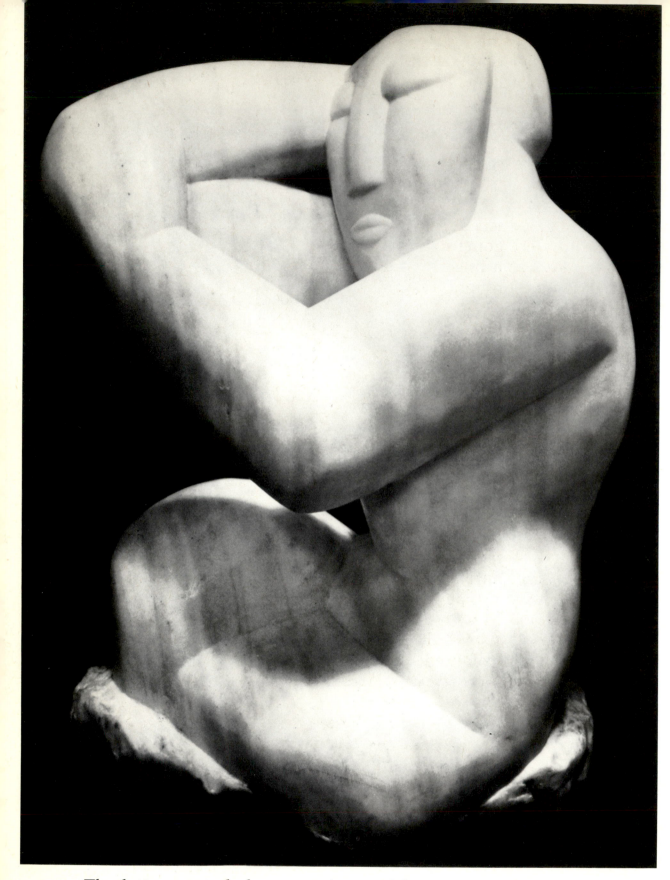

'Femme Assise' (or 'Seated Woman') belongs to the Musée National d'Art Moderne, Centre Georges Pompidou, Paris. It is one of many which I gave to form the Salle Gaudier-Brzeska, which was opened in 1965.

It is a most remarkable 'single figure', and it would not surprise me if it became one of the first things to see in the Museum, as the 'Venus of Milo', so derided by H. G.-B. himself, still is, in the Louvre. It is one of his last works, carved direct in the marble. This small block of stone he stole one evening from a builder's yard – he often would stand outside the fence for hours planning how he would use each block of marble he could see. This one was lying near the fence and was small, a rectangle almost the exact size of the carving he made from it (approx. 18 × 13 × 8 in.; 46 × 33 × 20 cm); he just managed to slide it out under the barbed wire of the fence (a tricky problem in morals).

That a man so young and unused to cutting in stone, seeing in the block the hidden form of his creation, should have been able to achieve this miracle, goes back to Michelangelo, and for all I know surpasses him.

The letter quoted above continues: 'The great thing is:
That sculpture consists in placing planes according to a rhythm
 painting " " colours " "
 literature " " stories " "
 music " " sounds " " and that movement
outside any one of these is not permitted, that they are severely confined and limited, and that any intrusion of one into the domain of another is a fault in taste and comprehension.'

In 1912, almost at the beginning of his sculptural career, he had been in London for about a year and a half, and was in the midst of his most extreme poverty; success suddenly seemed imminent. That it vanished Gaudier took in his stride, nothing seemed to dismay him. (See note 3, p. 240.)

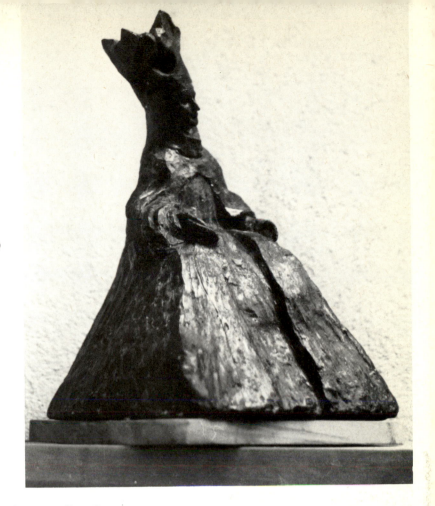

I quote from *Savage Messiah*:

'One evening just as they had packed up their few belongings and were going to leave for other lodgings there was a ring at the bell. It was Mrs Hare who brought with her particulars of a real live commission. There was a proposal to make a small statue of Madame Maria Carmi who was then taking the part of the Madonna in "The Miracle" at Olympia. Mr Hare had spoken to Lord Northcliffe and a few others, and Lord Northcliffe had said he would give fifty pounds. It was hoped that they would raise a subscription of two hundred pounds, and they would like Gaudier-Brzeska to do the statue.

'With some difficulty they [Miss Brzeska and H. G.-B.] managed to accomplish their removal, and get to Mrs Hare's house in Kensington in time to be taken to the show. At first Henri could not get into the right mood, and spent his time drawing horses, but towards the middle of the performance he took fire and did many excellent drawings of Maria Carmi. Mrs Hare has a very beautiful one, which reveals in an amazing way his sculptural instinct. He did a statuette, and two plaster casts were made, one of which Gaudier coloured.

'Lord Northcliffe did not like them, gave Mrs Hare five pounds for the artist, and the idea was dropped.'

This statuette, as will have been seen, is now in Kettle's Yard; I bought it from Brooklyn, N.Y. It is astonishing how this statue is pivoted on an absolute perpendicular, which from a side view is also right at its central point. This was entirely in keeping with the posture adopted by Maria Carmi, and by her successor, Lady Diana Duff Cooper.

In December of that same year he was given a ticket to the Albert Hall, and describes his excitement to Miss Brzeska by letter (*Savage Messiah*, p. 131): 'Last night I went to see the wrestlers – God! I have seldom seen anything so lovely – two athletic types, large shoulders, taut, big necks like bulls, small in the build with firm thighs and slender ankles, feet sensitive as hands, and not tall. They fought with amazing vivacity and spirit, turning in the air, falling back on their heads and in a flash were up again on the other side, utterly incomprehensible. They have reached such a state of perfection, can whirl him five times round and round himself, and then let go so that the other flies off like a ball and falls on his head – but he is up in a moment and back again more ferocious than ever to the fight – and Pic who thought he would be smashed to bits! I stayed and drew for hours.'

Seine Frau Violine — Es war eins eins alte Professor der hatte eine schöne Violine, welche heiste "wundersame Dame". Er liebte sie so viel dass er schlafte mit sie und mit seine fingeren sie singen machte. Diese schöne Violine war seine Frau gemahlin, und er sagte dass sie war von Dame Musika selbste die Tochter, und die einsame Dinge er hatte schon bei sich im Welt. (Die Zeiche an dieser Seite ist ein Bild von dieser wunderschöne Violine)

This drawing of a violin by Gaudier, 1910, when he was nearly eighteen and staying in Germany first drew my attention to his genius – it loses much of its vibration in reproduction, judged by the writing which was crystal clear. The drawing itself is so tender, and sound is almost heard. I felt that Dürer would have done no better.

A little more than three years later, years of extreme poverty, and perhaps fifteen months before he was killed, he obtained in London his first studio. He describes it in a letter to Miss Brzeska, January 1913 (*Savage Messiah*, p. 135): 'The studio is a marvellous place, and I feel as if I had been lifted from Hell to Heaven. I am filled with inspiration and burn with the holy and sacred fire of creation. What infinite peace after the hellish din of Redburn Street!

'Ideas keep rushing to my head in torrents, my mind is filled with a thousand plans for different statues. I'm in the midst of three, and have just finished one of them, a wrestler, which I think is very good. I'm also doing sketches for a dozen others. God, it's good to have a studio! It's disgusting that so fine a hole should remain empty while I am at this filthy ''business'', Zosik could be quiet here, and would write better than while stowed away in the country.'

Miss Brzeska when she came thought otherwise – 'when she arrived the studio was in the utmost dilapidation. "There was a pool of water on the floor – the roof had fallen in: the Underground trains which passed just outside the window made a row enough to split my head in two, the draughts on all sides were as if we were on a lighthouse in the open sea, soot from the stove suffocated my nose and throat . . ." '

She got influenza and lay ill for a fortnight. Such was their life.

William Congdon

'Venice from the Giudecca'

Even as an 'abstract' picture can be realistic or local, so a 'realistic' picture can be abstract or general, and Congdon's paintings enter this latter group. He certainly presents 'the dull substance of this flesh with new living fire', a task not easy at the best of times and the more remarkable when the symbols of his expression are such popular ones as Venice, the Colosseum, Naples. I had thought that Bellini had made a final statement in regard to the Piazza and the Basilica, that Canaletto had achieved the canals, and Corot the Piazzetta; but Congdon has reached a new form and a new intensity with twentieth-century liveliness rooted in the fourteenth. Just as the underlying quality of life remains intact through the upheavals of war, so his flame-like and thrusting campaniles do not fall however much they lean. His dark palaces, drowned in the horizontal waters of the Adriatic, are still lived in, not only by the ghosts of past centuries, but by contemporary life, yet on his flat panels all this is a mysterious curtain, covering the design of the artist's intensity. A tumultuous Van Gogh beneath the surface of a Klee, a Greco beneath a Claude Lorrain, a Brancusi mingled with a Bernini. A Venetian palace by Sargent becomes the signature of Sargent, it is neither the subject nor the artist; so distracts from each by its immediate glamour, and does not enter into the act of living; but Congdon, even if he signs his name twice in the sky (as above), clarifies this life, through the piercing sensibility of the artist, in terms of paint. He has the painter's love of texture, the sculptor's love of form, the artist's love of interrelated order. To walk in Rome, after seeing a Congdon, is a new experience. Façades are vital through his vision; colour and form take a new coherence. This is the stuff of artists and it is

useless to complain that he is realistic, that he is romantic, that he is not in the fashion; he is beyond fashion and is part of our contemporary life; and as an artist one of its bravest and most generous exponents.

There has, I suppose, always been a dictatorship in art; it must be this or that; but art cannot be bound in this way, for the human spirit is limitless, and art is the expression of that spirit. Picasso uses the teeth of a horse, a bone, rich volumes of tone, to convey his outlook; Cézanne an avenue of trees; Van Gogh a chair. The symbol is of no importance, the artist is everything and he must burn his impression into the plate of our civilization.

Perhaps Congdon's chief realism lies in his paint itself. Like Van Gogh, almost, he would remake his subject in volume of paint. The richness of Italian history is echoed by his rich paint, it flows sometimes like molten lava, it solidifies into the wonder of stone, it is shot with gold and silver, the glitter of sunlight or moonlight on this marbled world, this watered world of sky and air. The mood of his idea finds its balance in volume and colour, and a new emotion is created, a new life in terms of a painting, and in this a new reality, no longer dependent on the outward world from which it sprang. It is a painting, an independent entity. In this painting of 'India', tigers are alive, all over the place, while in the painting of Venice, so obviously by the same hand, no tiger could exist but pigeons can. It is interesting to question what the artist has done to create this fantasy.

'India'

My first meetings with Congdon were in his paintings, always of Venice, in various American Art Galleries, and then in a small New York Exhibition, again mostly relating to Venice. They greatly impressed me, his boldness with a palette knife, building campaniles and palaces, as it were. I was given the photograph of a painting of many arched windows in stone, all different and yet all the same – I have forgotten where – perhaps the Doge's Palace. A little after, with all this in mind, and with a visit to Venice freshly captivating me, I was on a ship which in this fast-becoming fantasy, even as I write – I would like to think of as my departure from Venice, but which more likely was taking me from New York to Gibraltar. It was a warm day with several flirting couples around me. I was trying to put into words things which had been evoked by his work, and which now seem to me to express much of the life lying within his paintings, and much of what I came to feel while constructing Kettle's Yard many years later.

A Projection: Venice

(1) The slant of sky, bare feet against the sun,
 Love urgent and sex imprisoning the spirit.
 A bird flies into the water,
 Columns of darkness still the heart.
 Light breathes through windows, stirs in the eternity of instant;
 Columns of stone,
 Diversity of unity.
 As one heart is separate from another, so do these windows combine
 In the oneness of a building,
 Their intimacy responding to adventurous passion.
 Touch, revealing by experiment, affection; as still water crystals a pool,
 And gives it entity.
 Stones which are turned start wings,
 Wings rooted in heaven and earth,
 A living thread
 Between the present and the past.
 Fear hovers within the perimeter of sleep, teasing the mind,
 Knives cut sharply the shape of beauty,
 Palaces lift into the air.

(2) The palace soars into the air;
 The surface of the water hardens, taut-stretched to hold its rising;
 Night like a cloud envelops it.
 Its slow construction
 Stone by stone,
 Each stone the passion of the artist,
 Now emblemed in eternity,
 Yet vanished in the mirrored sky.
 Love like a phoenix rises,
 Doves leave their nesting arches,
 Sunlight presses to the root of flowers
 Waves caress the shores of earth.

(3) St Praxed's ever was the church for peace,
 And in this morning light vision lengthens,
 The heart is jubilant;

And love like the texture of a leaf accords its beauty.
The earth's surface is a tiny crust and in that crust lies Venice,
Threaded by Adriatic seas;
There is no separation possible,
In darkness and in light,
In cold and warmth,
Vibrates her diamond quality within the world;
Like an illumined ship carried on phosphorescent waves.
She touches the celestial air as Adam's hand towards God.
Fingers that reach to bridge the unfathomed spirit.

'Piazza San Marco' 1956

Almost as a birthday present for Kettle's Yard, Congdon gave me the little 'Piazza', which reminded me of a painting by Sano di Pietro. I put it into my bathroom where I knew it had to go, a lovely light where it was part of the texture about it. It is calm and reflective. I felt no need to theorise about it, for it is so simple; a quick moment of life, a smile and an acceptance, in which fleeting moment the artist stirs with the breath of God these ancient characters and reveals their stillness.

 As I continued to live with it I found that I never walked in that Piazza nor did I see the Campanile, these physical aspects of the place; but dwelt rather in the sensation of stones and their immeasurable security.

'Five contemporary British artists, 1940'

A number of years ago I wrote (not published) about five friends who had already been my friends for 16 years or so – which gets us back to 1924. They were David Jones, Ben Nicholson, Winifred Nicholson, Alfred Wallis and Christopher Wood. Kit Wood, as he was then known, died when he was 29 and Alfred Wallis was already over 80, having started to paint when he was 75. They all knew each other quite well, and what is more, all but Alfred Wallis would agree with putting the others in the first rank amongst contemporary British painters, and perhaps they would each one have singled out, for special mention, Alfred Wallis the fisherman. He would have put none of them anywhere, a queer lot he thought them, and of his own work he thought nothing. He wrote to me, 'I paint things that used to be and there is only one or two what has them and I does no harm to no one.' So he spent his time reading his Bible, improvising strange melodies on a kind of organ he had, and painting memories of the past on the backs and sides of cardboard boxes which he got from the neighbouring grocer. All this of course in 1940 was in the present not the past.

Alfred Wallis

In seventy years' contact with the sea, awake at any time – day or night, in darkness or light, storm or calm, a great deal of experience must have accumulated, and it is out of this store that this old man produced his paintings. When he painted the sea and a ship he knew that the ship is feather-light as compared to the vast weight of sea. How was he to express this in terms of paint, this very obvious fact so little realised by other painters? It is not easy to express and I wrote of it at length – but I don't suppose that

Wallis gave it a conscious thought, for when he painted, his awareness being so sure, it comes out right. He knew what it was to be at sea – entirely and totally – his paintings carry with them a ship-feeling, and a land-in-the-distance feeling and a pitching and a tossing and a passing of lighthouses and other ships and a blinding of spray, and a vastness of sky which somehow seems above and below.

Christopher Wood wrote of him in about 1924 'I am more and more influenced by Alfred Wallis, not a bad master though, he and Picasso both mix their colours on box lids! I see him each day for a second, he is bright and cheery. I'm not surprised that no one likes Wallis' painting, no one liked Van Gogh for a long time did they?'

I found written on a slip of paper 'an artist is one who sees the universality of the common incidents of life in an individual manner'. I don't know who wrote this – I may even have written it myself. I think it right so far as it goes, and it applies quite clearly to Alfred Wallis. He gets a shock, is it of joy, out of what he sees. It is the same with Christopher Wood, it comes in upon them with a vivid intensity and absorbs their whole nature, they become the thing they are seeing; then through that strange miracle which is art they express themselves on paper, cardboard or canvas, and the result, though it has little reference to actual appearances, does directly symbolise the most significant realities of the thing represented.

Wallis wrote to me of his paintings: 'The most you get is what used to be, all I do is out of my memory. I never see anything I send you now, it is what I have seen before. I am self taught so you cannot like me to those that have been taught both in school and paint. I have to learn myself, I never go out to paint nor I never show them.'

The three-masted ship, anchored in harbour, has that strange immobility and over-life-size feeling common to ships standing in quiet water. It has a sort of desolate assertiveness in which it is almost impossible to sense its cutting activity once it is on the high seas. Even the lighthouse has come to rest, perpendicular instead of thrown to an angle, and the sails are furled, looking like snow from some polar voyage, and emphasising the closing-in of life. At this point the cinema can add its own particular grace; it can show this snow falling off, the sails beginning to shake as a bird will shake its wings, their unfurling and awakening into the

great light of day; the sunlight sweeping out their creases and the wind tautening their surfaces until the ship stirs in that water which had so closely cupped it, breaks its constraint and rides the sea.

Many Alfred Wallis paintings have appeared in the course of this book. I like to have them everywhere, but I would like, a little at random, to consider two others a little more closely. The 'Street Scene' which is painted on the reverse of the 'Three-Master' is one. (A very clever man slit in two the cardboard on which they were painted.) Who can follow or explain the process which has found so varied an assembly of lines, which has been able to place so many spots (I refer to the windows) on the space to be covered, and yet keep them significant; and what is more keep them from making sudden and boring patterns in themselves? They are placed with so subtle a judgment, quite unconsciously, as far as intellectual intention is concerned, that they can be quite simply accepted as a whole. A detailed and factual analysis would lead into a quagmire; skyscrapers of some fourteen storeys, in a little fishing village where probably no home has more than three floors; and the startling dexterity of these dark roofs, like the wings of birds in flight, how rightly they suggest their purpose against every rule of conventional perspective. In all this and in all his work he captures the universal aspect of his picture as opposed to its local one. Wallis is never local.

Though he is always drawing the same ships, the same houses, the same water, each of his pictures is entirely a new experience, and this is natural in one so direct. His mood, the thing which made him want to paint, to tell himself, as it were, some past memory, dictates the composition. I am sure that he never sets about to enclose his vision, his thought, into some preconceived scheme of colour or design. It is the immediate welling-up of his vision, rich in actual experience. It is experience which gives colour to our actions. So with Wallis design comes, with its subtly variant lines and spaces; not through experience in the art of drawing and painting, but from closeness, almost identification with the thing he is drawing.

In the 'Bridge and Boats' there is such a tossing and activity of little boats, as opposed to the unshakeableness of the great bridge, and with it there is a fine filling of the space available. Look at these arches, follow from one to the other their change of shape, each one a new arch, a new sensation experienced in going through each, here a hazard, there a calm, and yet each is entirely part of the same bridge. The fundamental character of things is never for a moment lost sight of, and yet nothing is ever fixed with the frigid limitation of a particular moment. These are things I cannot explain or prove, I feel it is so, and that it is in this direction that art lives. It is because of this simple living quality that artists gain vitality and assurance from the paintings of Alfred Wallis.

Christopher Wood

This 'Self Portrait' of Christopher Wood hangs in the house extension of Kettle's Yard. It is of 1927, 'painted from memory like a fairy prince' he told someone in a letter. He is surrounded by Paris from the windows of the studio, dressed in his harlequin jersey and Breton trousers, the familiar objects of his life by his side, paints, pipe and lighter. There is an emphasis on the hands and face which makes the human element the one which dominates the picture. It is himself, painting himself in the material world of his own studio.

In his good moments, and it is only in its good moments that art is attained, he had the same simple liveliness and freedom from the local found in Alfred Wallis.

He was known to his friends as Kit Wood and died in 1930 when he was 29 years old. In his life he had a sweeping joyous contact with a visual reality; and the paintings resulting from this contact are supremely rational.

He painted them in order to put down in his enthusiasm, the reality of the thing he saw; it was an expression springing directly from the desire to say 'I love this' and not from a motive of boasting a technical dexterity. This technical aspect of a painting did not occupy his thought, for he was essentially a painter. He was one of the few English artists who painted by nature, taking to it, as he took to all he did, with a simple directness. To paint a picture, to eat a dinner, to talk to a friend, to do a thousand other things, was just to live, and he lived more dangerously than most.

There were so many things characteristic of him and these pervaded his paintings. His vast interest in his subject and his ability to make us interested too. His paintings retain a sense of wonder, wonder which is at the root of all art. His excited and exciting vigour clamoured for expression; making him often impatient of detail, in his anxiety to grasp the intensity of the whole, before it fled him or he it. His means of expression were always at his finger-tips. He couldn't state his feelings in a fumbling or inadequate manner, they were too exciting for that, and carried all before them. He enters so richly into the essentials of his 'subjects'; the warmth of humanity nourished his vision. An artist who can so reduce the so complex structure of the visual world, as he could, could not lack understanding of human structure and proportion. His eyes saw things newly and his seeing created new feelings. His paintings may look 'realistic' but it is realism of a very acute kind. They don't hold subtle problems, in front of them you don't think; you live. He invites us to share his own experience. A bunch of flowers is a bunch of flowers, smell it. A street is a street, walk up it. He kept the pleasant and uncomplicated outlook on life which makes the English a nation of poets and footballers.

In a letter describing the country around Mount Aetna he broke off with 'What a country! Too poetical to be described by an Englishman although we are the greatest poets in Europe and feel things in our own northern way more than the Italians, but dare not say so.' Christopher Wood dared fully, he painted without hesitancies or embarrassments, straight from the heart; and poetry in its clearest sense is the result. Like Gainsborough and early Constables his pictures have this very English quality which makes of a painting the spiritual realisation, profoundly significant, of homely things. His problem was to create a parallel to visual facts and not an imitation; his subjects only excite his fancy by their pictorial significance. He loved trees and boats, or the sea, as things to paint, and he at once saw them as paintings. Thus they were ready made, so to say, but in accomplishment they were visually far from the chosen subject. He had the power of interpretation in a high degree, and an extraordinary perception of relevant matter. With these qualities to help him, the picture is ready in his instinct; and with his simple relationship to his medium, the actual statement follows with comparative ease, as if they were almost automatic interpretations of the trained instinct. The majority of people look no further than the visual, but the artist must find and reveal in his picture of the sea (I am looking at one by Winifred Nicholson at this moment; it will come later) its immense changeableness, its volume, its colour, its smell, its perpetual movement, and eventually reach the simple, yet intensely true statement of these things as seen in his painting. Nothing is lost by simplification, everything is gained. By his remarkable sense of tone, a sense seldom at fault, he gives authority to his simplest statements. A talking brush Kit Wood had, and talk which was alive from corner to corner of his canvas; an easy manipulation of paint, free but never showy or slick. He does not clutter his idea with irrelevant furnishing, indeed so truly is he master of the situation that he can leave large restful spaces for the eye to dwell upon, spaces held by the force of his intention. 'I love ships' he said, 'they have such interesting lives.'

In 'Building the Boat' we can see these spaces, but so clear is the bone-structure of the picture, that we are unaware of them. The facts are so exactly stated that the whole story is before us at a glance.

He was very interested by the sadness of this scene – perhaps enhanced by the darkness of this photograph – skeletons of ships in process of being built, which foreshadow the skeletons of the fishermen who would take them out to sea and not return. Wives and mothers, who had

sent their husbands and their sons, help a younger generation to build new ships of death. I see this in his thought since he wrote of it in a letter. How pictorially he has visualised it; without a shade of sentimentality. It is a clear straight statement, vigorous and human, which belongs to that very English world of such clear statements as Shakespeare's sonnets. This was painted two months before his death.

He wrote in regard to his work as a painter: 'I think I have ascertained mine, and that is that. I have gone one per cent of the journey and all the rest to learn. It is terrible to think this, but still it is better to realise it before it is too late to start again . . Work has become more and more of a passion to me and it is the only thing I really enjoy. And this is left to me to do, to make things more simple, with a good firm edge to everything, that nothing should be indefinite or arbitrary.' Again, 'My brain, life, work, everything is a maelstrom at the moment. I can't explain it. I work at a terrific speed and force, but at the same time in a sort of trance, not knowing exactly what I am doing, and yet making every super-human effort of brain and body. Sometimes I work from ten in the morning until five in the evening, literally without stopping to look at what I am doing, as I am so terribly absorbed. This complete lack of sense of what is going on around me; then when I stop my work, I am frightened by the smallest event that breaks in on my complete privacy of reflection.'

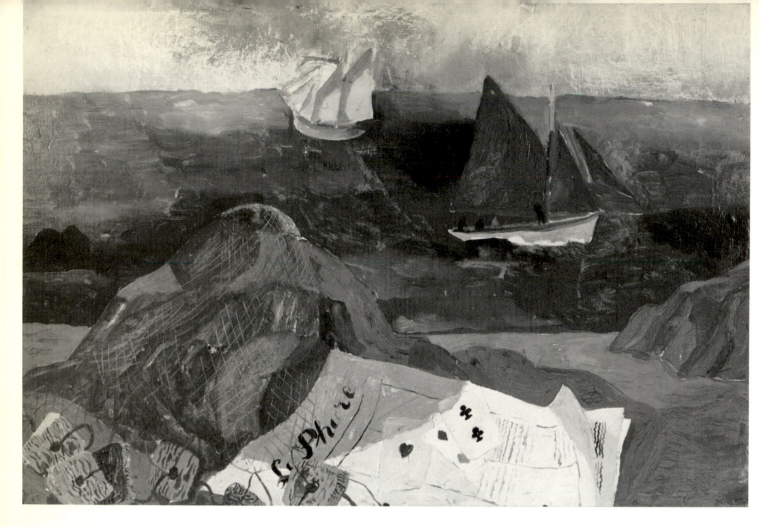

In 'Le Phare' which I think to be one of his best paintings, conveying both the mystery and the openness of his character, there is a strong and clear portraying of the abstract qualities which come first in the making of a work of art. Its local aspects are negligible. The picture is essentially a thing of itself. It is the sea, in terms of paint; and boats too, and beyond this, it is the world of the artist's thought conveyed through the close juxtaposing of his lights and shades; these exquisite whites on white and darks on dark; revolving in its own mystery, as simply as the world itself revolves. These whites and blacks introduce the thought of seagulls whose presence would have disturbed the quiet of the picture. I suppose all this touches on the school of expression termed surrealist, but such painting was surrealist in just this way many hundreds of years ago, and had a snap and extra vitality which today's school has lost in the way that the pre-Raphaelites lost the deeply moving truthfulness of their masters. Christopher Wood, though he was aware of contemporary thought was never bounded by it; he lived always, and expressed himself always, directly from himself.

'Seamen and Mermaids' (in the ground floor Extension), perhaps his last work and perhaps unfinished, is an unusual one for Wood, it is painted out of his imagination and is not a parellel to visual facts. Perhaps it is symbolic of his temporal end, this phantom ship which may be the ship he had so loved all his life and had so often painted. These phantom sailors, alive, still, for him as they man the yards and glide from his living world, the outside world of air and sunlight, into that unseen, eternal place which is to us limited to here and now.

Winifred Nicholson

In the mid-1920s when I first came to know her, Winifred Nicholson was a leader – not only in a transformed style of painting – but in life itself. She and Ben Nicholson transformed everything – wooden boxes became stylish chairs, ugly stoves were desirable objects and butter-muslin came into fashion.

Like Christopher Wood's her painting comes close to the physical, a sensuous love of life's intimacy treated with a penetration and a sparkle which makes her painting companionable and universal.

She is essentially a woman painter in the way that Jane Austen's writing is a woman's and not a man's, and Emily Brontë's too; she stands, I think, foremost amongst those of today (1940). She does not endeavour to hide her sex in her work, she is proud of it and brings to painting a woman's attitude which no more competes with a masculine one than did Emily Brontë's. They are both inherently feminine. This should not be a curiosity, but it is, for it is very rarely that in externalised expression a woman reaches the essence of her own personality.

Her earliest work at Kettle's Yard was painted in 1923 (reproduced earlier in the book). It is 'Flowers in Paper'. It has not only the local life of these particular objects, flower, pot, plant, paper; it has the sense of air and space, of birds in the air, of sounds and warmth, of domestic life in its essential simplicity; and of the joy of opening windows; not only material ones, into a bright morning. Much more beside; the poetry of life, but seasoned with a strong robust element of common sense, the touch of reality; that actual world which is so necessary to such an artist as Winifred Nicholson in order to call out her power and response; a response which is to produce a work of her own in the likeness of the world that touches her.

I so well remember her bringing back this 'Seascape' after her first morning on the sands beyond Bamburgh. It was a windy morning and she had difficulty in holding the wet oil from blowing against her. I had never seen sea treated in this way; so loose, so bold, so unconcerned with detail. She seemed to have brought all the world up the steep hill to the castle where we had spent the previous night. That tremendous sky and the rich warmth of sand; and where could she have

been in that overwhelming pulsation? As I write now in this book, all that was 55 years ago, and the urgency of her work still holds me. It lives now in Kettle's Yard.

Her large 'Landscape' has always been to me a great world of beauty, it has an uplift of light, everything is growing and spreading from the bottom of the painting to the top, and all is infused by the clean vigour of early morning.

There is a feeling of universal birth, and this is characteristic of Winifred Nicholson's work. It is not the solitary life of the local object that she sees, but that of its species.

It is difficult to understand now why such work was so scorned. In the 'Landscape' the road got nowhere; 'It isn't a picture' was a constant reply to my questioning. In the 'Seascape' it had no form and again it wasn't a picture.

Artists are ahead of their time and few people are accustomed to their language, each artist speaks with a different tongue. We need the blessing of Pentecostal Grace for artists to become 'inseparate from our lives', as Cowper says, 'and cleave through life inseparably close'.

The formal quality of Winifred Nicholson's work, for all its seeming informality and simplicity, is very powerful, highly organised. Her flowers which seem so flower-like, and I know of no one who approaches so closely to the pure clarity of flowers themselves, are profoundly characteristic of the strength of mind and character which has received and responded to the flower life; making from this life a life of its own, a massive simplicity which is yet so delicate, so poised, so true.

Choice, the human experience, is very chosen, sifted by a deep discipline and carved from the welter of life's experiences. It has grand acceptances, most sensitive and immediate perception, and it has its grand refusals.

Winifred Nicholson and Christopher Wood have this in common; they both have a deep respect for something outside themselves; the world, the universe, good, sorrow, joy and so on. They recognise instinctively and clearly some objective reality, and their own vital relation to it. They are responsive to the sensuous, the whole outside world in which they live, responsive with a certain plainness and direct normal sanity.

Christopher Wood accepts more, has a richer humour and humility, a greater reach and a more deeply coloured organisation as an artist, and not by any code of morality

or philosophy, while she would consider life in the austerity of her own demands, and in her approach to it, she must take the full and sole responsibilities for her moral and intellectual decisions, acts and choices.

Wood on the other hand, is more catholic, has a zest for life and an untroubled implicit faith in it, a faith and an aliveness which would persist even if he visited Hell; instinctively relying on some rightness at the heart of the universe which will guide, direct and sustain the creature unfailingly for all its faults and sins, and through personal blindness. In these so different approaches both are steered by a common sense close to a wide and deep-seated tradition; and in the strength of this tradition are enabled to make free personal experiments.

Winifred Nicholson is a colourist. Colour has always been her chief interest. She wrote 'as a child I painted rainbows . . . sunlight coming through chestnut leaves, setting a leaf aglow . . . things up against windows so that the sunlight could be seen coming through them, all luminous; contrasted with the sunlight striking on them, all shine. I never painted in a room that did not face the sun, nor when the sun was not shining.'

A young man came to tea, his sister was engaged to Jake Nicholson whom he had not met. 'I can show you his portrait' I said; and this is it. It was a little odd to meet one's future brother-in-law in this way. (See p. 103, where the meeting took place.) I was only able to get 'Jake' because the dealer would not show it in an exhibition, it was too childish. Twenty years later he thought it one of the best.

'Jake'

Ben Nicholson (before 1940)

I have wondered for long, perhaps from 1924, the date of our first meeting, till now, 1940, and I am still wondering, how I can convey some understanding of Ben Nicholson's work as an artist. He is certainly the most prominent painter in England today. Like others he is of course aware of an objective reality, but beyond this he seems to me to recognise and express the force of an inner idea. It is dangerous to classify so I will leave this for the moment, noting roughly the differences: outward and inward, like breathing out and breathing in since both are breath. Most of his works, like those of Picasso in France, evoke so much prejudice that the onlooker is unable to accept them for whatever they may be, and discover in them the beauty which his belief in art had led him to expect. 'Why does he do it, what is he after?' is always the cry; each new phase producing a new clamour; but always somewhere the artist is saying the same fundamental things, and a new carriage does not necessarily denote a new character.

Ben Nicholson has always been a master of drawing and of technique, so all that can be left on one side; we need never be bothered by the thought that 'the teapot's awry because he can't draw', or if something looks muddled it's because he couldn't do it rightly. He can and he does. This strangeness is for one thing due to his having grasped a wider view of perspective. Until the coming of cubism, Western perspective had started from a given point, but then there began to be several points, and objects were seen from several sides at once. In his painting a jug for instance, it is drawn out of this fuller consciousness; its base perhaps seen from above, its lip

from below, resulting in an apparent contortion to a school-bred vision, but to the artist himself a sense of greater perception, a liberation. Again I would leave it for the time being and go again to the artist's fundamental relationship with life.

The outsider, coming to this painting, grumbled that the jug was too big, that the plate was vertical to the table, if indeed there was a table, that contrary to all reason the cut lemons did not fall off the plate, that the knife stood up without support and was not lying on the plate, that the mug was doing a vanishing trick to the left. It was with this outlook that an artist in

the mid-twenties had to contend; and the amazing rendering of an interior so dramatically lit, and so constructively, by shadow and light, remained unheeded. To the critic the objects might be what he could see in any shop window, while the artist might have been thinking of a cathedral set in its town square, or a mountain rising from a plain, or, as I look at it, the Campa in Pisa with Cathedral, Baptistry and Leaning Tower, floodlit as by the moon. As Ben Nicholson would have said, 'It's a tricky business.'

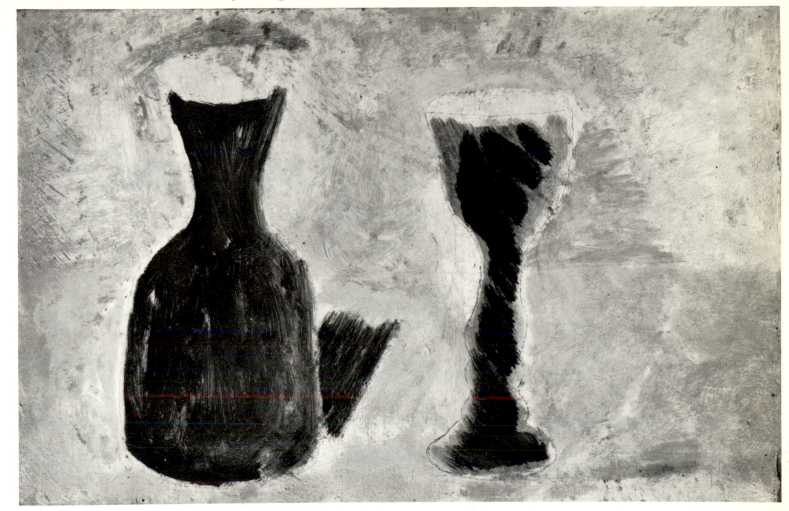

For the artist shape and enveloping light may not even relate directly to other shapes, to other lights. His thought is of a relationship between one human being and another, of spiritual contact, that elusive thing which is brought into existence.

I remember when I first saw the painting of 'Jar and Goblet', in 1925 at the beginning of Ben Nicholson's use of collective goblets as a means of expression. I thought that its subject was friendship. What came to my mind was the togetherness of these two objects, and their separateness: the effect of one line on another, the flow from one to the other, and I scarcely saw that they were vases, so I was quite unaware of anything unusual in the drawing. The thought had conveyed itself to me, the objects were a means to an end.

To come back to the painting of a jug, it seems now so far away, but is on the preceding page. The placing of this bottle, object, be it what it may; its nature, its colour, the thing itself, the table; these are merely a code, a cypher used by the artist to tell of his own experience in life, his realisation of a certain truth.

The realisation is intense, of a white-hot intensity, he has entered into the very life of what he is painting; while we see only the outside. From his point of view it must seem different from the way it does to us.

It is given to the artist, because of his deep research, to come close to the meaning of common objects which we have only accepted conventionally. Our vision has become stagnant, for we are all taught to see alike. We know things by labels, but the artist goes beneath the label and again feels that almost primordial stirring between himself and his 'subject'.

Ben Nicholson has a remarkable sensibility to tone: his awareness in rendering that changing period of light which lies between night and day, the mysterious moments

of dawn, of evening. Claude has this power too in an intense degree. This expression of the beauty of light, and of darkness, which is another form of light, has always been of interest to painters, and to Ben Nicholson this interest has been constant; and in it and about, this visual emotion lies deep woven, the fantasy of his close thoughts and his interior ideas.

Ben Nicholson treats painting as a game; he is English and games are serious, and his work has the light beauty of a *pas de ballet*. His simplicity and care of execution is in one movement with his idea, which expresses itself directly in his work, his fantasy being peculiarly free.

He seems to touch and reach the world through ideas; not thought, in the usual sense, but rather feeling. Persons, direct experiences, sensuous objects; these become transmuted, embodied somehow into an Idea; an abstract feeling which touches him to the quick, which is the life of his inner citadel, a citadel ceaselessly at work.

His paintings do not seem to be an immediate response to the visual world, as in the case of Christopher Wood; his reactions before they take shape as art, seem to undergo a long period of filtration; much, almost all, is discarded, and what remains is subjected to his tireless energy, an energy guided by an extraordinary power of sensibility.

This painting called 'Goblets and Pears' was thought impossible when it was painted in 1924; and why? – because the goblet was on the lean and goblets didn't lean that way; obviously the artist couldn't draw. In those days objects in a painting had to behave as they would outside the painting. It would have been all right for the Virgin Mary in a Renaissance Annunciation to lean back for the Archangel to come in; but for a goblet to do so to give room for the pears was out of the question.

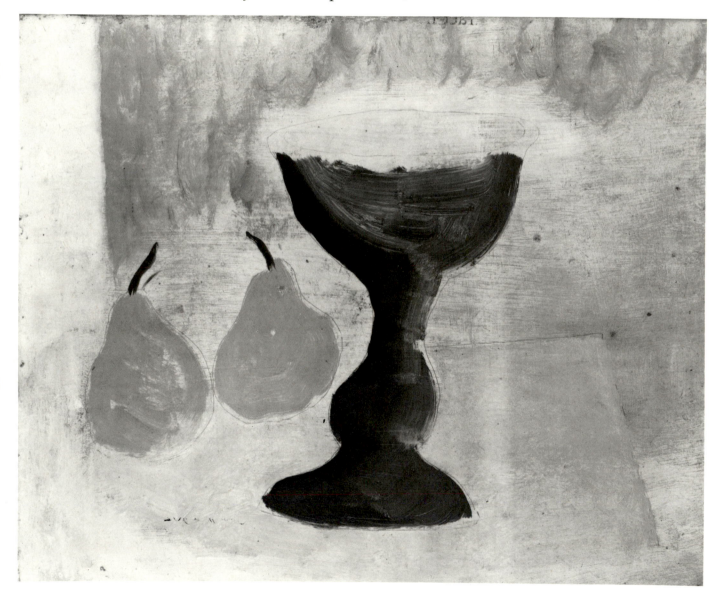

Today in 1982 none of this would be apparent, but only the rhythm of lines and spaces: so we have evidently made progress in our perception.

If Ben Nicholson painted jugs and mugs where others painted figures, or landscapes, the thought or emotion is no less present. He spoke once of his first visit to the top of a snow mountain, and when he came down, the only thing he could find to paint, to express all the glory he had seen, was his bedroom jug and basin.

His Idea has at present (1940) ceased to express itself through bottles and basins. These have developed into squares and circles; but the picture behind them and about them, the Idea, is still as independently alive, is indeed the more so as he himself grows freer.

I once asked if he thought that the present form of so-called abstract painting should develop into an expression more closely allied to our normal traditions, and he answered by an analogy. 'You cannot ask an explorer to explain what a country is like which he is about to explore for the first time; it is more interesting to investigate the vitality of the present movement than to predict its precise future development; a living present necessarily contains its own future and two things are indisputable; that the present abstract movement is a living force, and that life gives birth to life.'

In 'Argos' I was so happy to obtain this example of new life. It cries out for colour, in which it so excels; so subtle a combining of blues and greys, entirely personal to Ben Nicholson.

'Argos', 1962

David Jones

David Jones is, I suppose, not only the best water-colourist working in Great Britain today [1940] but by far the best engraver, a poet and writer of genius, in all a most imaginative artist. He is essentially an artist, in the way that William Blake is an artist: every thought that goes through him must turn to art. Like most artists he has an appreciation of concrete things; but he sees much more than the actual world in seeing the actual world. His touch with reality, as much as any living artist I know, goes back to a well of essential life. It is the grand unchanging reality which underlies the changing actuality of the world which at clear moments our quickest apprehensions see. His work at first glance often seems muddled, childish, tortured, but as it is lived with, it surprises by its real comprehension of the living world. I once bought a fine eighteenth-century goblet, because I thought it might companion one painted by David Jones in a large flower painting we had; but to my surprise David Jones's shone through with symbolic wonder while the glass one had no living force. I put it elsewhere and it was again beautiful, a subject for an artist.

There is a large water-colour of a cat asleep in an armchair; a domestic scene, curtains fluttering and the humdrum of daily life. At first sight it had seemed a haphazard conglomeration of objects. It takes time to focus the mind to an artist's way of thought, and so few people are aware of this.

In the picture to begin with there is indoors and outdoors, the quiet peacefulness, the fundamental shelter of a house looking out onto the world. The outside penetrates the inside, yet the inside remains an interior.

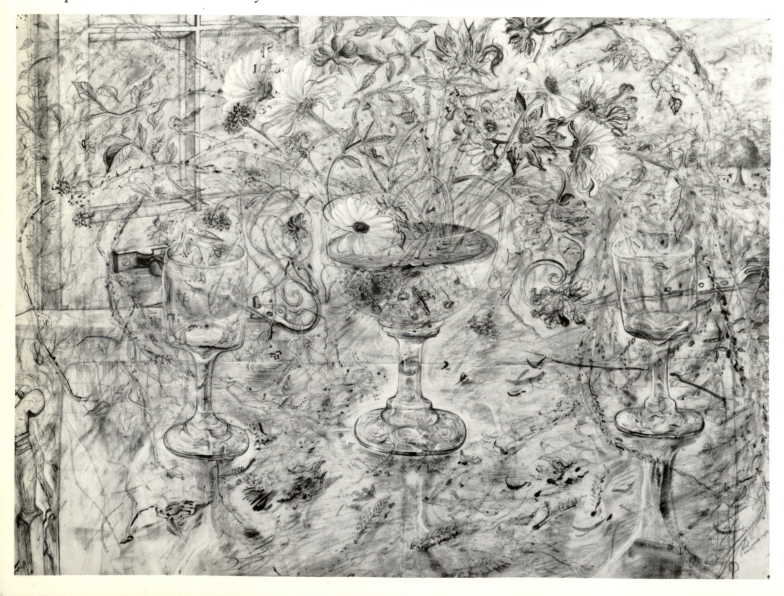

Trees, seen through the window, springing so naturally from their native soil, could never by any stretch of imagination live on the near side of the window; and through this it can be seen, that for all the sameness pervading the whole painting, there is a difference. The artist has no need to define it with the precision of an academician; nor would he do so, for indoors and outdoors, town and country are not so grossly different; an accident has changed their aspect, for so recently trees grew where now a cat sleeps in the shelter of an armchair.

Windows and walls are to a certain extent an abstract idea, as the surrealists have endeavoured to manifest. In London I lived in a room which edged a busy street, full of movement and hurtling lorries. But for the thin glass of the window and the screen of the wall, one brick thick, I should all the time be watching with anxiety, but with this protection, which in reality is no protection, I sit in total peacefulness, complete unawareness of the outside world, as though I were in the heart of the country.

The window and the wall in this painting retain a sense of substance being insubstantial. The academician would have made a conflict between his glass and his no glass, his bricks and his air; he would have needed to hold tightly to the convention of these things in order to convey the shelter of indoors; but David Jones can fuse the two and still retain his shelter and the less limited openness of the outside.

The curtains too have, in the painting itself, their particular nature, they blow in the wind, they are a barrier against the light, they can enclose the room from an outside gaze and shut off the outside from the inside; and yet no change occurs, the outside is still close-touching the inside. They are made of thread, fine almost as air, which by the subtle process of the loom, gives them substance, but for all that substance, the artist does not forget their essential delicacy. His consciousness of the actual life and nature of all that he draws is intense. Compare the cat with the armchair. The chair is of wood and has indeed some affinity with the trees outside, but the sap no longer thrusts itself upward, the wood has been cut to conform to a certain shape, it is quiescent. But the cat, for all his sleeping, is intensely alive; almost quivering in anticipation of alarm; his feet, so forceful and so violent, are suspended movement

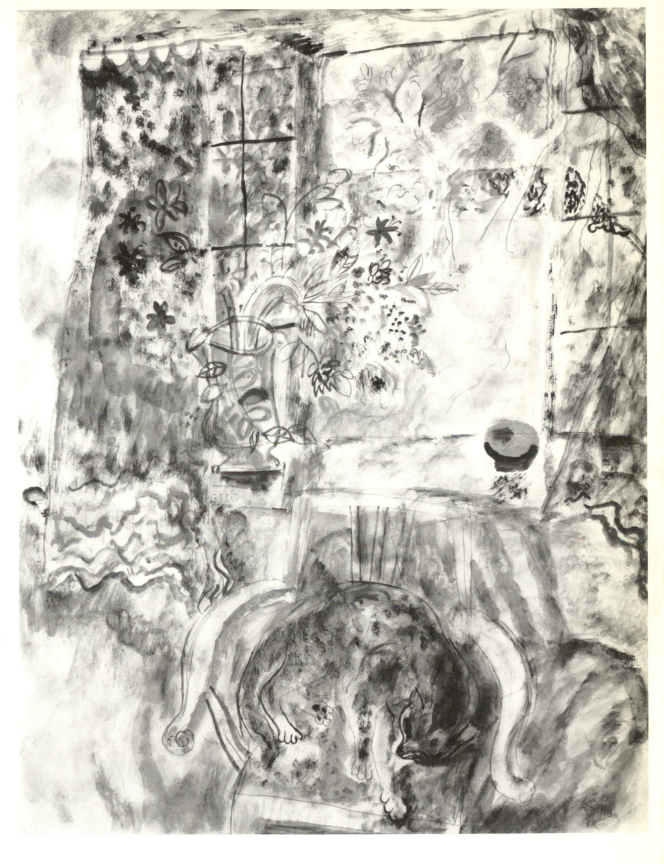

and vitality. Potential alertness is in every line of this cat which slept so peacefully until our thought disturbed him; but the chair remains impassive. This is true drawing, but the experts say David Jones can't draw.

He was staying in Northumberland and had gone to his room to make a painting from his window of some trees in the park. They looked like cabbages, a great green mass of endless foliage. How could anyone paint them? Then almost in a rage he cried, 'But they are trees, *trees*, *trees*, they must make a picture!' And in an agony of realisation, of reaching to the actual, and thrilling tree-life, he found an expression in paint. This wrestling to achieve expression is not unusual in artists; each good painting is the victory out of struggle. There is a whiff of El Greco in David Jones's work; at the age of 24 he was profoundly moved by El Greco's 'Agony in the Garden', at that time acquired by the English National Gallery.

I was once passing through Lourdes in a train and, looking out of the window, not knowing I was there, I was at once in David Jones's painting of this very scene. The whole atmospheric proportions were the same; the tempo of this painting; and yet there was everywhere a visual difference, so different as to be almost unbelievable that it was the same place.

Now that years have passed I can no longer, even visually, distinguish Lourdes from this pictorial representation of it. It fits it like a glove the hand.

Jones has always been very conscious of the particular character in the differing aspects of life. This consciousness is at the root of man's awareness, a direct unprejudiced comprehension of what a thing really is. A picture, no less than a candelabra, or a hay-wain, must be a thing, with its own life and way of living; dependent on its own proportion, proportion due to its own being. Jones says that this 'thingness' of a painting has been his sheet-anchor in times of bewilderment, which is at all times.

A painting must hold the nature of its every moment. David Jones learnt this through the doctrinal definition of substantial Presence in the Sacramental Bread. He realised that a tree in a painting, or a tree in an embroidery, must not be a representing only of a tree, of sap and thrusting wood; it must really be 'a tree' under the species of paint, or needlework or whatever. The inward thought and the outward form cannot be separated without loss to the whole. All this predominates in his work both as a painter or an engraver. There is ever this sense of change, of movement; life perpetual in its ever-varying thrusting. Many ideas were clarified for him, so liberating him. The Church's insistence on the reality of matter and spirit, that both are real and both good, wedded for him form and content, and demanded that in each particular, the general should shine out, and that without the particular there can be no general for man.

The most important for him was that God made and sustains everything gratuitously. It is similarly this gratuitous quality, its less or greater presence, that makes a painting good or bad.

As a writer his thought was equally lucid and equally complex, though always resolved. A little before 1940 he had completed *In Parenthesis* which I thought to be the finest 'war book' of our time, and this was the opinion of many leading critics. Jones himself said that it was not a war book although it 'happens to be concerned with war. It has to do with some of the things I saw, felt, and was part of at a time of war and in a place of war.'

In the 30 years following 1940 he wrote a great deal, and, as in his paintings and engravings, here too, his words, his prose, have a way of quickening the perceptions; with the awareness of the artist he has penetrated beneath the outward form to disclose the essential beauty of true living and the eternal need so to live in spite of every obstacle. In his own words 'an apostolic actuality, a correspondence with the object, a flexibility'.

'Vexilla Regis' painted in 1948, is so called because of the hymn used in the Roman rite as part of the Good Friday liturgy which began with the words 'Vexilla Regis prodeunt', and refers to the Cross as a Tree. This painting is I suppose one of the

most remarkable metaphors relating to the Crucifixion. To my mother, who had bought this painting, David Jones wrote that it was associated with the collapse of the Roman world. 'The three trees as it were left standing on Calvary – the various bits and pieces of classical ruins dotting the landscape and also other things, such as the stone henge or "druidic" circle a little to the right of the right-hand tree in the distance and then the Welsh hills more to the right again, the rushing ponies are, more or less, the horses of the Roman cavalry, turned to grass and gone wild and off to the hills . . . The leopard's pelt and the trumpet in the left-hand bottom corner are supposed to be the instrument and insignia of a Roman "buccinator" or trumpeter, as though the owner of them had been part of the guard on Calvary – that sort of idea. The tree on the left of the main tree is, as it were, the tree of the "good thief", it grows firmly in the ground and the pelican has made her nest and feeds her young in its branches – Our Lord is likened to a pelican in her piety in one of the Latin hymns of Thomas Aquinas. The tree on the right is that of the other thief. It is partly tree and partly triumphal column and partly imperial standard – a power symbol, it is not rooted to the ground but is part supported by wedges. St Augustine's remark that "Empire is great robbery" influenced me here. It is *not* meant to be *bad* in itself but in some senses proud and self-sufficient. Nevertheless it is shadowed by the spreading central Tree and the dove, in fact, hovers over the tree of the truculent robber for somehow or other he is "redeemed" too!'

I used to tell visitors about all this almost in these same terms without having seen his letter to my mother, and in writing to me he put 'Your mother drove up to the picture in a big way.' I think it was the only painting she had ever bought, she was over 80, felt she could no longer travel abroad, and so might sit and travel into 'Vexilla Regis'. Somewhere at the foot of the central Tree is a red robin whose red breast is said to be due to blood falling from the side of Christ. The good thief's tree will one day reach the stature of the central one while the other tree will fall to dust and disappear, but the thief will be redeemed by the Roman habit of crowning the Eagle with laurel which will fall into the earth, take root and grow to be a tree full of strength and beauty.

David Jones once sent me a short autobiography, which I left with the Tate Gallery when I retired. It ended with a short passage, to me of such importance, that though it has been quoted elsewhere I will repeat it, since I want it to inform this book.

'If you would draw a smith's arm, think of the twisted blackthorn bough, get at some remove from your subject. If you would paint a wedding group concern your mind with the wedding supper of the Lamb.

'If you would draw a bruiser don't neglect to remember the fragility of this flesh or you will be liable to make only a vulgar *tour de force*, and to obscure the essential humanity of your gross man. There should be always a bit of a lion in your lamb. The successful work of art is one when no ingredient of creation is lost, where no item of the Benedicite omnia opera Dominum is denied or forgotten. This is not easy.

'It was I believe, the greatest Welsh poet of the fourteenth century who remarked of the falling snow, that the angels were at their white joinery in heaven, that the saints were plucking their geese. It is important to be anthropomorphic, to deal through and in the things we understand as men – to be incarnational. To know that a beef-steak is neither more nor less "mystical" than a diaphanous cloud. God loves both. The painter more than any man must know that the green grass on the hill and

the fairy ring are both equally real. He must deny nothing, he must integrate everything. But he must deal only with what he loves, and therefore knows, at any given time. He will come a cropper if he tries to be more understanding or inspired than he really is. Let him love more and more things. "It is better to love than to know" is his golden rule. He does not experiment like a man of science. As Picasso says, "He does not seek, he finds." '

I think the engraving 'The Dead Albatross' is for me the best in this series of life-giving engravings. There is an astonishing sense of ship and water and so great a feeling for the engraving's relationship to the printed page it balances. There is a rich store of perception, strongly rendered. I want to introduce another account of an albatross with which David Jones was familiar. It is a footnote somewhere in *Moby Dick*.

'I remember the first Albatross I ever saw. It was during a prolonged gale, in waters hard upon the Antarctic seas. From my forenoon watch below, I ascended to the overclouded deck; and there, dashed upon the main hatches, I saw a regal feathery thing of unspotted whiteness, with a hooked, Roman bill sublime. At intervals it arched forth its vast archangel wings, as if to embrace some holy ark. Wondrous flutterings and throbbings shook it. Though bodily unharmed, it uttered cries, as some king's ghost in supernatural distress. Through its inexpressible strange eyes, methought I peeped to secrets not below the heavens. As Abraham before the angels, I bowed myself: the white thing was so white, its wings so wide, and in those for ever exiled waters, I had lost the miserable warping memories of traditions and of towns. Long I gazed at that prodigy of plumage. I cannot tell, can only hint, the things that darted through me.'

This book is dedicated

to God, ever present

Quotations in the order of their occurrence

These quotations are really a few of the many thoughts which were constantly in my mind while engaged in the putting together of Kettle's Yard. At that time I learnt, by heart, many things, and now in this book a few keep returning, but in a fragmentary way; for I have forgotten much and of what remains, only here and there do shadows clarify. They are not placed in any special order nor do they in any way set out to correspond to their neighbouring photographs except in the instance of the Buddha. *The Sonnets* without further note are by Shakespeare: as is also a play. I have entered only the first line or part of it. I have added a few of the quotations that have crept into the text, for the pleasure of repeating them.

Authors or titles, with page numbers of quotations from each

Photographers. Their several efforts contribute overwhelmingly to the serenity of this book; I thank them, and I hope this list is accurate.

Notes

1. I am most grateful to Hughes Massie Ltd for permission to quote four of Roy Campbell's translations of poems by St John of the Cross. These will be found on pp. 8, 81, 98, 171, and a single line on p. 104. These poems are published in hard covers and paperback, a fantastic store of beauty.

2. I am glad to be able to print, with the author's permission, the first poem about Kettle's Yard to be published in English or, I think, in any language. This poem, printed on p. 126, is by Robert Jondorf and is taken from *Messages from Planet Earth, Galleries of the Mind*, p. 32 (Birds Farm Publications, Barton, Cambridge).

3. M. Roger Secrétain's life of Henri Gaudier-Brzeska, entitled *Un sculpteur maudit: Gaudier-Brzeska 1891–1915* with a preface by Jean Cassou, was published in December 1979 by Les éditions du temps, 58 rue du Montparnasse, Paris 75014. This is the first book to be published in France about this sculptor. It gives a full account of his life, both as a person and as a sculptor, with plentiful illustrations; placing him in the top rank of French sculptors.

 In November 1981 a French television documentary of one hour's duration was completed for distribution throughout France. This is, as M. Secrétain said of his own book, a 'réparation française' for 66 years of neglect since the artist's death in 1915.

4. I think that somewhere in this book I have used the words 'a pool of silence', perhaps twice. If not, I use them now, that I may express the pleasure the phrase has been to me, as also my indebtedness to T. E. Lawrence who, in *The Mint*, wrote of his barracks at night as 'a white-walled pool of silence'.

5. This book had already gone to its publishers when I received from Australia a very large and well produced book written by Murray Bail and published by Bay Books Pty Ltd of New South Wales.

 It is a life of Ian Fairweather, generously supplied with large colour reproductions of his work.

 In a remarkable way it reveals the inner force of his talent which places him amongst the foremost of Australian artists – perhaps even their leader. The book becomes, as it were, a Retrospective Exhibition, presenting him as an artist who had a consuming passion for the art of painting, of creating pictures with no matter what perishable material, and with little thought, either for their inspiration or their future.

Coda

An unexpected extra! These twelve photographs were taken by Anthony Miller, principal lecturer and Head of the Design Department at Newman College, University of Birmingham; assisted by Peter Harper of the same Department and senior lecturer in Ceramics.

Anthony Miller is researching the place of natural forms in post-Second World War art education. At Kettle's Yard he and Peter Harper found wonderful material to help them in their quest.

The beauty of these photographs asserts their pleasure and interest, and I here express my gratitude for this lively Coda to the book.

I add a few words of information.

<div align="right">1 November 1981</div>

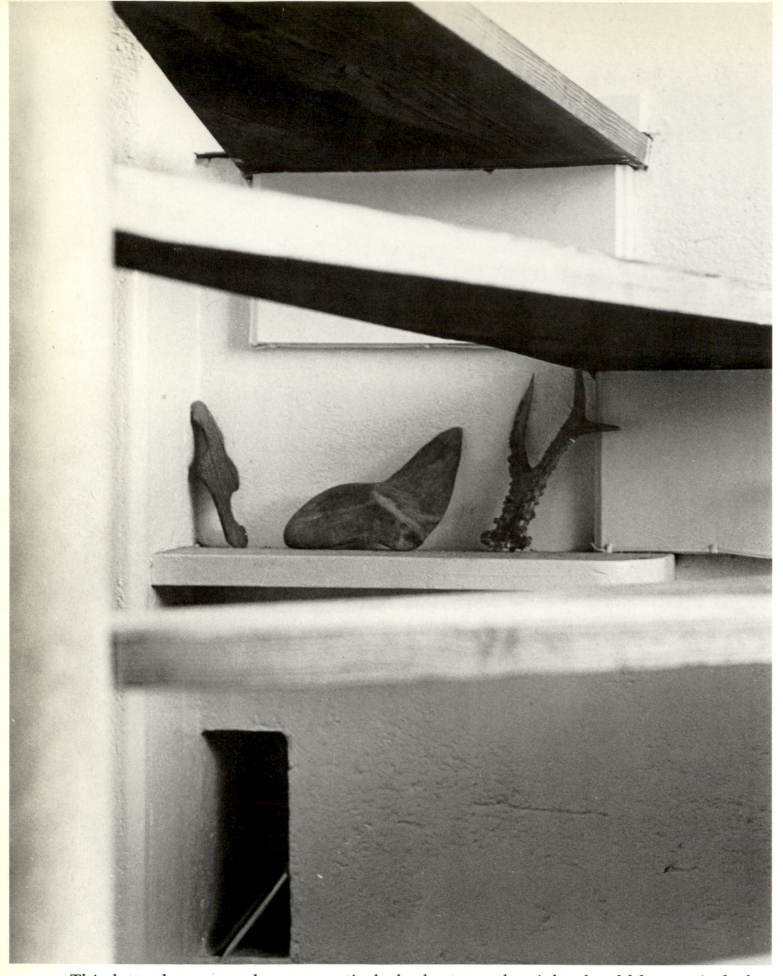

This letter-box proved very practical: the horn on the right should be vertical: the strip of drift-wood on the left has not been shaped by human hand.

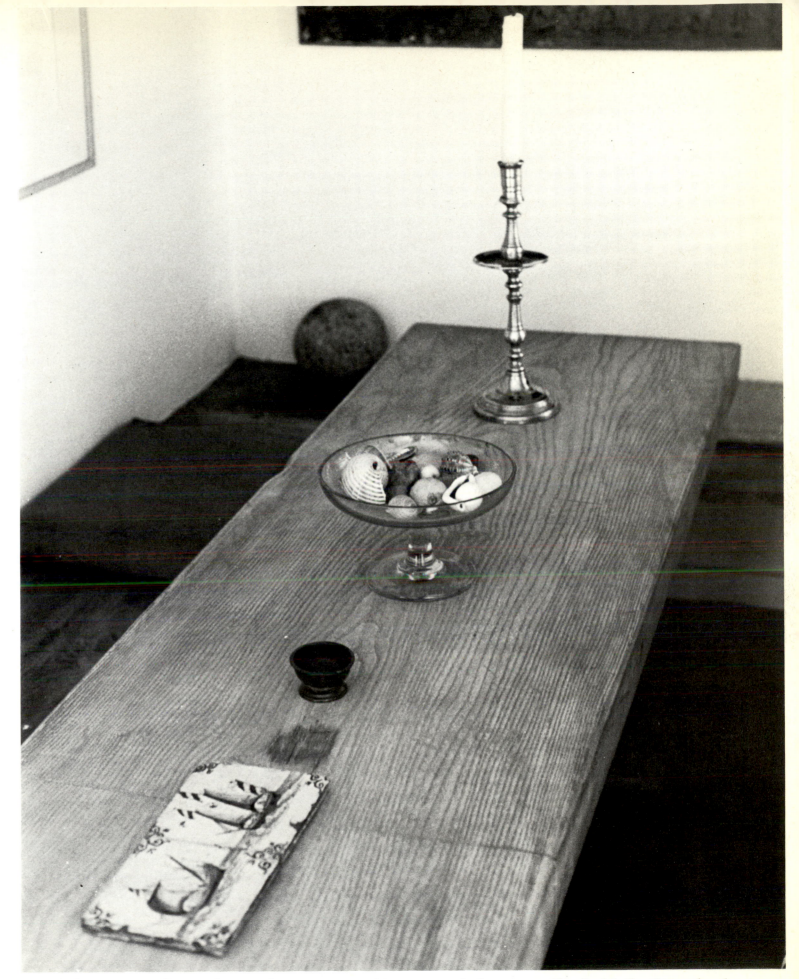

I had forgotten about the unfortunate stain – some ink was spilt, I think. I pushed the two delft tiles along to cover it.

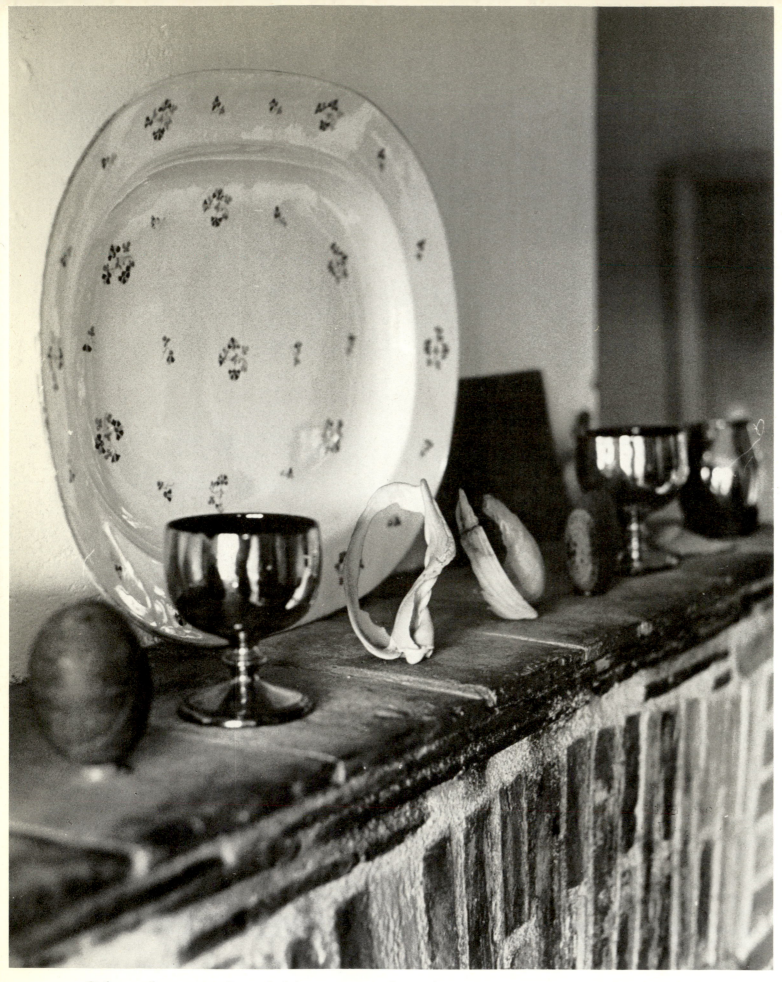

Other photographs of this area are found on pp. 27, 34, 35, but not so dramatic

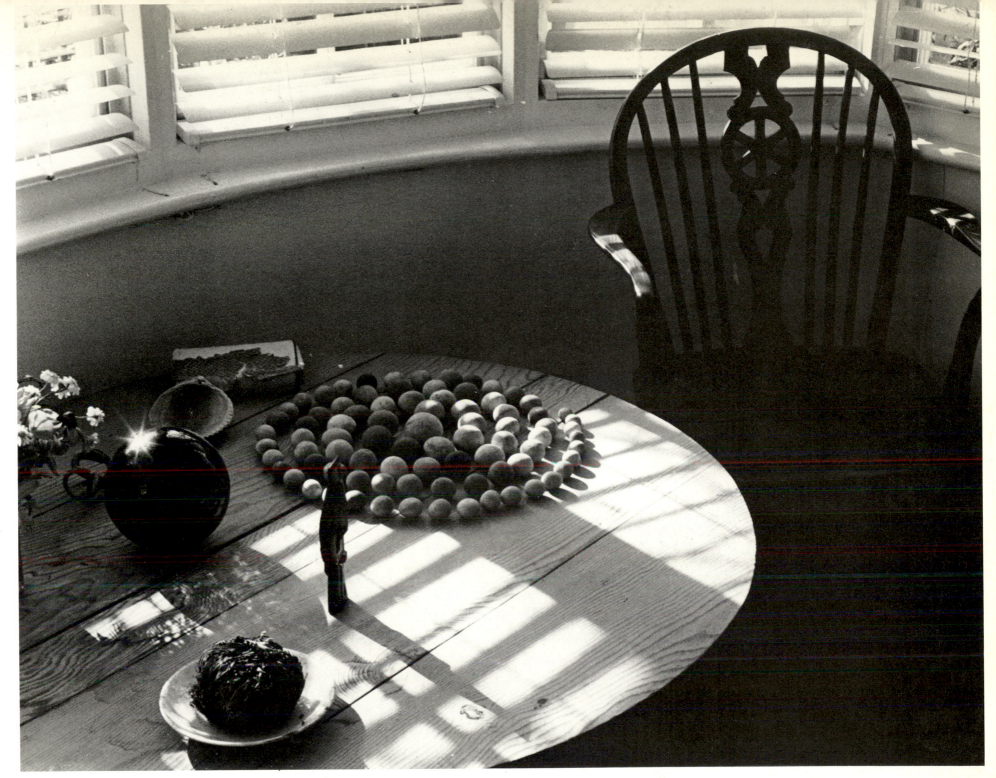

This is a great wonder of beauty and typifies what is for me Kettle's Yard's unique character. It could be anywhere, and for some reason isn't.

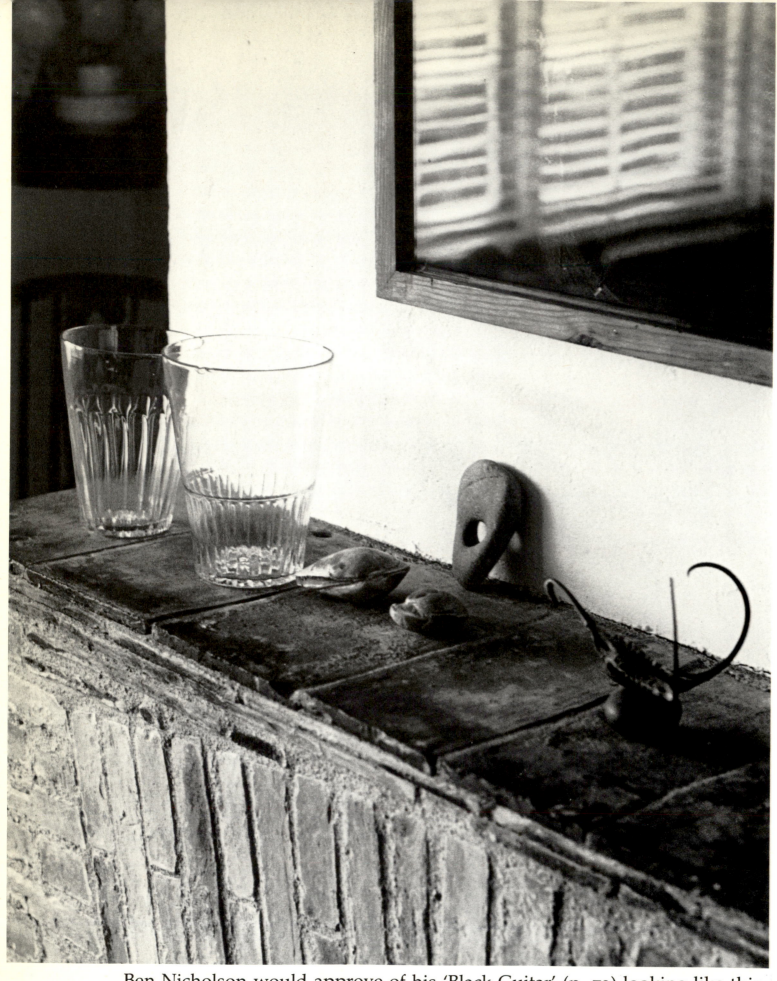

Ben Nicholson would approve of his 'Black Guitar' (p. 73) looking like this.

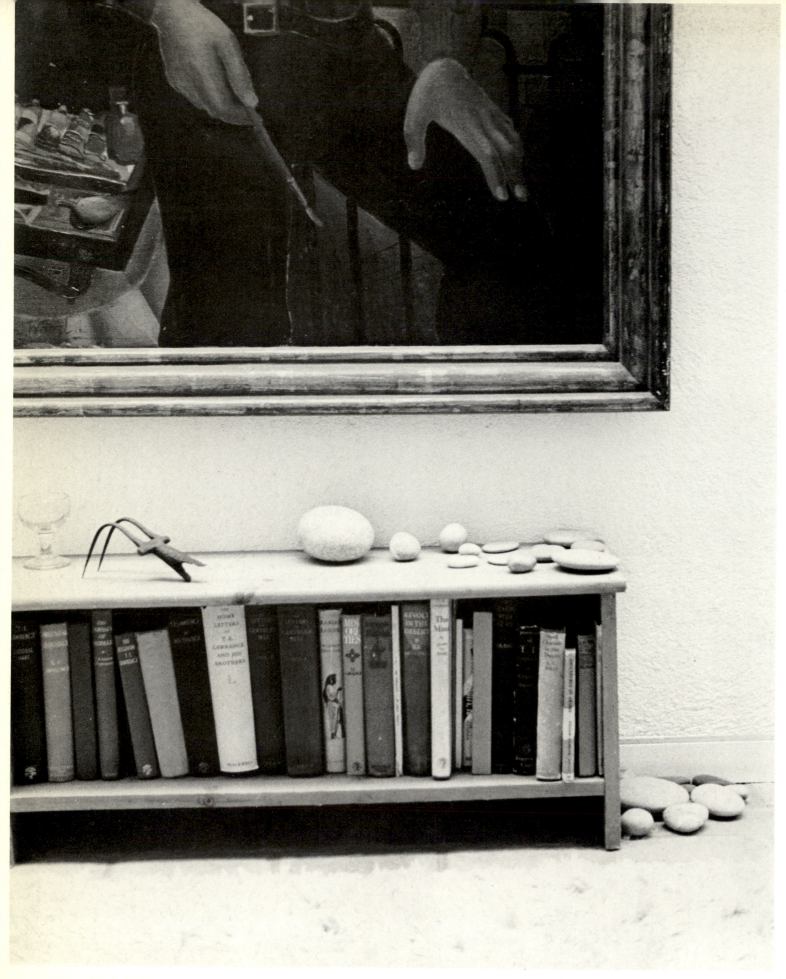

A very impressive 'Detail' from Christopher Wood's 'Self Portrait'. It reveals his startling energy in a way I had not noticed before.

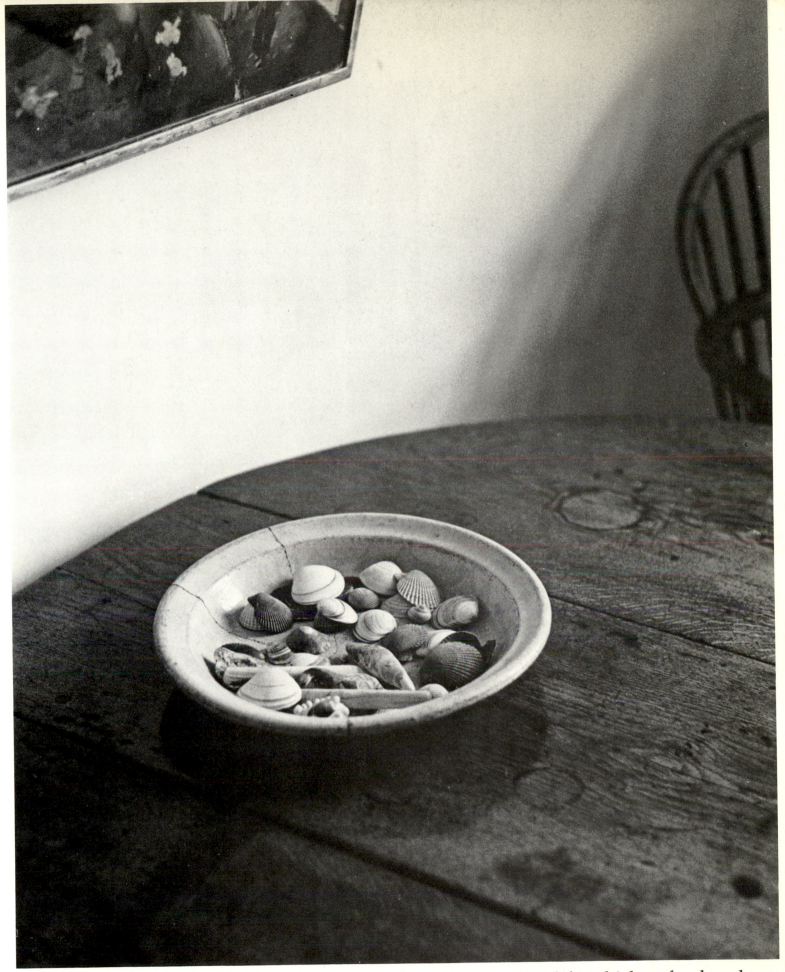

Before we lived in 'Les Charlottières' (p. 21) this plate was used for chicken food and its home was on the ground, and I doubt if it was ever washed.

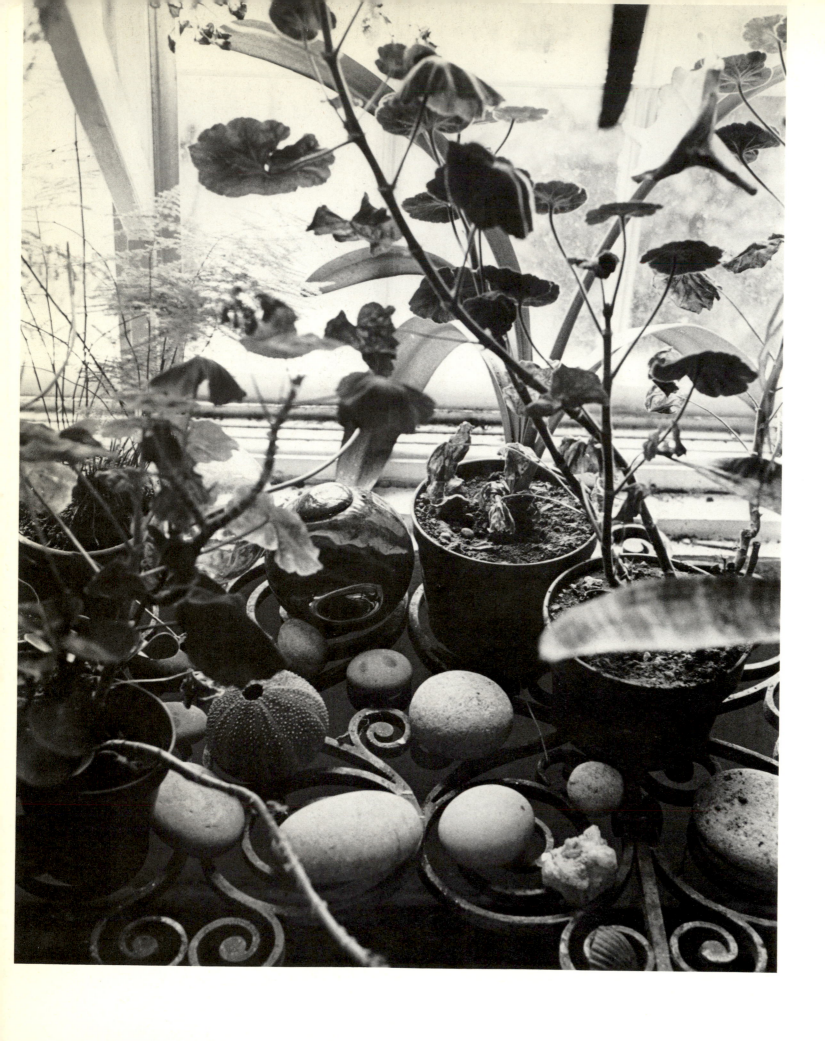

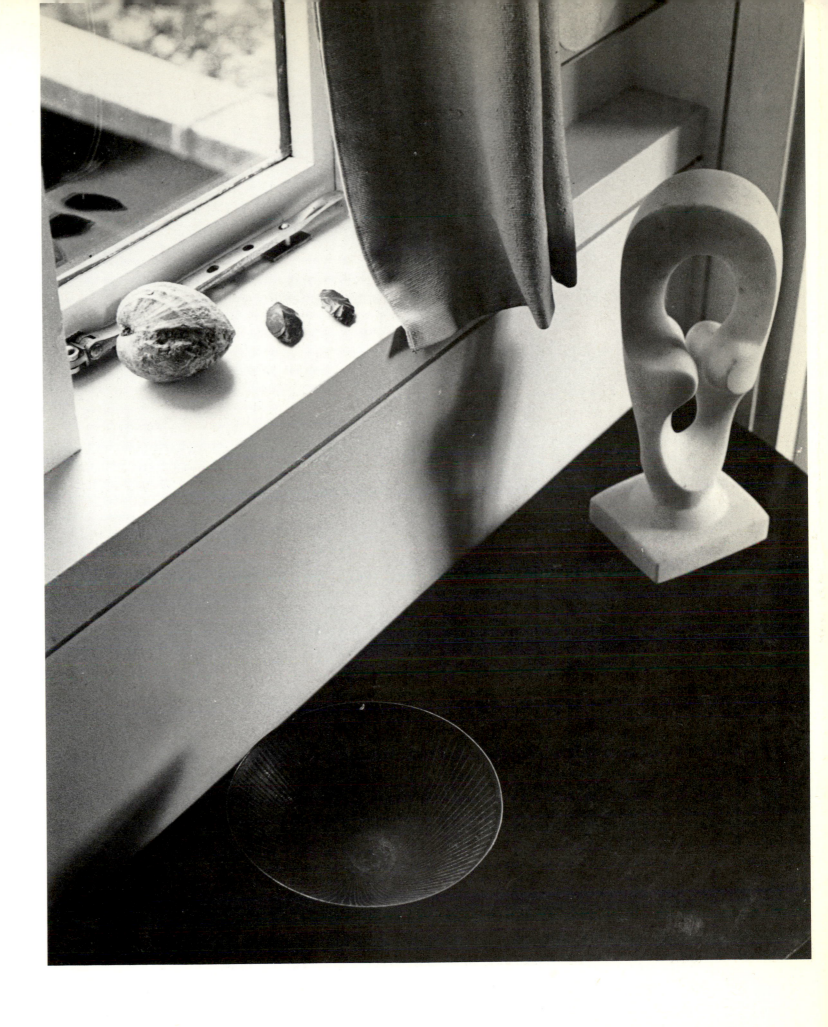

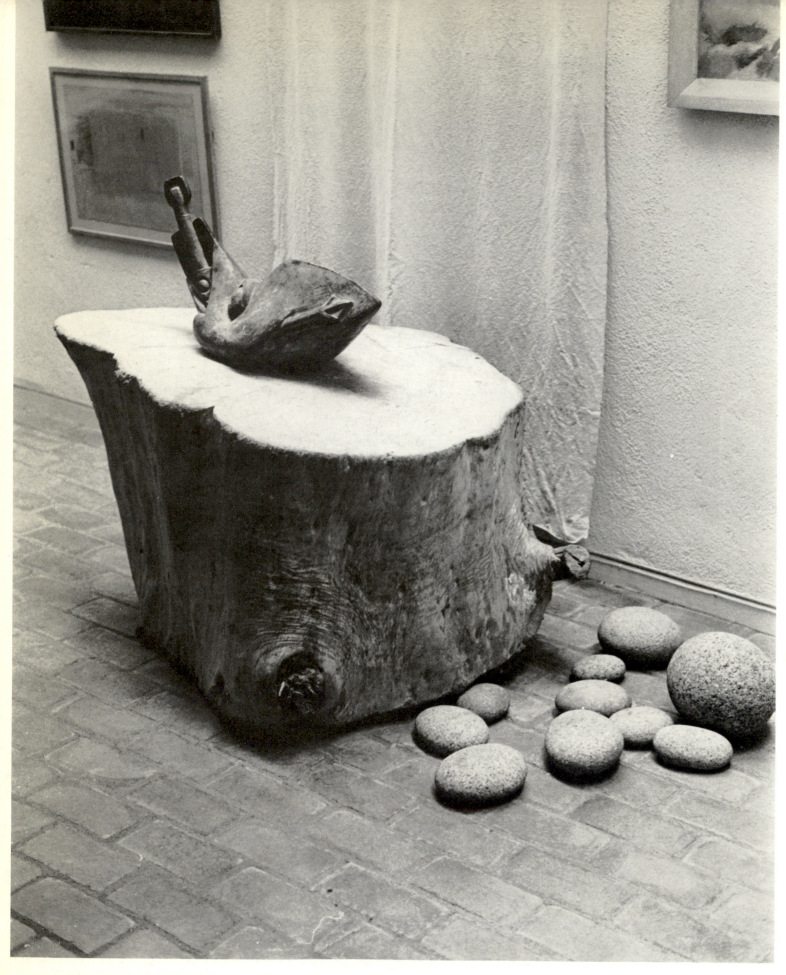

I am very glad to have this view of the plinth (p. 191). My grandson Philip took his
turn in washing the pebbles, also from the Scilly Isles.

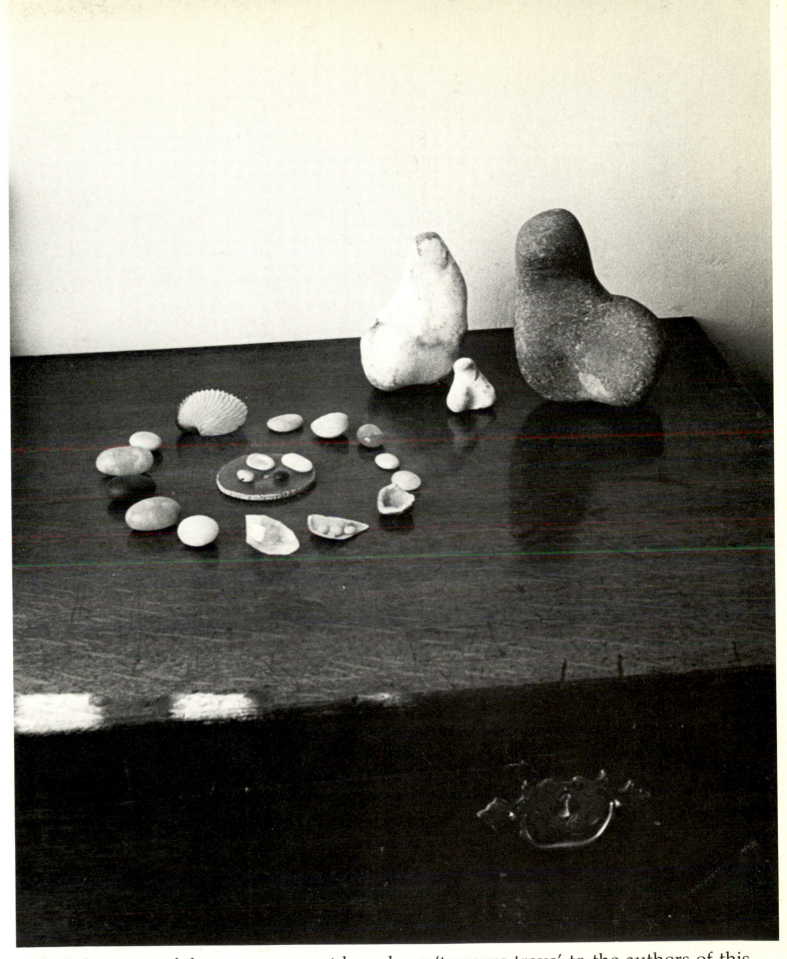

This little group of three stones must have been 'treasure trove' to the authors of this Coda, and becomes a fitting end to this book in words associated with Mary, Queen of Scots, which were embroidered, perhaps by herself, on her Chair of State: 'en ma fin est mon commencement' ('in my end is my beginning').

Of many thousand kisses, this poor last I lay upon thy lips.
Antony and Cleopatra